great big book of
FASHION ILLUSTRATION

MARTIN DAWBER

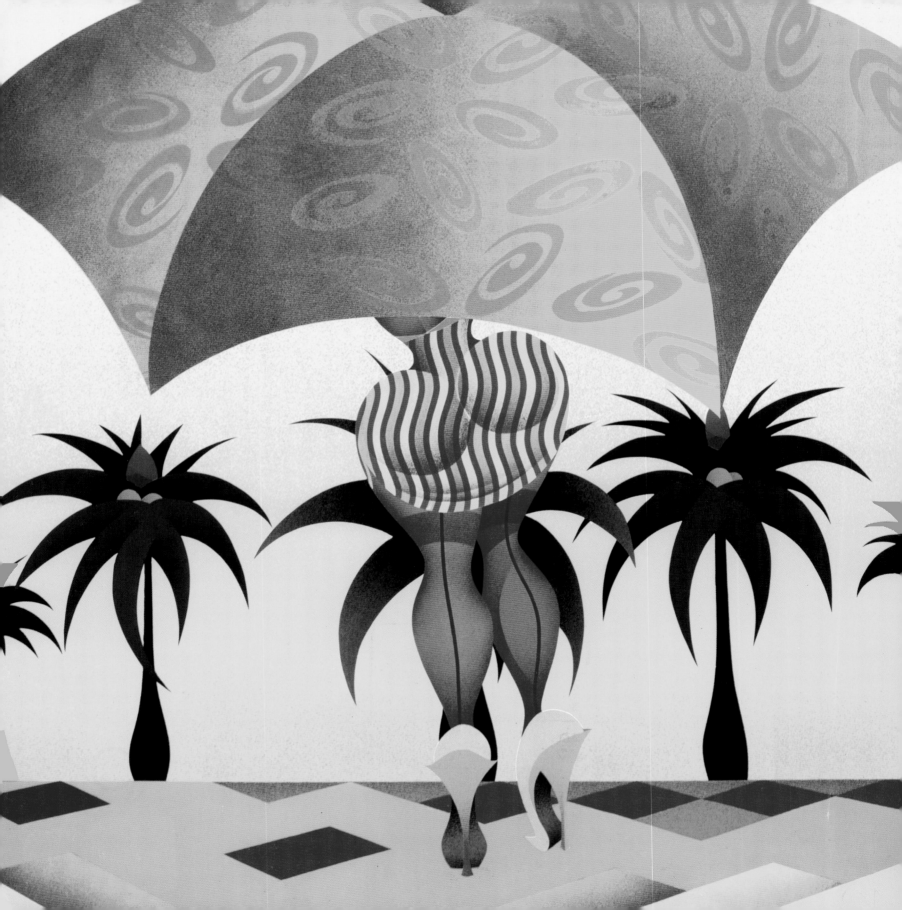

great big book of
FASHION
ILLUSTRATION

MARTIN DAWBER

BATSFORD

You don't stop working because you grow old,
You grow old because you stop working.
Fanny Waterman

This book has a long overdue dedication to everyone at Batsford, but especially Tina, Kristy and Komal for their collective faith. An author could not ask for a better team.

First published in the United Kingdom in 2011 by
Batsford
10 Southcombe Street
London W14 0RA

An imprint of Anova Books Company Ltd

ISBN: 9781849940030

A CIP catalogue record for this book is available from the British Library.

18 17 16 15 14 13 12 11
10 9 8 7 6 5 4 3 2 1

Reproduction by Mission Productions Ltd, Hong Kong
Printed by Toppan Leefung Printing Limited

This book can be ordered direct from the publisher at the website:
www.anovabooks.com, or try your local bookshop

Distributed in the United States and Canada by Sterling Publishing Co.,
387 Park Avenue South, New York, NY 10016, USA

Page 2
Sid Daniels
Trocadero Mambo (2001)
Acrylic on canvas

Right
Marguerite Sauvage
Anja (T-shirt Design) (2009)
Pencil on paper, Adobe Photoshop

Contents

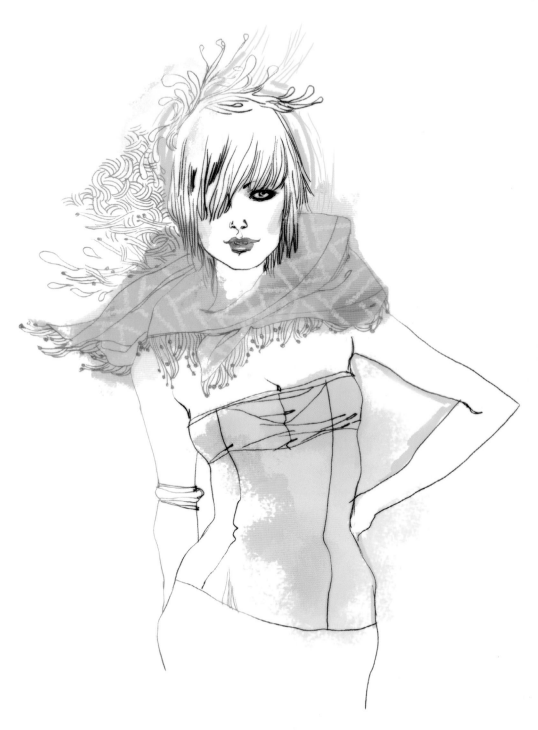

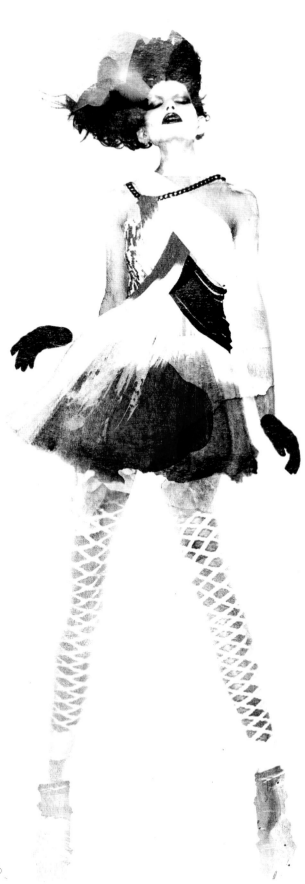

Foreword

Great Big Book of Fashion Illustration takes on an enormous task, showcasing some of the best talents from around the world. Martin Dawber reprises his role once again as the global seeker of all good expressions in print and digital art, and brings each work to the reader with much admiration and respect, with bolder and innovative ideas set to influence new trends in fashion.

Fashion illustration is, after all, an almost lost art, with our digital age providing endless alternative sources for creating and crafting new art forms amid limitless boundaries. But even before the creation begins, a vital ingredient of creativity called inspiration must be present. It's the kind of magic that many people aspire to possess, yet few succeed, even in a culture where money can buy virtually everything else.

The word 'inspiration' stems from the biblical realm of the Divine Inspiration, due to its mysterious origins with no scientific explanation for its existence. According to T.S. Eliot, inspiration is like a visitation from something profound and incomprehensible, yet its presence reassures us, or at least reminds us that some of the best things about us are beyond our control. Inspiration may not belong to mere mortals, yet it is only individuals who can be inspired by whatever is around them. The sights, smells, sounds, and reflections of different countries are imprinted with individual and personal characteristics, all almost as unique as one's thumbprint, making a clear mark of distinction of one from the other. Inspiration today is as profound or as unique as one makes it out to be. The type of creative work seen in Tokyo, is different to that in London, Paris, or India. That's because every individual interprets creativity in so many aspects and personal permutations; that it is almost impossible to classify or dictate what is accepted and what is not. Creative expression is almost like existing in a fantasy world, where margins are never defined and the vision is only as vibrant or luxurious as one's imagination allows.

In many ways, *Great Big Book of Fashion Illustration* is a brilliant example of this sort of fresh, energetic essence, brimming with a multitude of progressive ideas, evolving attitudes, and vivid expressions by select fashion illustrators from around the world. Some people might just call this book a 'divine illustration'.

William Teo
Vice Dean, Office of Academic Affairs & Head, Department of Fashion Studies
Nanyang Academy of Fine Arts, Singapore

Luis Tinoco
Top magazine (UK): Rodarte (2009)
Watercolour, Adobe Photoshop

Introduction

We should talk less and draw more. Personally I would like to renounce speech altogether, and like organic nature, communicate everything I have to say in sketches -
Johann Wolfgang von Goethe (1749–1832)

The scope for today's fashion illustrators is ever widening. The illustrators and artists featured in *Great Big Book of Fashion Illustration* relish the opportunity to embrace a multitude of techniques and values that challenge the accepted 'rules' of traditional fashion expression. Finnish fashion illustrator, Jarno Kettunen, who describes his backstage action drawings as 'visual violence' states that 'illustrators offer society a new layer of perception, another way of seeing things. It is very direct, spontaneous and expressive'.

Illustrators are free to employ drawing, painting, collage, photography, the latest digital software, and much more. Today's techniques are endless and run parallel to the dramatic changes in 20th-century design and technology. Chinese illustrator Wendy Ding, who studied at Sheridan Institute in Oakville, Canada sums up her role: 'We make the world a more beautiful and fun place to live in. We can't help but remind everyone through our work that, hey, it's OK to kick off your shoes and do a wild dance, from time to time'.

Within today's mass media frenzy, what is considered a fashion illustration can be as difficult to pin down as the subject matter itself. 'I think it has to do with beauty, sensuality, styling, looseness, colour and texture' admits Spanish graphic artist and illustrator, Robert Tirado. 'A good fashion illustration should be fresh, cool and creative'.

As couture continues to journey further away from the familiar with each catwalk extravaganza, it is imperative that any contemporary fashion illustrator worth their salt is allowed the freedom to breathe and re-interpret these Gaggaesque extravagances through their own individual language and self-expression. There has never been a more exciting time to be one of today's documenters of trend and image. 'My childhood dreams of becoming a fashion designer triggered me towards fashion illustration' acknowledges self taught Russian fashion illustrator, Svetlana Makarova. 'I like to express myself, my mood, and my personal taste through my illustrations. Every day I get to know more and more new tricks and interesting techniques. It is all really very inspiring and motivating'. Artist and illustrator Wendy Plovmand's own interest in fashion began at the Design School of Denmark. Not deterred by her tutor's advice that it was a difficult business she persevered onto a Masters Degree at Central Saint Martin's in London. 'After five years in the illustration business I chose to focus on fashion since I enjoyed it the most. It made sense for me and my work. Nearly all my dream assignments and clients are to be found in the fashion field. I would love to do a fashion campaign for one of my favourite designers like Stella McCartney or Diane von Furstenberg, that would be so interesting and fun and amazing!'

Contemporary illustration is about communicating a personal feeling rather than presenting a precise drawing of its subject. Today's fashion illustrator can wallow in this artistic freedom and use all the tricks up their sleeve to interpret the essence of their subject. However, for Alcine Perryman-Burrow, who began her career as a fashion illustrator over twenty years ago by working for some of Chicago's

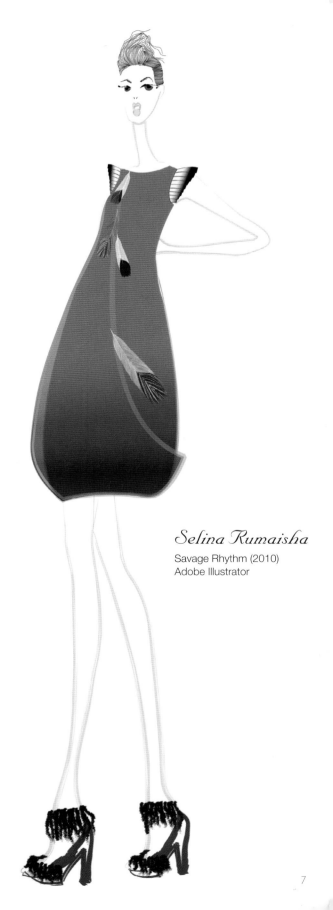

Selina Rumaisha
Savage Rhythm (2010)
Adobe Illustrator

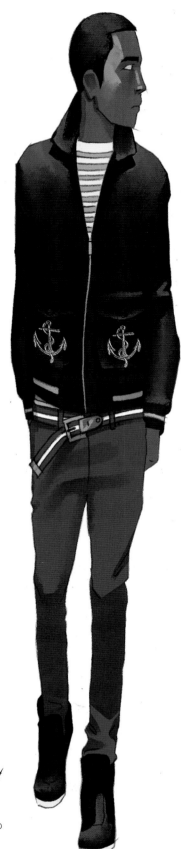

Brandon Kent
Graham

Black Bomber (2010)
Pencil, Adobe Photoshop

leading department stores, there is no getting away from the necessary basics: 'The one thing that helped me the most as a fashion illustrator were the classes I took in fashion drawing and life drawing while at art school. There really is no substitute for being able to draw the human form'. She goes on to explain how the illustrator's kit bag has subsequently evolved: 'I think it's important for an illustrator to be willing to pick up new tools in order to move their art forward. In the early 1960s most illustrators worked exclusively with a brush. In the 1970s some artists were working in pen and ink, others were trying markers and by the 1980s Antonio fascinated us all with his detailed pencil drawings. Today we have the computer, which I see as still another tool to explore. The truth is you can create a beautiful drawing with any media once you get comfortable with it'.

Visually capturing the vibe of present-day culture's manners and modes is the ideal pursuit for any illustrator. Illustrator Mariya Paskovsky, who was born in Russia and now works from her studio in Canada, draws upon all her personal experiences when constructing her work: 'I love drawing and creating new characters. It's as if I'm writing a play. Illustration is very forgiving and open to any experimentation. My chubby or super-skinny girls are very happy the way they are, for they are living in their imaginary, stylized and drawn world where nobody can accuse them of being too fat or anorexic'. At its most rudimentary the term fashion illustration can simply be defended as pictures that express fashion. Their function is to articulate the mood swings of an industry that re-invents itself every six months.

Up until the early 1930s when Condé Nast initiated the trend to move towards photography as the preferred arbiter for capturing fashion, a magazine editor had relied solely upon drawing and painting to visualise their written words for its readers. The best illustrators were exceptional visual storytellers, enhancing any narrative with their personality and flair. Working from his studio in San Pedro, California, illustrator Rob de Bank takes a philosophical view: 'I think people would like to see more illustration in publications, but photography is thought to show true reality and that's what the publishers think their readers want. Now with Photoshop, is there really any true reality anymore? Illustration offers a bit of fantasy that comes directly from the mind of the artist'. Contemporary illustration is moving towards a more conceptual approach that forces each artist to sieve reality through their own subconscious to generate a more personal re-interpretation of contemporary culture's manners and modes. 'Drawing is like channeling energy from an unknown source', agrees Puerto Rican fashion illustrator, Carlos Aponte. 'It's like being a medium. I sit on a chair with a white piece of paper and just go into my own kind of trance or world to solve the visual problem. Everything today can be so literal; fashion magazines have become catalogs. But there are still some people with vision that work to sustain that marriage between art and fashion'.

It has to be acknowledged that its once unique currency has recently been devalued. Because everyone now owns some form of graphic-design programme within their computer's software, many consider this has given the game away by revealing the magician behind the curtain. New Jersey figurative artist known as Brine remains concerned that 'it's certainly made people less picky. I find horrid examples of typography and design that would not have existed in print 30 years ago!'

The individuality of the painted or drawn illustration has also been replaced in popular mass media by the stock image libraries that flood into the editorial inbox. Although they may appear cool and contemporary to the uninitiated, the technique and imagination is frequently throwaway. For American fashion illustrator Renee Reeser Zelnick, who has two decades of experience within the industry, 'it is pretty easy to spot the hacks that rely solely on digital trickery. The internet has allowed a whole new group of individuals to call themselves graphic designers and illustrators without the experience, talent and professionalism to back it up. As artists and illustrators, we possess skills others do not have – we can visualize what is not there and draw and paint it into existence'. London-based artist Rowan Newton, who studied illustration at the University of Westminster, holds fast to his opinion that 'it's more important than ever that someone who calls themselves

an illustrator is actually capable of drawing. After the home computer boom, illustration has come full circle and the computer is now starting to be used to compliment the art rather than replace it.'

The real benefit of the communication highway are the opportunities for exposure and self-promotion that were previously unknown. Today's visual artists now have unlimited means to connect with the world. Although a fine artist may prefer to tap into the whole gallery and museum arrangement for their representation, today's technology savvy illustrator, by making use of the internet, doesn't even need an agent to get their work out there and noticed. Websites and personal blogs have 'become the norm and is a great way to keep fans and clients updated with news, shows, and work in progress', confirms Wendy Ding. 'With social media like Facebook and Twitter, it can really help to establish a devoted following and that is so valuable today'. Canadian illustrator Danielle Meder, working from her studio in Bancroft, Ontario, is even more convinced of the advantages: 'Without my computer and an internet connection, I wouldn't have a career as a fashion illustrator. Putting your work out there on the internet is an absolute necessity. While we are all figuring out what the new paradigm is in media, getting into it ahead of the curve can only be an advantage'.

Despite the opportunities for social networking, most illustrators' physical practice is a solitary environment. Many prefer to work within their own private space away from the distraction and interference of others. Indian artist Hormazd Narielwalla is quite resolved about this: 'A big "do not disturb" sign is placed on my studio door. I hate being interrupted and bothered'. This can offer a more individual approach to the traditional working day as Belgium artist Ellen van Engelen explains: 'I have a completely different rhythm than people with a nine-to-five job. I can get up later if I don't have to finish something quickly and I can always work later into the night or at weekends if I have a lot of work'. However that doesn't mean that it's an easy option as Greg Paprocki, a graduate from the University of Nebraska, makes clear: 'I'm very disciplined when it comes to a schedule. I usually have multiple projects going on at the same time. So, in order to keep everything moving smoothly, I have to avoid as much wasted time as possible'.

Nevertheless, the process of conjuring up new illustrations is not always guaranteed to turnout as planned, as self-taught Ukrainian illustrator Lyuobov Dubina reveals. 'I really love everything about what I am doing but most of all I enjoy the metamorphosis that occurs when drawing up my sketch ideas. Normally at the beginning you have one picture in your mind's eye, but during the drawing process, it keeps on changing and becomes more interesting, much more expressive. So much so that I often don't know how it will finally finish up'.

Fashion illustrators function within a highly competitive market where most of their work is inevitably carried out on a freelance basis. Kari Moden, a graduate of the Berghs School of Communication in Stockholm, although relishing the fact that 'I don't have a boss' still recognizes that it can be a swings-and-roundabouts situation. 'I really like the freedom of my work even if I sometimes dislike the feeling of having an on-call job. You can't plan a lot and it's hard to say no to a commission even if you are fully booked. For me the stress is short deadlines, but most of the time I quite like that'. Former pre-med student David Pfendler, now following his dream from his Greenwich Village studio, also agrees that 'as a freelance artist you have little control over when the work comes in, and how you work within it and around it. Marketing is the toughest part of the freelance business. It's always "all or nothing", which can be very stressful, but once you get through a few tough ones, you learn to roll'.

Fashion illustration may have once allowed itself to be elbowed towards the back of the class behind the glamour and immediacy of photography, but there is increasingly room, and more importantly, a creative need, for the type of contemporary illustration on show in *Great Big Book of Fashion Illustration*: artists that enjoy taking risks and delight in giving their audiences a very personal snapshot of contemporary fashionable life.

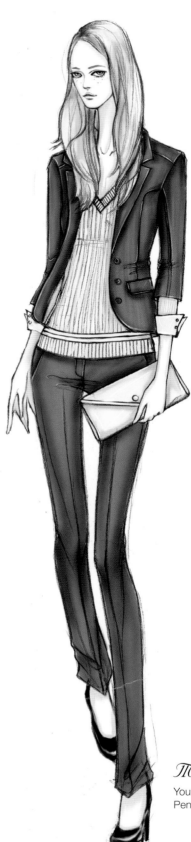

Mengjie Di
Young Women Uniform (2010)
Pencil, Adobe Photoshop

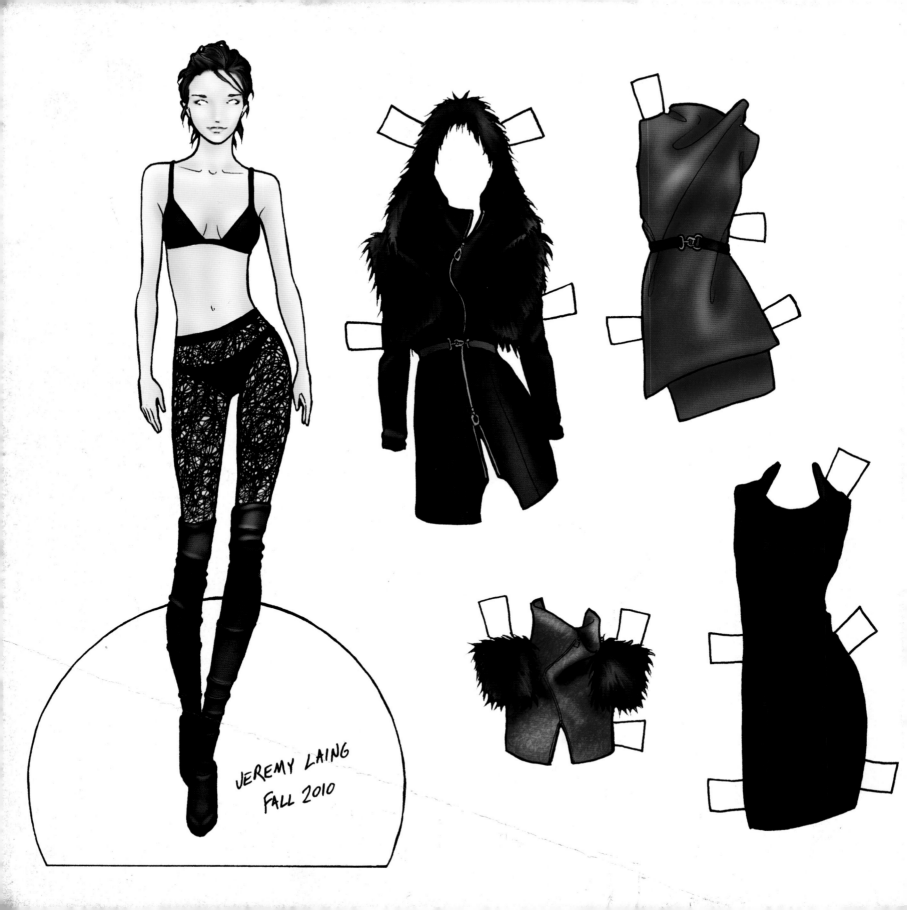

JEREMY LAING
FALL 2010

Womens-
wear

previous page:

Danielle Meder

Jeremy Laing Fall 2010 Paper Doll (2010)
Ink, Adobe Photoshop

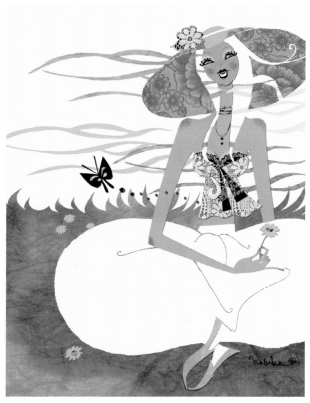

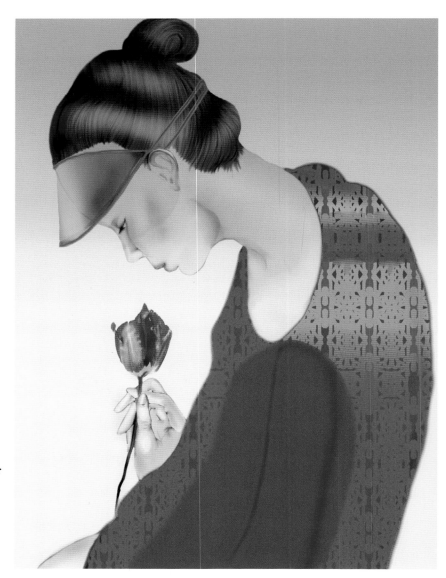

Nobuko Takagi

Personal Work (2008)
Adobe Photoshop

Artaksiniya

The Sunny Flower (2010)
Adobe Photoshop

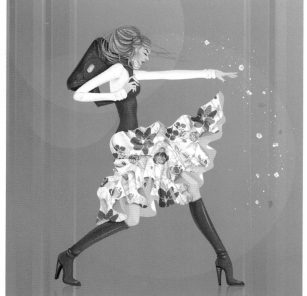

Svetlana Makarova

Orange Girl 2 (2009)
CorelDRAW

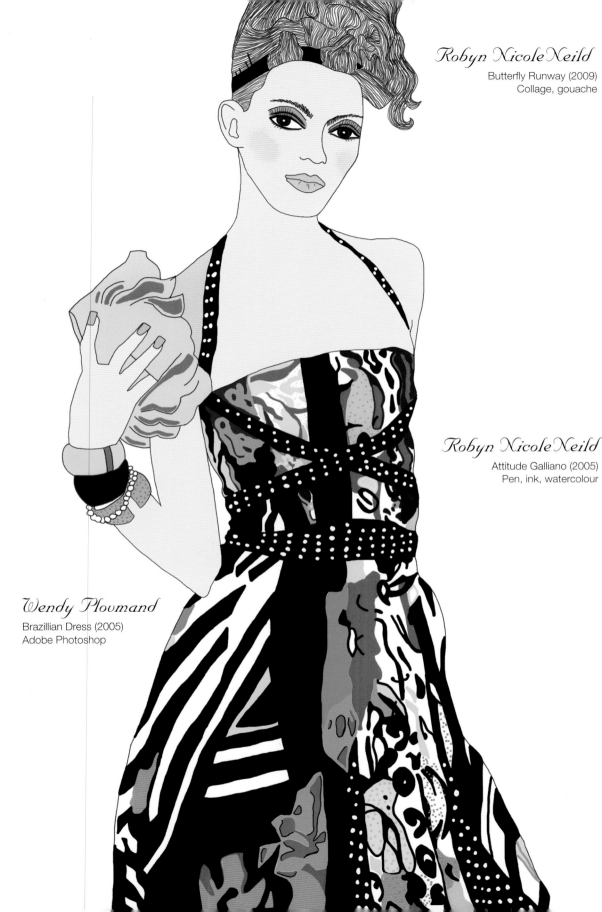

Wendy Plovmand

Brazillian Dress (2005)
Adobe Photoshop

Robyn Nicole Neild

Butterfly Runway (2009)
Collage, gouache

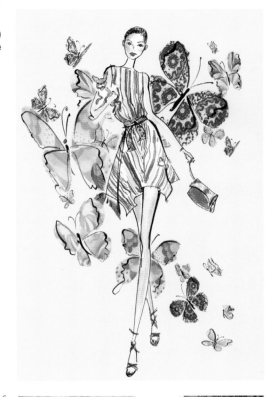

Robyn Nicole Neild

Attitude Galliano (2005)
Pen, ink, watercolour

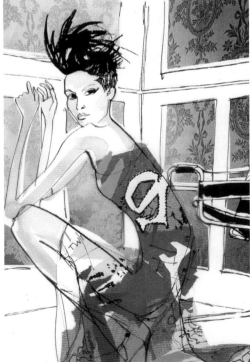

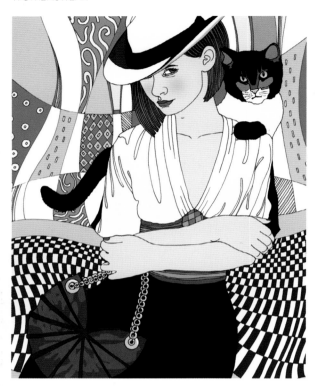

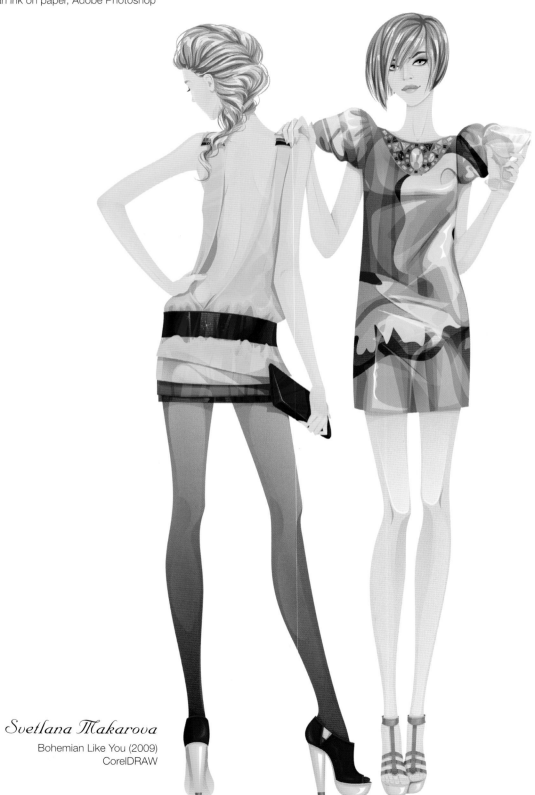

Anne Lück

Saisonelle magazine: Different Types of Parfum no.1 (2009)
Indian ink on paper, Adobe Photoshop

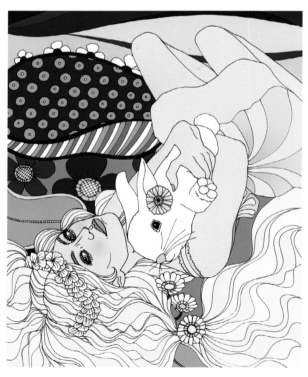

Anne Lück

Saisonelle magazine: Different Types of Parfum no. 2 (2009)
Indian ink on paper, Adobe Photoshop

Svetlana Makarova

Bohemian Like You (2009)
CorelDRAW

Annelie Carlström

The Queen of Minimarket (2008)
Pencil, Adobe Photoshop

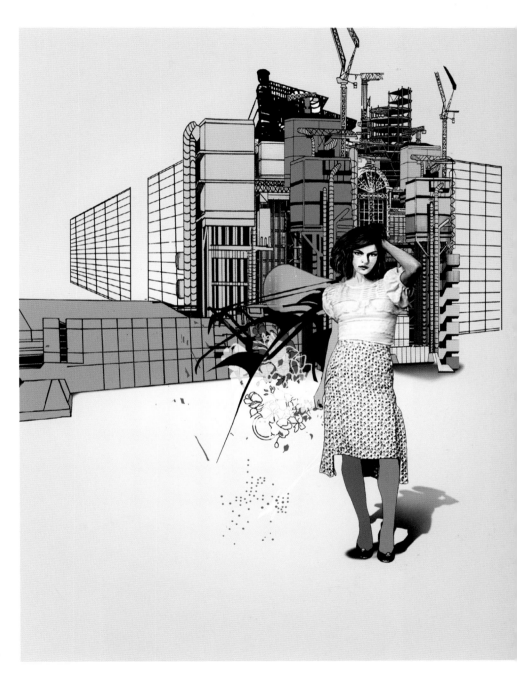

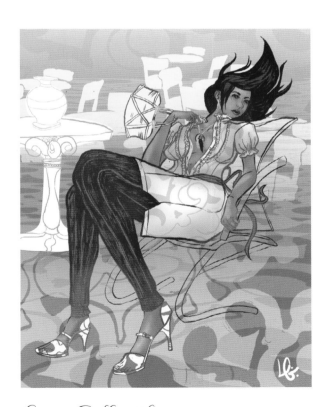

Laura Galbraith

Retro Windy Scene (2008)
Ink, Adobe Photoshop

Cityabyss Illustration

Milla/Free Project (2007)
Hand drawn, collage, Adobe Photoshop

Shiho Matsubara
Personal Work (2008)
Adobe Photoshop, Adobe Illustrator

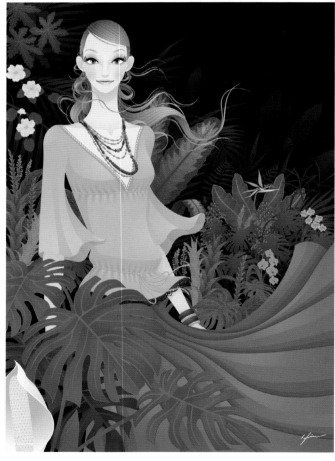

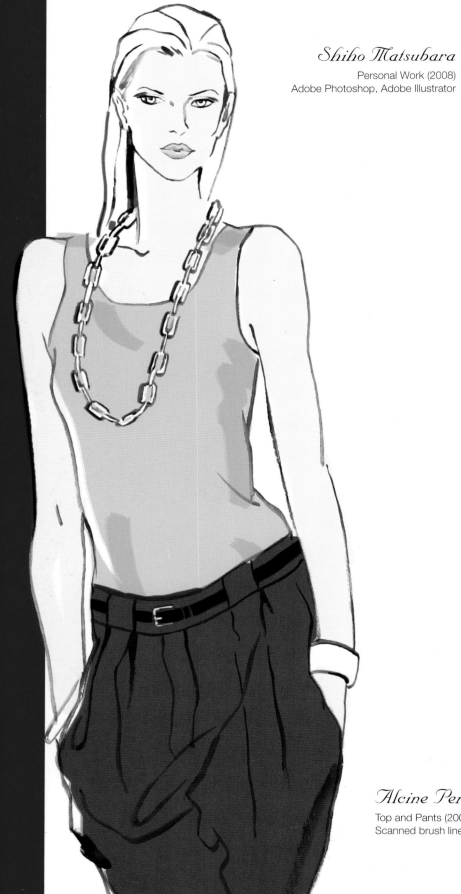

Kentaro Hisa
Personal Work (2006)
Adobe Illustrator

Alcine Perryman-Burow
Top and Pants (2009)
Scanned brush line drawing, Adobe Photoshop

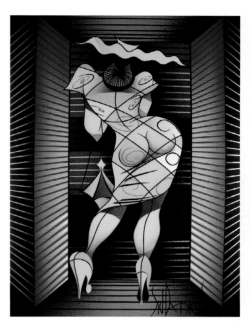

Sid Daniels

Kalamazoo No.2 (2008)
Acrylic on canvas

Genna Campton

Pattern (2009)
Pen, ink, Adobe Photoshop

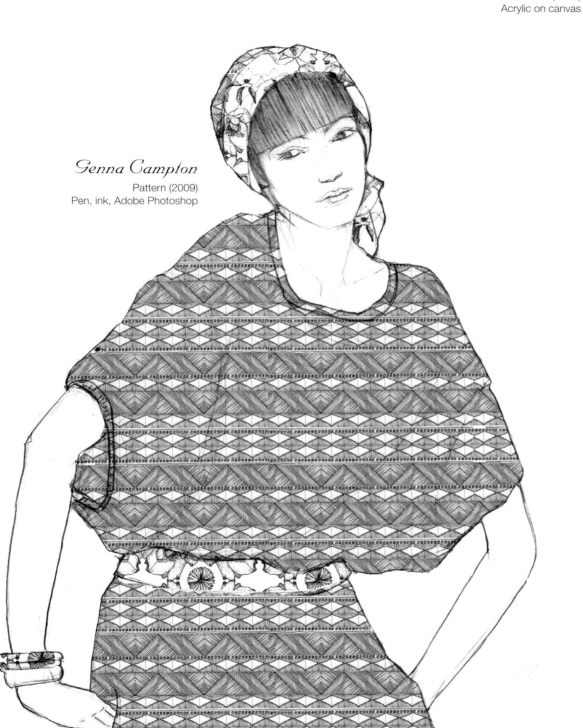

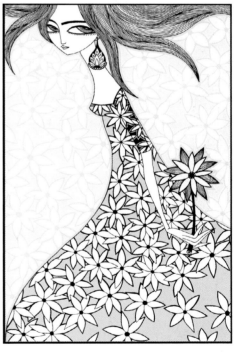

Mariya Paskovsky

Daisy (2009)
Ink, Adobe Illustrator

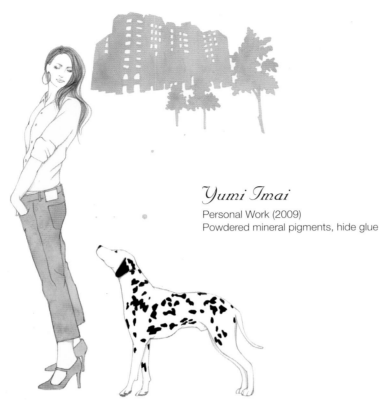

Yumi Imai

Personal Work (2009)
Powdered mineral pigments, hide glue

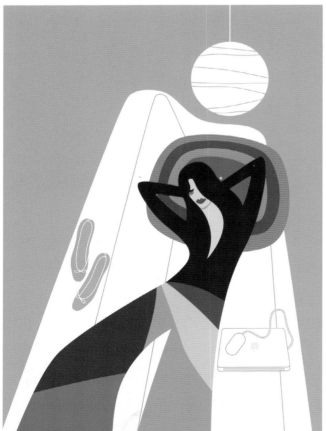

Kari Modén

Sofa (2007)
Adobe Illustrator

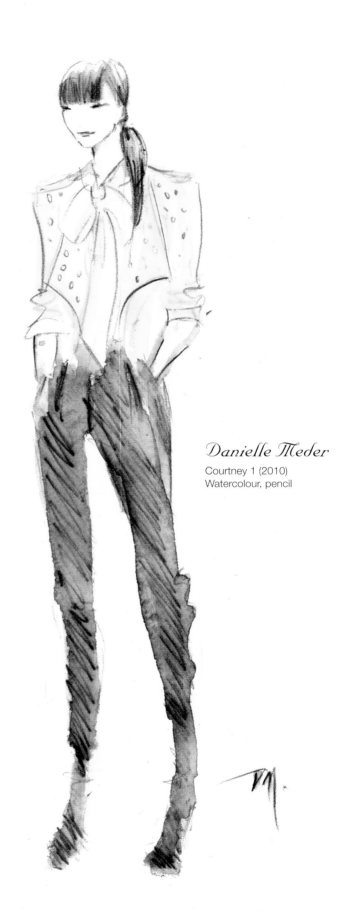

Danielle Meder

Courtney 1 (2010)
Watercolour, pencil

Shiho Matsubara

Personal Work (2008)
Adobe Photoshop, Adobe Illustrator

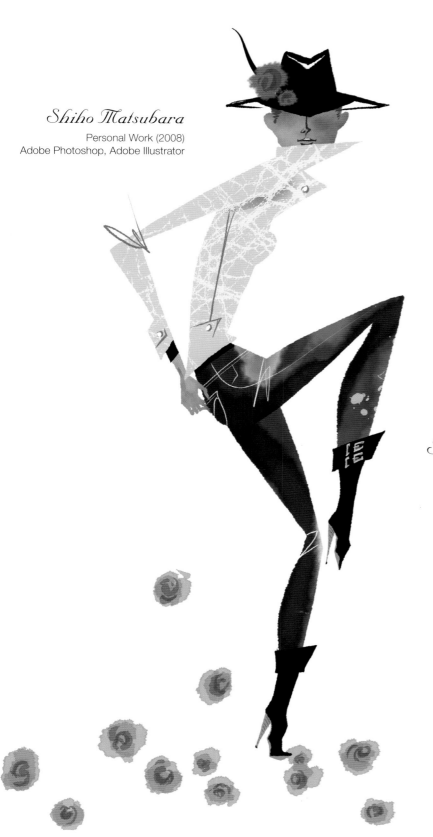

Hanako Komachi

Personal Work (2007)
Acrylic

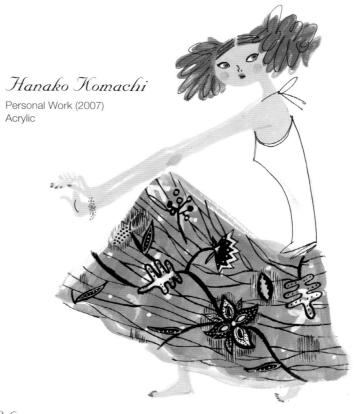

Shing Shimizu

Fashion 2 (2009)
Adobe Illustrator

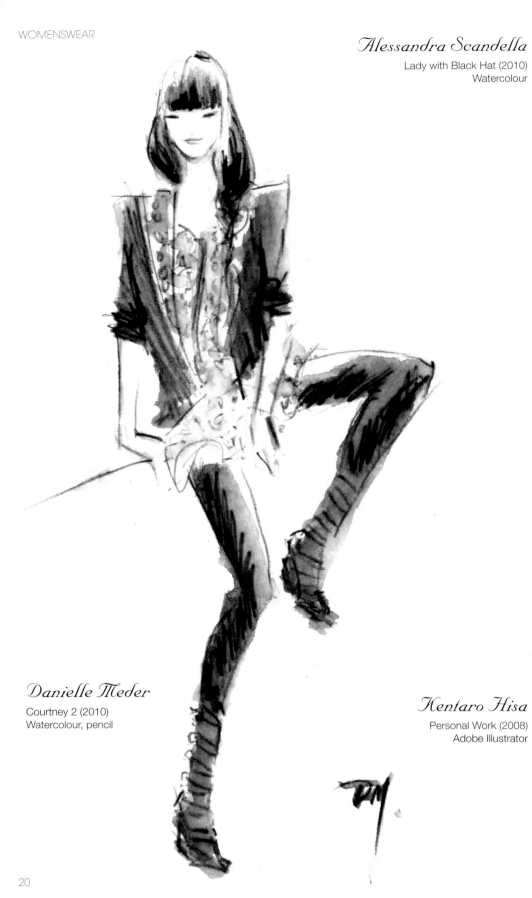

Alessandra Scandella

Lady with Black Hat (2010)
Watercolour

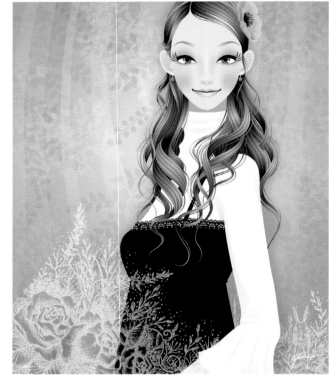

Danielle Meder

Courtney 2 (2010)
Watercolour, pencil

Kentaro Hisa

Personal Work (2008)
Adobe Illustrator

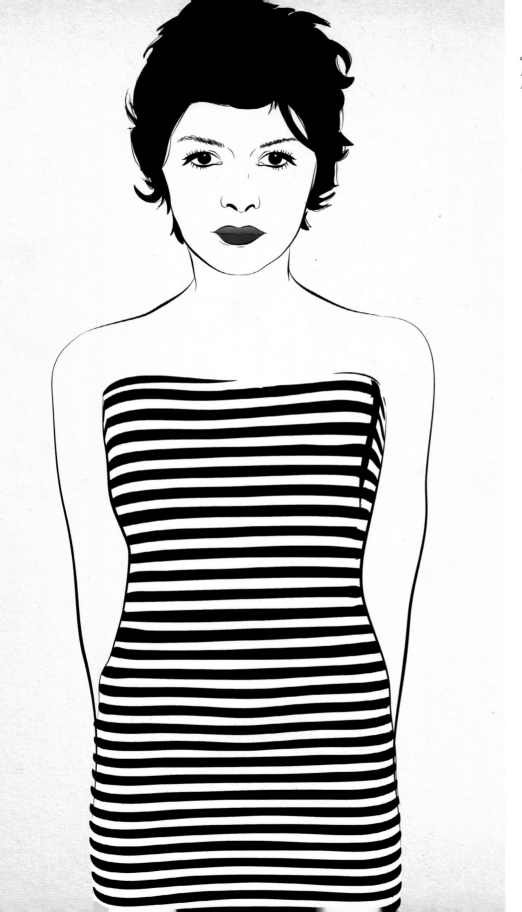

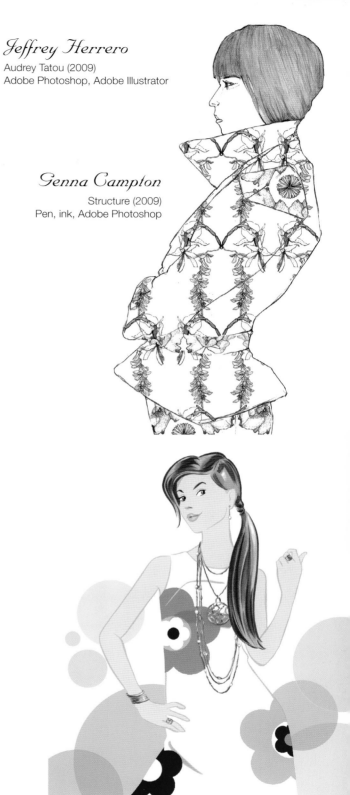

Jeffrey Herrero
Audrey Tatou (2009)
Adobe Photoshop, Adobe Illustrator

Genna Campton
Structure (2009)
Pen, ink, Adobe Photoshop

Monica Lind
Mary (2008)
brush, ink, Adobe Photoshop

Piet Paris

Nico (Commissioned by Oilily) (2002)
Stencil, paint, pastels

Megumi Mitsuda

Let's Go! (2009)
Watercolour, paper collage

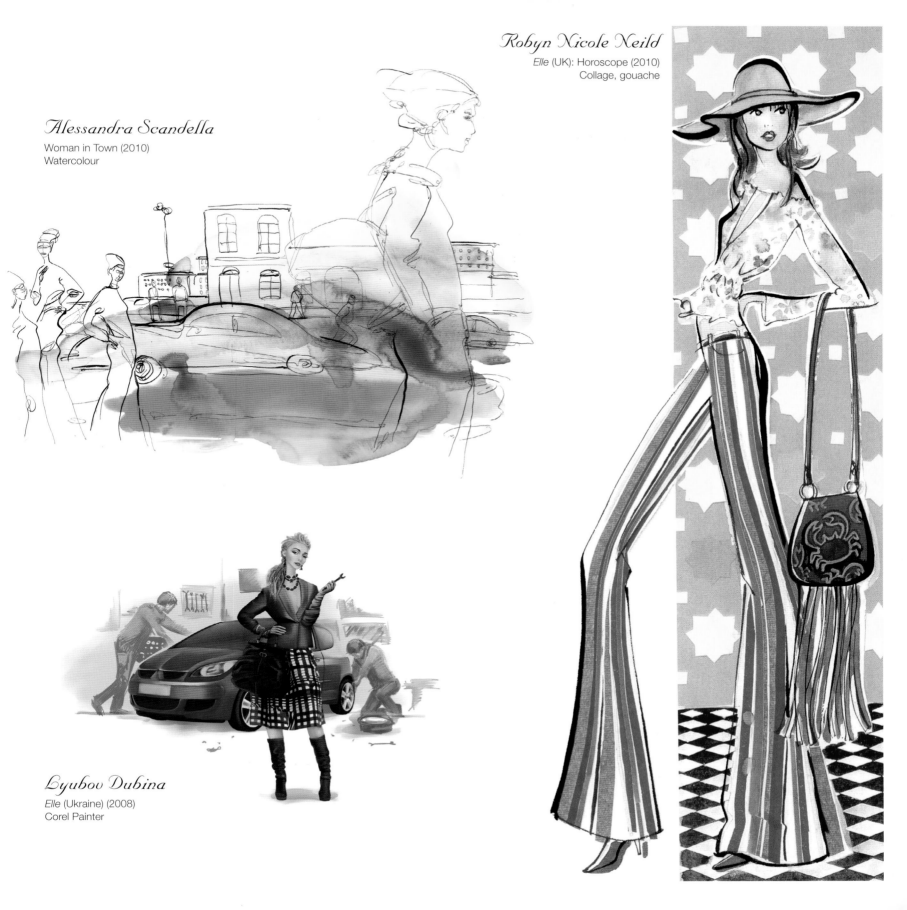

Alessandra Scandella

Woman in Town (2010)
Watercolour

Robyn Nicole Neild

Elle (UK): Horoscope (2010)
Collage, gouache

Lyubov Dubina

Elle (Ukraine) (2008)
Corel Painter

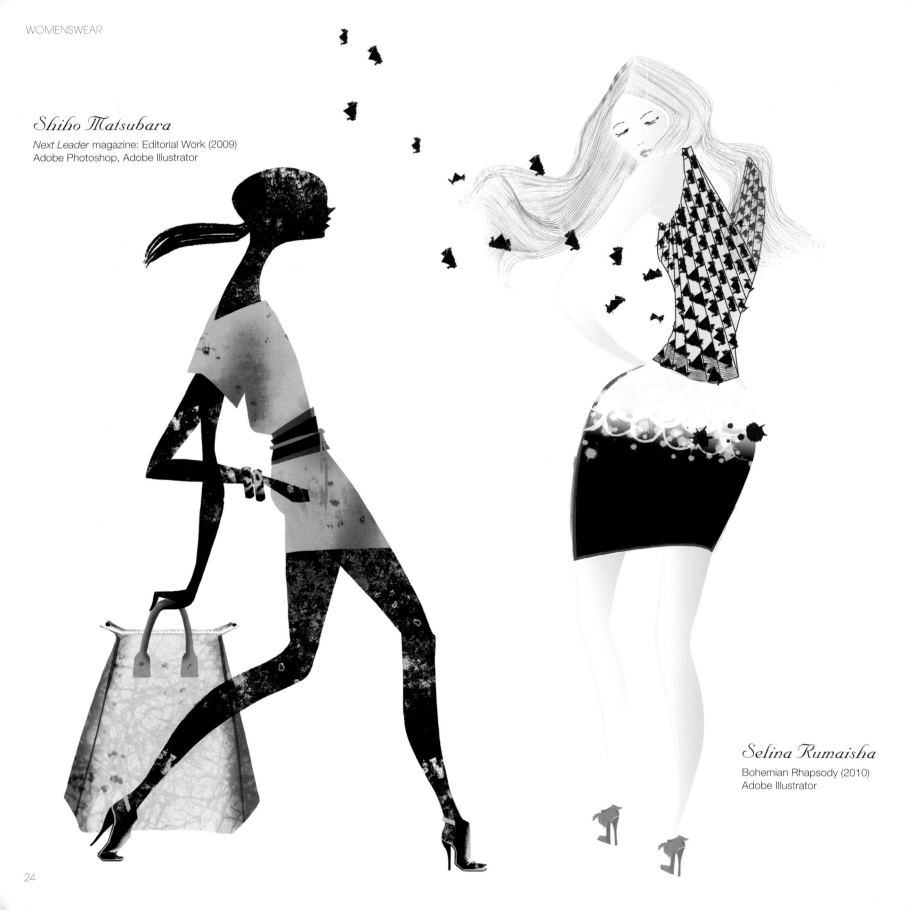

Shiho Matsubara
Next Leader magazine: Editorial Work (2009)
Adobe Photoshop, Adobe Illustrator

Selina Rumaisha
Bohemian Rhapsody (2010)
Adobe Illustrator

Kari Moden
Footprint (2008)
Adobe Illustrator

Shiho Matsubara
Personal Work (2008)
Adobe Photoshop, Adobe Illustrator

Ivan Kasaj
Lulu (2008)
Adobe Illustrator

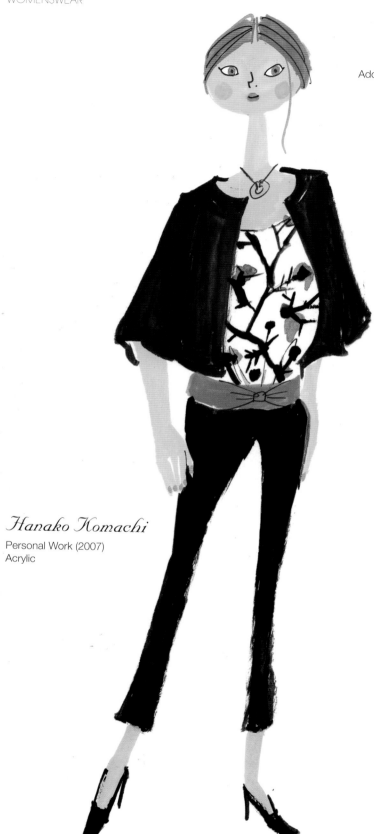

Shiho Matsubara
Personal Work (2008)
Adobe Photoshop, Adobe Illustrator

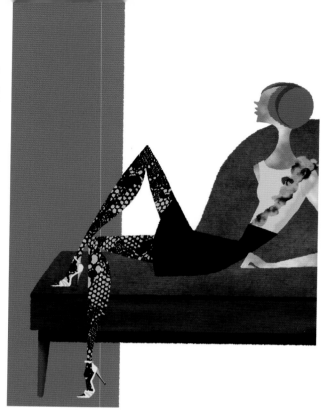

Hanako Komachi
Personal Work (2007)
Acrylic

Sherine Kazim
Innocenti's Girl (2010)
Adobe Photoshop

Maria Cardelli

Woman (2008)
Acrylic, enamel, collage on linen

Eva Hjelte

Denim Dress (2009)
Pencil, blue ink

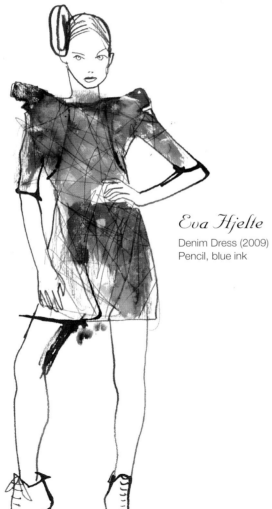

Lauren Bishop

Opium Gold (2006)
Pencil, pen, ink, Adobe Photoshop

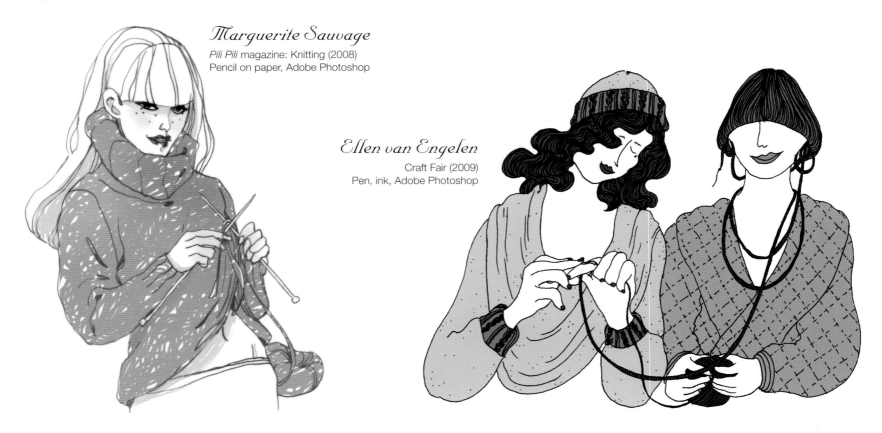

Marguerite Sauvage

Pili Pili magazine: Knitting (2008)
Pencil on paper, Adobe Photoshop

Ellen van Engelen

Craft Fair (2009)
Pen, ink, Adobe Photoshop

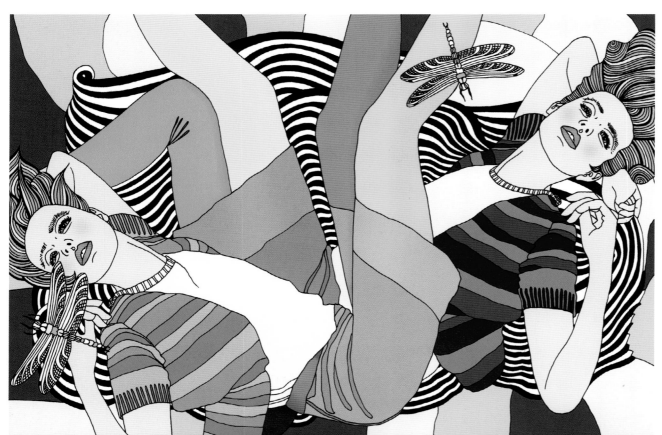

Anne Lück

Mirror Portrait no. 1 (2009)
Indian ink, Adobe Photoshop

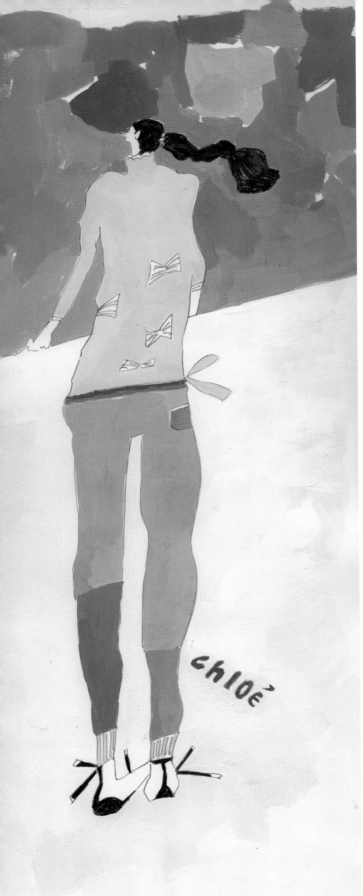

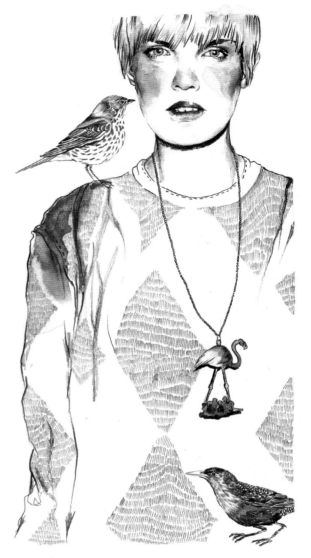

Makiko Noda

Chloe Likes Wind from the Outside (2010)
Pencil, coloured pencil, gouache

Esra Caroline Røise

Birdqueen (2009)
Pencil, watercolour

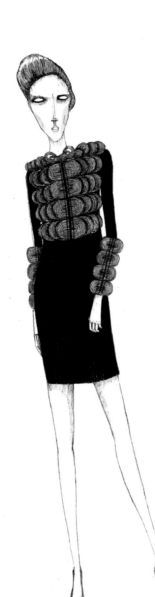

Alec Strang

Derek Lawlor for Marimekko (2009)
Propelling pencil, Adobe Photoshop

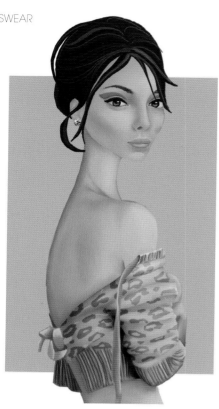

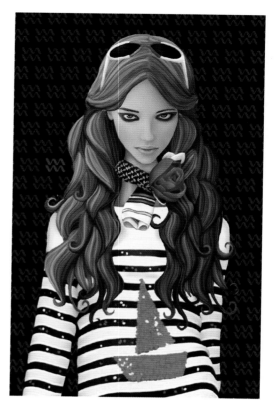

Lyubov Dubina
Illustration for Art Lebedev Studio (2009)
Corel Painter

Lyubov Dubina
Elle (Ukraine): Aquarius Horoscope (2009)
Corel Painter

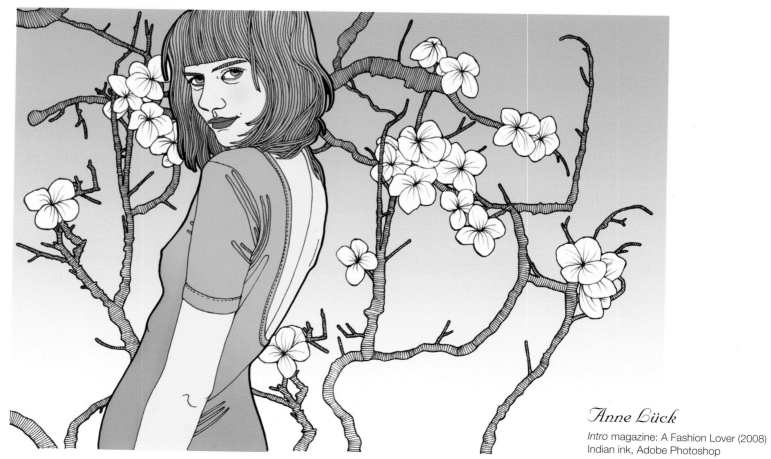

Anne Lück
Intro magazine: A Fashion Lover (2008)
Indian ink, Adobe Photoshop

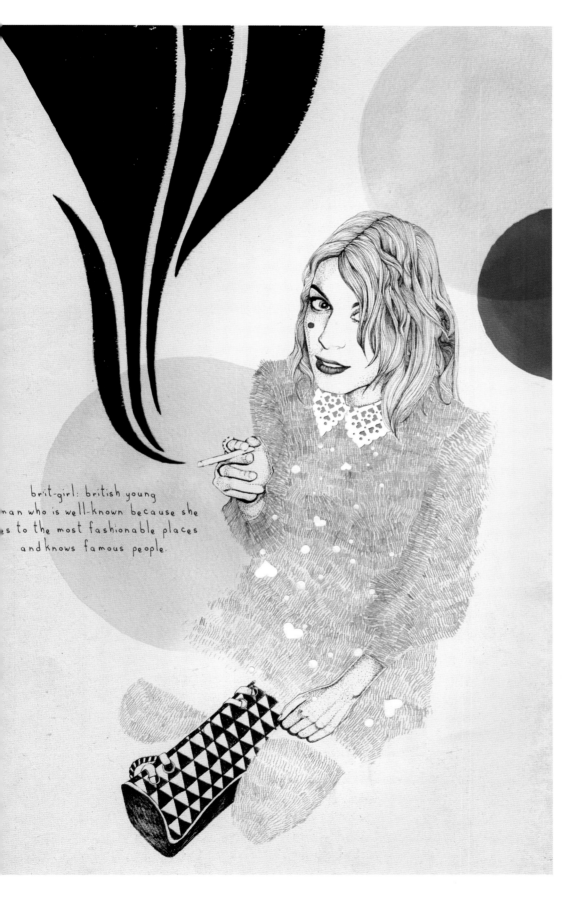

brit-girl: british young
man who is well-known because she
es to the most fashionable places
and knows famous people.

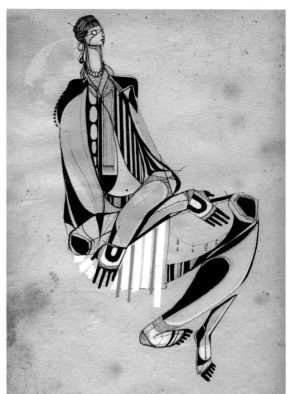

Amose

Asnobe (2009)
Ink, glued paper

Élodie Nadreau

Br'it girl (2009)
Pencil, watercolour, ink, cutout, Adobe Photoshop

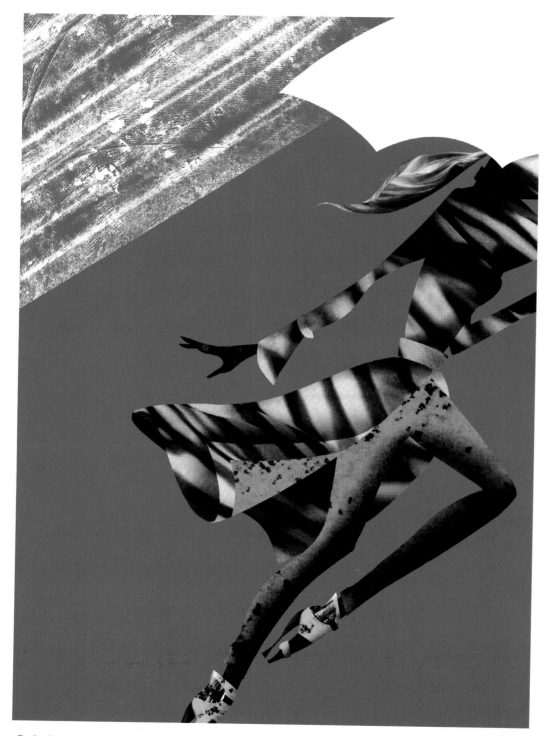

Sherine Kazim
Caught in a Downpour (2010)
Adobe Photoshop

Shiho Matsubara
Personal Work (2010)
Adobe Photoshop, Adobe Illustrator

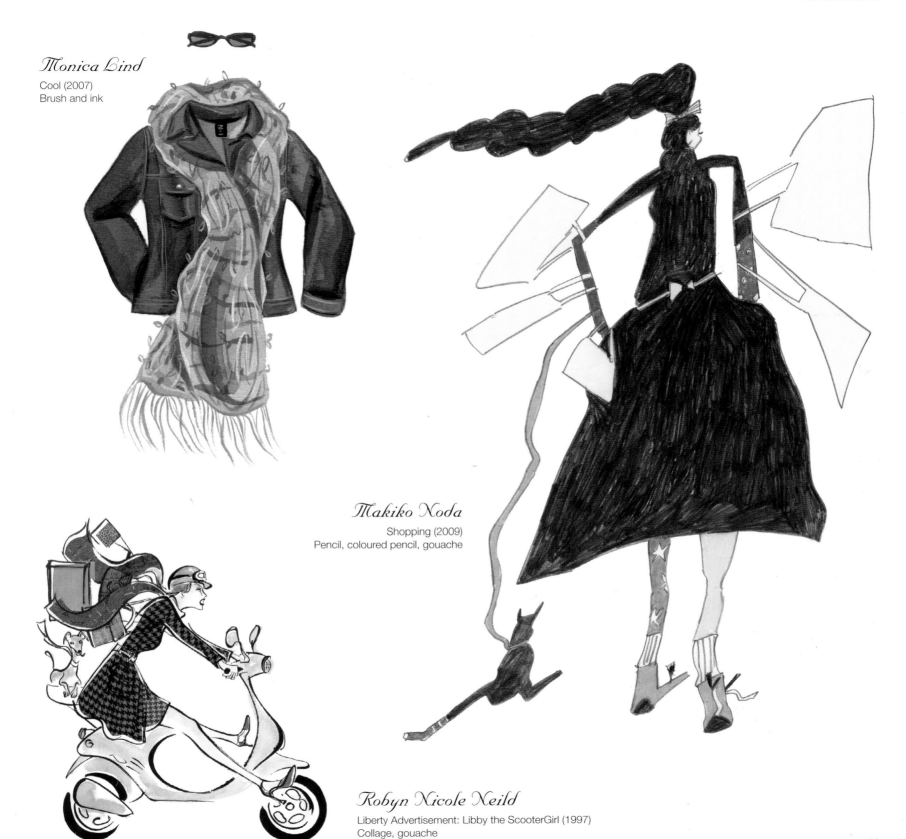

Monica Lind
Cool (2007)
Brush and ink

Takiko Noda
Shopping (2009)
Pencil, coloured pencil, gouache

Robyn Nicole Neild
Liberty Advertisement: Libby the ScooterGirl (1997)
Collage, gouache

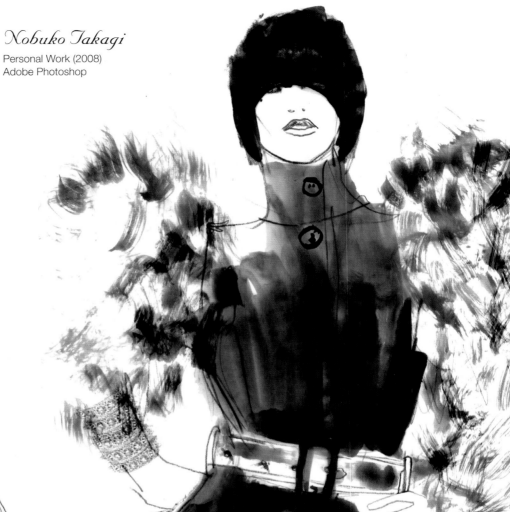

Nobuko Takagi

Personal Work (2008)
Adobe Photoshop

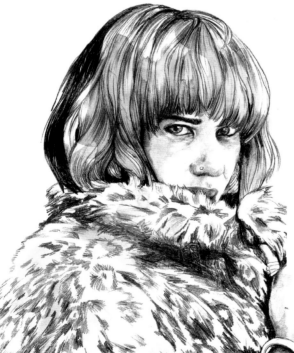

Eva Hjelte

Furcoat (2008)
Pencil, ink, acetone

Esra Caroline Røise

Santogold (2009)
Pencil, watercolour

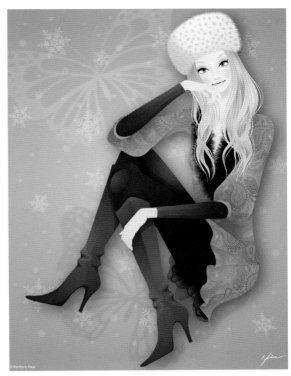

Kentaro Hisa

Personal Work (2005)
Adobe Illustrator

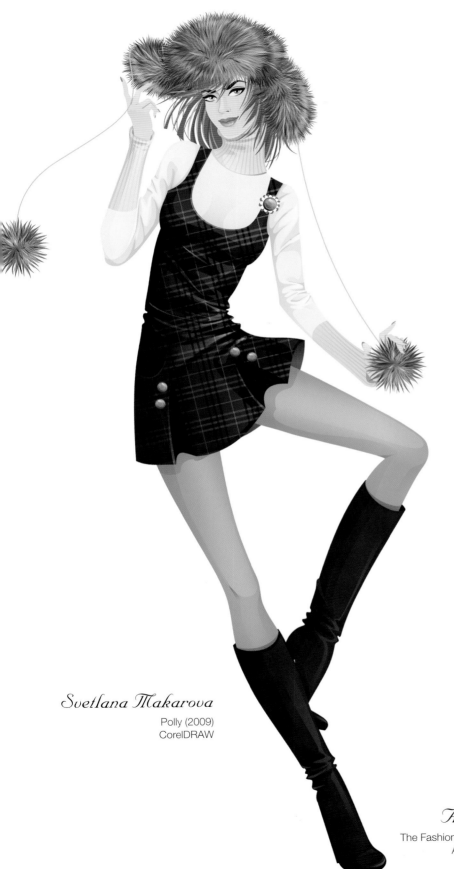

Svetlana Makarova

Polly (2009)
CorelDRAW

Artaksiniya

The Fashion Astronaut (2010)
Adobe Photoshop

Piet Paris

W Korea Advertisement: Beret (2008)
Spray paint, paper cutting

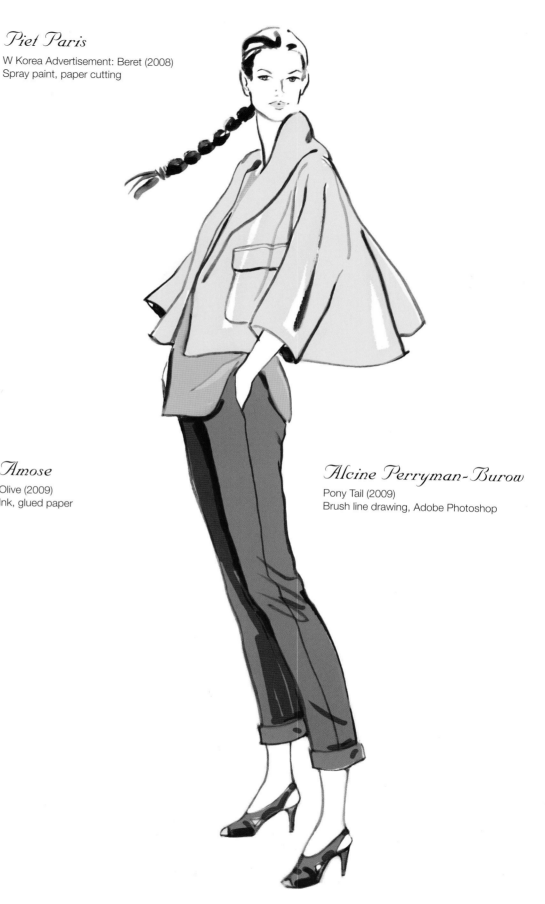

Alcine Perryman-Burow

Pony Tail (2009)
Brush line drawing, Adobe Photoshop

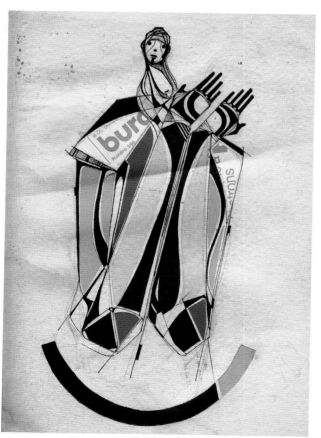

Amose

Olive (2009)
Ink, glued paper

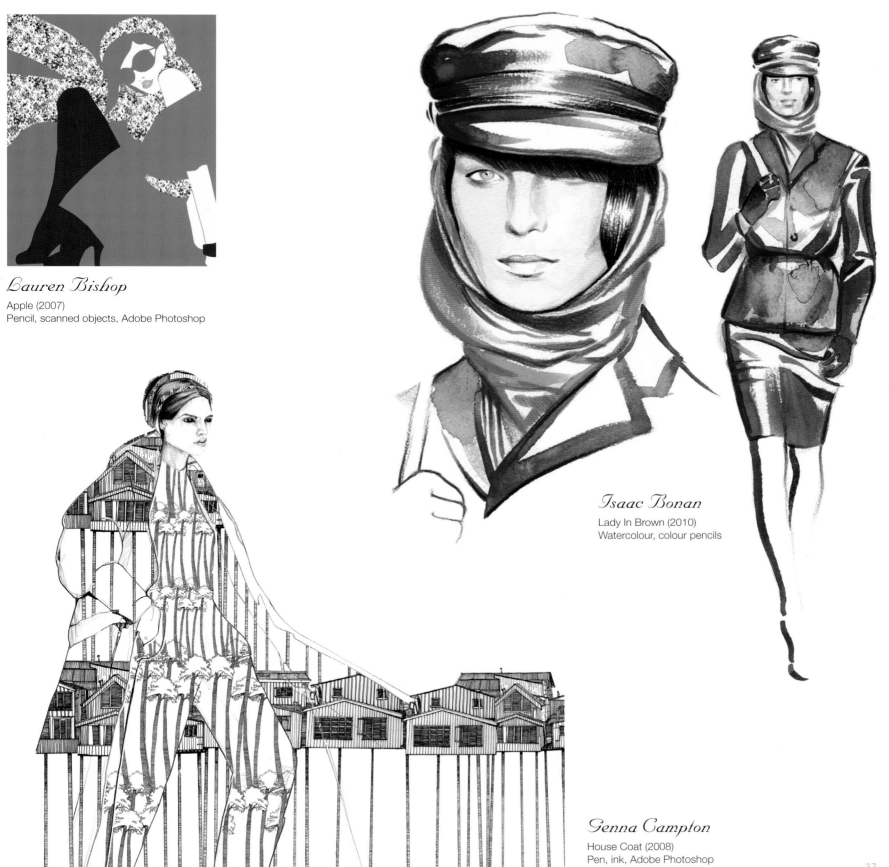

Lauren Bishop
Apple (2007)
Pencil, scanned objects, Adobe Photoshop

Isaac Bonan
Lady In Brown (2010)
Watercolour, colour pencils

Genna Campton
House Coat (2008)
Pen, ink, Adobe Photoshop

37

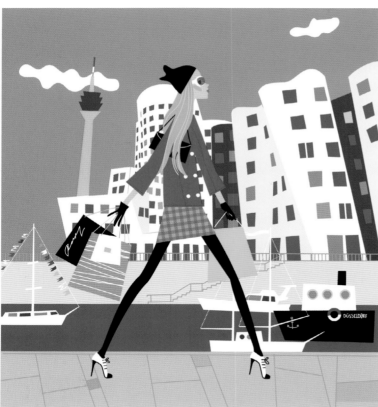

Maxim Savva

Independent Media Sanoma magazines:
Cosmopolitan Shopping (2009)
Adobe Illustrator

Megumi Mitsuda

Shopping (2003)
Watercolour, paper collage

Maxim Savva

Personal Work (2009)
Adobe Illustrator

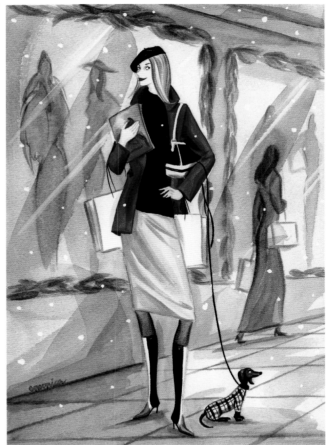

Monica Lind
Dog Walk (2000)
Brush and ink

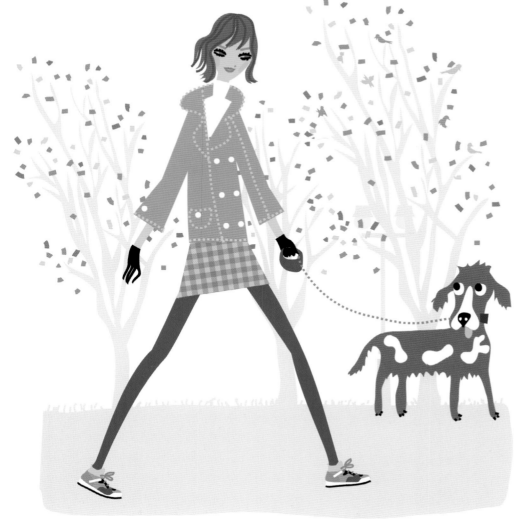

Maxim Savva
Independent Media Sanoma Magazines:
Cosmopolitan Magia (2009)
Adobe Illustrator

Christian Borstlap

Selfrides Spring Campaign (2000)
Adobe Photoshop, Adobe Illustrator

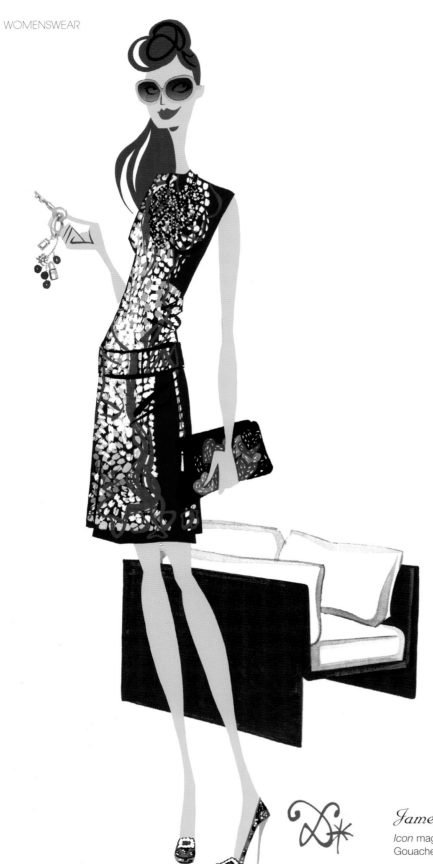

James Dignan

Icon magazine (Germany) (2009)
Gouache

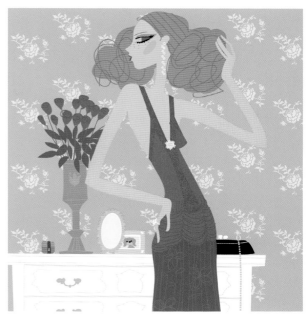

Maxim Savva
Independent Media Sanoma Magazines:
Cosmopolitan Shopping (2009)
Adobe Illustrator

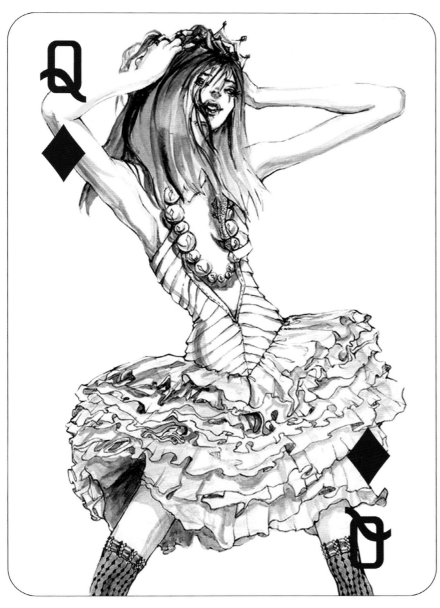

Connie Lim

Queen of Diamonds (2009)
Gouache, pen, ink

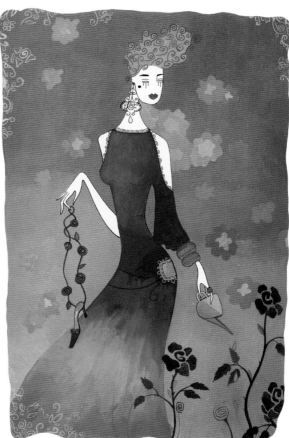

Daria Jabenko

Fashion Shoes (2008)
Gouache, ink

41

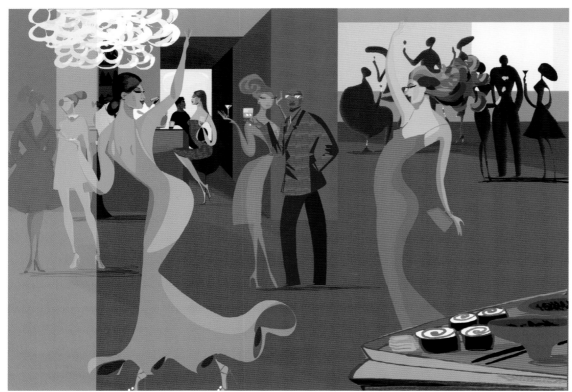

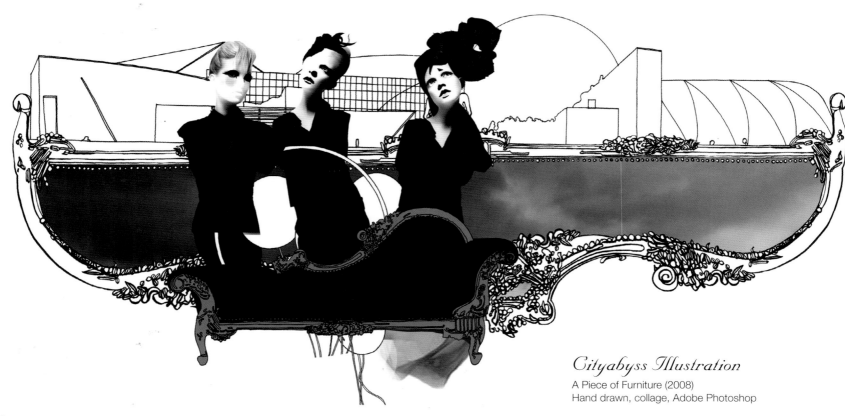

Cityabyss Illustration

A Piece of Furniture (2008)
Hand drawn, collage, Adobe Photoshop

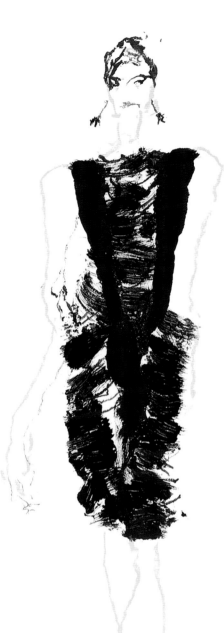

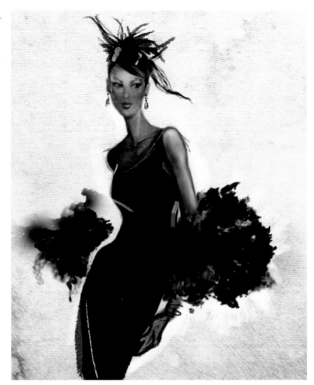

Renee Reeser Zelnick
The Little Black Dress (2007)
Prismacolour pencil, Adobe Photoshop

Jarno Kettunen
Jil Sander Womenswear Spring/Summer (2008)
Gouache, varnish, pastel, lead pen, sepia pencil

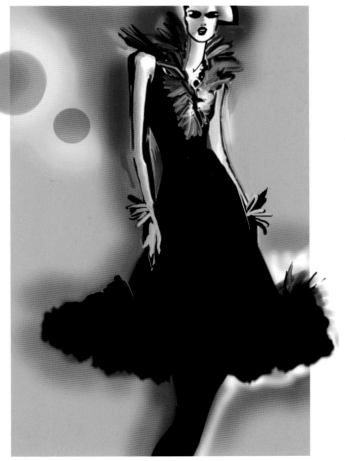

Renee Reeser Zelnick
Pink Sophistication (2007)
Prismacolour pencil, Adobe Photoshop

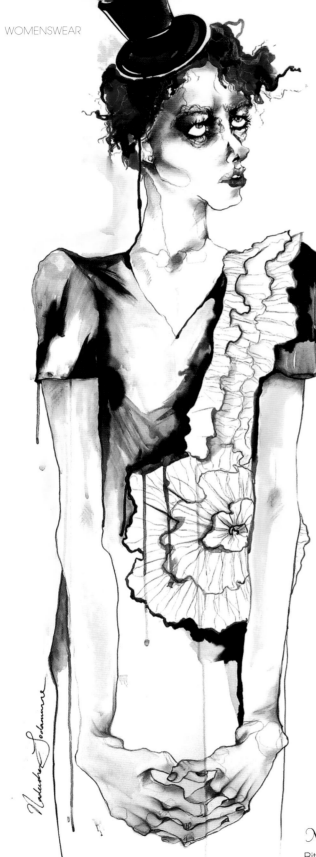

Camilla Gray

Dream Dress (Balmain) (2009)
Pencil, watercolour, Adobe Photoshop

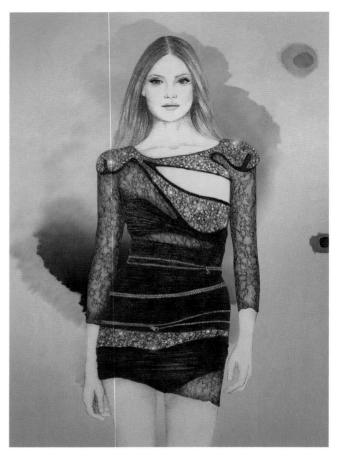

Sherine Hazim

The Débutante (2010)
Adobe Photoshop

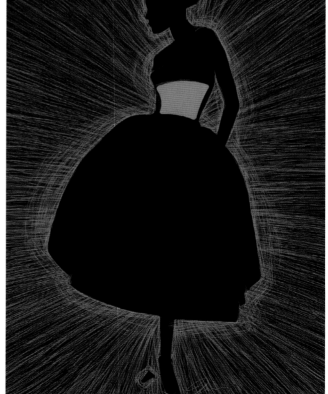

Nadeesha Godamunne

Rita (2009)
Charcoal, ink

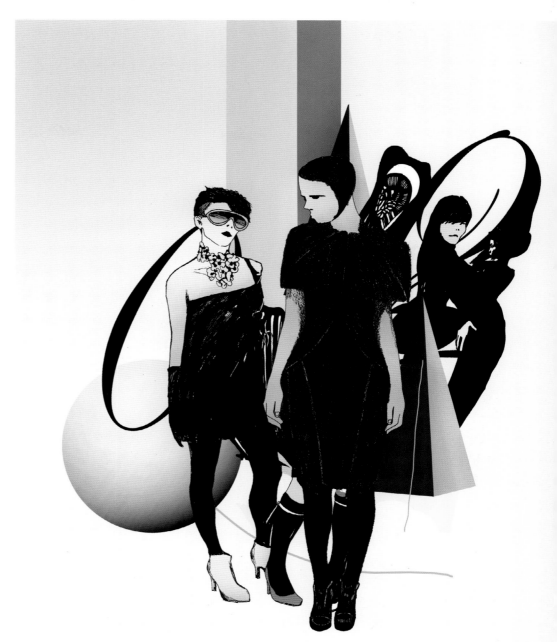

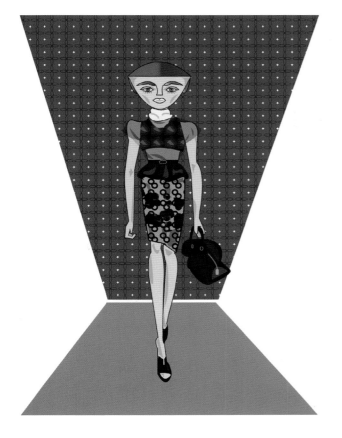

Han Mi-suk

Mysticism (2009)
Watercolour, acrylic, pen, ink, Adobe Illustrator, Adobe Photoshop

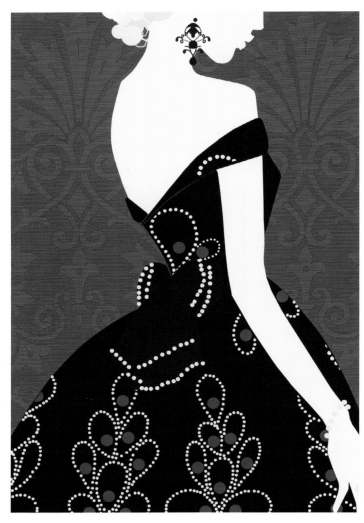

Lauren Bishop

Luxe (2008)
Pencil, scanned objects,
Adobe Photoshop

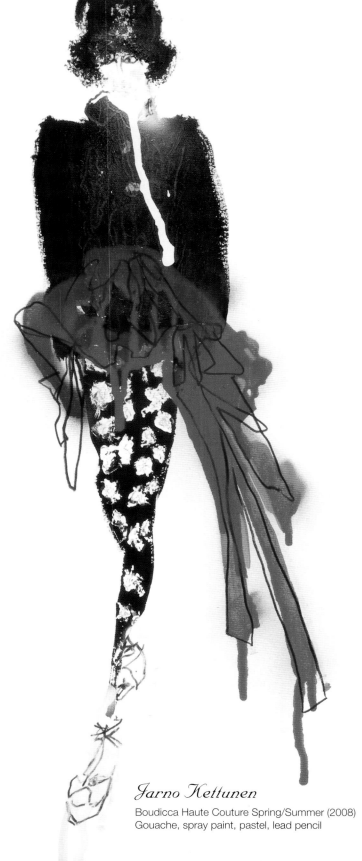

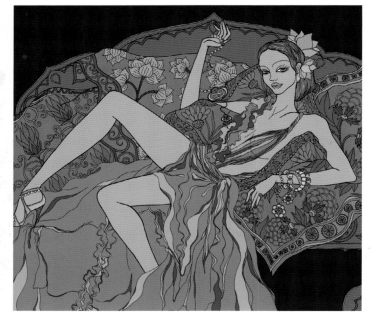

Mariya Paskovsky

Diva on a Sofa (2007)
Black ink, Adobe Photoshop

Jarno Kettunen

Boudicca Haute Couture Spring/Summer (2008)
Gouache, spray paint, pastel, lead pencil

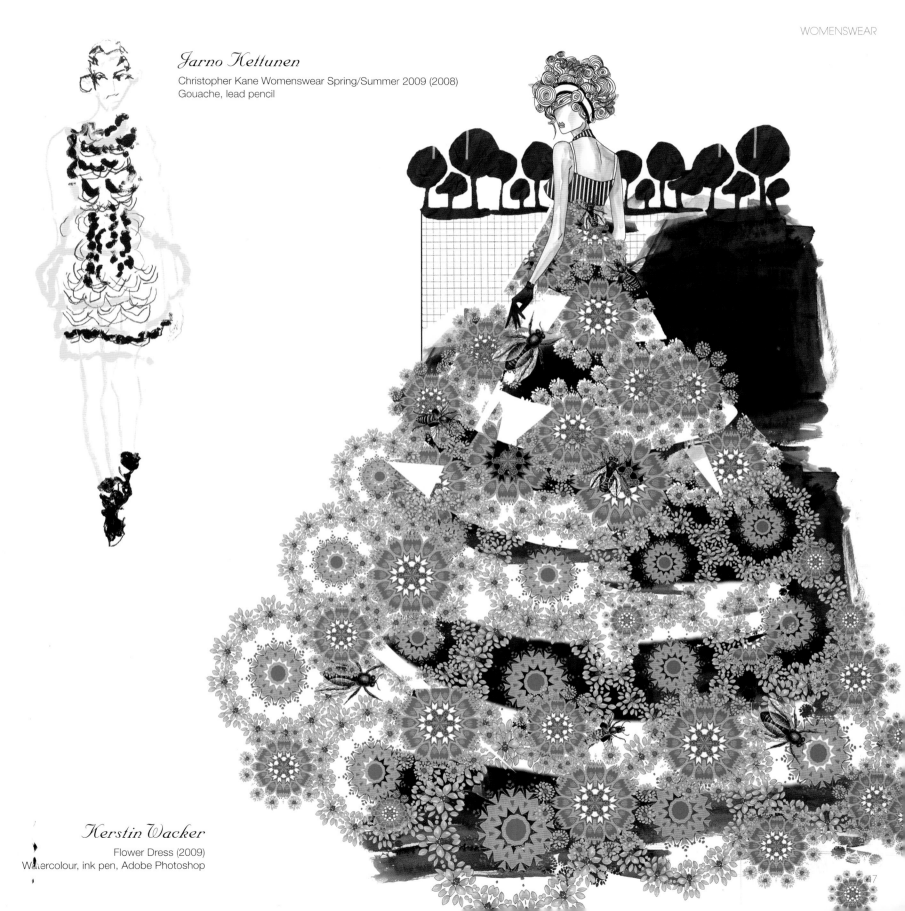

Jarno Kettunen

Christopher Kane Womenswear Spring/Summer 2009 (2008)
Gouache, lead pencil

Kerstin Wacker

Flower Dress (2009)
Watercolour, ink pen, Adobe Photoshop

47

Mariya Paskovsky

Party Girl (2010)
Black ink, Adobe Illustrator

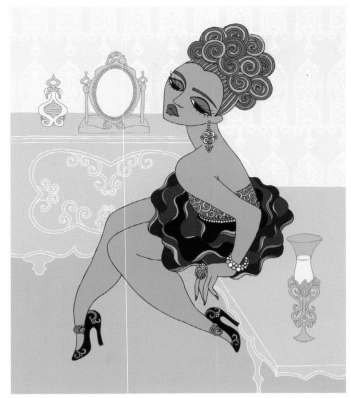

Svetlana Makarova

Blonde (2008)
CorelDRAW

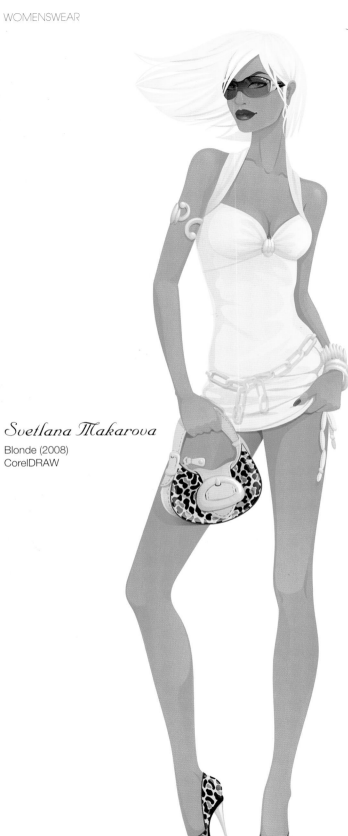

Lauren Bishop

Christmas Girl (2007)
Mixed media

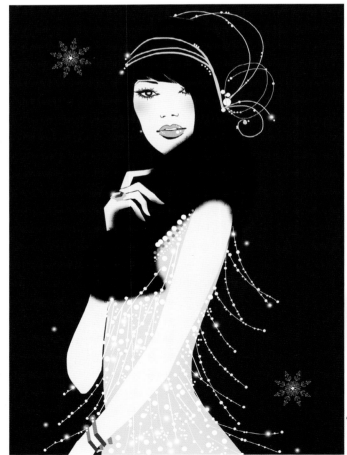

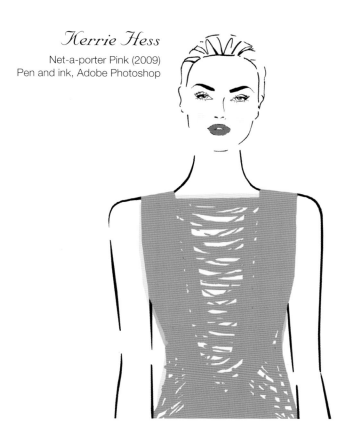

Kerrie Hess

Net-a-porter Pink (2009)
Pen and ink, Adobe Photoshop

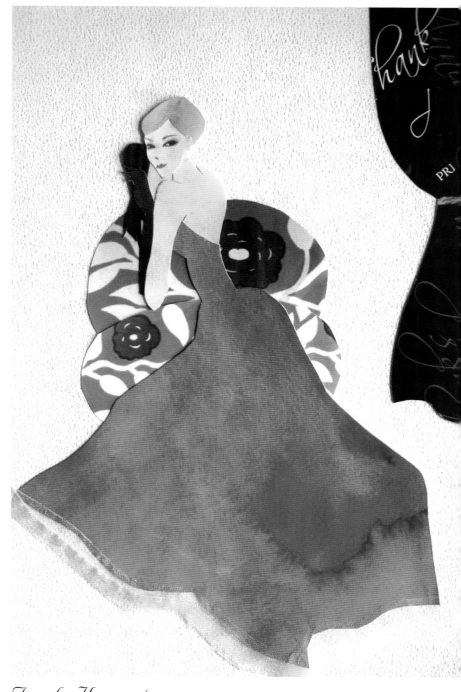

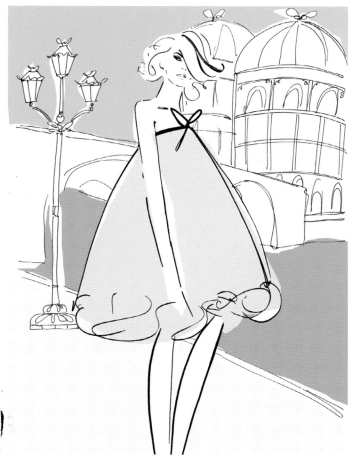

Tomoko Hanamoto

Personal Work (2010)
Collage, watercoloured and printed papers

Kerrie Hess

La Vie a Paris (2009)
Pen and ink, and Adobe Photoshop

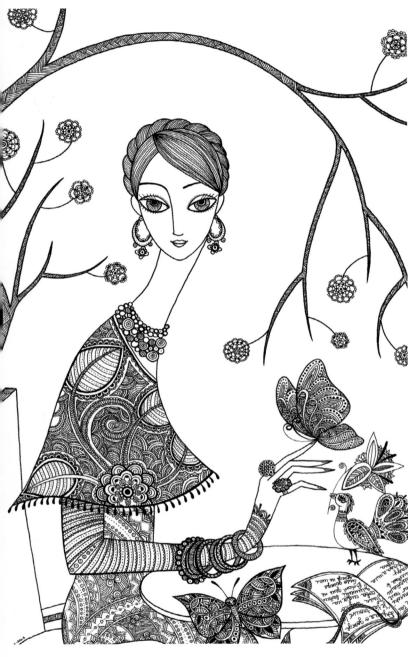

Mariya Paskovsky
Reading Poetry and a Butterfly (2007)
Black ink

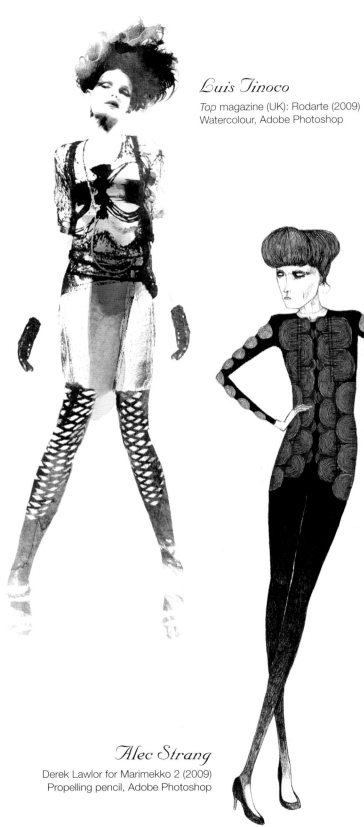

Luis Tinoco
Top magazine (UK): Rodarte (2009)
Watercolour, Adobe Photoshop

Alec Strang
Derek Lawlor for Marimekko 2 (2009)
Propelling pencil, Adobe Photoshop

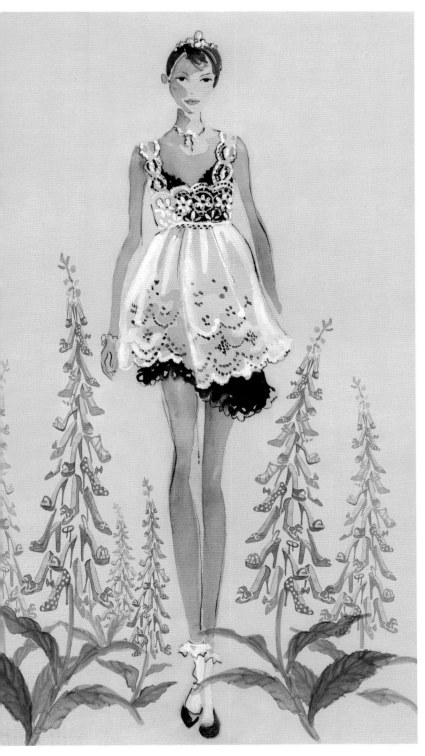

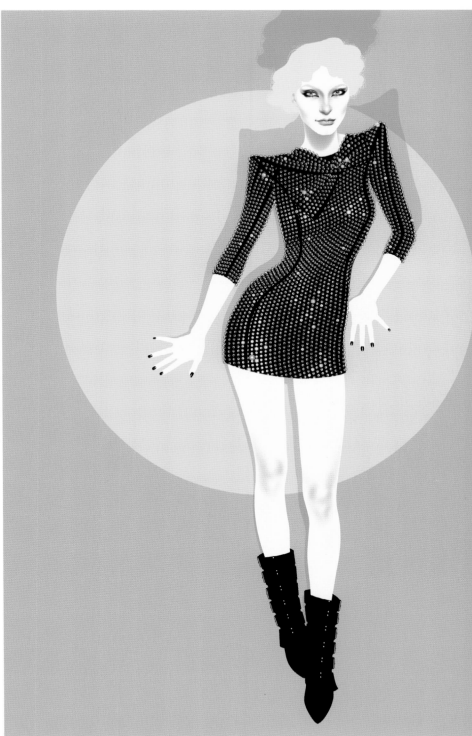

Robyn Nicole Neild

Enchanted Shoe Field (2008)
Gouache, pastel

Autumn Whitehurst

Balmain (2009)
Adobe Photoshop, Adobe Illustrator, Corel Painter

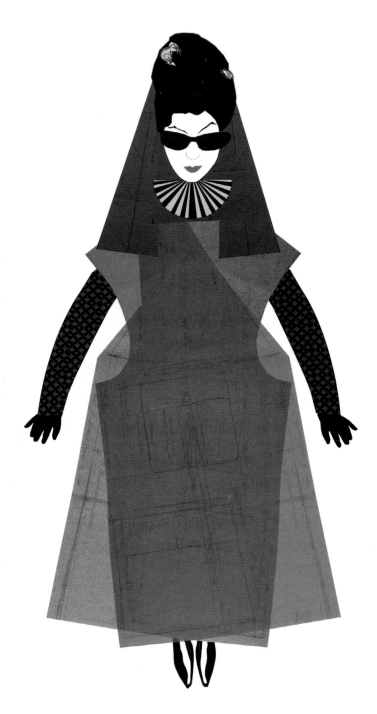

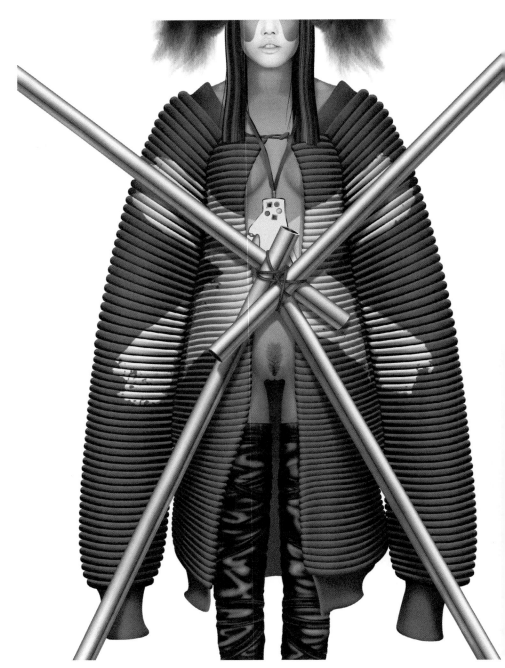

Hormazd Geve Narielwalla

Diane Pernet A.K.A ashadedviewonfashion.com (2010)
Photographic collage, Adobe Illustrator, Adobe Photoshop

Jesse Auersalo

Purple Wolf (2010)
Macromedia FREEHAND, Adobe Photoshop

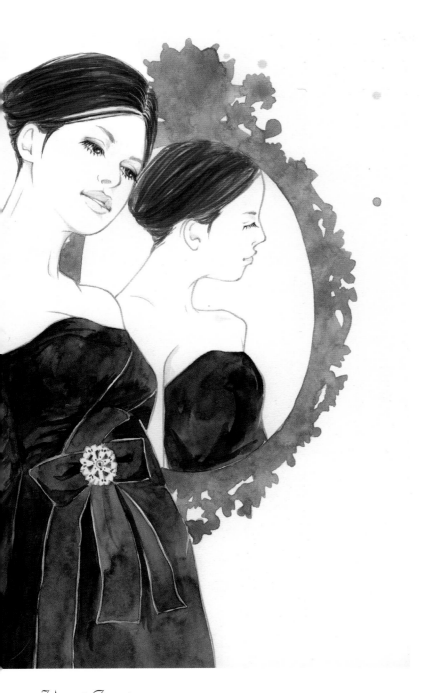

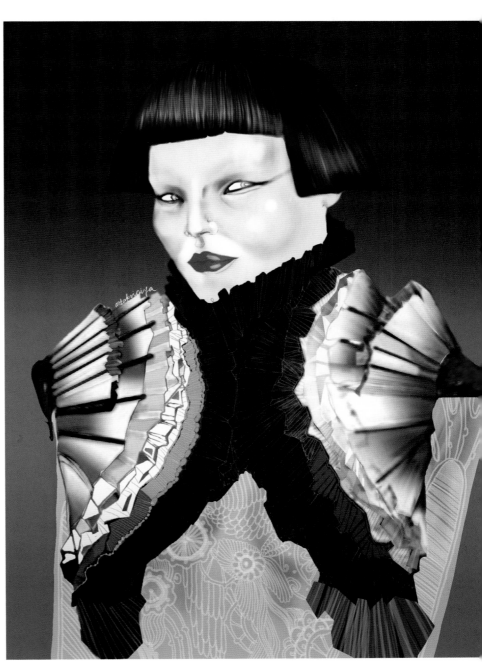

Yumi Imai
Personal Work (2009)
Powdered mineral pigments, hide glue

Artaksiniya
The Margiela Lady (2010)
Acrylic, Adobe Photoshop

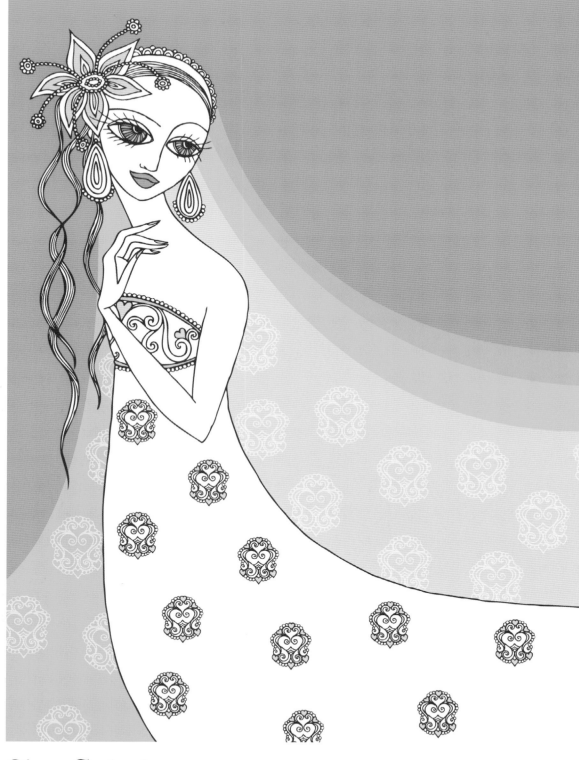

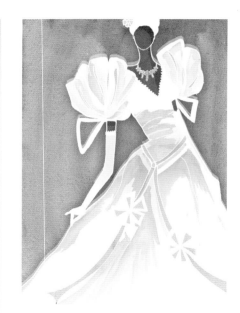

Kerstin Wacker

Wedding 1 (2008)
Watercolour, ink pen, Adobe Photoshop

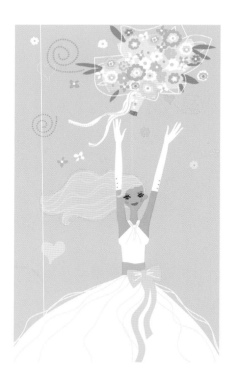

Mariya Paskovsky

Bridal Shower (2008)
Black ink, Adobe Illustrator

Maxim Savva

You and Your Wedding magazine: Bride (2008)
Adobe Illustrator

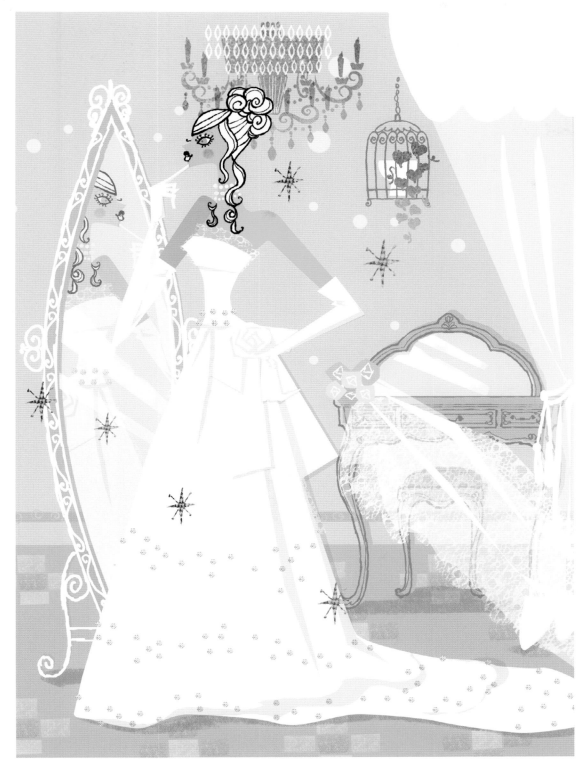

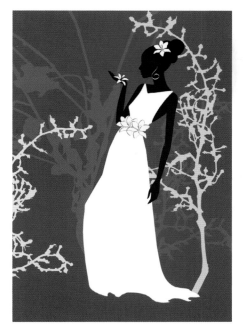

Maria Cardelli

The Wedding Dress (2004)
Ink, Adobe Photoshop

Nobuko Takagi

Beaumind-pluseye: Bride (2008)
Adobe Photoshop

Kari Moden

Bride (2009)
Adobe Illustrator

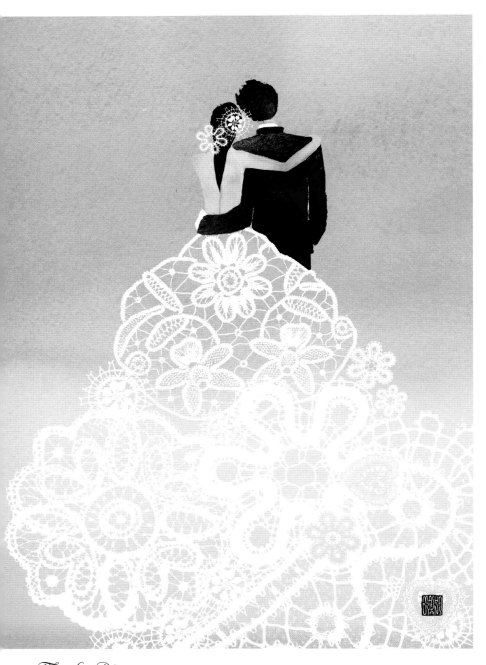

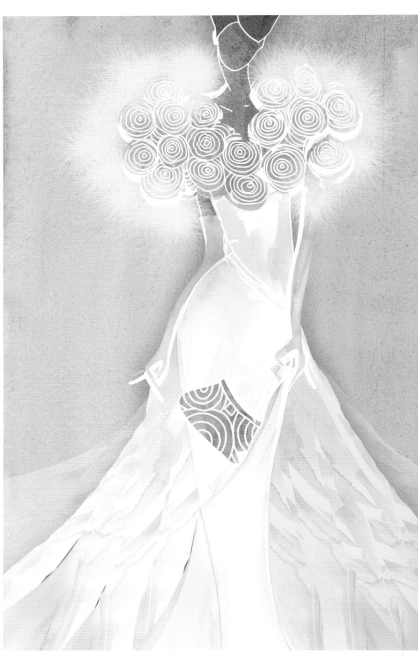

Masha D'yans

Lacecouple in Sunset (2008)
Watercolour

Kerstin Wacker

Wedding 2 (2008)
Watercolour, ink pen, Adobe Photoshop

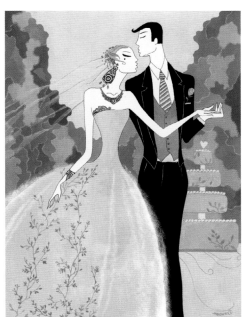

Daria Jabenko

Wedding Bliss (2009)
Gouache, ink

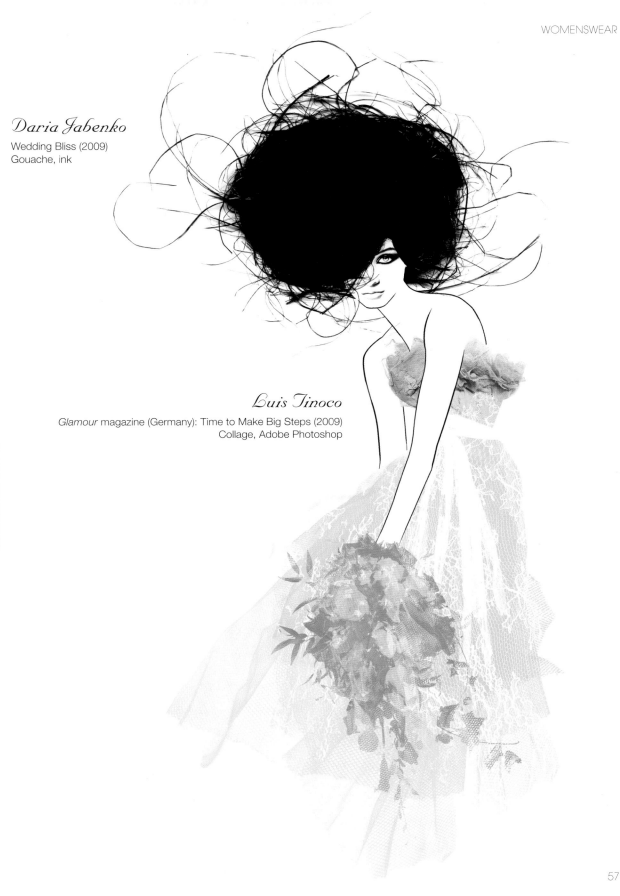

Luis Tinoco

Glamour magazine (Germany): Time to Make Big Steps (2009)
Collage, Adobe Photoshop

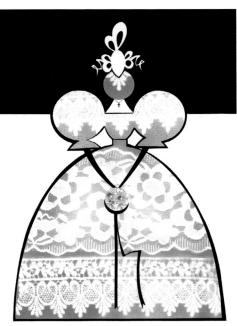

Piet Paris

'Fashion DNA' Exhibition (Amsterdam): Bride (2006)
Cutting, spray-paint

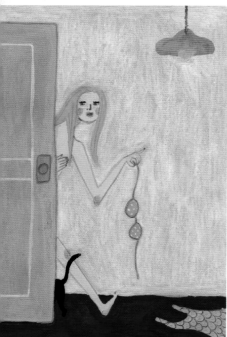

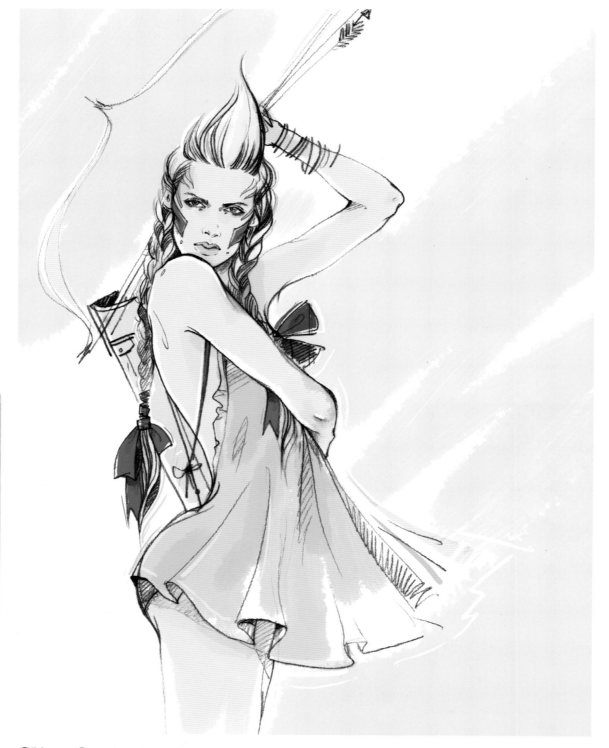

Hanako Komachi
Personal Work (2008)
Acrylic, coloured pencil

Alena Lavdovskaya
Elle (Russia): Summer Horoscope (2010)
Pencil, Adobe Photoshop

Samantha Hahn
Starlets (2009)
Pen, Adobe Photoshop

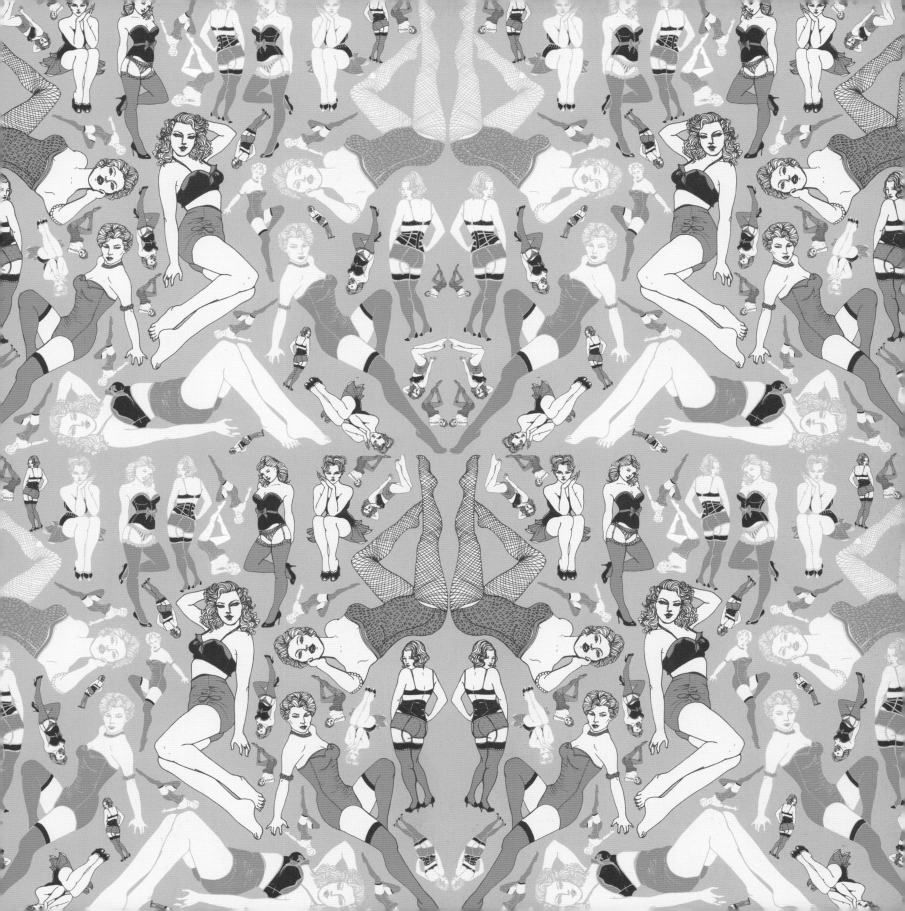

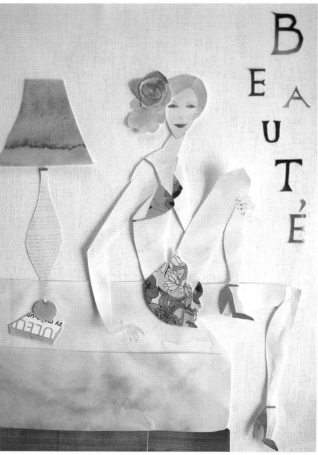

Tomoko Hanamoto

Personal Work (2010)
Collage, watercoloured and printed papers

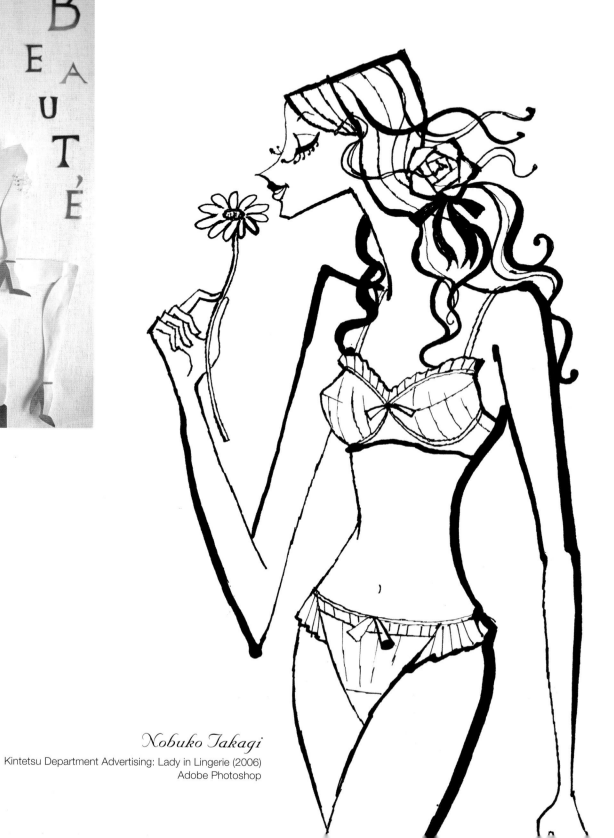

Nobuko Takagi
Kintetsu Department Advertising: Lady in Lingerie (2006)
Adobe Photoshop

Zhuzhu
My Heart (2010)
Adobe Photoshop

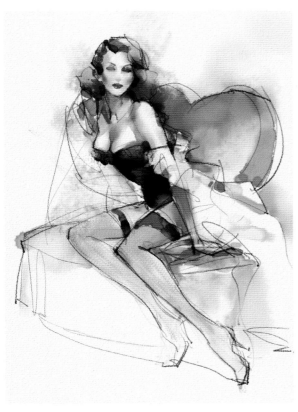

Robyn Nicole Neild
How To Apply Eye-liner (2002)
Pen and ink, watercolour

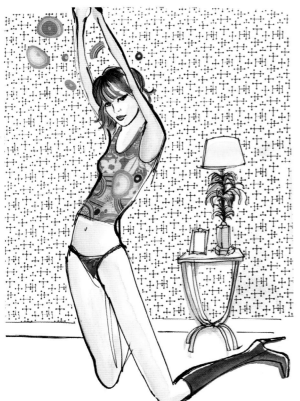

Robyn Nicole Neild
Attitude Girl 1 (2005)
Pen and ink, watercolour

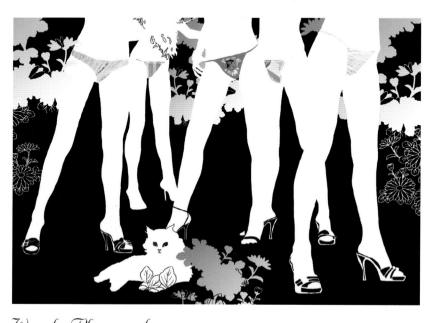

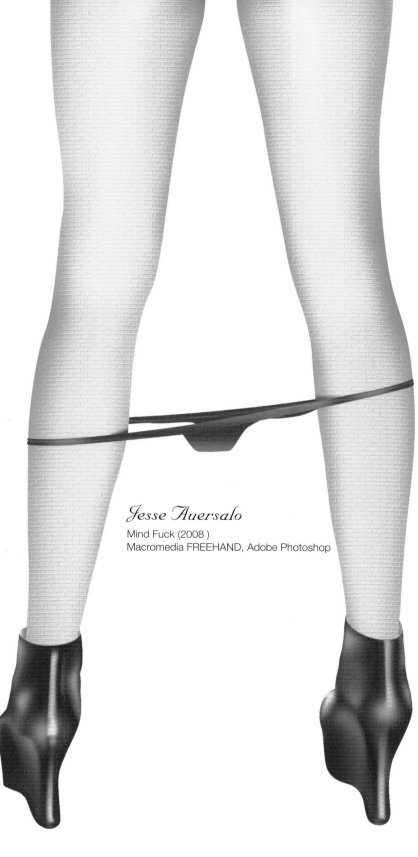

Wendy Plovmand

FemaleFantasy FantasyFemale 01 (2006)
Adobe Photoshop, acrylic, sticker, ballpoint

Jesse Auersalo

Mind Fuck (2008)
Macromedia FREEHAND, Adobe Photoshop

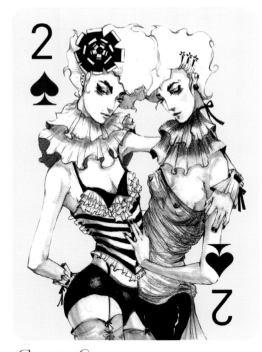

Connie Lim

Two of Spades (2009)
Gouache, pen and ink

Ivan Pols

Slipping (2007)
Adobe Photoshop

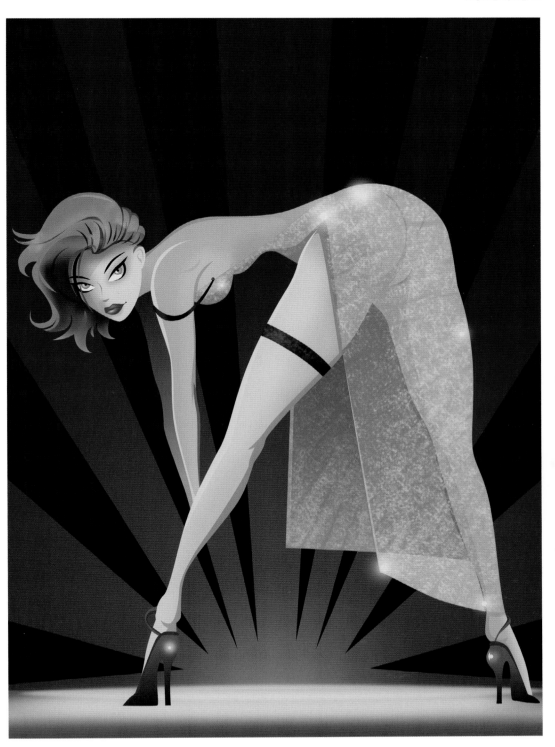

Charlene Chua

Bend (2005)
Macromedia FREEHAND, Adobe Photoshop

Autumn Whitehurst
Katya K1 (2006)
Adobe Photoshop, Adobe Illustrator, Corel Painter

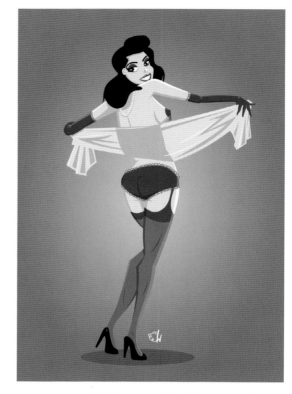

Christopher 'Wing' King
Burlesque Dancer Pin-Up (2009
Pencil, Adobe Illustrator

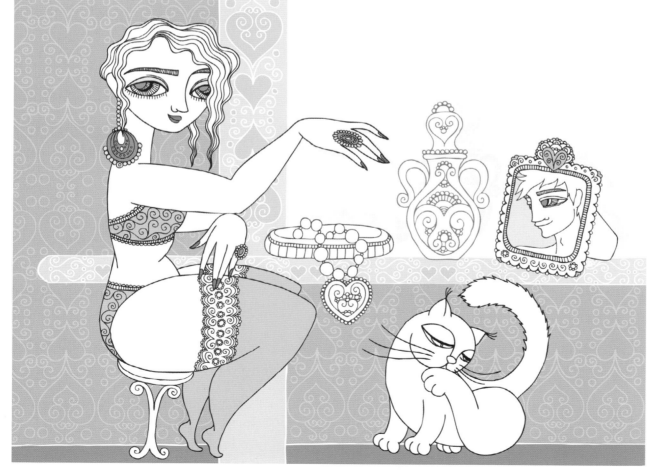

Mariya Pakovsky
La Belle du Matin (2010)
Black ink, Adobe Illustrator

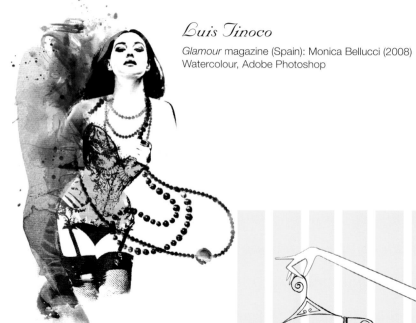

Luis Tinoco

Glamour magazine (Spain): Monica Bellucci (2008)
Watercolour, Adobe Photoshop

Kerstin Wacker

Zodiac Signs: Libra (2006)
Ink pen, Adobe Photoshop

Barbara Jensen

Kay (2007)
Watercolour, coloured pencils, inks, charcoal

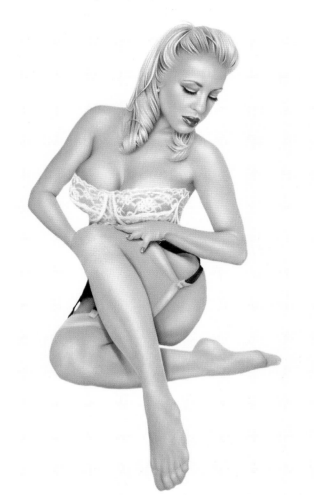

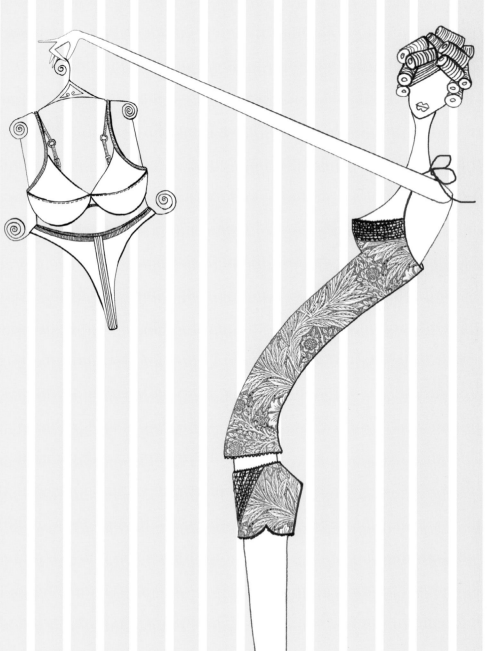

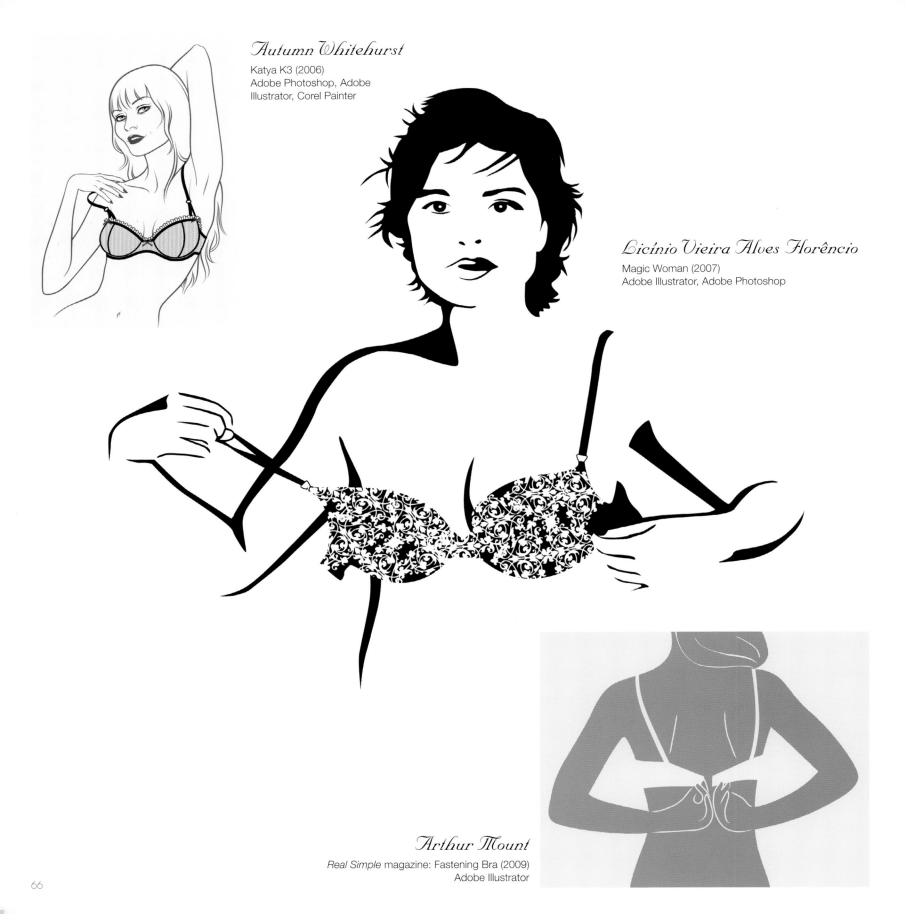

Autumn Whitehurst
Katya K3 (2006)
Adobe Photoshop, Adobe
Illustrator, Corel Painter

Licínio Vieira Alves Florêncio
Magic Woman (2007)
Adobe Illustrator, Adobe Photoshop

Arthur Mount
Real Simple magazine: Fastening Bra (2009)
Adobe Illustrator

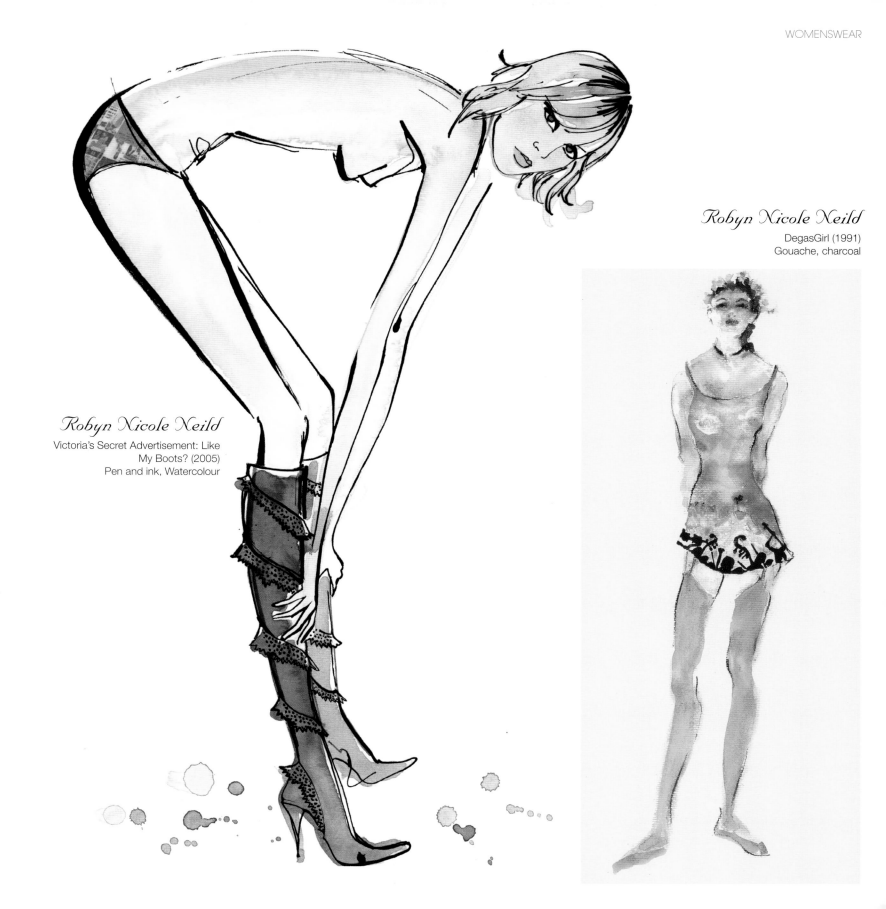

Robyn Nicole Neild
DegasGirl (1991)
Gouache, charcoal

Robyn Nicole Neild
Victoria's Secret Advertisement: Like
My Boots? (2005)
Pen and ink, Watercolour

Amy Booton

Audacious Chartreuse (2009)
Watercolour, Indian ink, pen

Jesse Auersalo

Mind Fuck (2008)
Macromedia FREEEHAND, Adobe Photoshop

Ana Cade

Lace Jump Suit (2010)
Pencil, ink

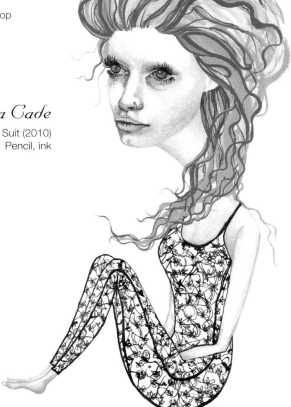

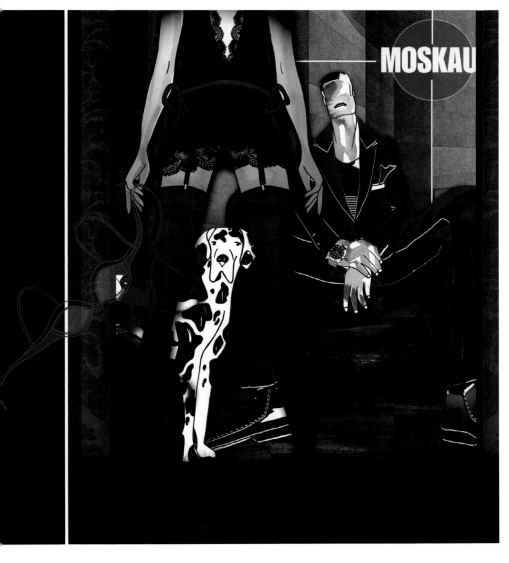

Kerstin Wacker

Moskau (2009)
Watercolour, ink pen, Adobe Photoshop

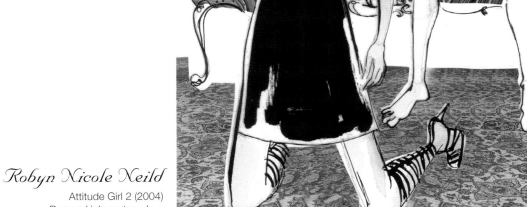

Robyn Nicole Neild

Attitude Girl 2 (2004)
Pen and ink, watercolour

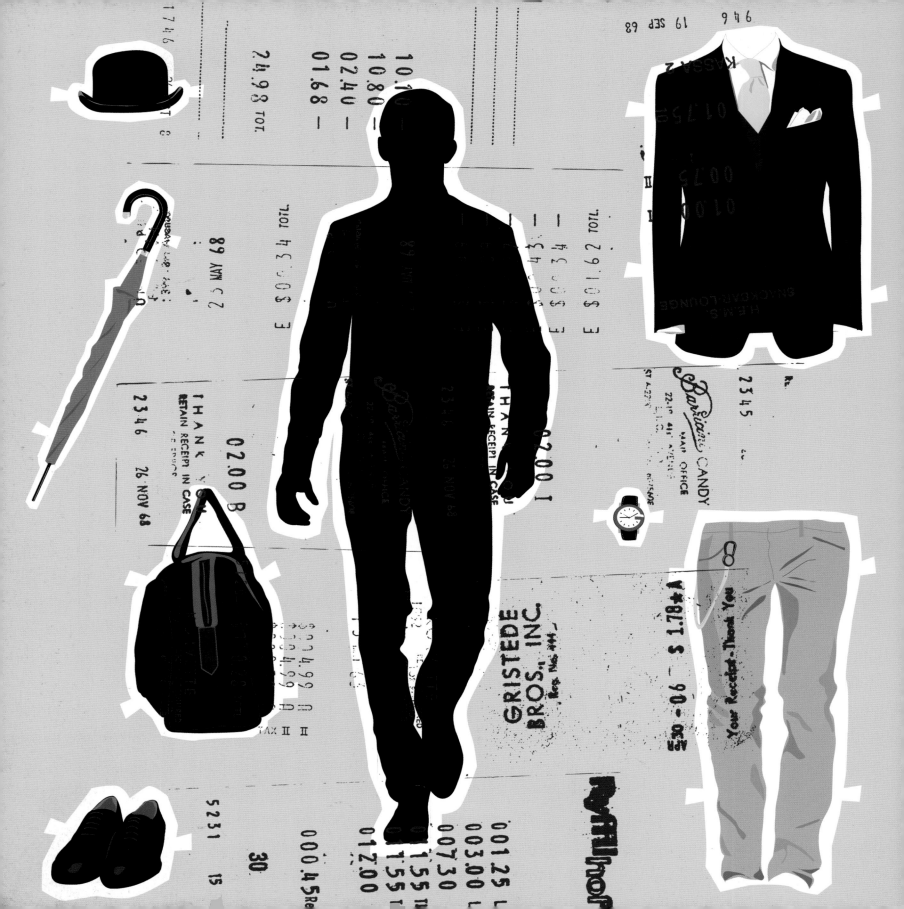

Menswear

previous page:

Puntoos Design & Illustration Studio

Cut-out (2007)
Adobe Illustrator, Adobe Photoshop

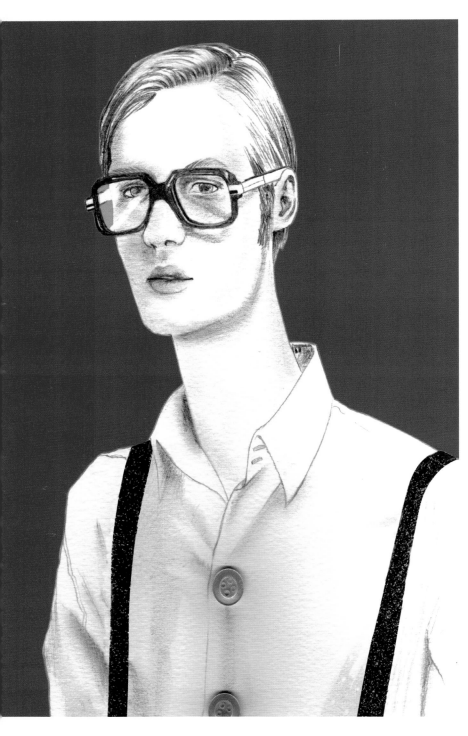

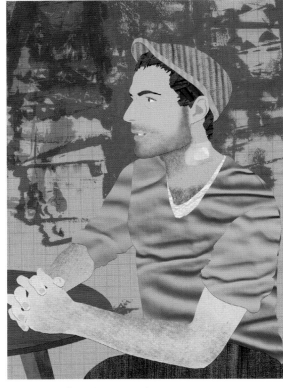

Finna Leibenguth

David (2009)
Paper, fabric, acrylic paint, Adobe Photoshop

Adriana Munoz

Red Boy (2008)
Pencil, glitter, Adobe Photoshop

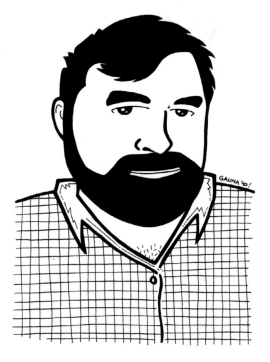

Ruben Gauna

Guibu (2010)
Ink

Alcine Perryman-Burow

Casual Guy 1 (2009)
Adobe Illustrator

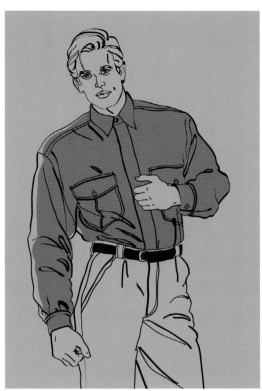

Genna Campton

Handsome (2009)
Pen, ink, Adobe Photoshop

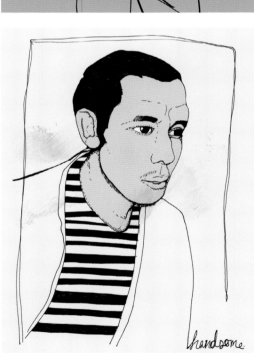

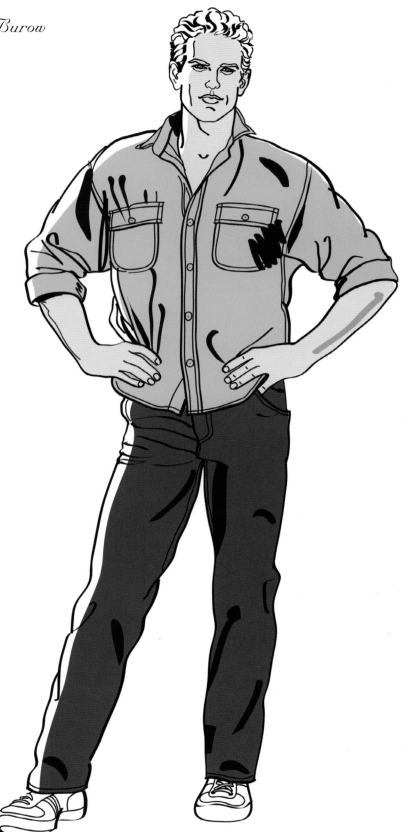

Alcine Perryman-Burow

Casual Guy 2 (2009)
Adobe Illustrator

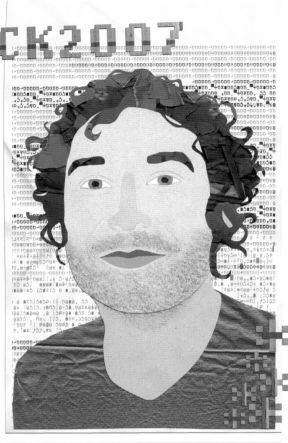

CK2007

Finna Leibenguth

Christian (2009)
Paper, fabric, Adobe Photoshop

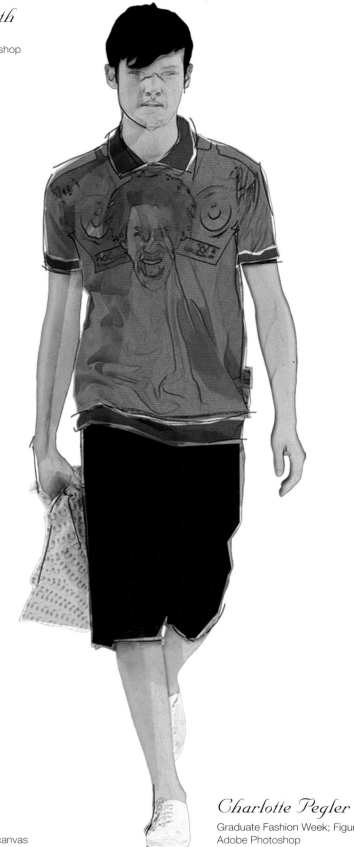

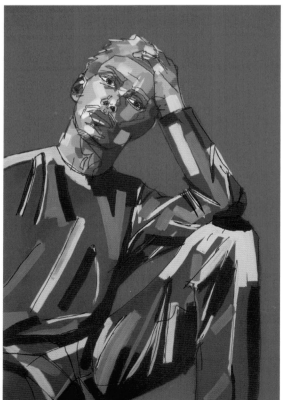

Rowan Newton

John (2009)
Acrylic and spray paint on canvas

Charlotte Pegler

Graduate Fashion Week; Figure 1 (2009)
Adobe Photoshop

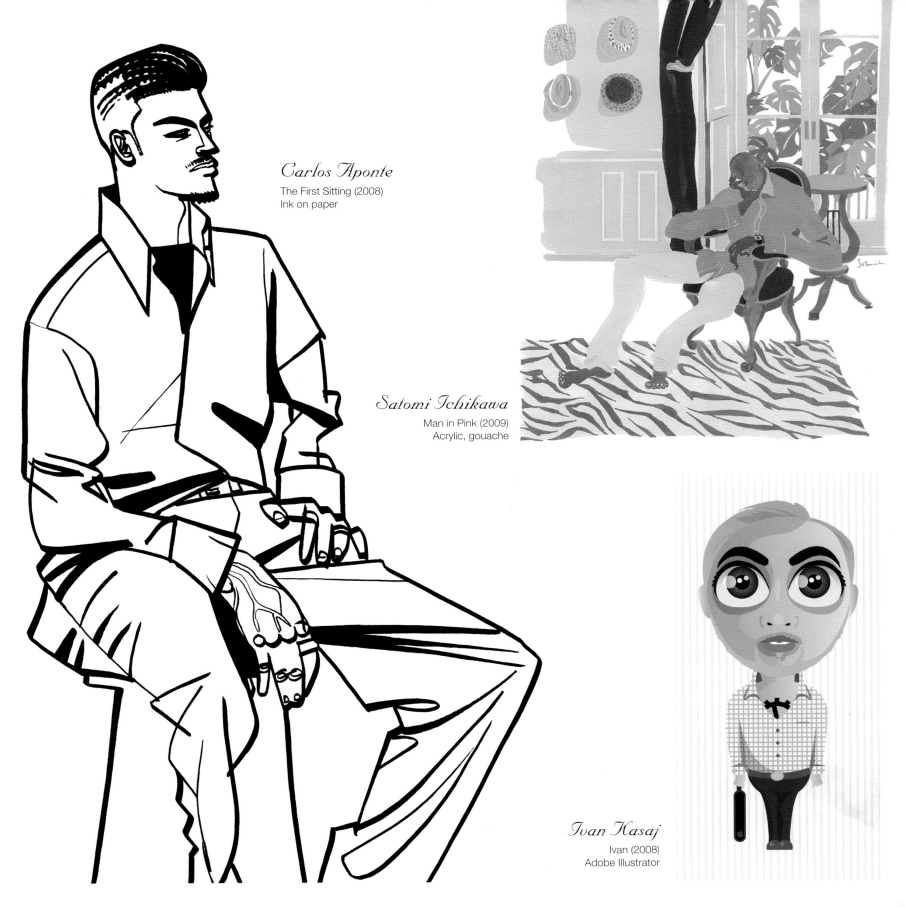

Carlos Aponte
The First Sitting (2008)
Ink on paper

Satomi Ichikawa
Man in Pink (2009)
Acrylic, gouache

Ivan Kasaj
Ivan (2008)
Adobe Illustrator

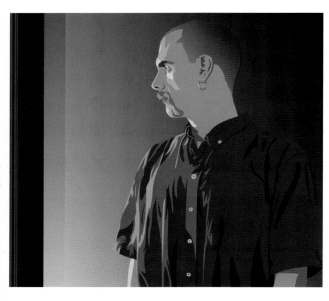

Arthur Mount
POZ magazine: Mr Wells (2005)
Adobe Illustrator

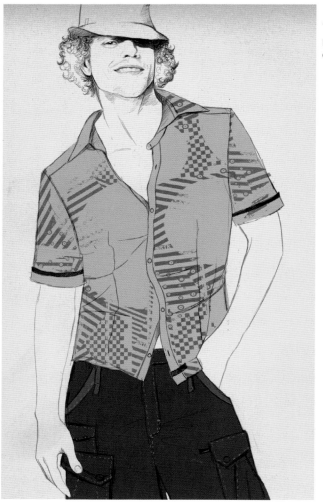

Sandra Suy
Lucas (2008)
Corel Painter, Adobe Photoshop

Carlos Aponte
Gilbert & Lewis Promo (2009)
Ink on paper

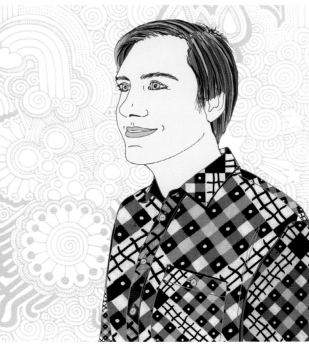

Heike Cimato

James Broad (2010)
Collage, fineliner pen, Adobe
Illustrator, Adobe Photoshop

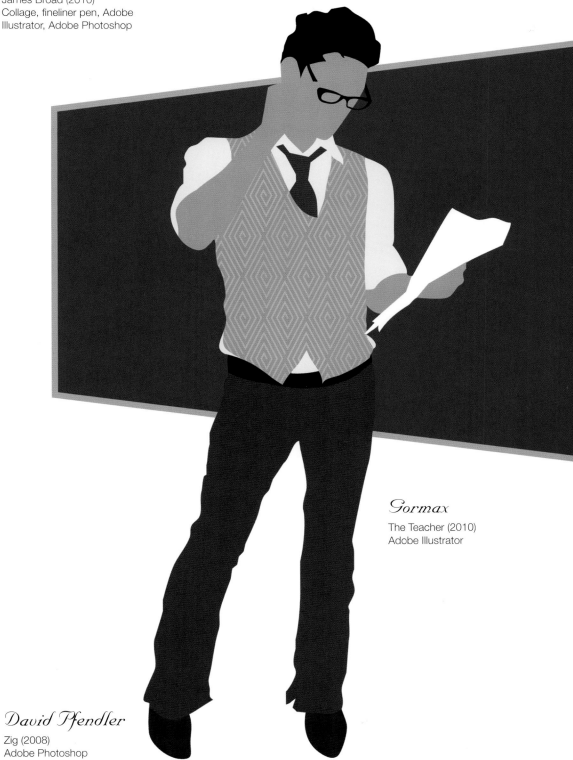

Gormax

The Teacher (2010)
Adobe Illustrator

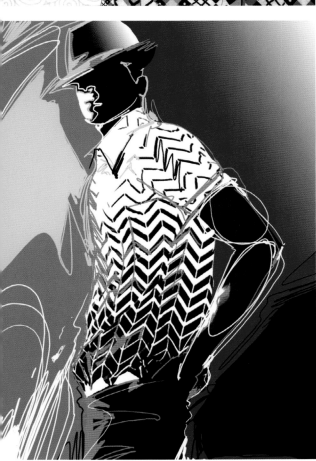

David Pfendler

Zig (2008)
Adobe Photoshop

Tim Degner

My Father (2007)
Pen, Adobe Illustrator

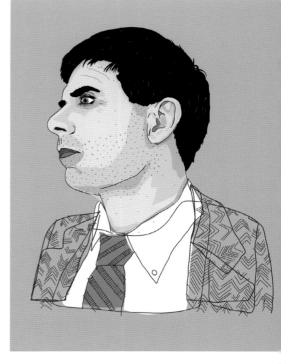

Kerstin Wacker

Maximillian + Friends (2008)
Watercolour, ink pen, Adobe Photoshop

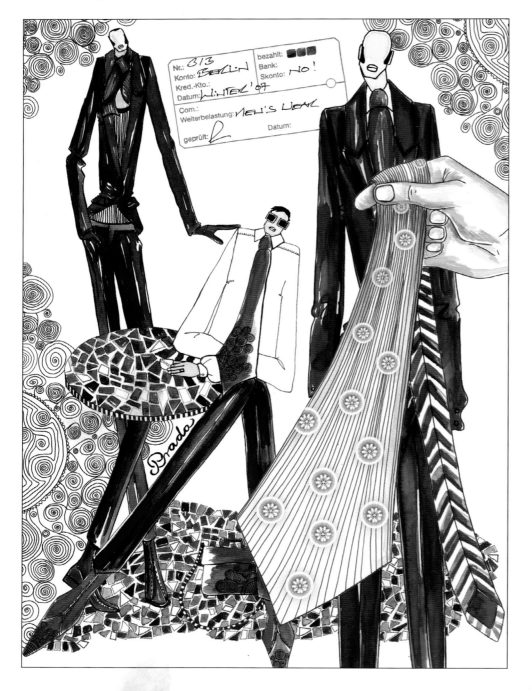

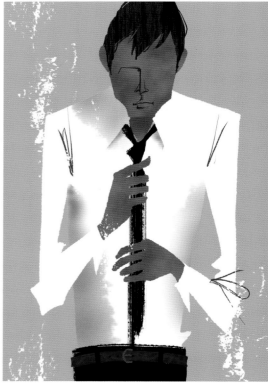

Shiho Matsubara

Personal Work (2008)
Adobe Photoshop, Adobe Illustrator

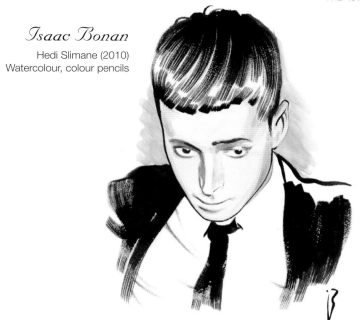

Isaac Bonan

Hedi Slimane (2010)
Watercolour, colour pencils

Anne-Li Karlsson

Man of the Year (2005)
Ink, crayon, Adobe Photoshop

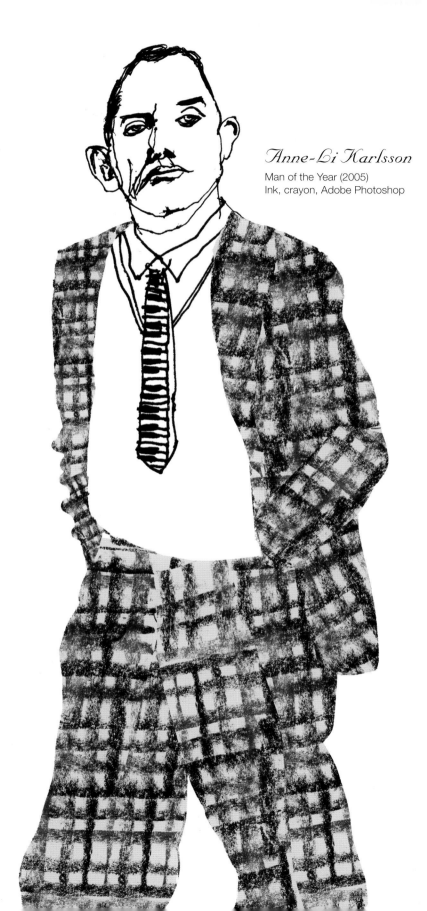

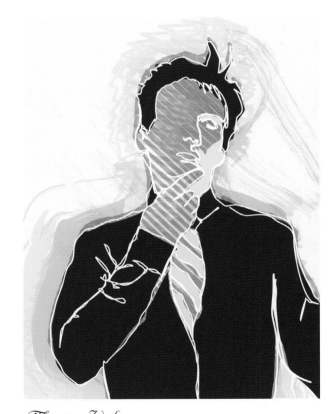

Monica Velasquez

S-Type (2007)
Adobe Photoshop, Adobe Illustrator

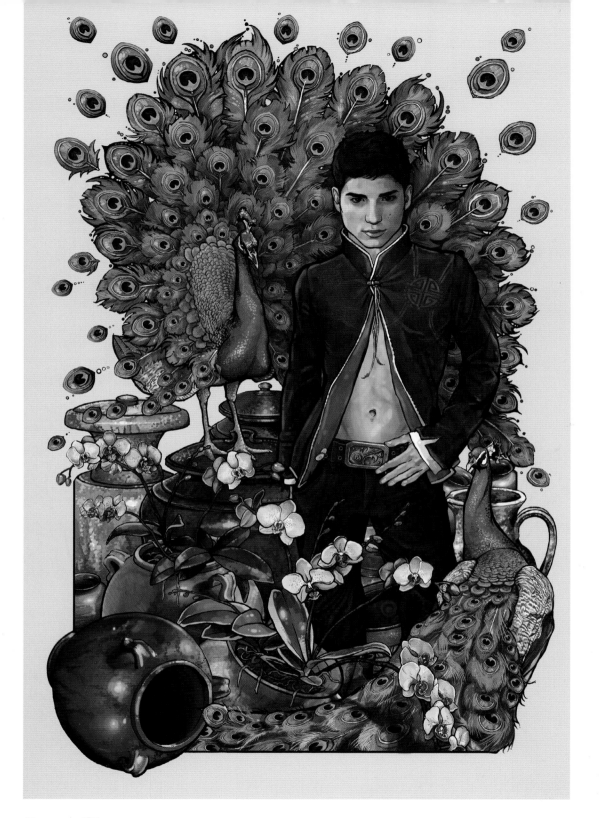

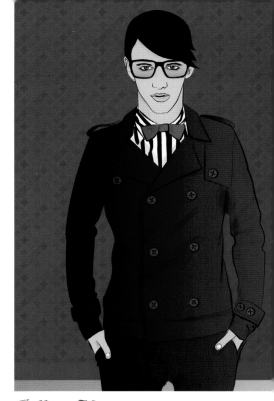

Jeffrey Herrero
Gafapasta London Style (2009)
Adobe Illustrator

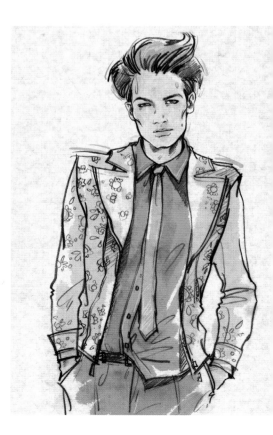

Dustin Papow
Exotic Fortunes (2006)
Adobe Photoshop

Alena Lavdovskaya
Elle (Russia): St Valentine's Special (2010)
Pencil, Adobe Photoshop

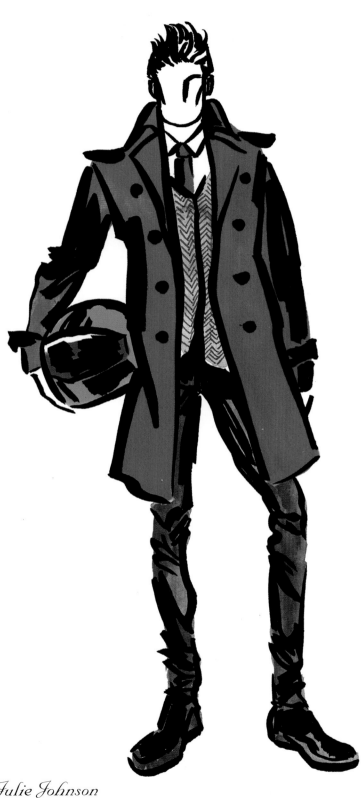

Isaac Bonan
Man Catwalk II (2010)
Watercolour

Julie Johnson
Biker (2009)
India ink, watercolour, Adobe Photoshop

Alena Lavdovskaya
Advertising campaign for TSUM 2009/10 (2009)
Pencil, Adobe Photoshop

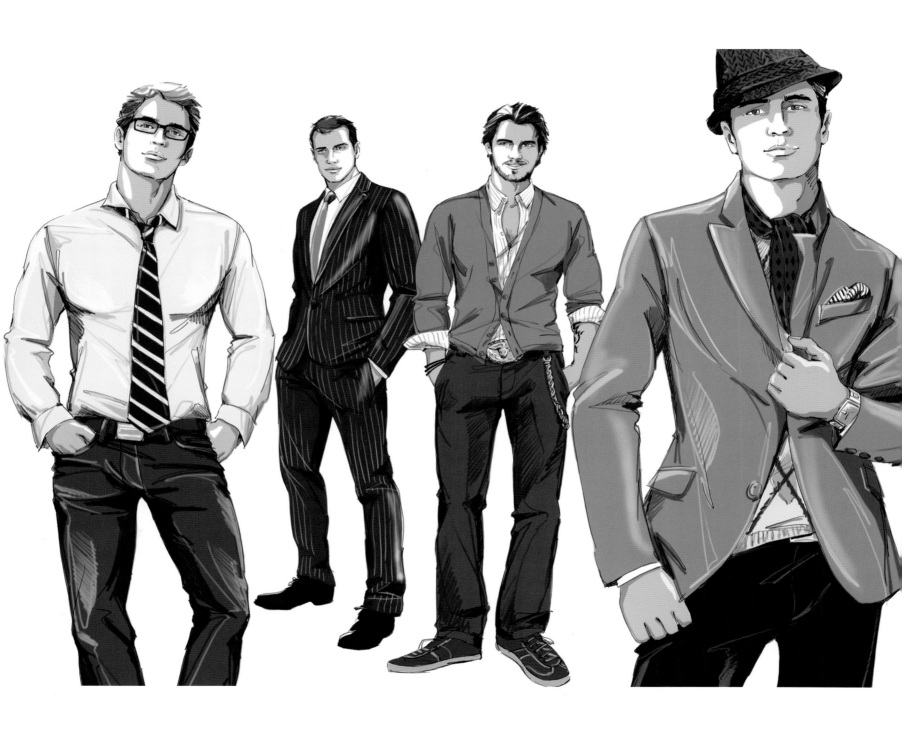

David Pfendler
Dandy (2007)
Adobe Photoshop

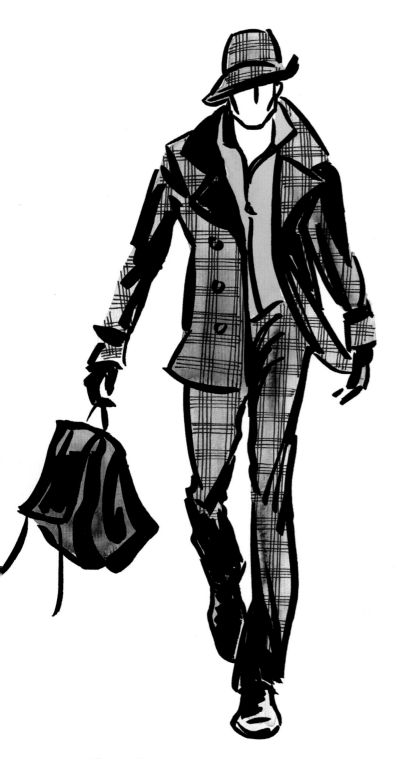

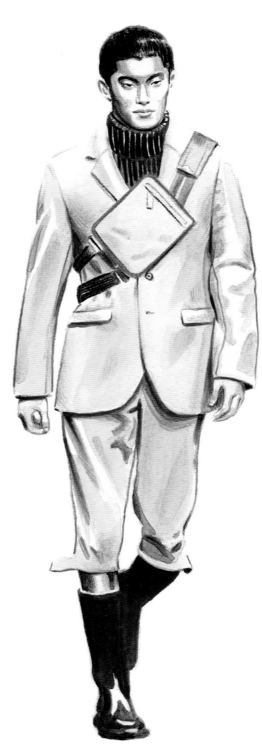

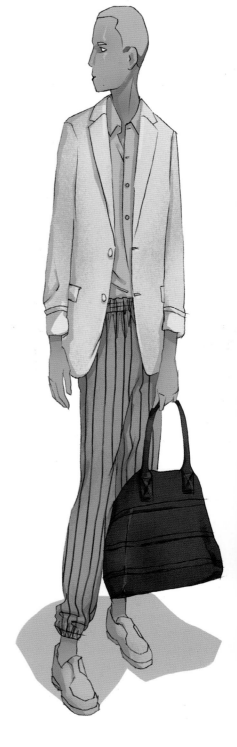

Julie Johnson

Check Me Out (2009)
India ink, watercolour, Adobe Photoshop

Isaac Bonan

Man Catwalk VII (2010)
Watercolour, colour pencils

Brandon Kent Graham

Acapulco (2010)
Pencil, Adobe Photoshop

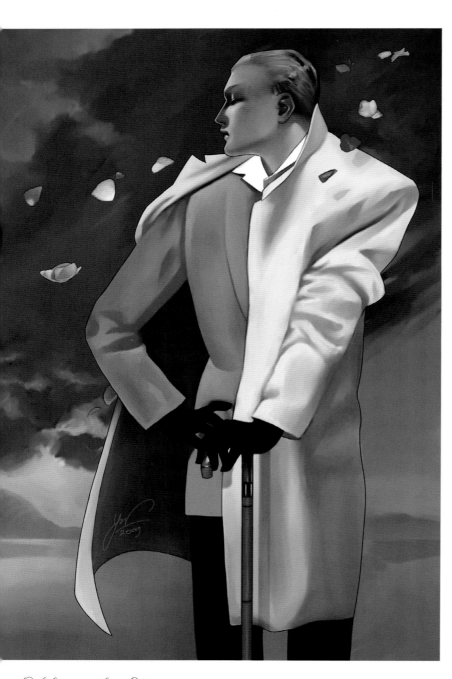

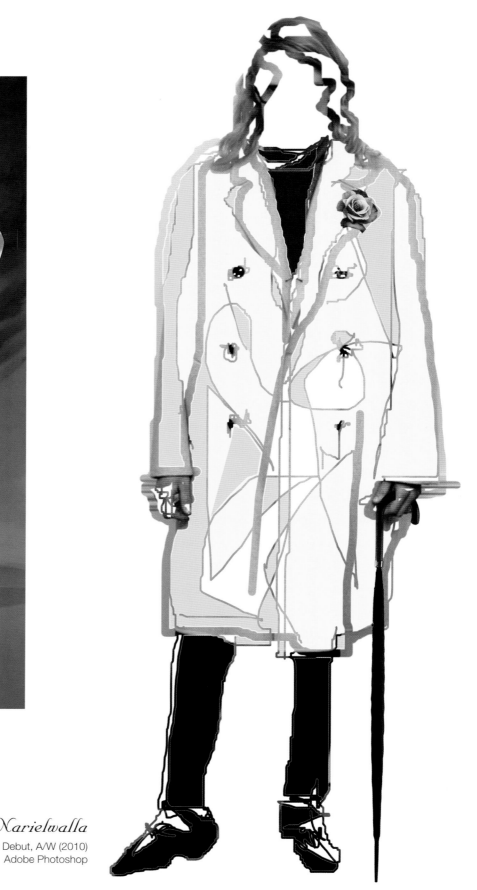

Odile van der Stap

High and Mighty (2009)
Corel Painter X

Hormazd Geve Narielwalla

Michelle, Gieves & Hawkes London Fashion Week Debut, A/W (2010)
Adobe Photoshop

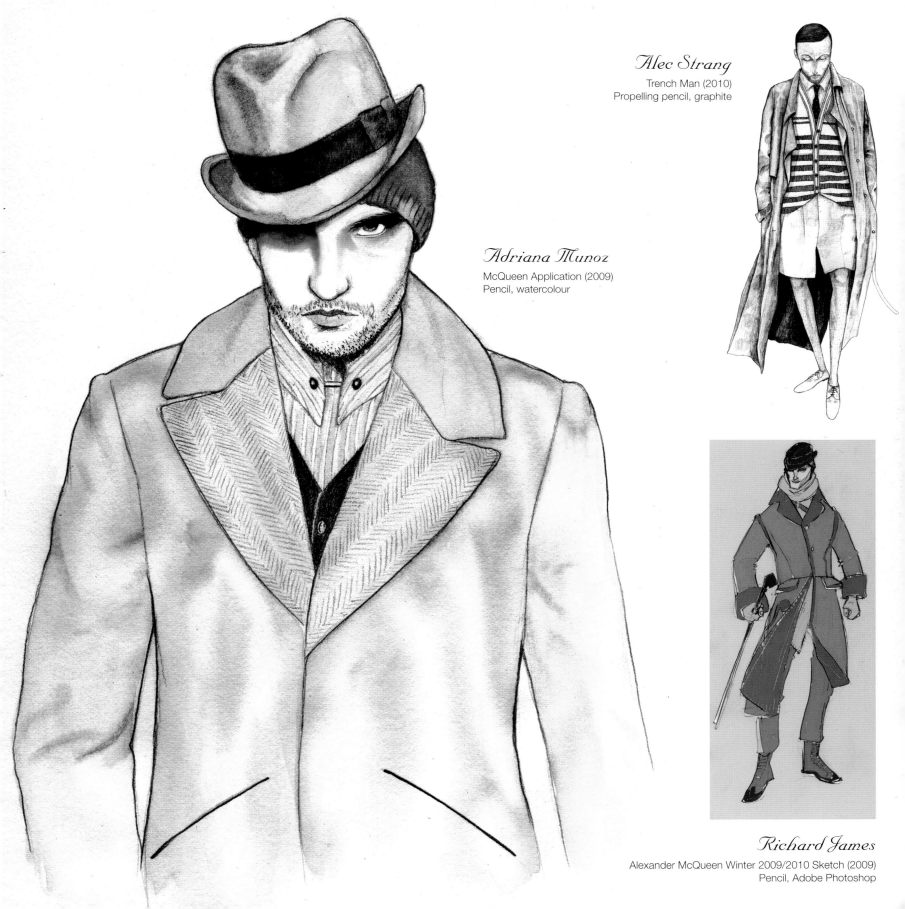

Alec Strang
Trench Man (2010)
Propelling pencil, graphite

Adriana Munoz
McQueen Application (2009)
Pencil, watercolour

Richard James
Alexander McQueen Winter 2009/2010 Sketch (2009)
Pencil, Adobe Photoshop

Svetlana Makarova

Man 01 (Character for Shoes' House 'Forum', Russia) (2009)
CorelDRAW

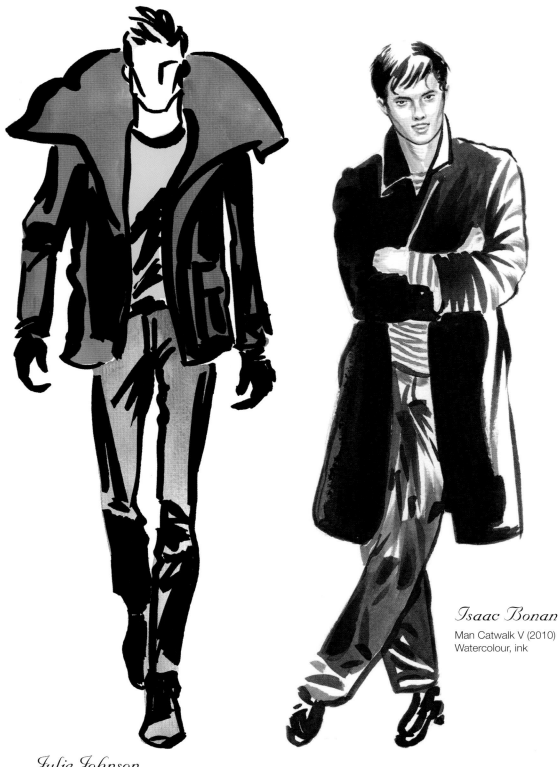

Isaac Bonan

Man Catwalk V (2010)
Watercolour, ink

Julie Johnson

Woodsman (2009)
India ink, watercolour, Adobe Photoshop

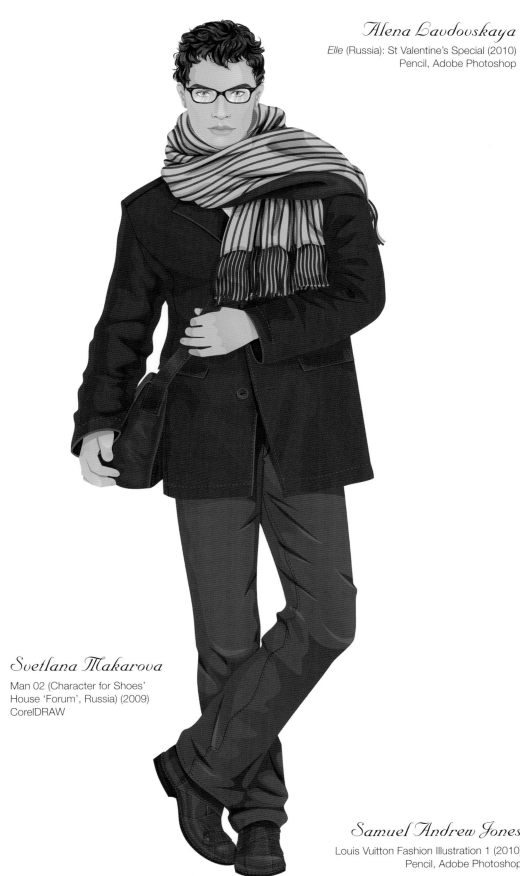

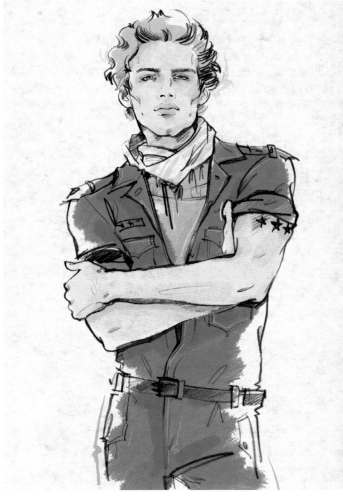

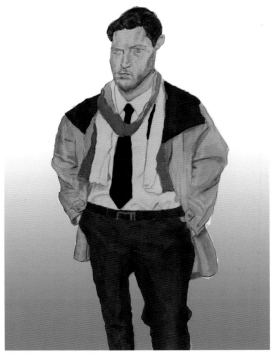

Alena Lavdovskaya
Elle (Russia): St Valentine's Special (2010)
Pencil, Adobe Photoshop

Svetlana Makarova
Man 02 (Character for Shoes'
House 'Forum', Russia) (2009)
CorelDRAW

Samuel Andrew Jones
Louis Vuitton Fashion Illustration 1 (2010)
Pencil, Adobe Photoshop

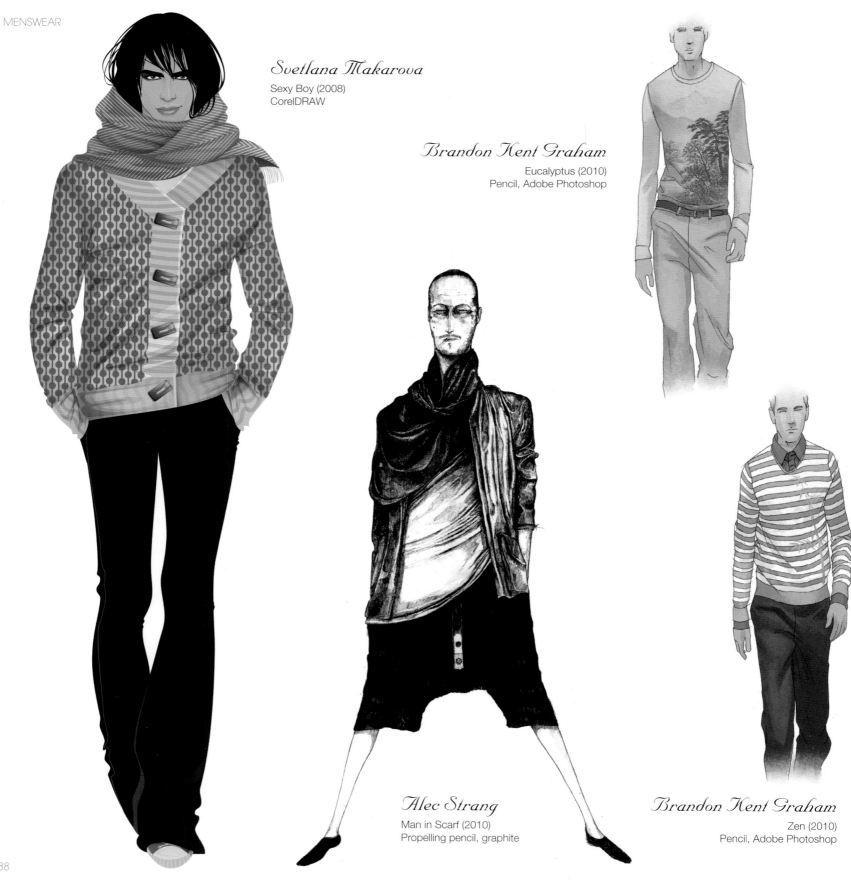

Svetlana Makarova

Sexy Boy (2008)
CorelDRAW

Brandon Kent Graham

Eucalyptus (2010)
Pencil, Adobe Photoshop

Alec Strang

Man in Scarf (2010)
Propelling pencil, graphite

Brandon Kent Graham

Zen (2010)
Pencil, Adobe Photoshop

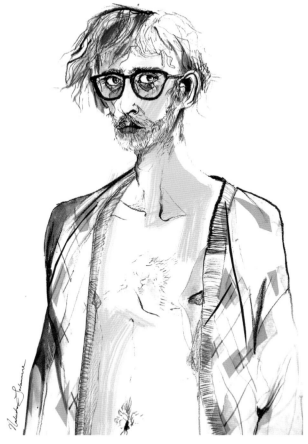

Nadeesha Godamunne

Geek (2009)
Colour pencils, Adobe Photoshop

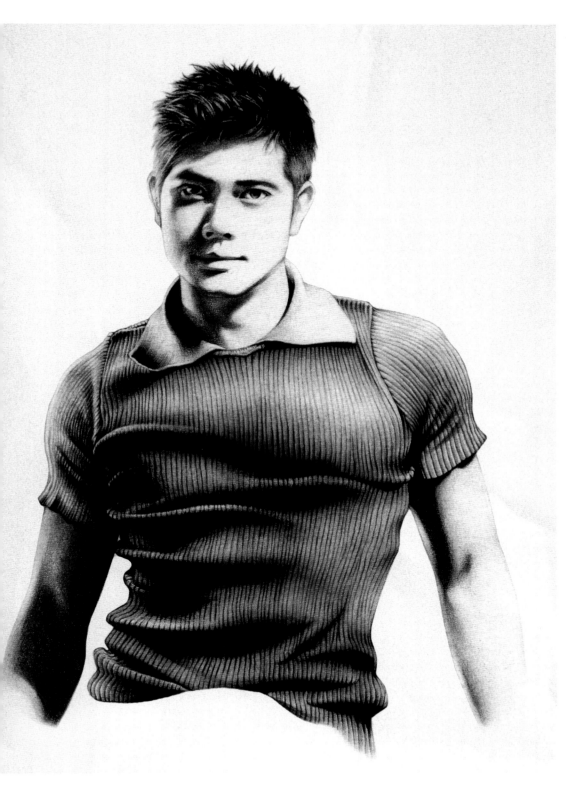

Jason Siew

Cool – Aaron (1996)
Coloured pencil

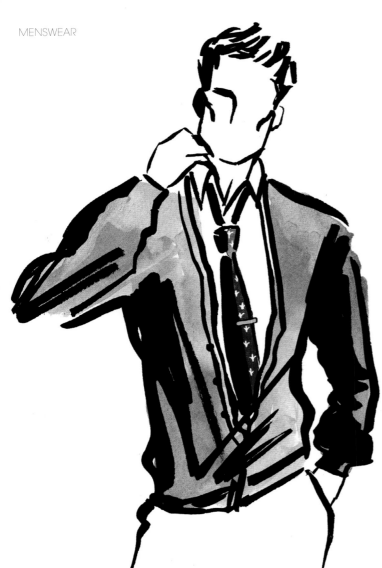

Alena Lavdovskaya

Elle (Russia): St Valentine's Special (2010)
Ink, Adobe Photoshop

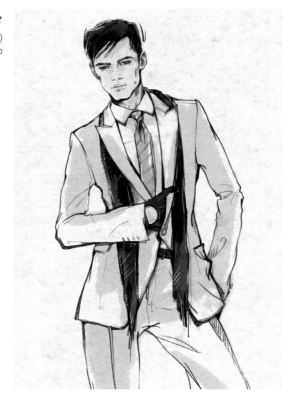

Julie Johnson

Cardigan Man (2008)
India ink, watercolour,
Adobe Photoshop

Oscar Gimenez

Spring in Monaco (2008)
Pencil, Adobe Photoshop

David Pfendler
Times Square (2006)
Adobe Photoshop

Puntoos Design & Illustration Studio
MySuitNY (2009)
Fabric, Adobe Illustrator, Adobe Photoshop

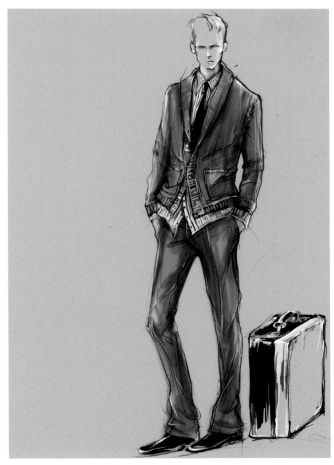

Mengjie Di
Men's Uniform (2010)
Pencil, Adobe Photoshop

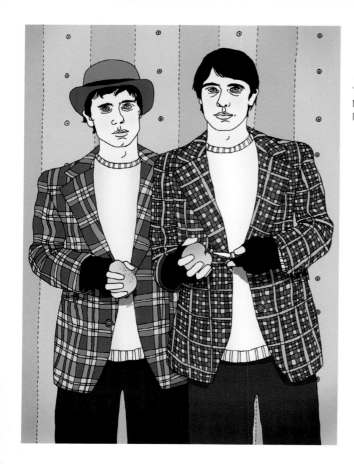

Anne Lück

Mirror Portrait No. 2 (2009)
Indian ink, Adobe Photoshop

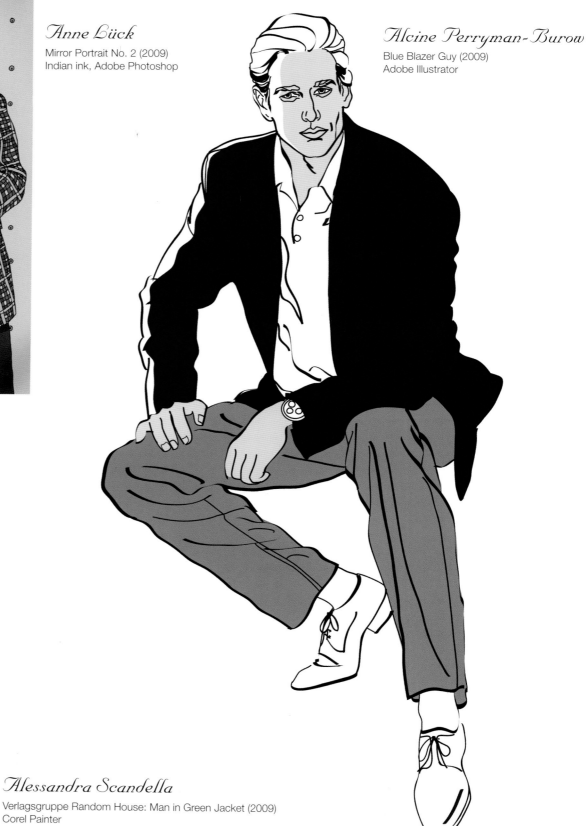

Alcine Perryman-Burow

Blue Blazer Guy (2009)
Adobe Illustrator

Alessandra Scandella

Verlagsgruppe Random House: Man in Green Jacket (2009)
Corel Painter

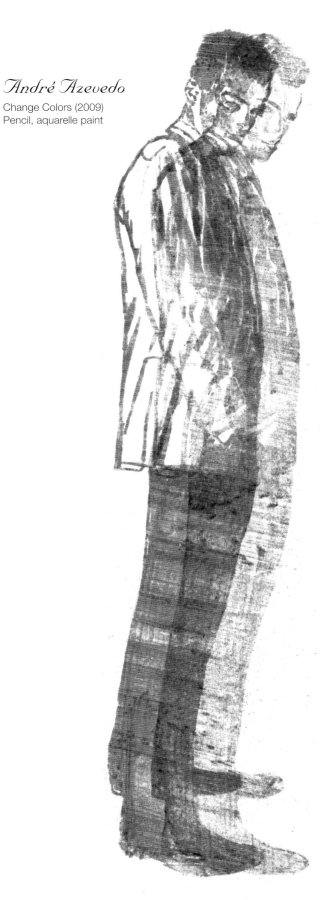

André Azevedo
Change Colors (2009)
Pencil, aquarelle paint

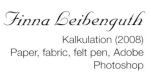

Finna Leibenguth
Kalkulation (2008)
Paper, fabric, felt pen, Adobe
Photoshop

Rowan Newton
Just in Time (2005)
Acrylic and spray paint on canvas

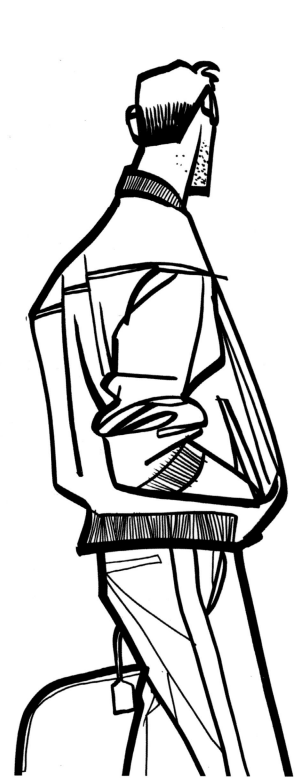

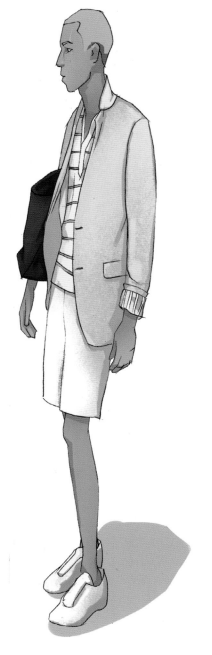

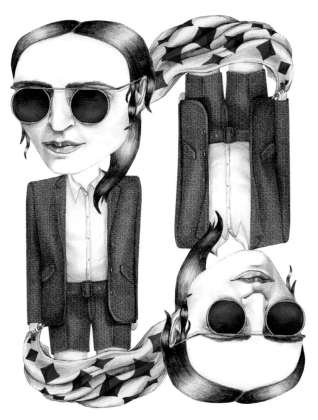

Annelie Carlström

The Jack of Minimarket (2008)
Pencil, Adobe Photoshop

Brandon Kent Graham

T.G.I.F. (2010)
Pencil, Adobe Photoshop

Carlos Aponte

Spring Jacket (2007)
Ink on paper

Andrew Gibson
Waistline (2009)
Pencil, Adobe Photoshop

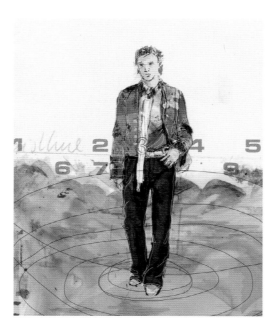

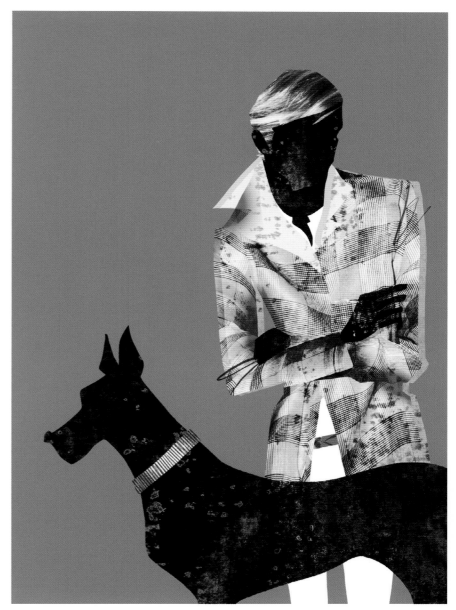

Shiho Matsubara
Personal Work (2009)
Adobe Photoshop, Adobe Illustrator

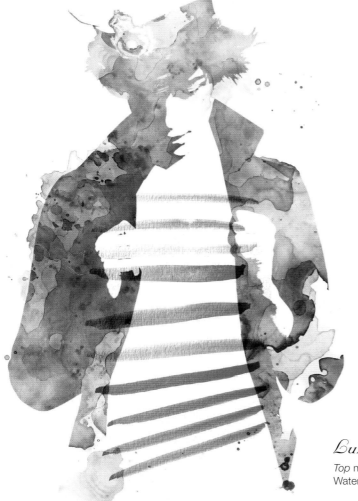

Luis Tinoco
Top magazine (UK): Jean Paul Gaultier (2009)
Watercolour, Adobe Photoshop

Julie Johnson

Acting Green (2009)
India ink, watercolour, Adobe Photoshop

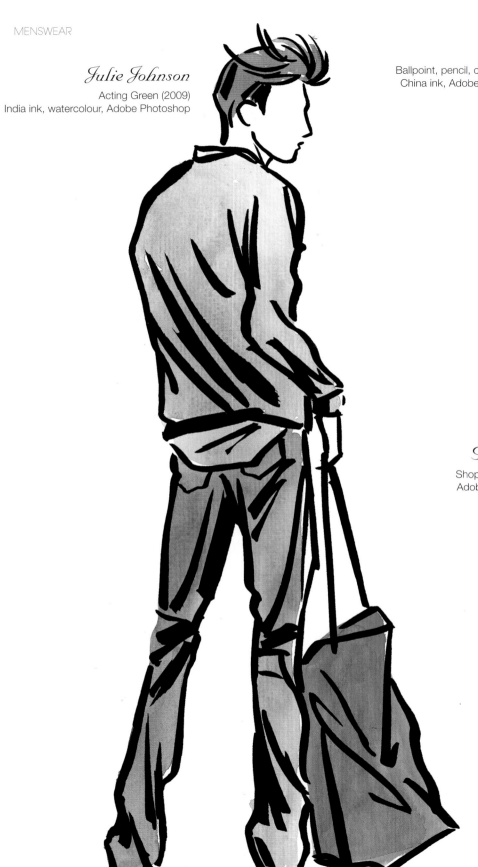

Neo

Ali (2010)
Ballpoint, pencil, coloured ink,
China ink, Adobe Photoshop

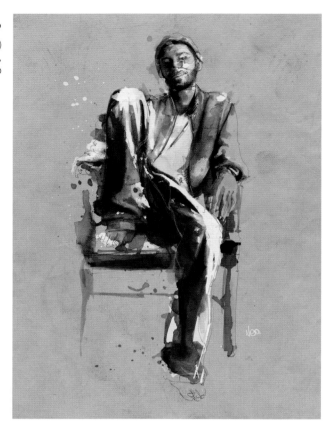

Gormax

Shopping (2010)
Adobe Illustrator

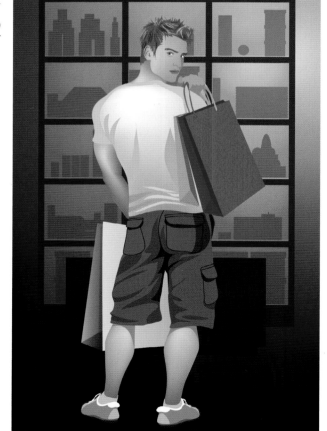

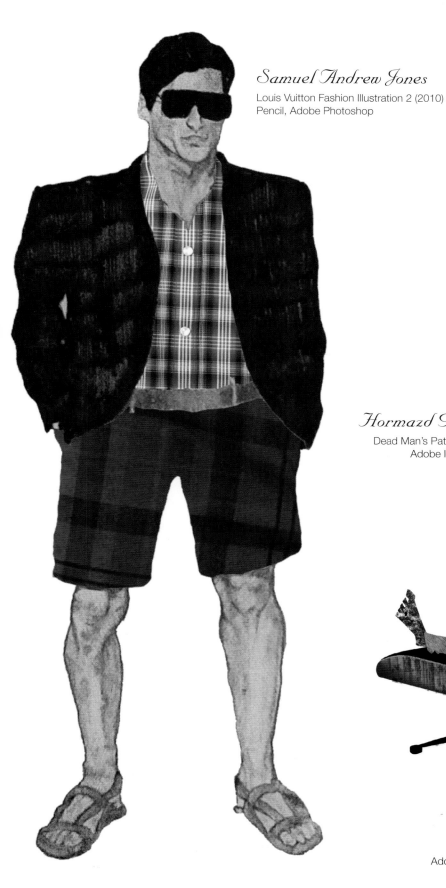

Samuel Andrew Jones

Louis Vuitton Fashion Illustration 2 (2010)
Pencil, Adobe Photoshop

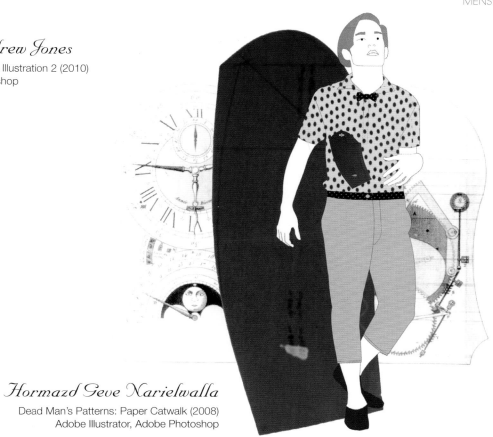

Hormazd Geve Narielwalla

Dead Man's Patterns: Paper Catwalk (2008)
Adobe Illustrator, Adobe Photoshop

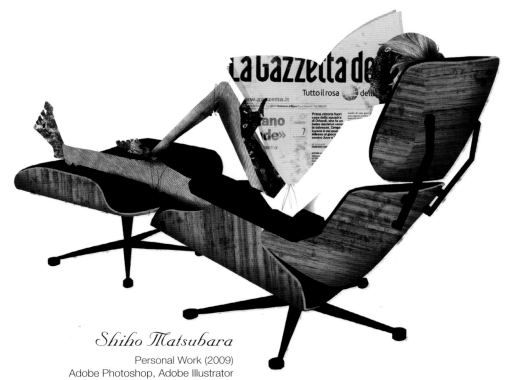

Shiho Matsubara

Personal Work (2009)
Adobe Photoshop, Adobe Illustrator

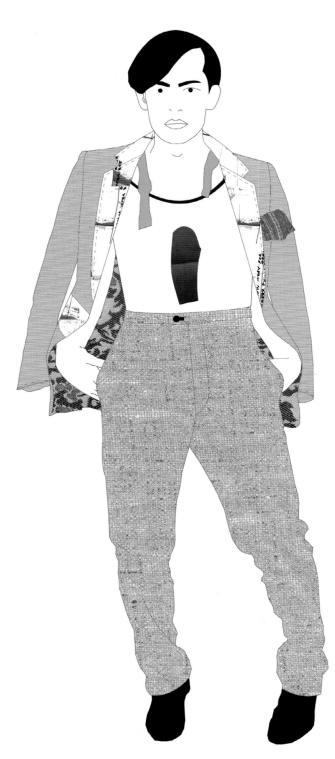

Danielle Meder

Philip Sparks Spring 2010 Paper Doll (20
Ink, Adobe Photoshop

Gary Goh

Chad Brown CCY (2009)
Adobe Illustrator

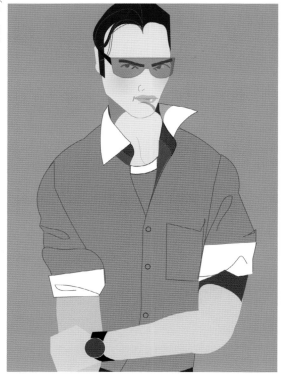

Hormazd Geve Narielwalla

Dead Man's Patterns: Paper Catwalk (2008)
Adobe Illustrator, Adobe Photoshop

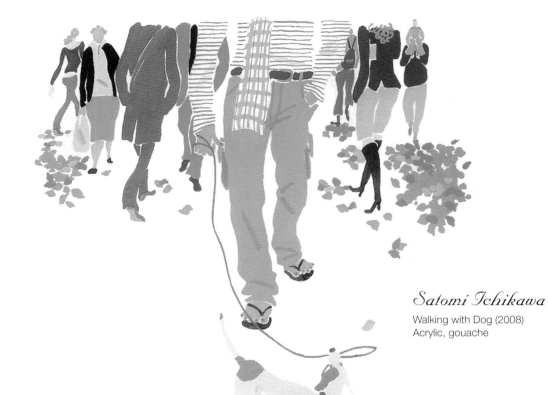

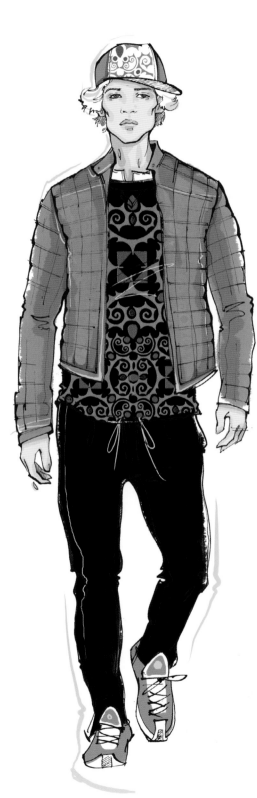

Satomi Ichikawa

Walking with Dog (2008)
Acrylic, gouache

Alena Lavdovskaya

Illustrations for www.stylesight.com (2009)
Ink, Adobe Photoshop

Julie Johnson

Red Fedora (2008)
India ink, watercolour, Adobe Photoshop

Richard James
Fashion Drawing 8 (2009)
Marker pen

Charlotte Pegler
Graduate Fashion Week: Figure 2 (2009)
Adobe Photoshop

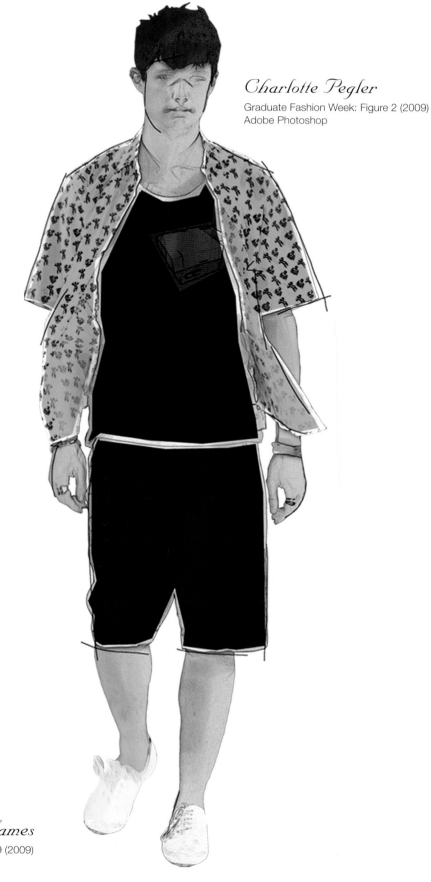

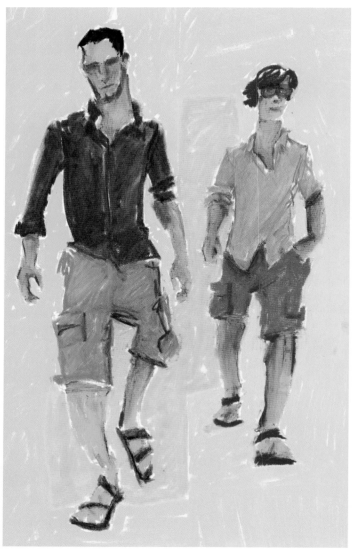

Richard James
Fashion Drawing 9 (2009)
Oil pastel

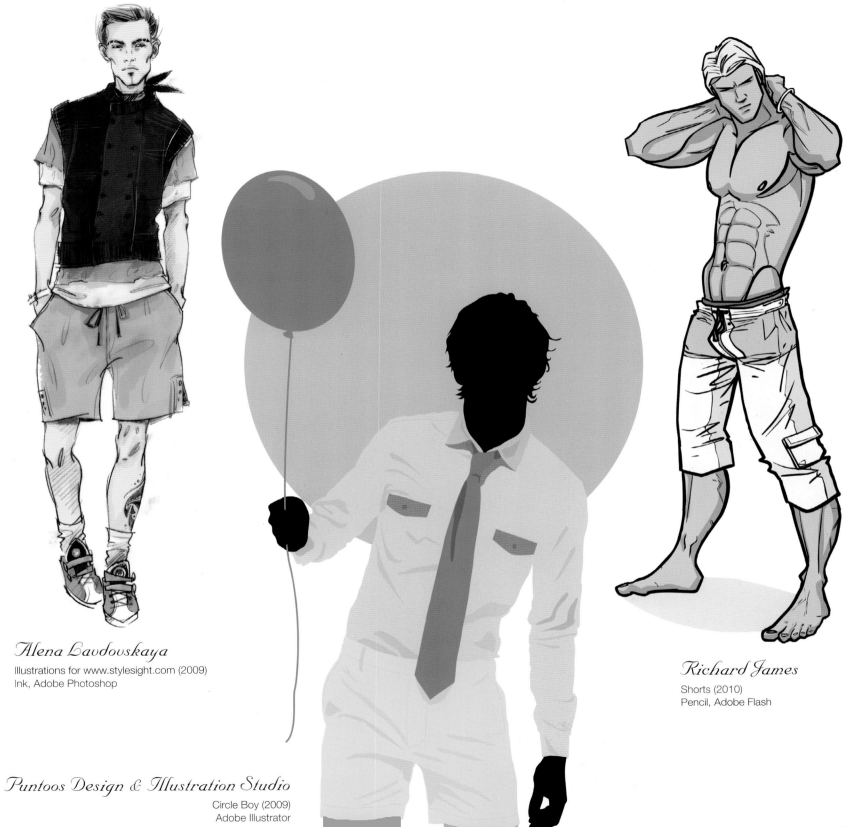

Alena Lavdovskaya
Illustrations for www.stylesight.com (2009)
Ink, Adobe Photoshop

Puntoos Design & Illustration Studio
Circle Boy (2009)
Adobe Illustrator

Richard James
Shorts (2010)
Pencil, Adobe Flash

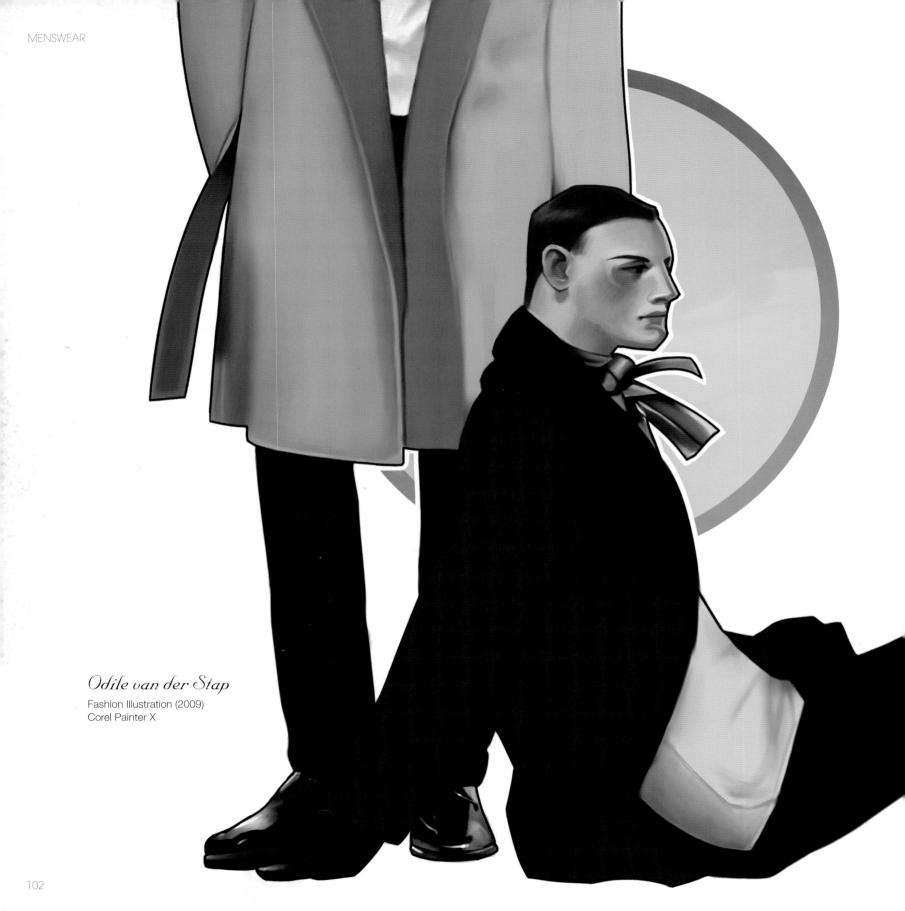

Odile van der Stap

Fashion Illustration (2009)
Corel Painter X

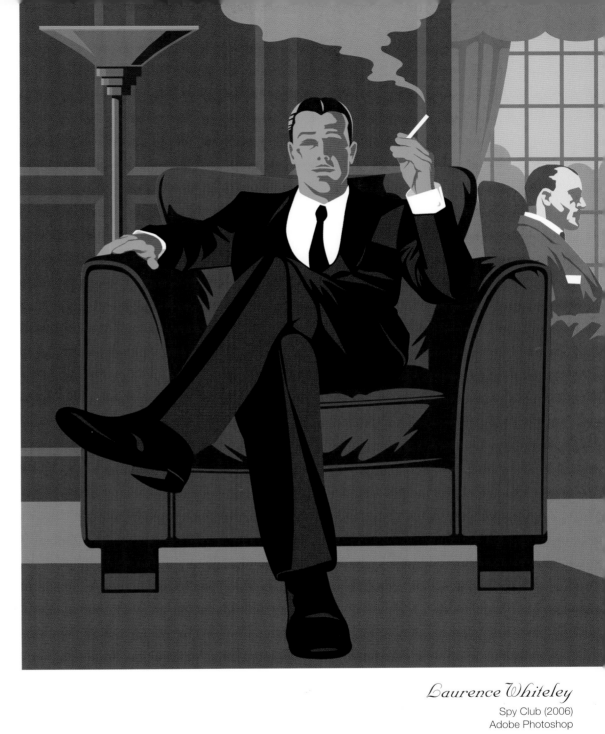

Laurence Whiteley
Spy Club (2006)
Adobe Photoshop

103

Phil McCollam
Self Portrait – Smooth (2006/2007)
Adobe Illustrator

Anne-Li Karlsson
Man of the Year (2005)
Ink, crayon, Adobe Photoshop

Julie Johnson
Seated Suit (2009)
India ink, watercolour, Adobe Photoshop

Christian Borstlap
Selfridges Spring Campaign (2000)
Adobe Illustrator, Adobe Photoshop

David Pfendler
Wetcross (2006)
Adobe Photoshop

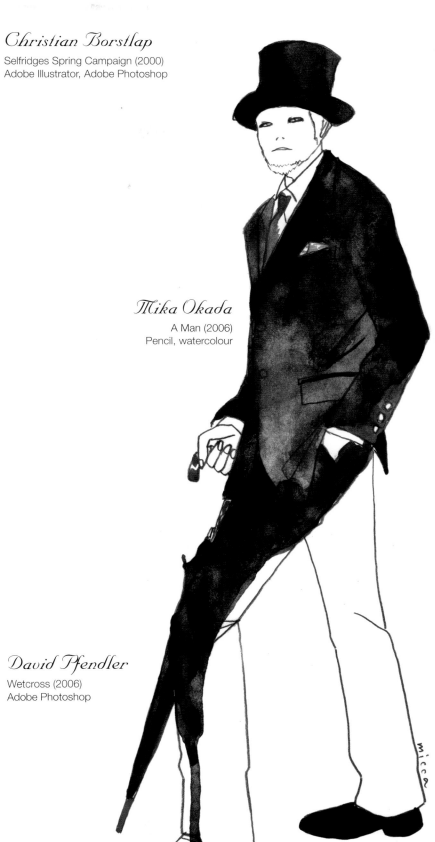

Mika Okada
A Man (2006)
Pencil, watercolour

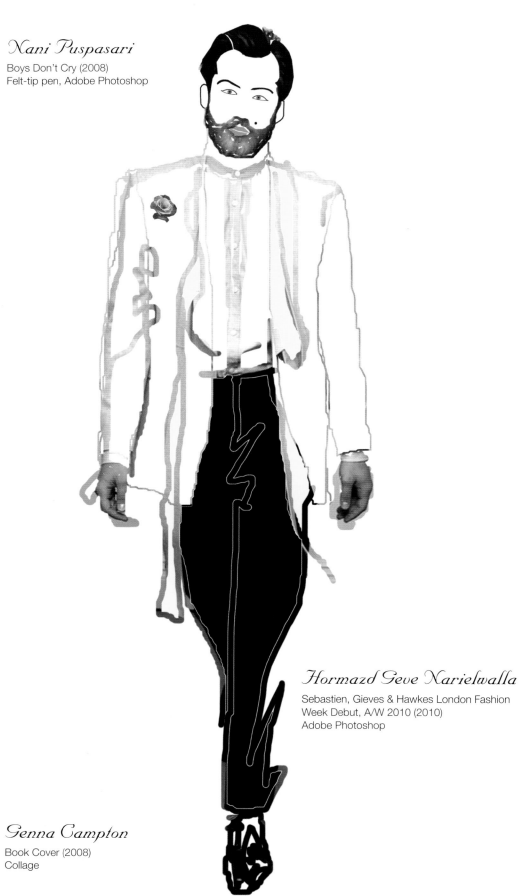

Nani Puspasari
Boys Don't Cry (2008)
Felt-tip pen, Adobe Photoshop

Hormazd Geve Narielwalla
Sebastien, Gieves & Hawkes London Fashion
Week Debut, A/W 2010 (2010)
Adobe Photoshop

Genna Campton
Book Cover (2008)
Collage

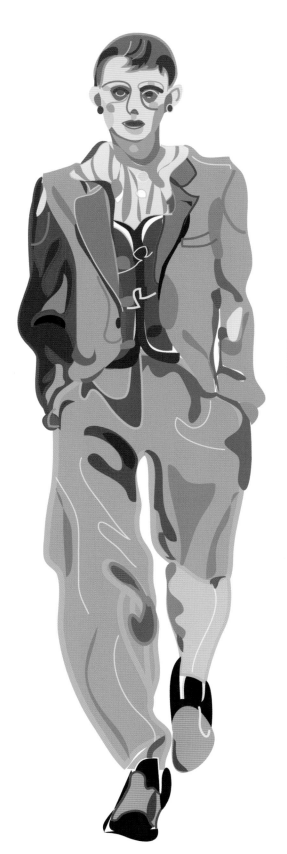

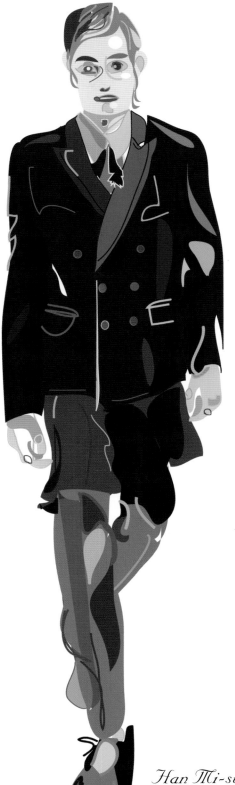

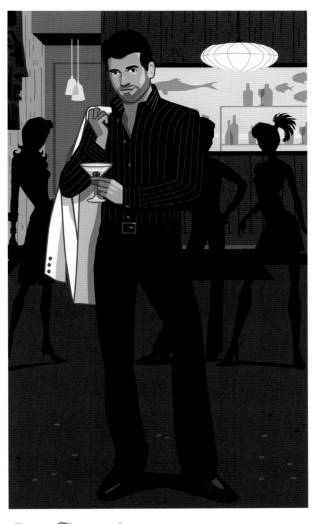

Greg Paprocki
Lounge Guy (2008)
Adobe Illustrator

Han Mi-suk
Extraordinary + Kunst (Art) (2010)
Watercolour, acrylic, pen and ink, Adobe Illustrator, Adobe Photoshop

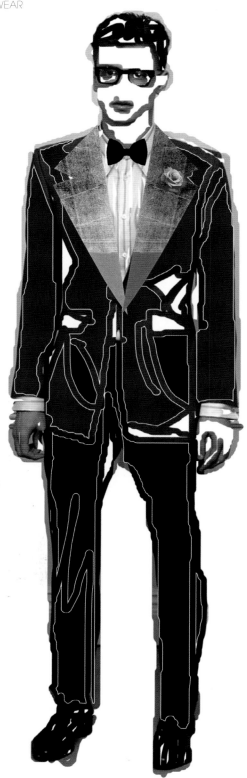

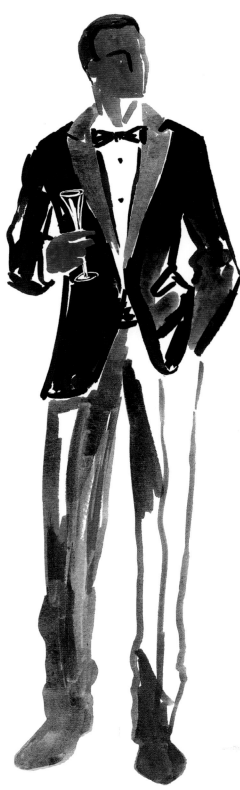

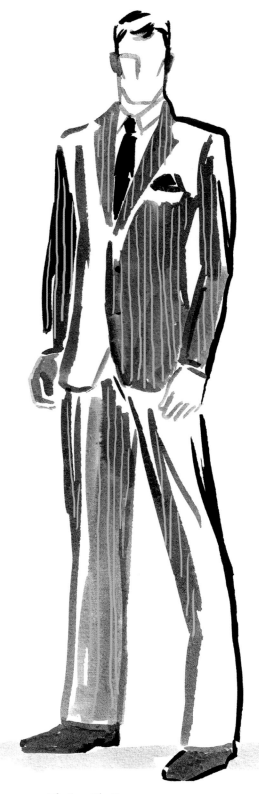

Hormazd Geve Narielwalla

Christian, Gieves & Hawkes London Fashion
Week Debut, A/W 2010 (2010)
Adobe Photoshop

Julie Johnson

Inaugural Tuxedo (2008)
India Ink, watercolour

Julie Johnson

Wall Street (2008)
India ink wash, Adobe Photoshop

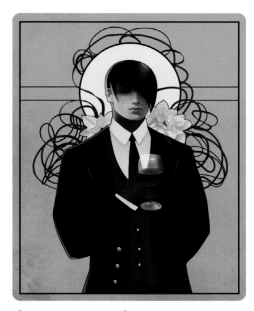

Odile van der Stap

Commission Pinkplaidrobot (2009)
Corel Painter X

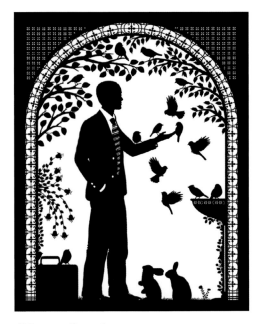

Anne Lück

Oppenheim magazine: Business Philanthropist, Sal (2009)
Indian ink on paper

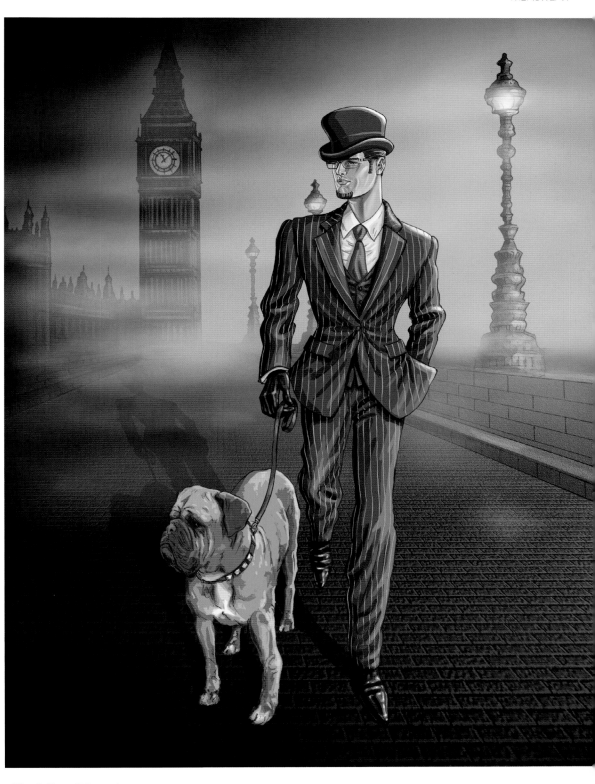

Rob De Bank

Dandy and Bully (2002)
Pen and ink, Adobe Photoshop

Alessandra Scandella

Guy in White T-shirt (Ullstein) (2009)
Adobe Photoshop

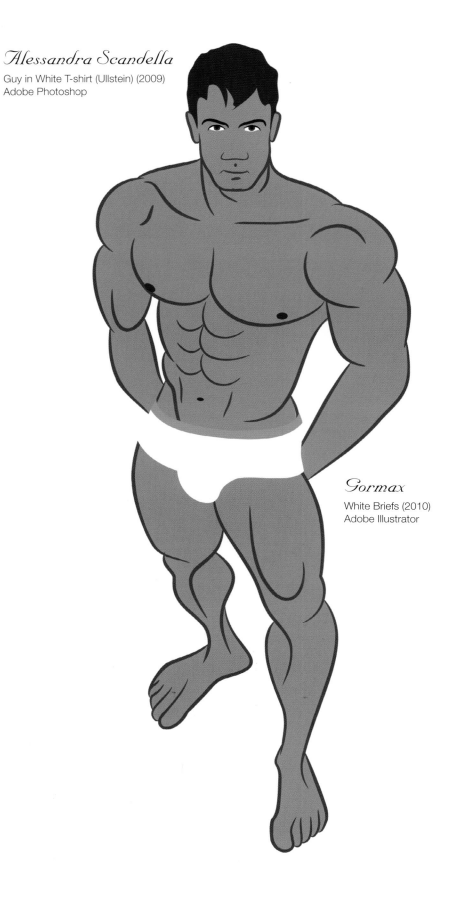

Gormax

White Briefs (2010)
Adobe Illustrator

Maria Cardelli

Interior of a Bathroom (2004)
Adobe Illustrator

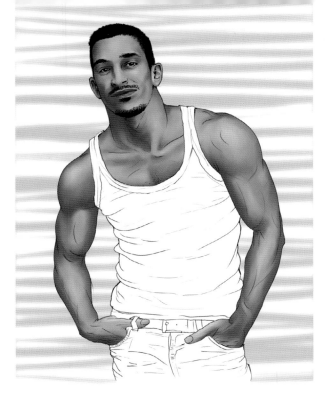

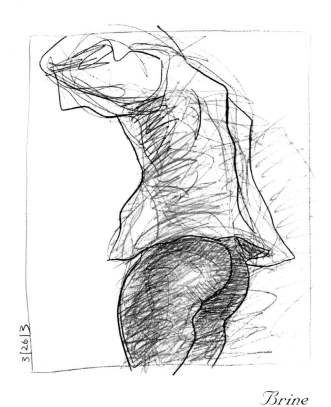

Gormax

Shirt (2009)
Corel Painter

Brine

David Shirt (2003)
Coloured pencil

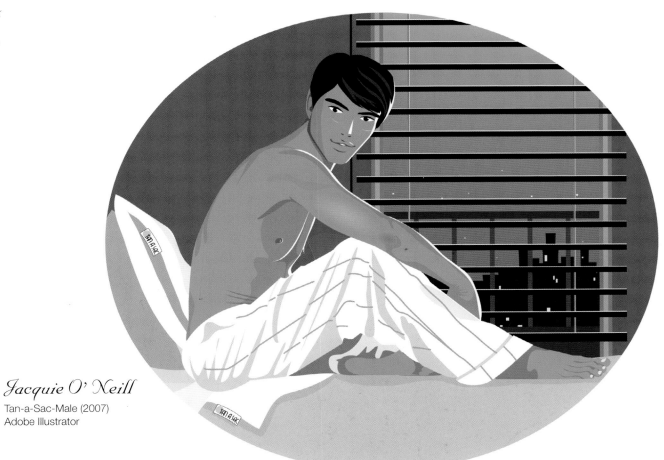

Jacquie O' Neill

Tan-a-Sac-Male (2007)
Adobe Illustrator

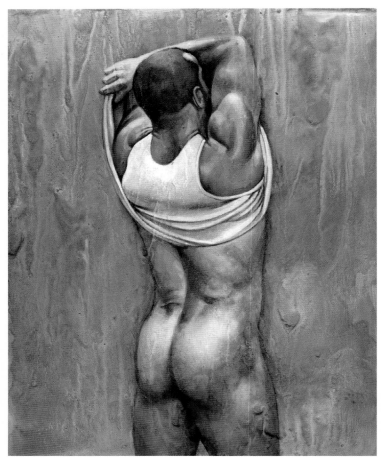

Chris Lopez

Anonymous 3 (2009)
Acrylic and stucco on canvas

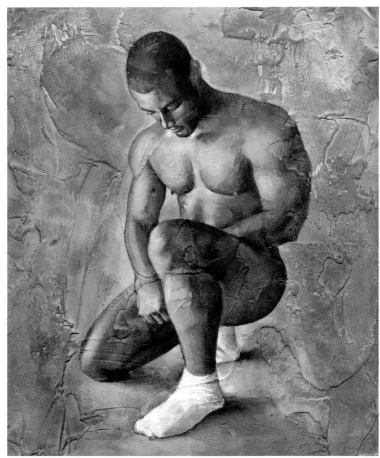

Chris Lopez

White Socks (2009)
Acrylic and stucco on canvas

Richard James

Carlos Resting (2002)
Adobe Flash

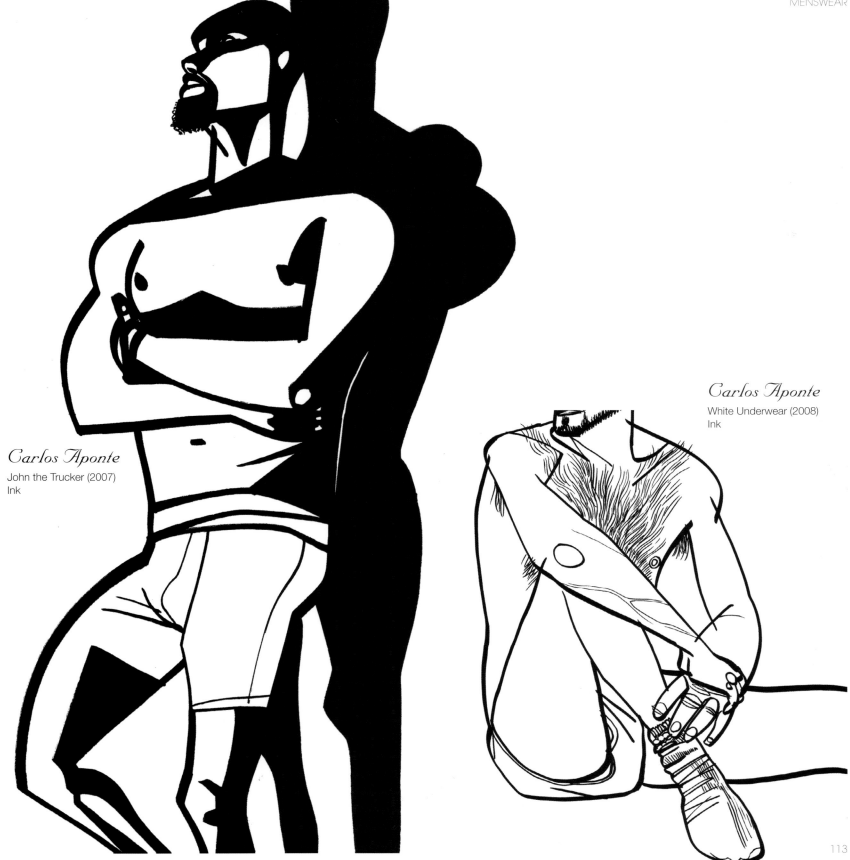

Carlos Aponte
John the Trucker (2007)
Ink

Carlos Aponte
White Underwear (2008)
Ink

113

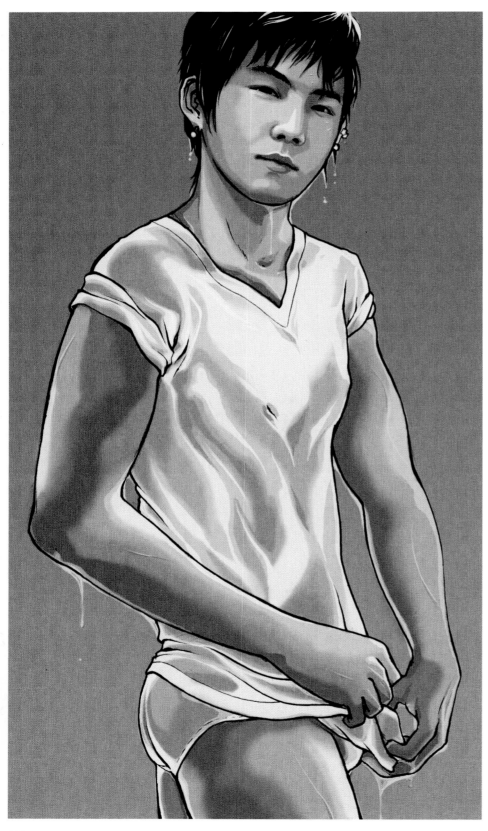

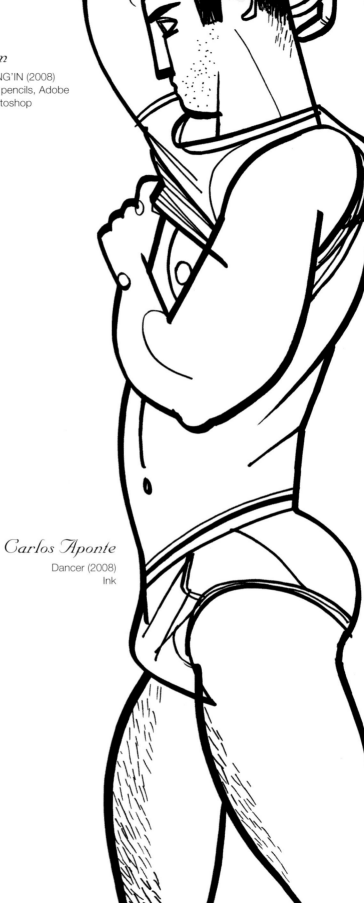

izm
KANG'IN (2008)
Ink, pencils, Adobe
Photoshop

Carlos Aponte
Dancer (2008)
Ink

Brine

Doug and Gonzalo (2007)
Coloured pencil

Brine

Ron Seated (2004)
Coloured pencil

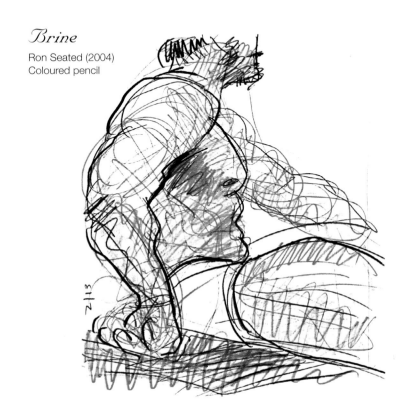

Gary Coleman

Contemplation (2001)
Oil on canvas

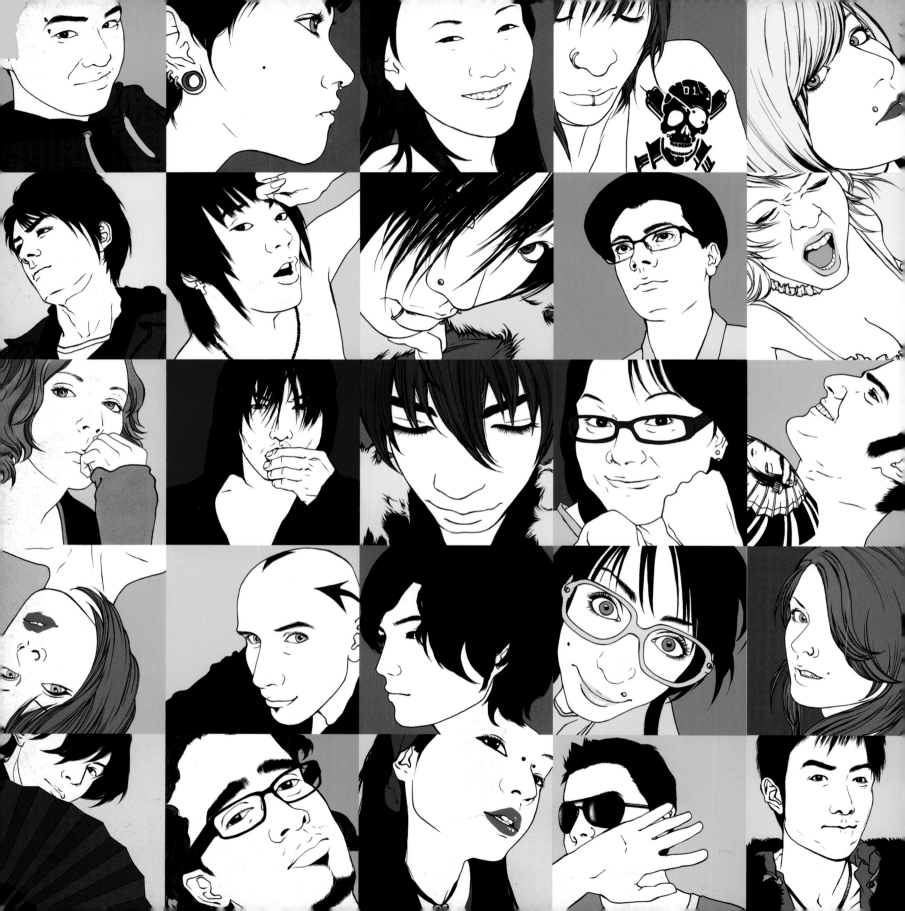

Youth Culture

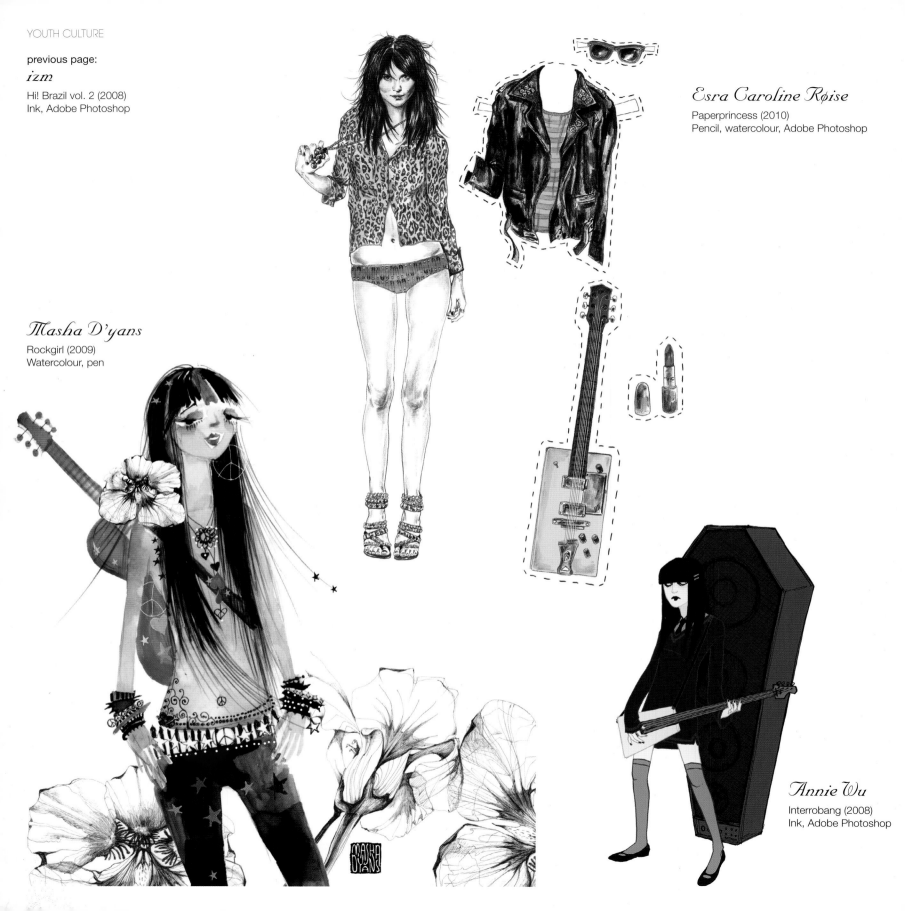

previous page:
izm
Hi! Brazil vol. 2 (2008)
Ink, Adobe Photoshop

Esra Caroline Røise
Paperprincess (2010)
Pencil, watercolour, Adobe Photoshop

Masha D'yans
Rockgirl (2009)
Watercolour, pen

Annie Wu
Interrobang (2008)
Ink, Adobe Photoshop

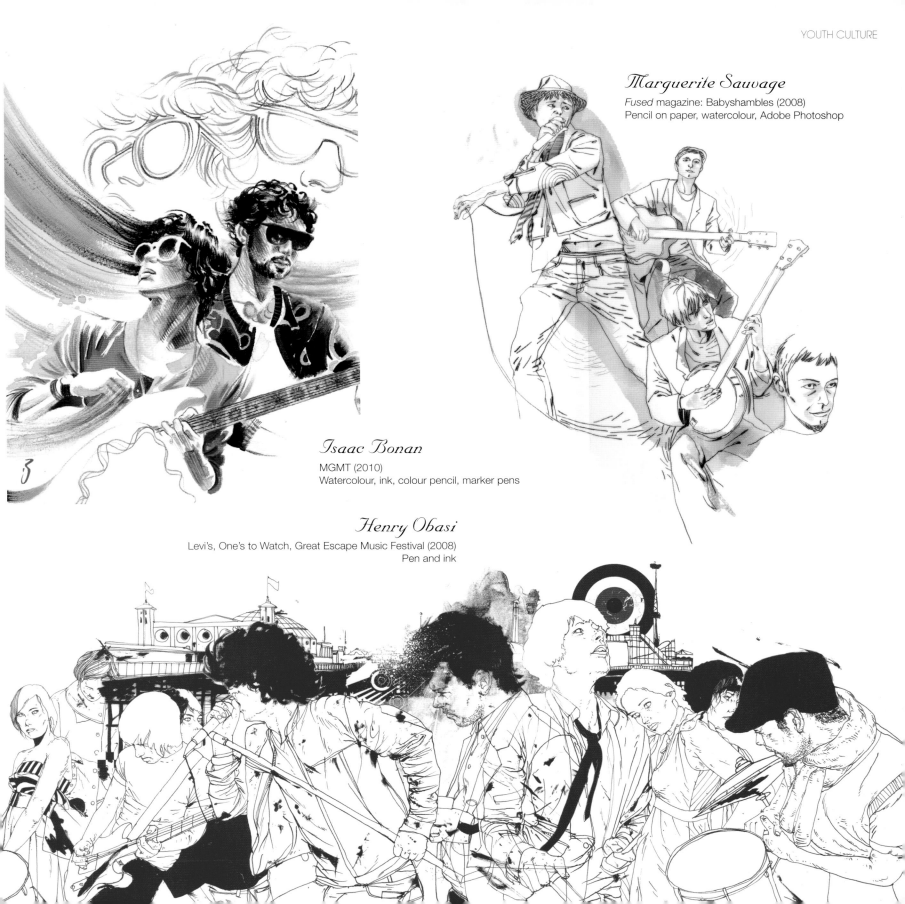

Marguerite Sauvage
Fused magazine: Babyshambles (2008)
Pencil on paper, watercolour, Adobe Photoshop

Isaac Bonan
MGMT (2010)
Watercolour, ink, colour pencil, marker pens

Henry Obasi
Levi's, One's to Watch, Great Escape Music Festival (2008)
Pen and ink

Ellen van Engelen

Eighties (2009)
Pen and ink, Adobe Photoshop

Annelie Carlström

Andreas Kleerup (2008)
Pencil, Adobe Photoshop

Satomi Ichikawa

My Favorite Music (2007)
Acrylic, gouache

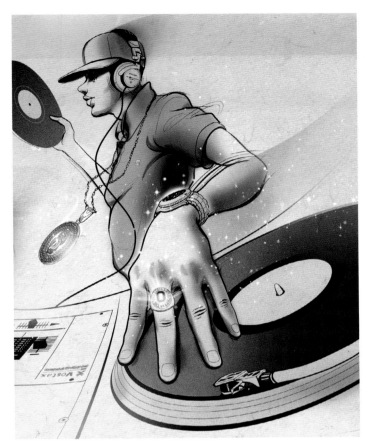

Shingo Shimizu

Ohio State University magazine: Hip Hop #1 (2008)
Adobe Illustrator, Adobe Photoshop

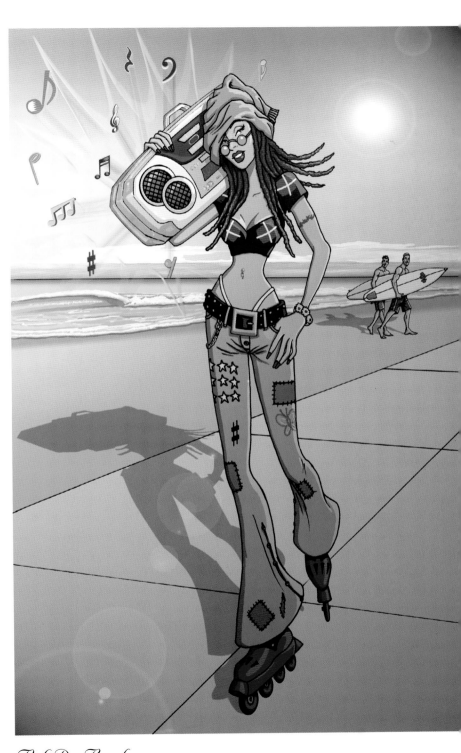

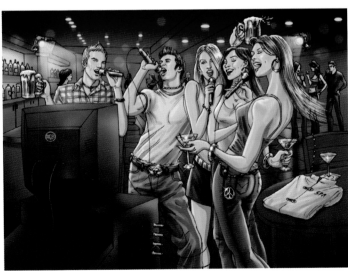

Rob De Bank

American Spa magazine: Karaoke Bar (2007)
Pen and ink, Adobe Photoshop

Rob De Bank

Rasta Skater (2001)
Pen and ink, Adobe Photoshop

121

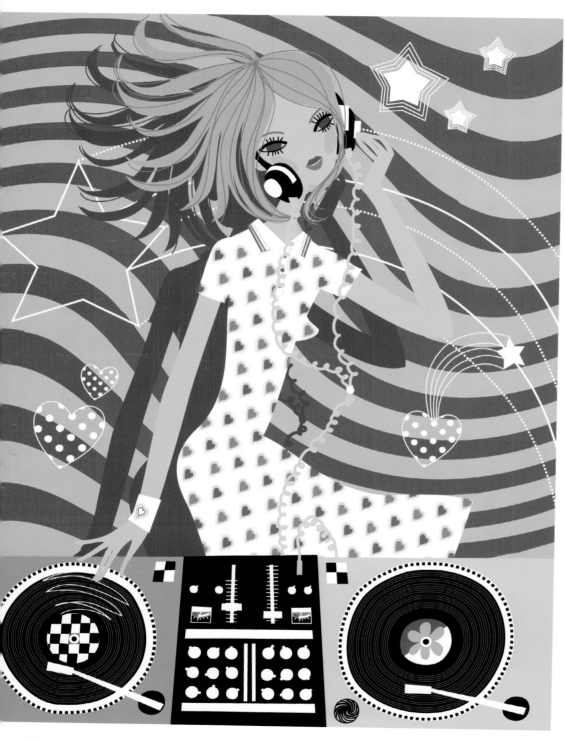

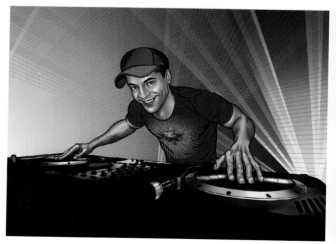

Licínio Vieira Alves Florêncio

Let'us Dance (2009)
Adobe Illustrator

Gormax

The DJ (2009)
Adobe Photoshop

Maxim Savva

Independent Media Sanoma magazines, *Cosmopolitan*: Nokia Promotion (2008)
Adobe Illustrator

Eamo Donnelly

Maxim magazine: We Love the Aughts (2009)
Pencil sketches, hand inked with brush on paper, Adobe Photoshop

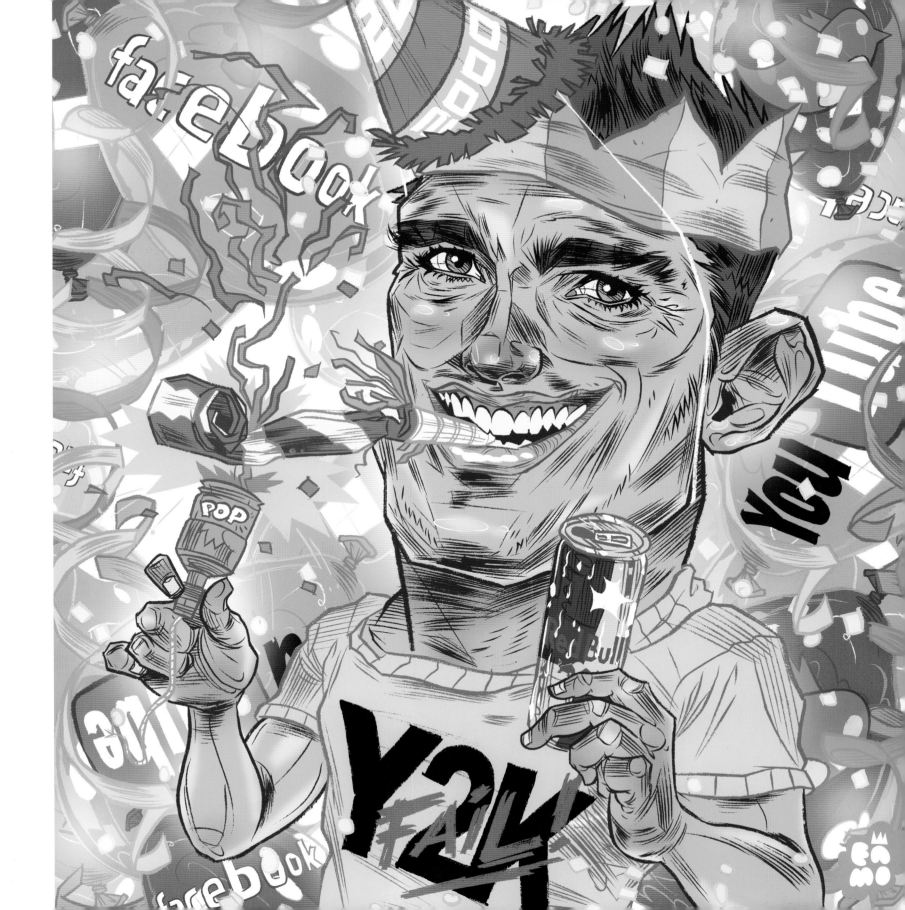

Grzegorz Domaradzki

I Love East (2008)
Adobe Illustrator

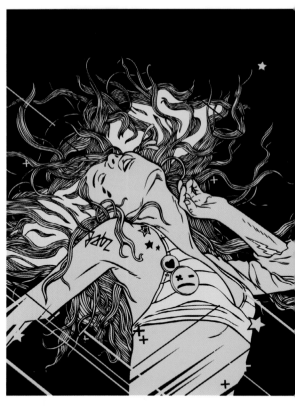

Dmitry Sergeev

Skate Punk (2008)
Adobe Photoshop

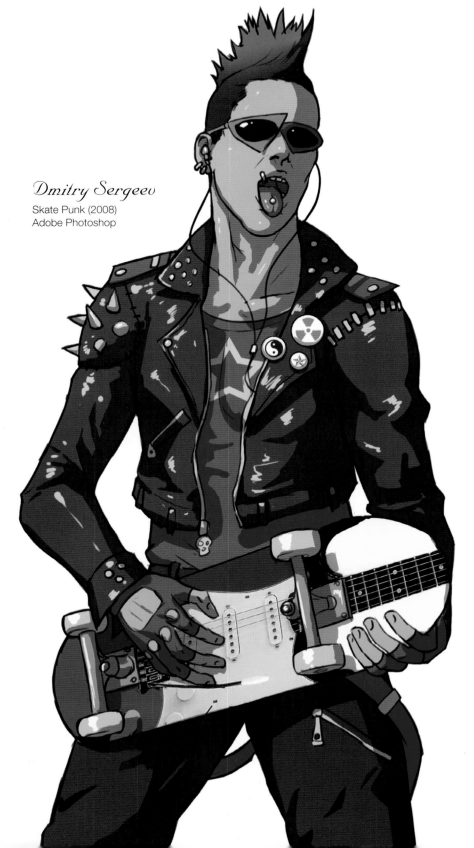

Rowan Newton

Pow (2008)
Acrylic and spray paint on canvas

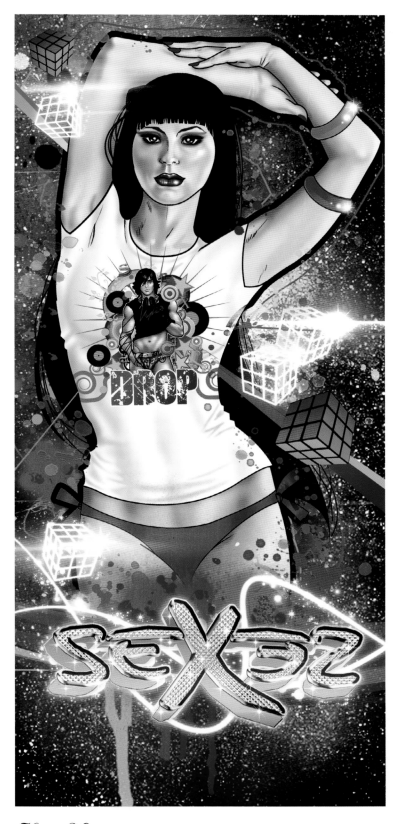

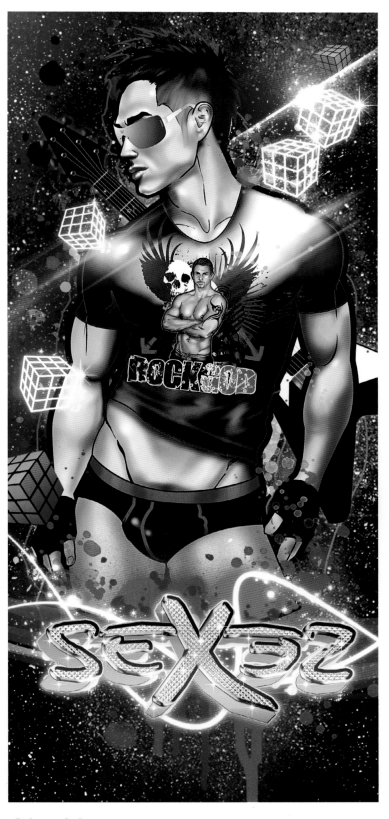

Kenji Nuñez

Sexes Drop Girl Banner (2008)
Pencil sketch, Adobe Photoshop

Kenji Nuñez

Sexes Rock Boy Banner (2008)
Pencil sketch, Adobe Photoshop

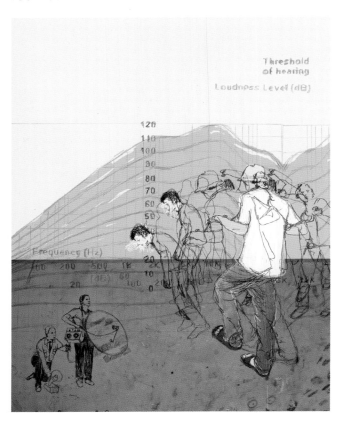

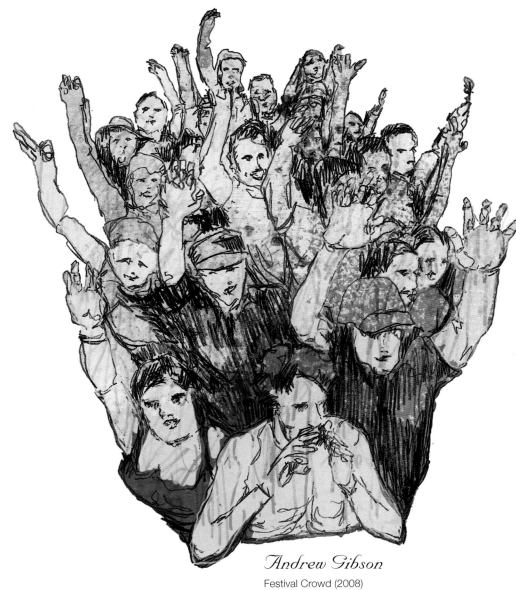

Andrew Gibson

Noise Pollution (2007)
Pencil, Adobe Photoshop

Andrew Gibson

Festival Crowd (2008)
Pencil, Adobe Photoshop

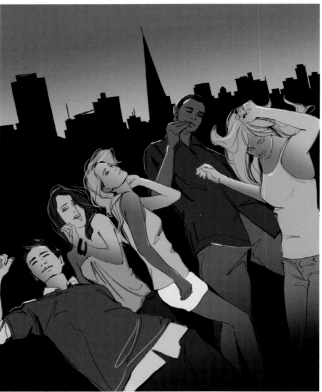

David Pfendler

Holla (2008)
Adobe Photoshop

Marguerite Sauvage
Glamour (US): Party (2008)
Pencil, Adobe Photoshop

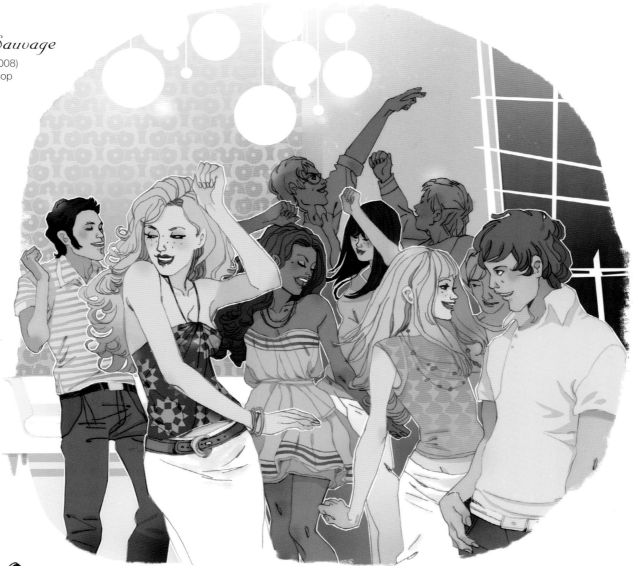

Marmushka

Jonathan (2010)
Pencil, pen, Adobe Photoshop

Finna Leibenguth
Disko (2008)
Paper, fabric, felt pen, Adobe Photoshop

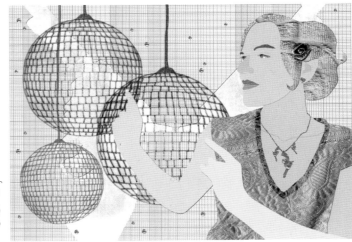

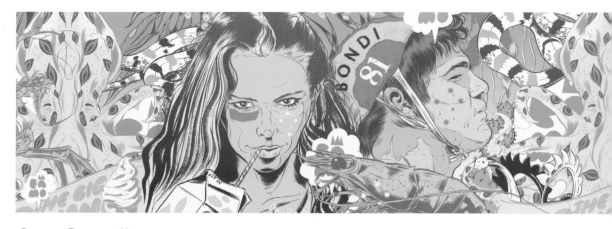

Eamo Donnelly
ESKY 1988 and Bondi 1981 (2008)
Pencil sketches, hand inked with brush on paper, Adobe Photoshop

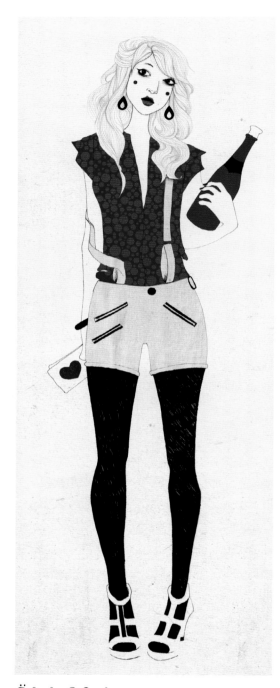

Élodie Nadreau
Happy New Year (2009)
Pencil, Adobe Photoshop

Mariya Paskovsky
Tea Party (2008)
Black ink, Adobe Illustrator

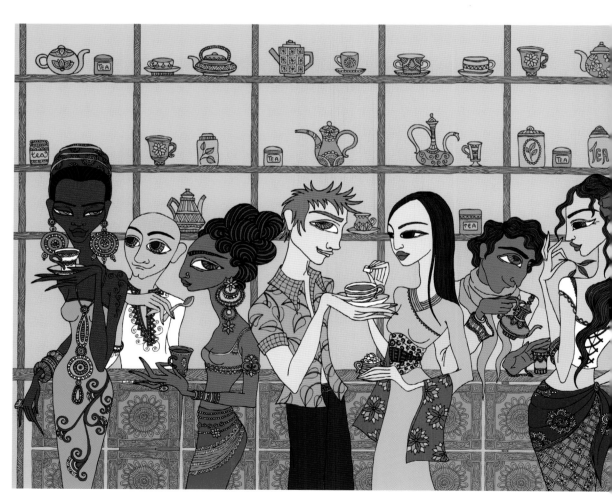

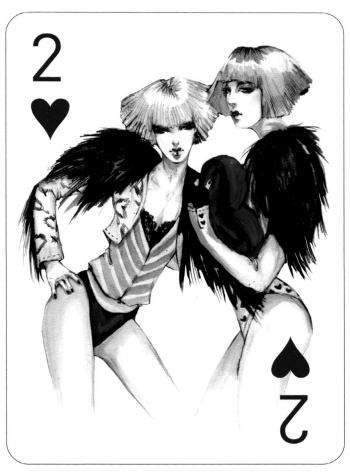

Connie Lim

Two of Hearts (2009)
Gouache, pen and ink

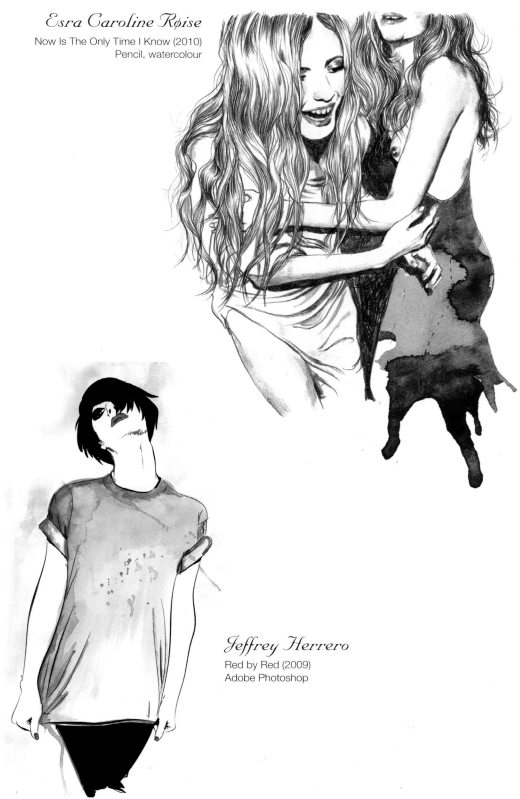

Esra Caroline Røise

Now Is The Only Time I Know (2010)
Pencil, watercolour

Jeffrey Herrero

Red by Red (2009)
Adobe Photoshop

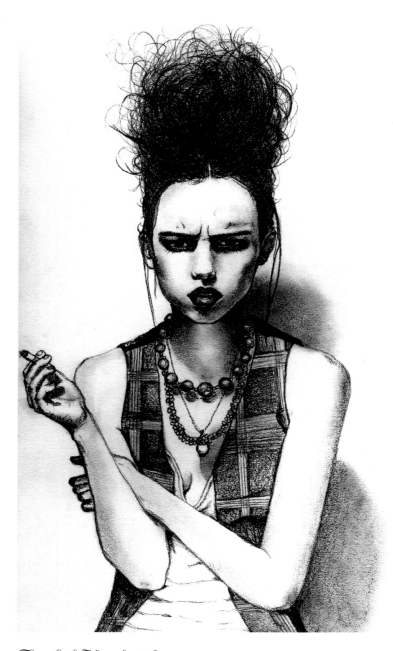

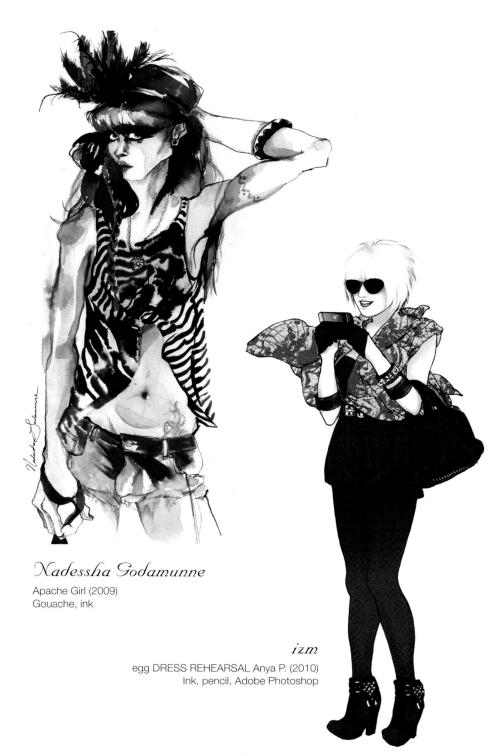

Rachel Hardwick
Untitled (2008)
Pencil

Nadessha Godamunne
Apache Girl (2009)
Gouache, ink

izm
egg DRESS REHEARSAL Anya P. (2010)
Ink, pencil, Adobe Photoshop

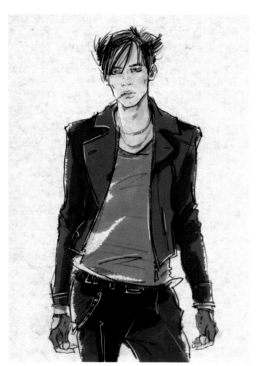

Fiona Maclean

Grunge Baby (2009)
Pencil, gouache, pastel, Adobe Illustrator

Alena Lavdovskaya

Elle (Russia): St Valentine's Special (2010)
Pencil, Adobe Photoshop

Nadeesha Godamunne

Tom & Jerry (2009)
Gouache, ink

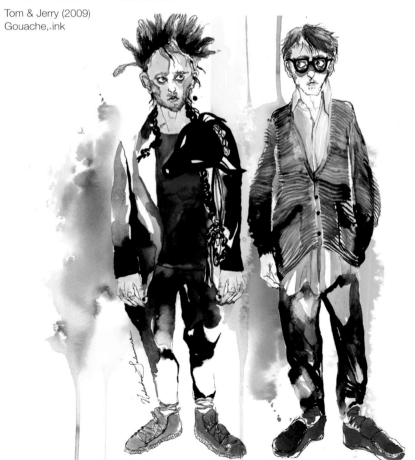

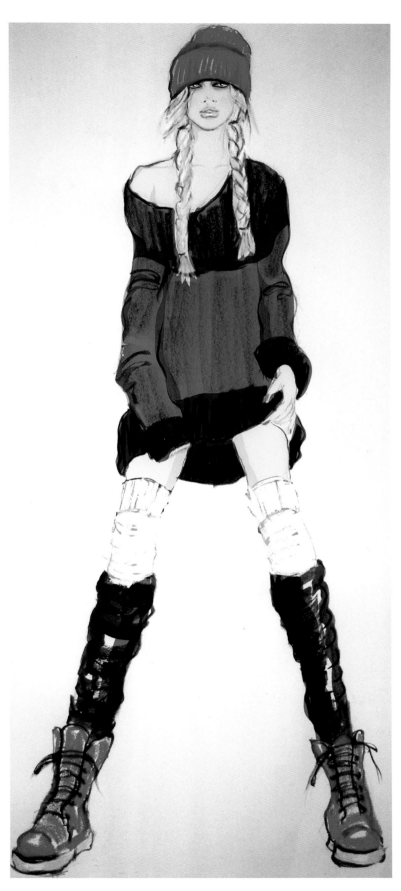

Carlos Aponte

Simon (2009)
Ink on paper

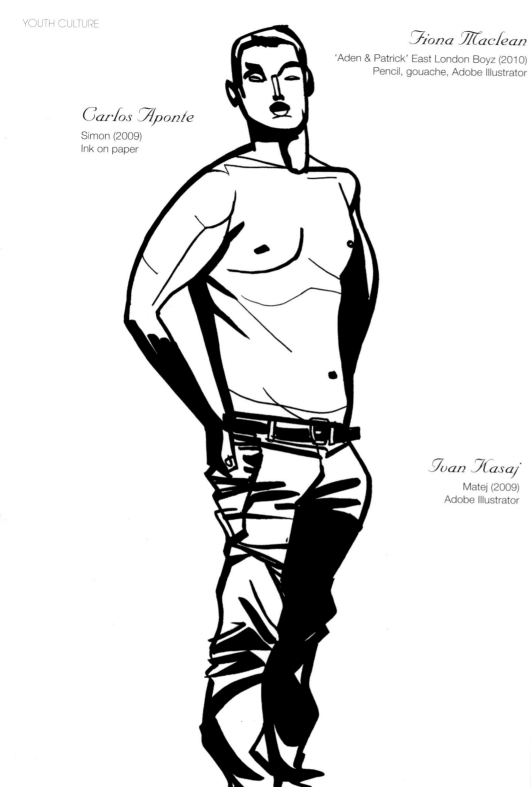

Fiona Maclean

'Aden & Patrick' East London Boyz (2010)
Pencil, gouache, Adobe Illustrator

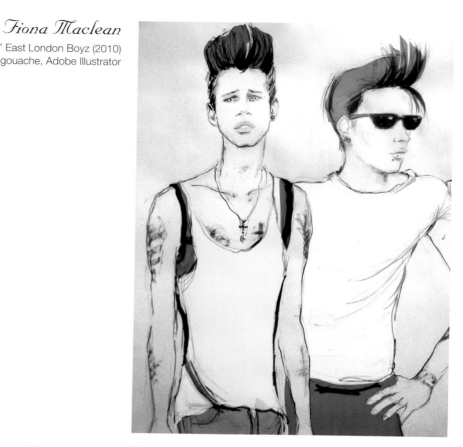

Ivan Kasaj

Matej (2009)
Adobe Illustrator

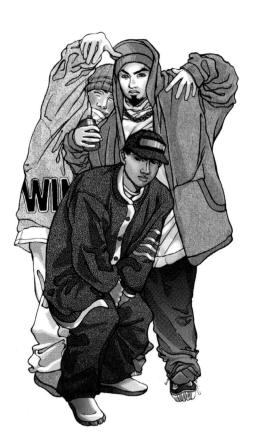

izm
WILLIAM [18] WINNER [20] & W.W.Jr. [22] (2008)
ink, pencils, Adobe Photoshop

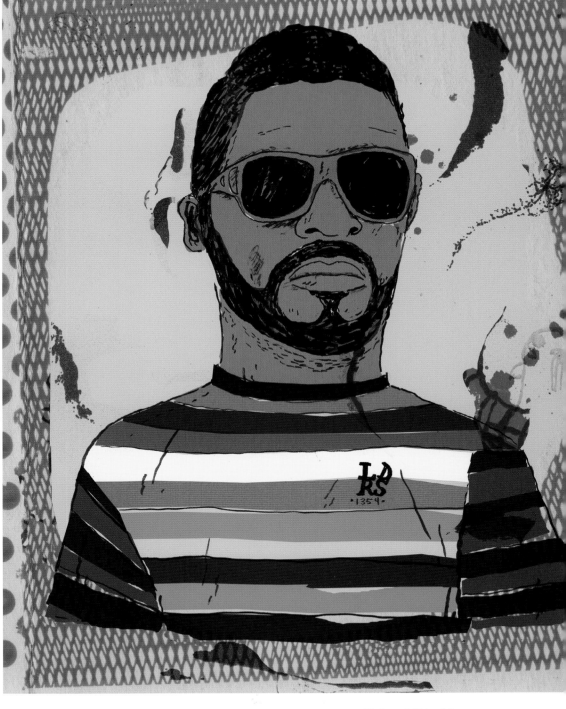

Daniel Hyun Lim
Fawn Fruits Fashion Blue Boy (2010)
Pencil, Adobe Photoshop

Mark Todd
Ldrs (2007)
Ink, Adobe Photoshop

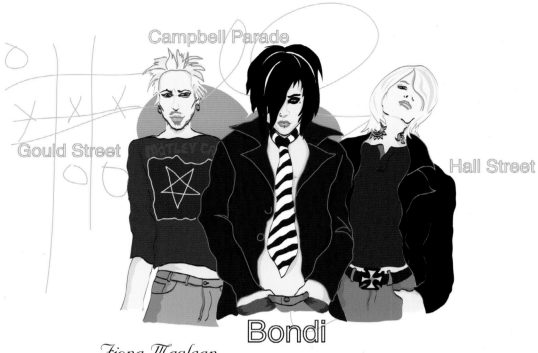

Fiona Maclean

Bondi Vibes (2008)
Adobe Photoshop, Adobe Illustrator

Annelie Carlström

Musse Hasselvall (2008)
Pencil, Adobe Photoshop

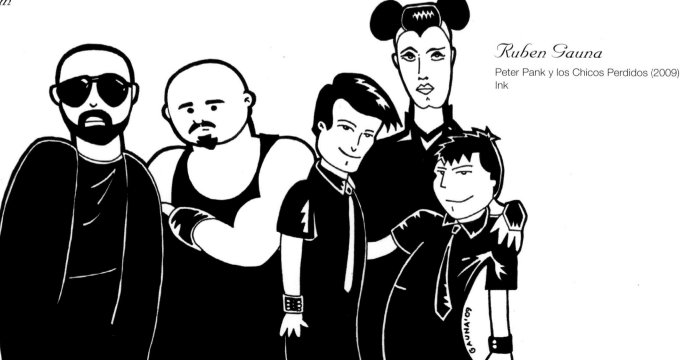

Ruben Gauna

Peter Pank y los Chicos Perdidos (2009)
Ink

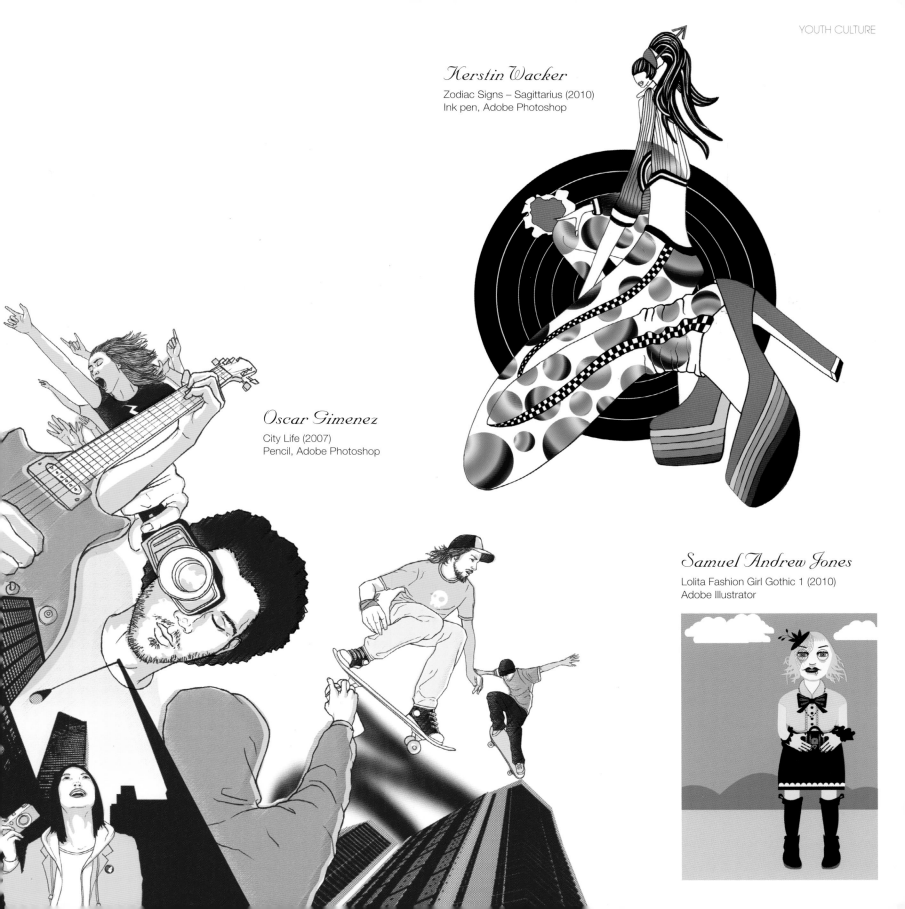

Kerstin Wacker

Zodiac Signs – Sagittarius (2010)
Ink pen, Adobe Photoshop

Oscar Gimenez

City Life (2007)
Pencil, Adobe Photoshop

Samuel Andrew Jones

Lolita Fashion Girl Gothic 1 (2010)
Adobe Illustrator

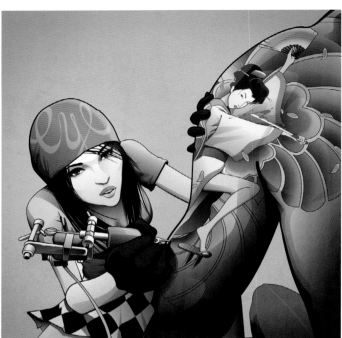

Shingo Shimizu

New Angeles magazine: Tat Master (2008)
Adobe Illustrator, Adobe Photoshop

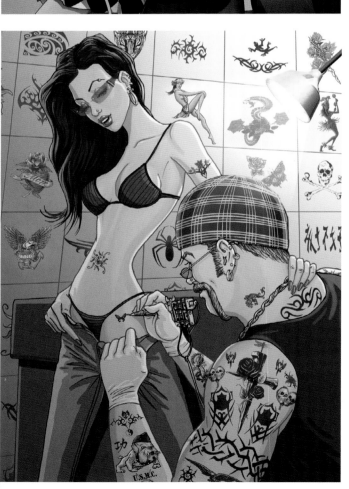

Rob De Bank

Tattooed Love Child (2002)
Pen and ink, Adobe Photoshop

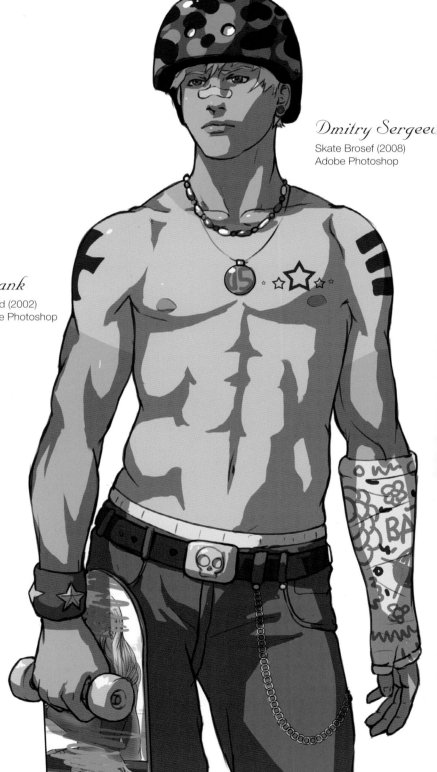

Dmitry Sergeev

Skate Brosef (2008)
Adobe Photoshop

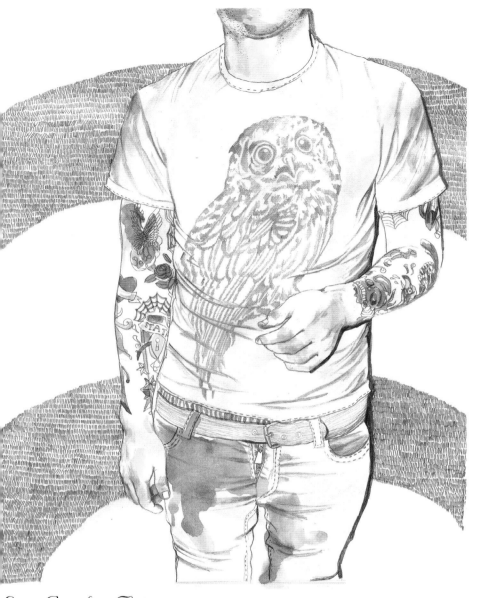

Esra Caroline Røise
Swinger (2009)
Pencil, watercolour

Adriana Munoz
Chic Geek Application (2008)
Pencil, watercolour, collage, fabric, photography, Adobe Photoshop

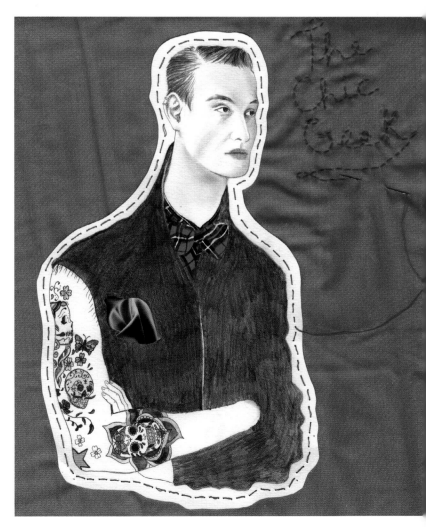

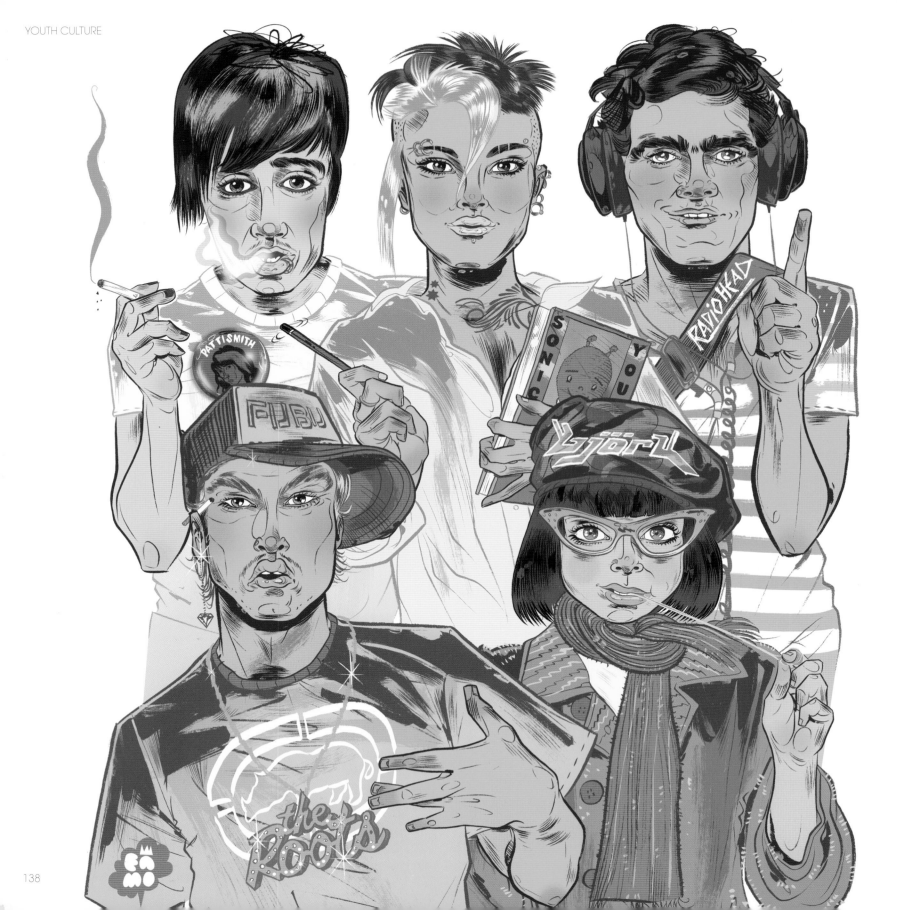

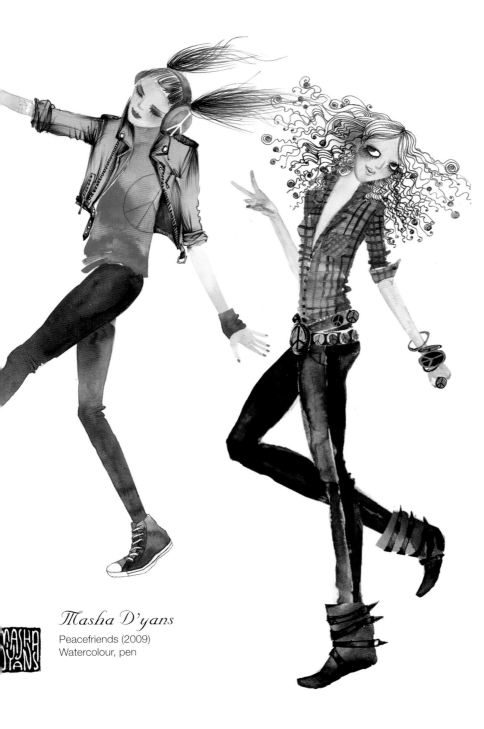

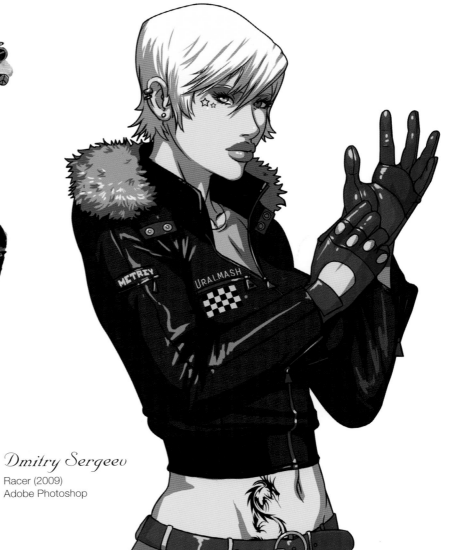

Masha D'yans
Peacefriends (2009)
Watercolour, pen

Dmitry Sergeev
Racer (2009)
Adobe Photoshop

...amo Donnelly
...dar magazine: Groupies (2008)
...ncil sketches, hand inked with brush on paper, Adobe Photoshop

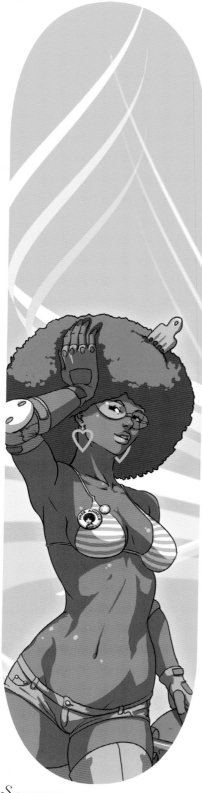
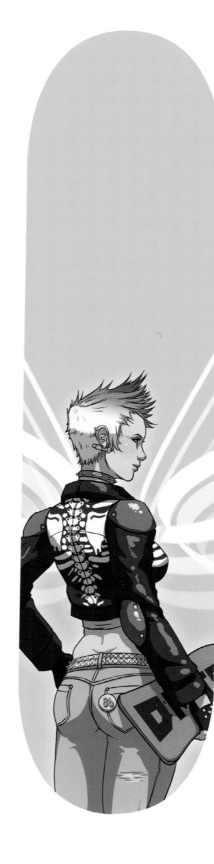
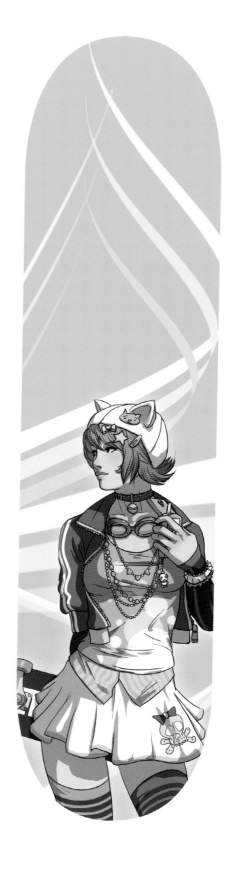

Dmitry Sergeev
Skate Girls (2007)
Adobe Photoshop

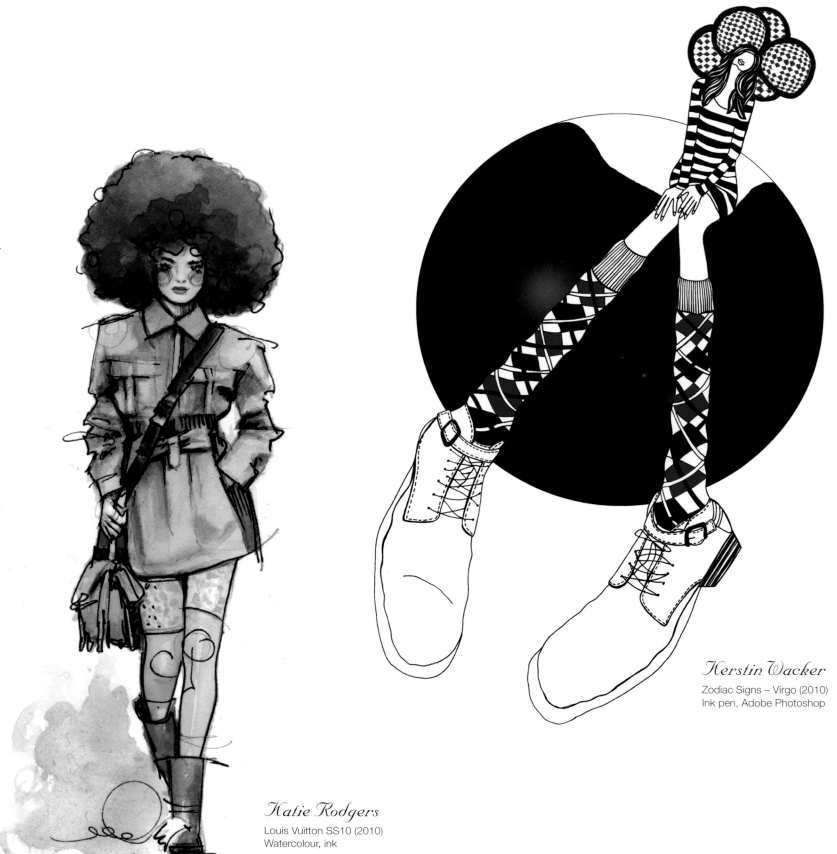

Katie Rodgers
Louis Vuitton SS10 (2010)
Watercolour, ink

Kerstin Wacker
Zodiac Signs – Virgo (2010)
Ink pen, Adobe Photoshop

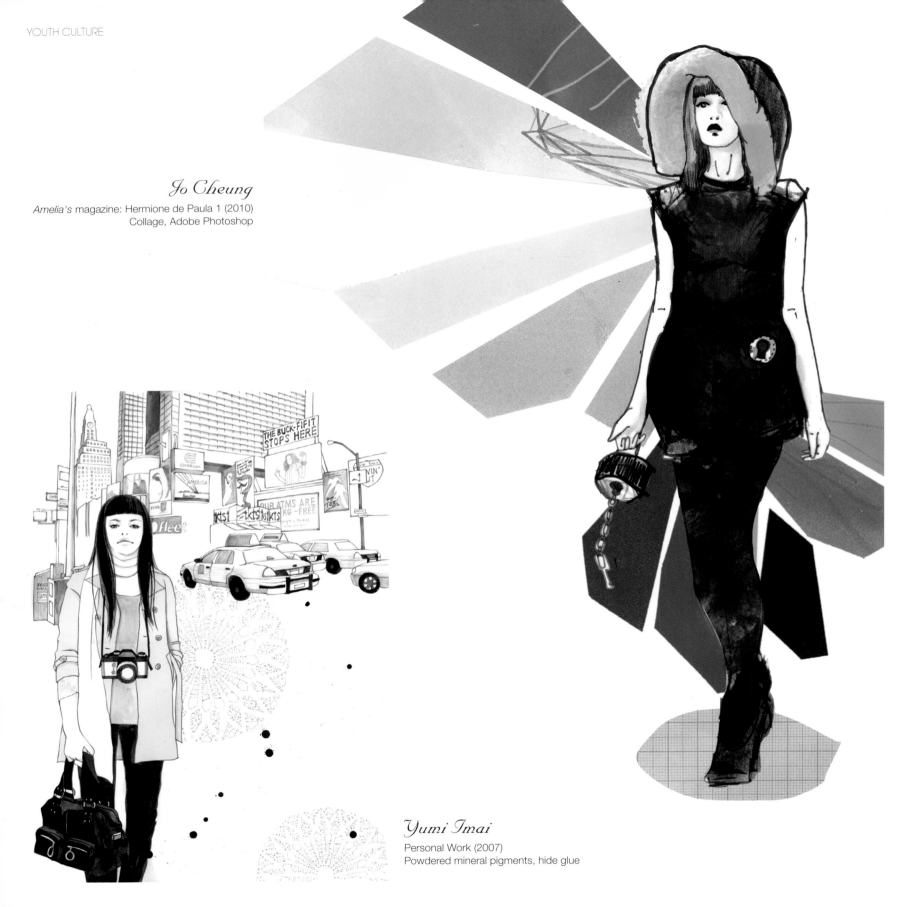

Jo Cheung
Amelia's magazine: Hermione de Paula 1 (2010)
Collage, Adobe Photoshop

Yumi Imai
Personal Work (2007)
Powdered mineral pigments, hide glue

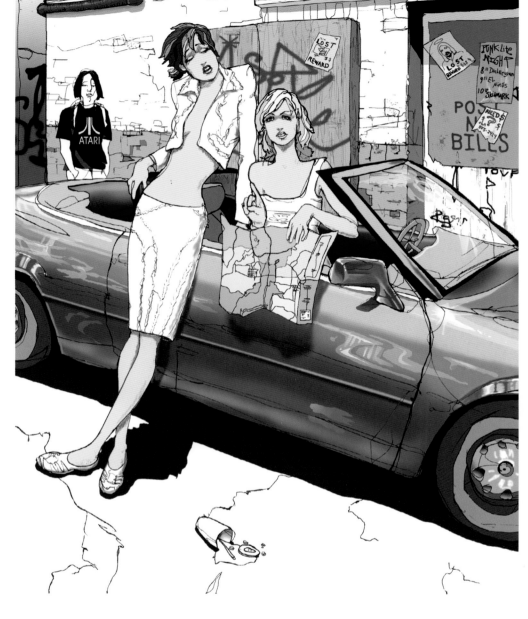

Julia Durgee
Clear magazine: Lost (2002)
Pen and ink, watercolour, Adobe Photoshop

Nani Puspasari
Miss.Pitta (2010)
Felt-tip pen

Katie Rodgers

Chris Benz (2010)
Watercolour, ink

Amy Booton

Casual Crimson (2009)
Watercolour, Indian ink, pen

SLEEVE MEASUREMENTS
Bend the arm slightly and measure from the shoulder to the elbow and then to the wrist. Take both measurements.

Upper Arm
Measure round the thickest part of the upper arm.

Wrist
Measure round the wrist just over the wrist bone.
The chart at the end of the chapter will enable y

HOW TO USE THE PATTERN
It is a wise precaution to check the pattern before needs to be shortened then money can be saved by bu needs lengthening you will know how much extra material
Pin the pattern together on the fitting lines and tr the pattern should be fitted to the one side of the b left-handed. One side of the body is usually the is the side which must be checked. Most commercial patter where to lengthen or shorten the patterns to make any at these points. If your pattern does not have these general rules should be followed.
Bodice Lengthen or shorten halfway between the under width midway of shoulder to waistline, parallel
Skirt Lengthen or shorten between the hipleve to the straight grain.
Sleeve Check the position of the elbow da It s of the elbow. Make the alterations above or be Alter the width through the centr straight grain
To lengthen each part of the pattern, cut thro strip of paper, keeping the width of the insertion ac
To shorten a pattern fold a tuck in the pattern piece
Paper patterns are cut to an average measurement any extra fat or protruding bones that you may have. together and to fit it to your figure before laying the pat tions which may be necessary can then be made. The fitting lines and all b ines must be

53

Maria Danalakis

Green Fashion (2003)
Collage on paper

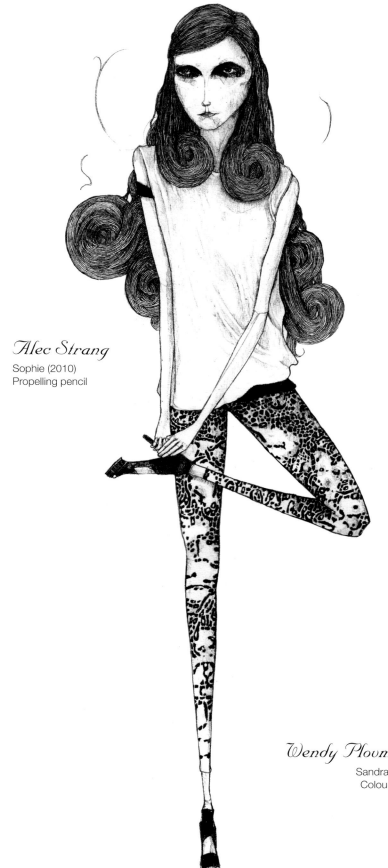

Jarno Kettunen

Levi's Backpocket Project (2007)
Gesso, lacquer paint and lead pencil
on Levi's backpocket

Alec Strang

Sophie (2010)
Propelling pencil

Wendy Plovmand

Sandra (2004)
Colour pencil

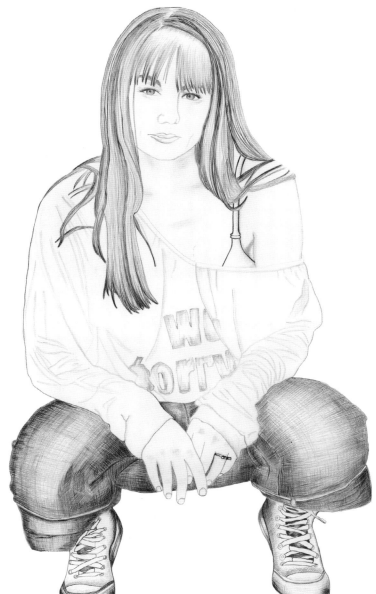

145

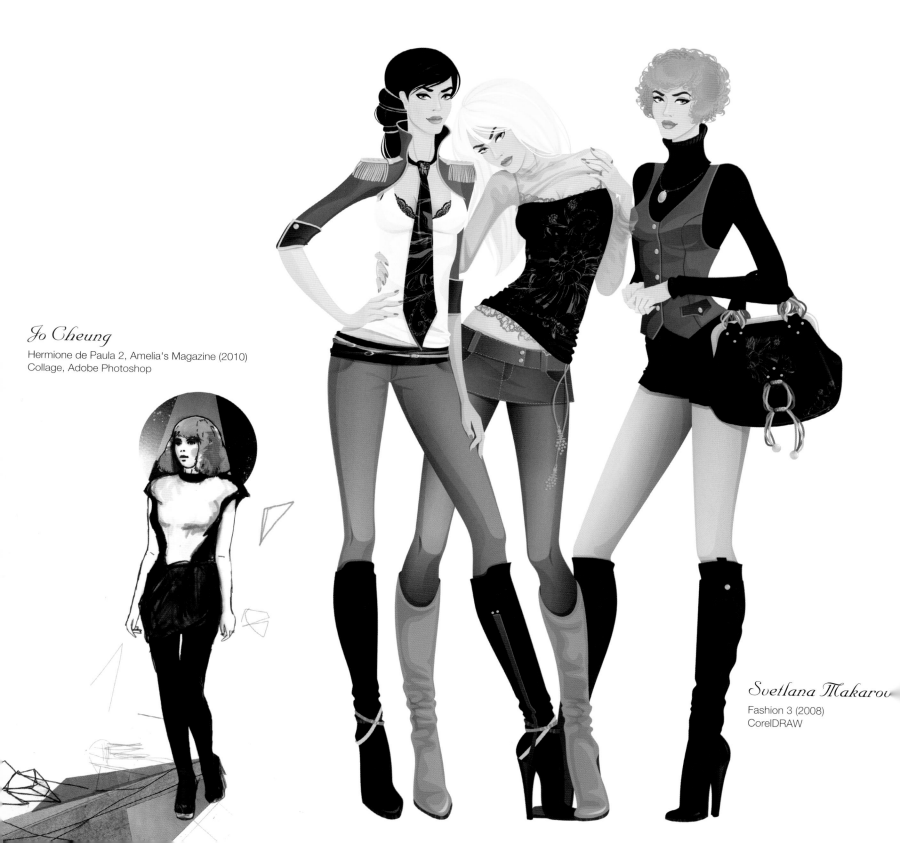

Jo Cheung

Hermione de Paula 2, Amelia's Magazine (2010)
Collage, Adobe Photoshop

Svetlana Makarov

Fashion 3 (2008)
CorelDRAW

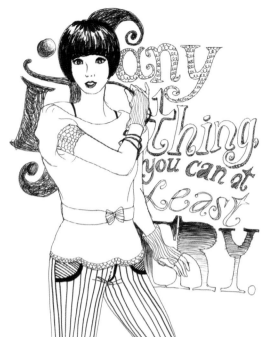

Wendy Ding

If Anything You Can At Least Try (2009)
Pen

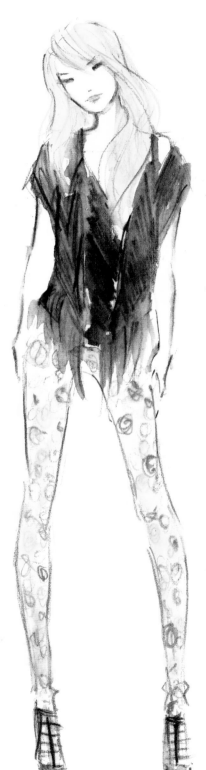

Danielle Meder

Laura (2010)
Watercolour, pencil

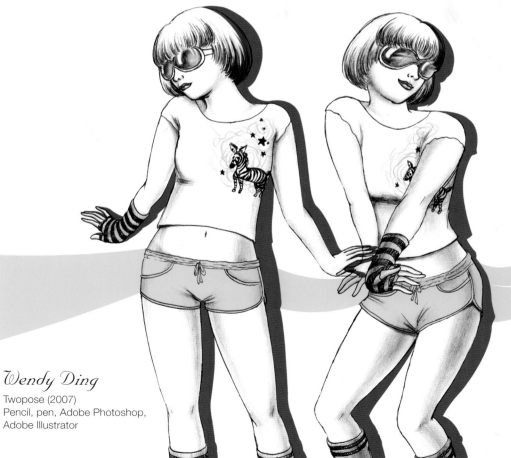

Wendy Ding

Twopose (2007)
Pencil, pen, Adobe Photoshop,
Adobe Illustrator

147

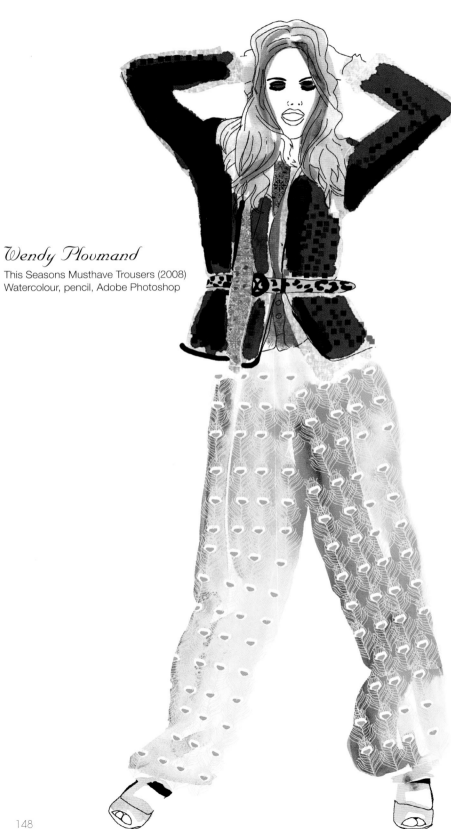

Wendy Ploumand

This Seasons Musthave Trousers (2008)
Watercolour, pencil, Adobe Photoshop

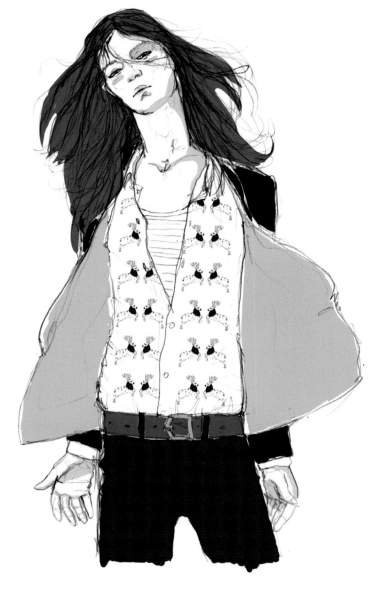

Loreto Binvignat Streeter

Ooh Deer! (2010)
Adobe Photoshop, Adobe Illustrator

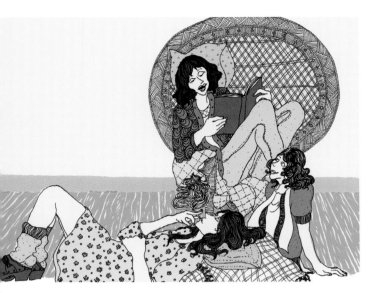

Ellen van Engelen

Reading (2009)
pen and ink, Adobe Photoshop

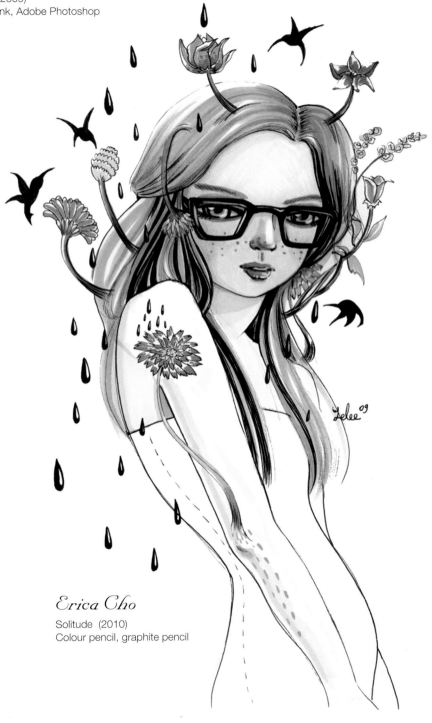

Erica Cho

Solitude (2010)
Colour pencil, graphite pencil

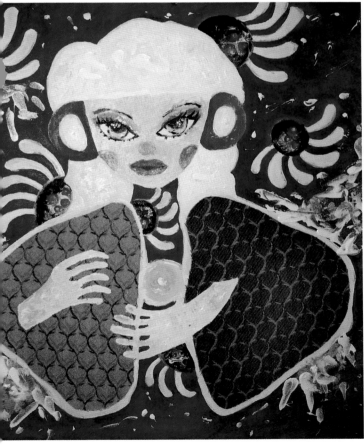

Nani Puspasari

Miss Godeliva (2008)
Acrylic and stitched fabric on canvas

149

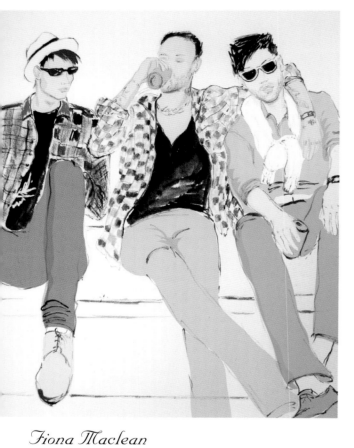

Fiona Maclean

Bondi Boyz (2010)
Pencil, gouache, pastel, Adobe Illustrator

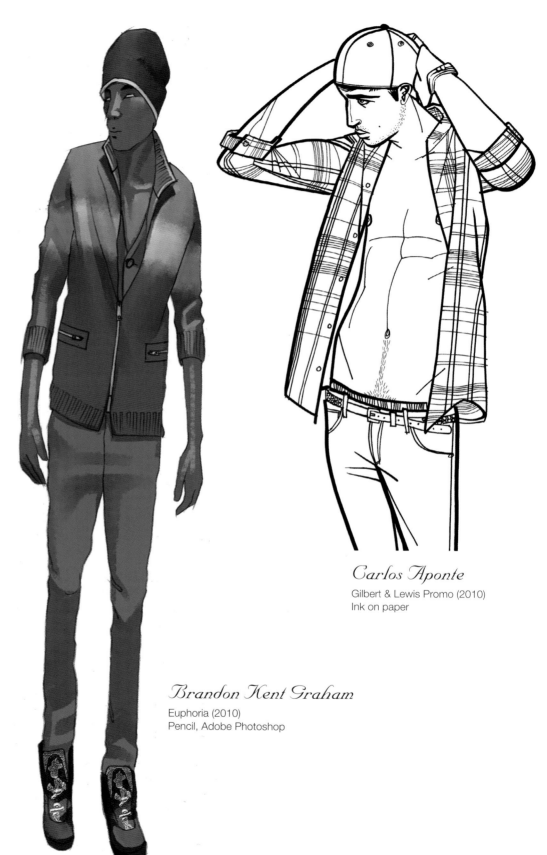

Carlos Aponte

Gilbert & Lewis Promo (2010)
Ink on paper

Brandon Kent Graham

Euphoria (2010)
Pencil, Adobe Photoshop

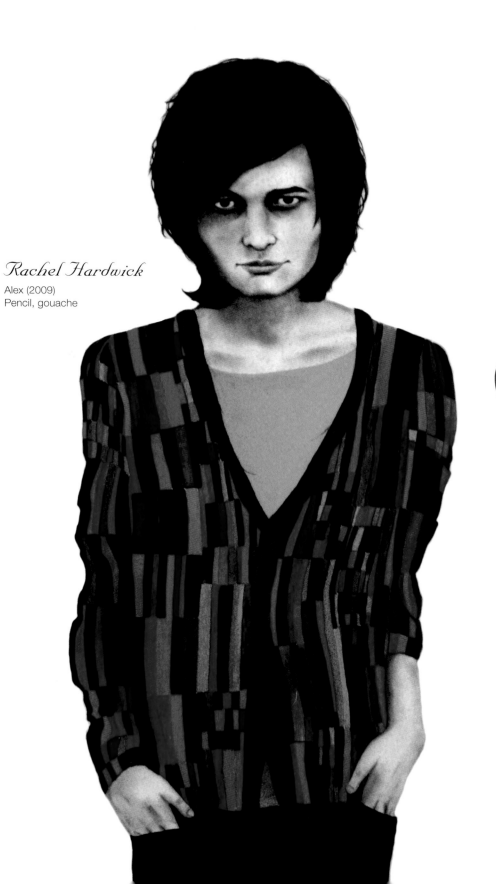

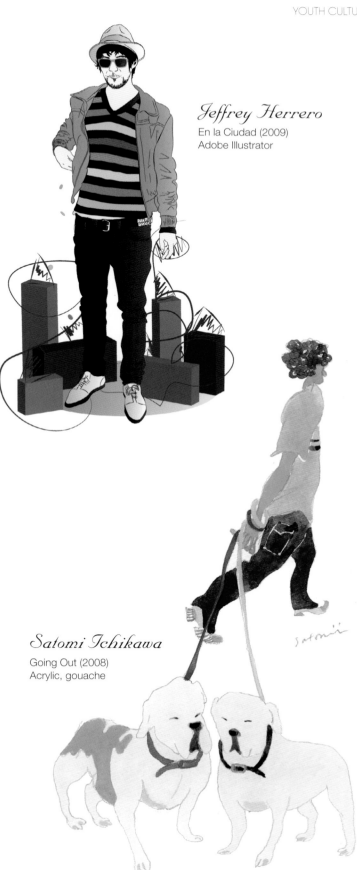

Rachel Hardwick

Alex (2009)
Pencil, gouache

Jeffrey Herrero

En la Ciudad (2009)
Adobe Illustrator

Satomi Ichikawa

Going Out (2008)
Acrylic, gouache

Grzegorz Domaradzki

Gabz (2007)
Acrylic and oil on canvas

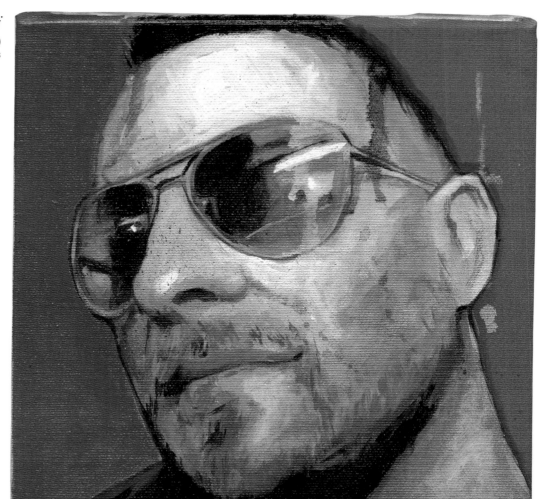

Richard James

Jon Kortajarena (2010)
Adobe Flash

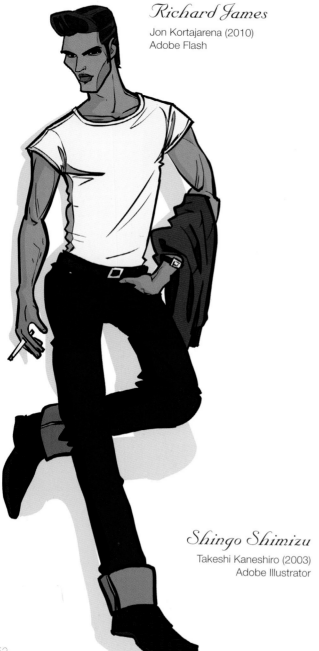

Shingo Shimizu

Takeshi Kaneshiro (2003)
Adobe Illustrator

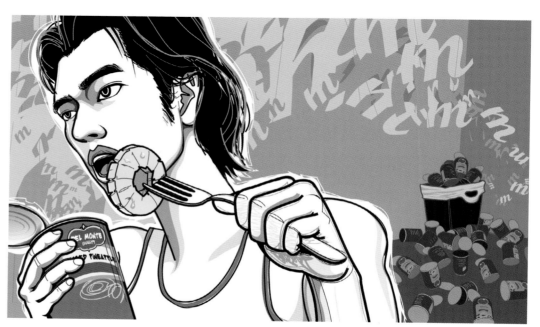

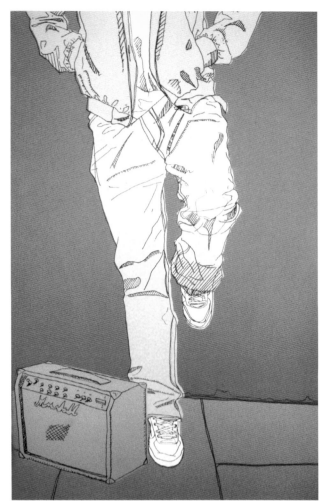

Rowan Newton

Best Foot Forward (2005)
Acrylic and spray paint on canvas

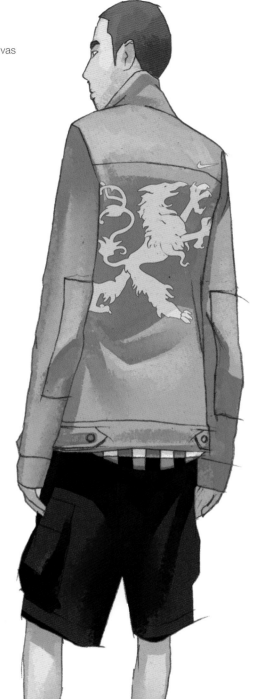

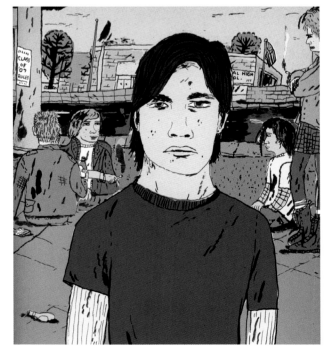

Mark Todd

High School Teen (2008)
Ink, Adobe Photoshop

Brandon Kent Graham

Shanghi (2010)
Pencil, Adobe Photoshop

153

Jarno Kettunen

Levi's Backpocket Project (2007)
Gesso, gouache, lacquer paint and lead pencil on Levi's backpocket

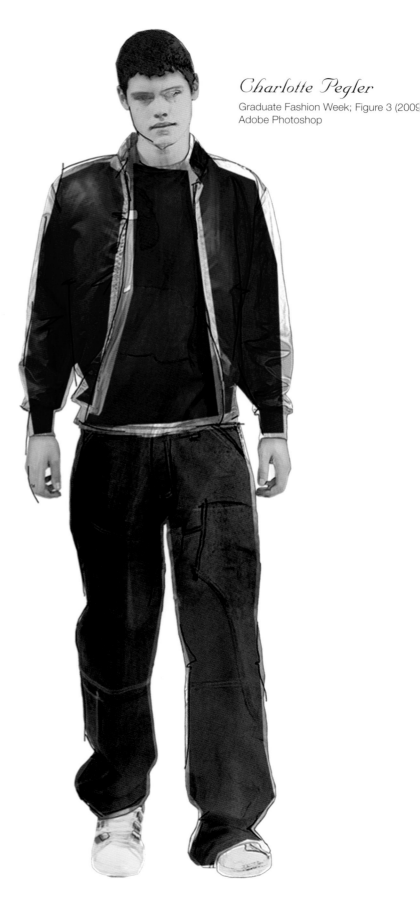

Charlotte Pegler

Graduate Fashion Week; Figure 3 (2009)
Adobe Photoshop

Grzegorz Domaradzki

KXX (2007)
Acrylic and oil on canvas

Fiona Maclean

Jed (2010)
Pencil, gouache, Adobe Illustrator

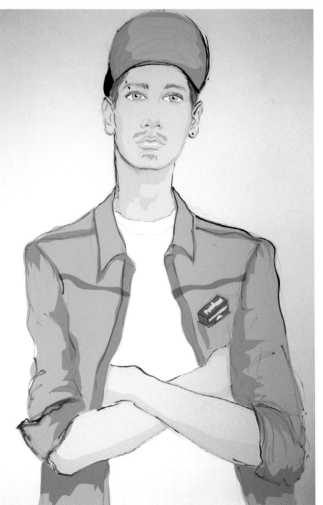

Hormazd Geve Narielwalla

Dead Man's Patterns: Paper Catwalk (2008)
Adobe Illustrator, Adobe Photoshop

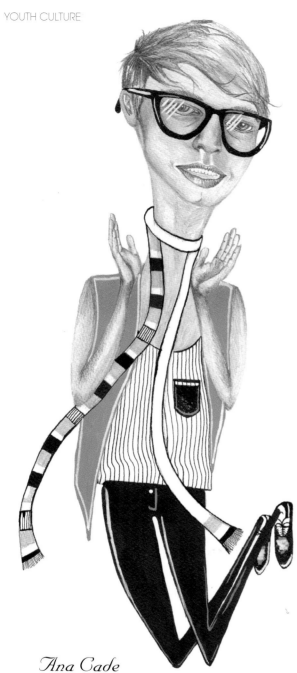

Ana Cade

Geek Sheek (2010)
Pencil, ink

Hormazd Geve Narielwalla

Midnight Shopping (2009)
Adobe Illustrator, Adobe Photoshop

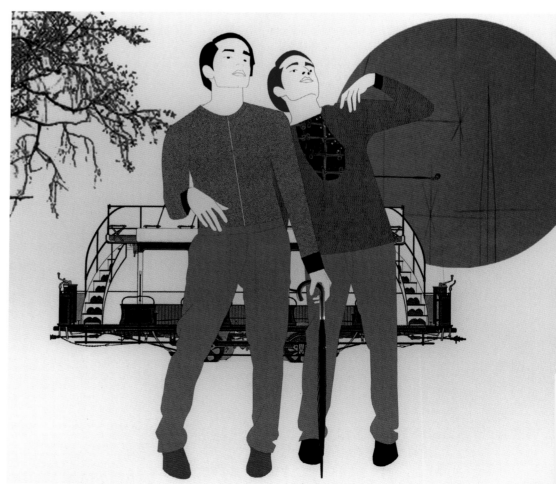

David Pfendler
Cred (2009)
Adobe Photoshop

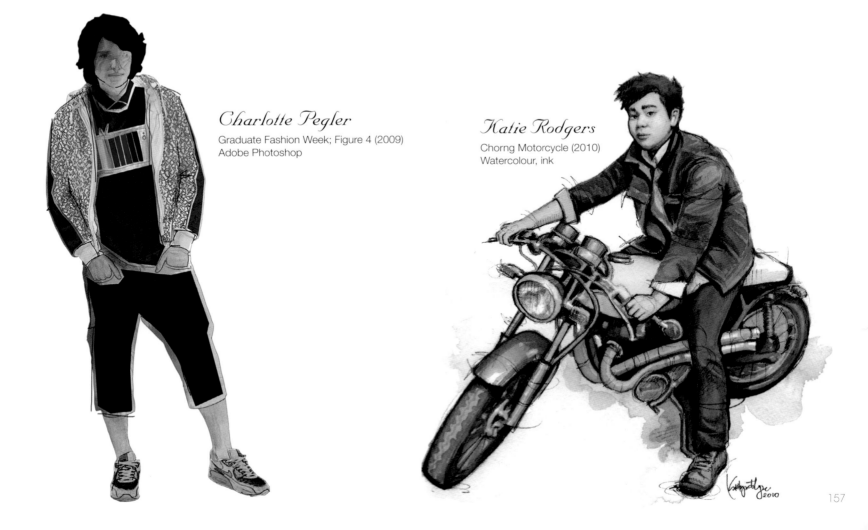

Charlotte Pegler
Graduate Fashion Week; Figure 4 (2009)
Adobe Photoshop

Katie Rodgers
Chorng Motorcycle (2010)
Watercolour, ink

157

Sandra Suy

Max (2008)
Corel Painter, Adobe Photoshop

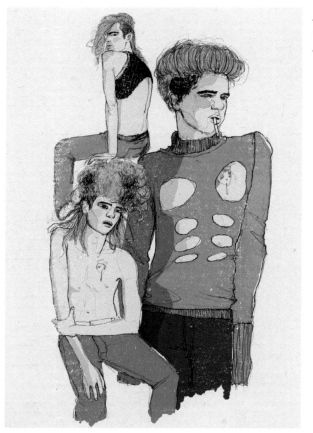

Loreto Binvignat Streeter

Boys, Boys, Boys (2010)
Adobe Photoshop

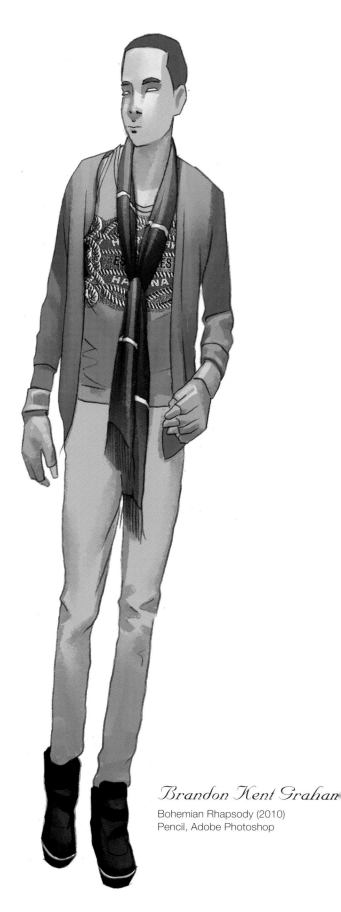

Brandon Kent Graham

Bohemian Rhapsody (2010)
Pencil, Adobe Photoshop

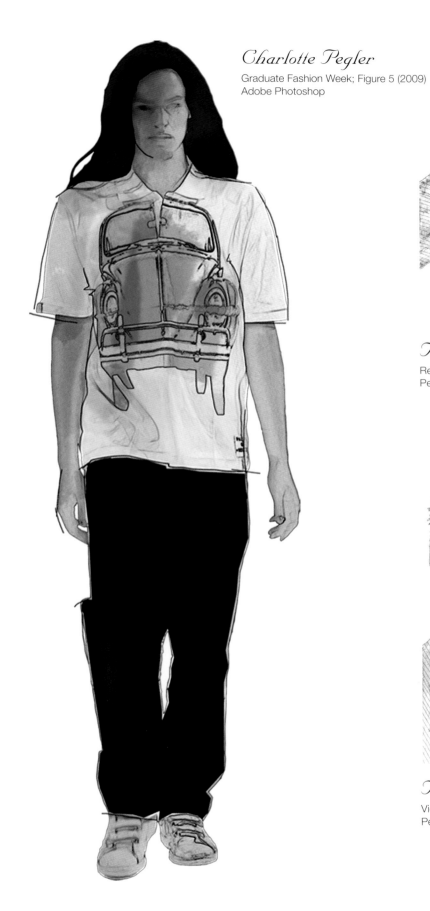

Charlotte Pegler

Graduate Fashion Week; Figure 5 (2009)
Adobe Photoshop

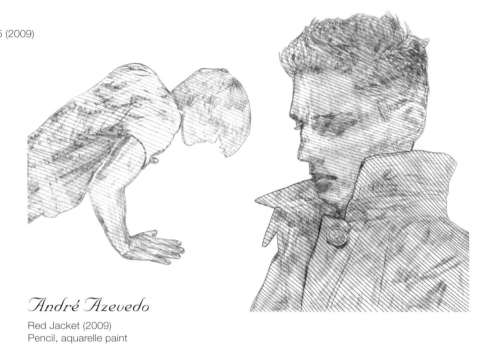

André Azevedo

Red Jacket (2009)
Pencil, aquarelle paint

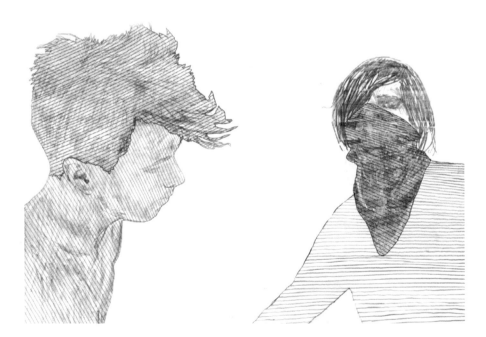

André Azevedo

Violent Playground 3 – OnSpeed (2009)
Pencil, pen

159

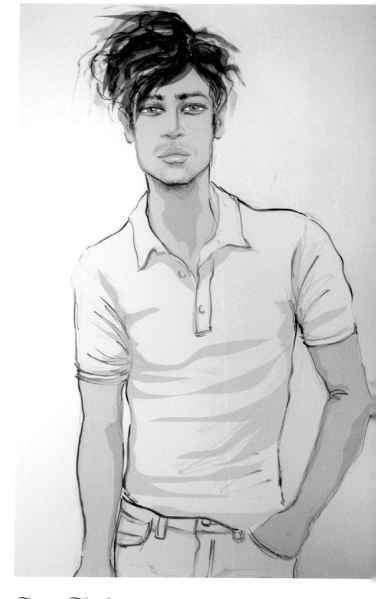

Fiona Maclean

Bailey in Pink Polo (2010)
Pencil, gouache, Adobe Illustrator

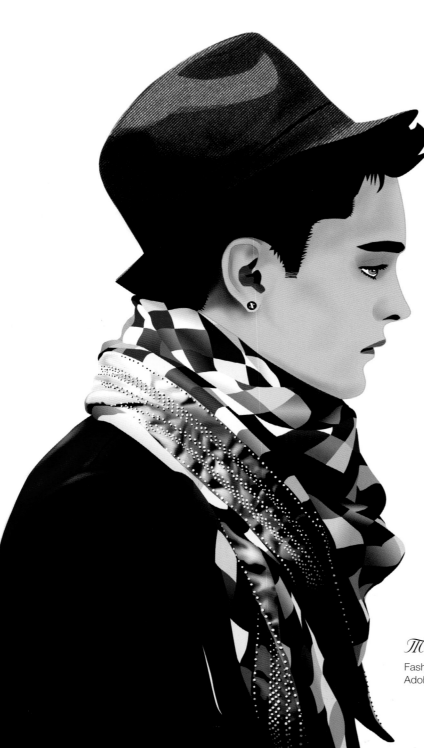

Meikei Tang

Fashion Icon (2008)
Adobe Photoshop

Monica Velasquez

Gene (2005)
Adobe Photoshop, Adobe Illustrator

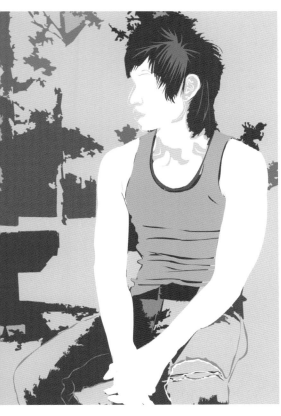

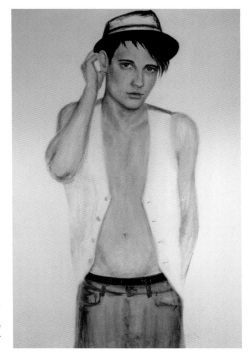

Fiona Maclean

London Dude (2010)
Pencil, gouache, Adobe Illustrator

Meikei Tang

Osaka (2007)
Adobe Photoshop

Oscar Gimenez

Spring in the City (2008)
Pencil, Adobe Photoshop

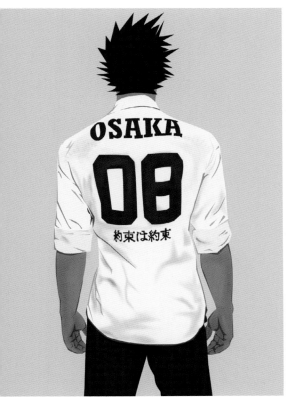

161

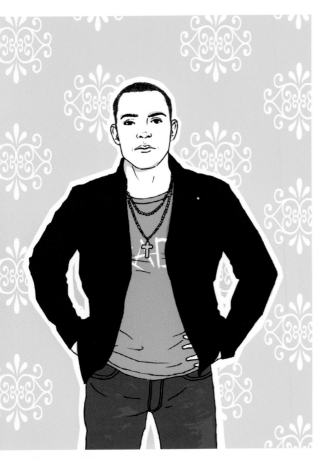

Oscar Gimenez

Rad Boy (2009)
Ink, Adobe Photoshop

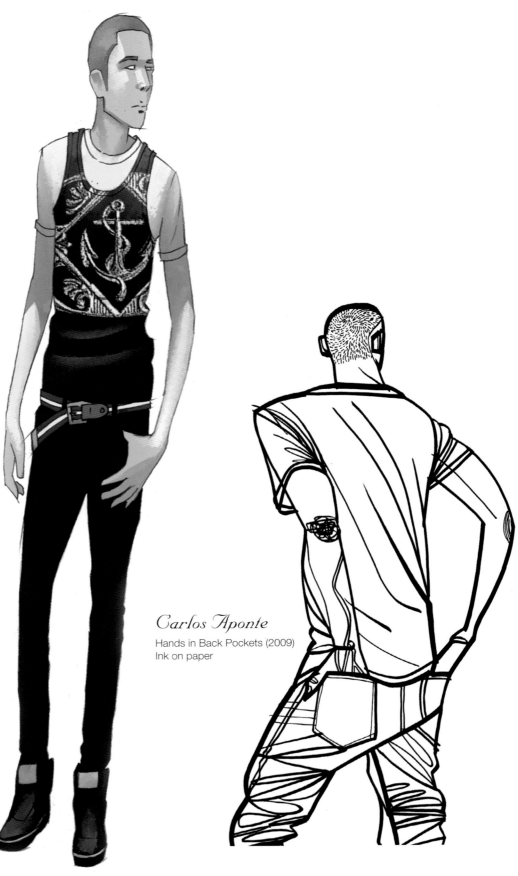

Brandon Kent Graham

Golden Anchor (2010)
Pencil, Adobe Photoshop

Carlos Aponte

Hands in Back Pockets (2009)
Ink on paper

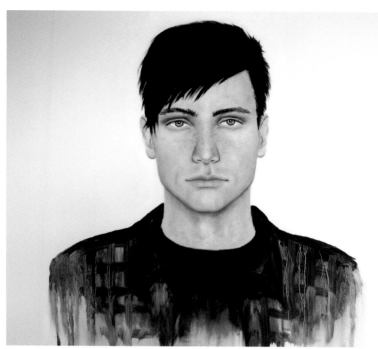

Fiona Maclean

Johnnie (2010)
Oil on canvas

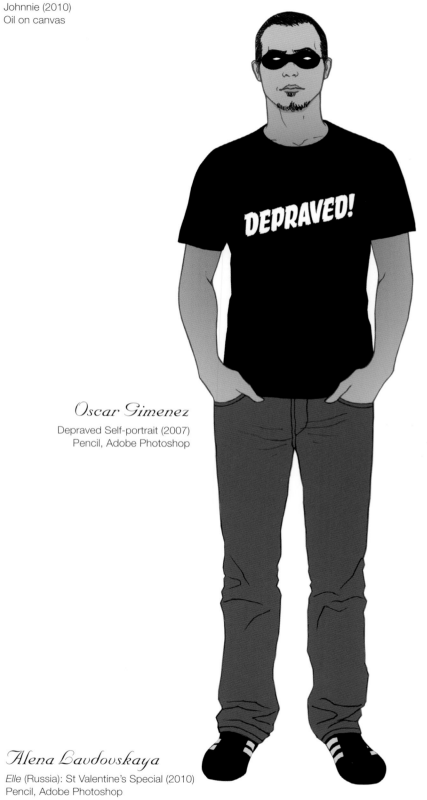

Oscar Gimenez

Depraved Self-portrait (2007)
Pencil, Adobe Photoshop

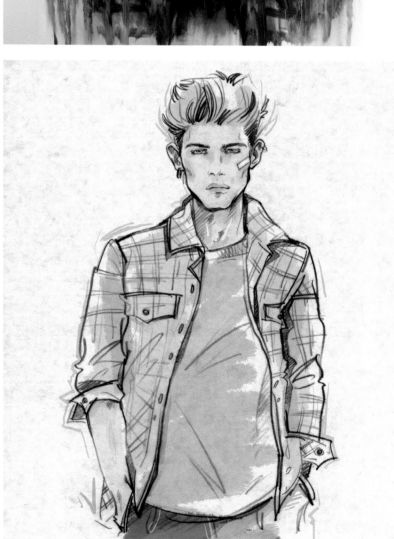

Alena Lavdovskaya

Elle (Russia): St Valentine's Special (2010)
Pencil, Adobe Photoshop

Christopher 'Wing' King
Teenage Kicks (2010)
Pen and ink, Adobe Illustrator

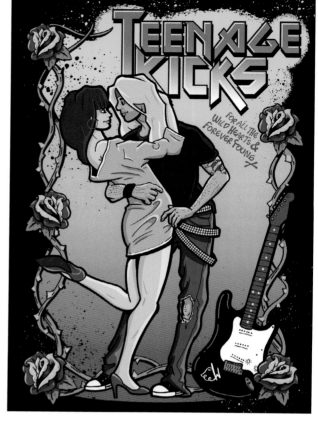

Ellen van Engelen
Sex at Work (2010)
Pen and ink, Adobe Photoshop

Jessica Woodhouse
Hansel and Gretel (2009)
Pen, Adobe Photoshop

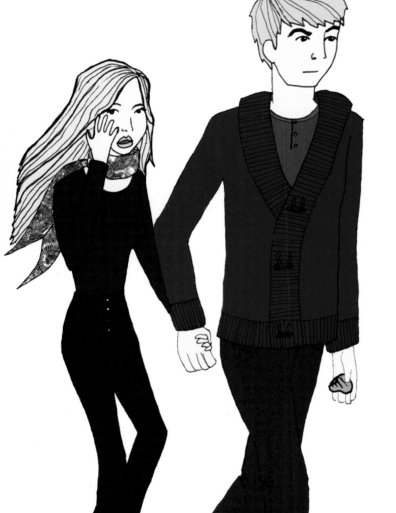

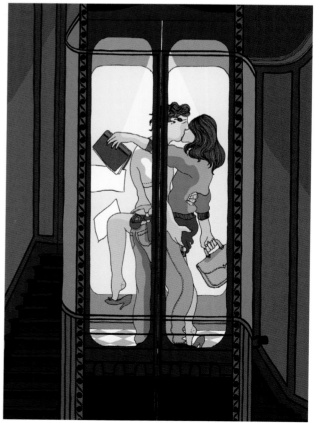

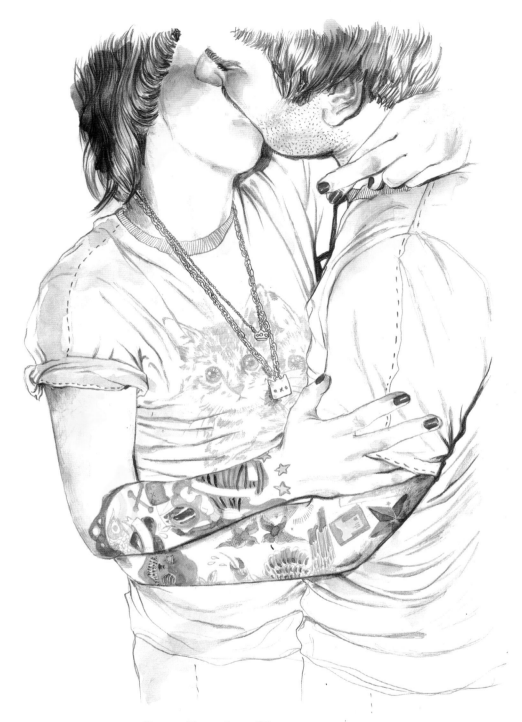

Erica Cho

Listen to Me (2010)
Colour pencil, graphite pencil

Esra Caroline Røise

100 Things to Do Before I Die (2009)
Pencil, watercolour

Monica Velasquez

Make-Up (2005)
Adobe Photoshop, Adobe Illustrator

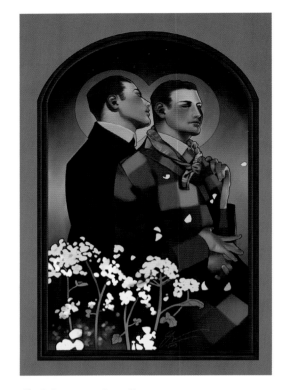 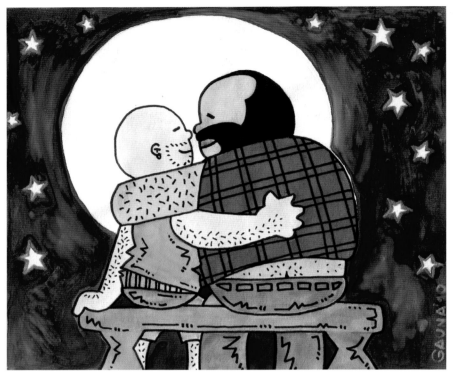

Odile van der Stap

Whispers Under the Stars (2009)
Corel Painter X

Ruben Gauna

Bearlentine: Series I-02 (2010)
Watercolour, ink

Agata Nowicka

I Never See Any Boys Kissing (2008)
Adobe Photoshop

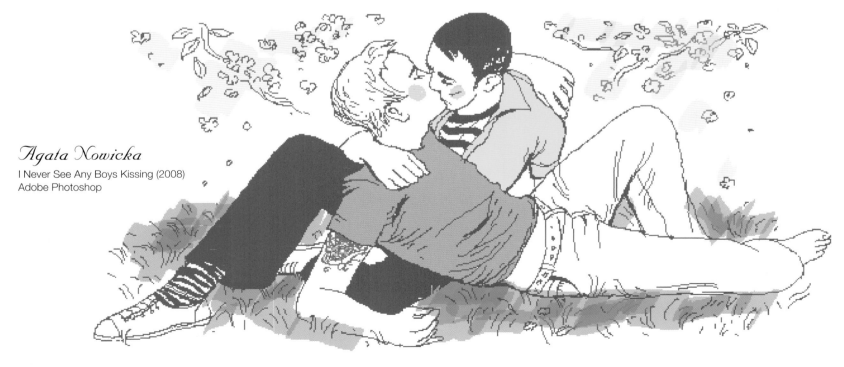

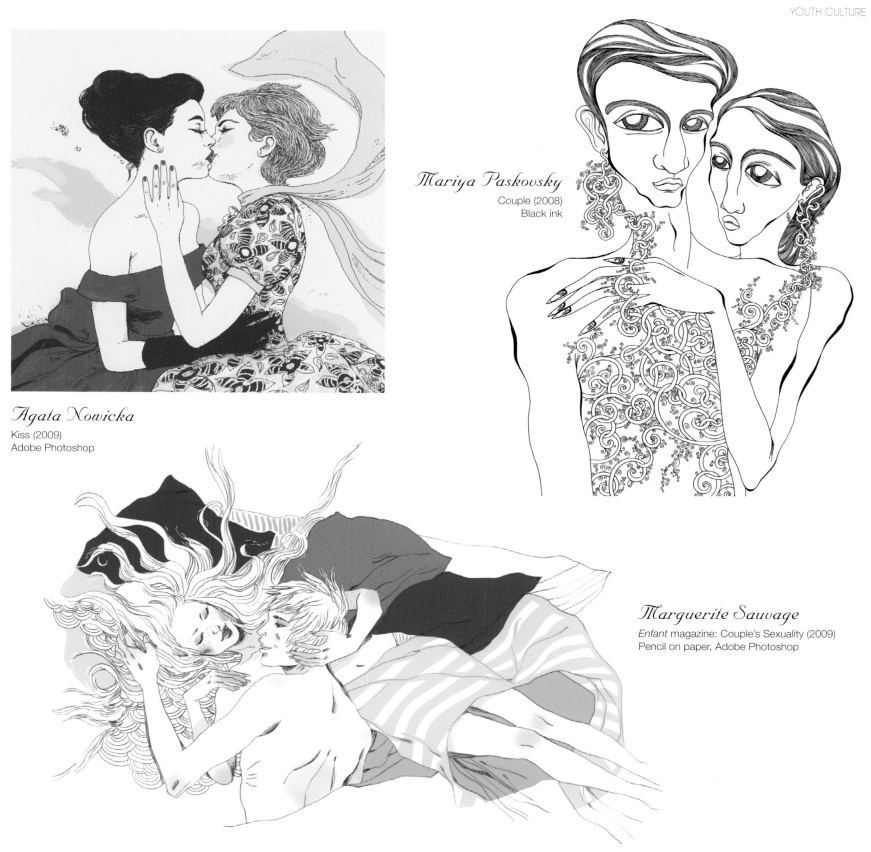

Agata Nowicka
Kiss (2009)
Adobe Photoshop

Mariya Paskovsky
Couple (2008)
Black ink

Marguerite Sauvage
Enfant magazine: Couple's Sexuality (2009)
Pencil on paper, Adobe Photoshop

David Pfendler

Snuggler (2008)
Adobe Photoshop

Paloma Spaeth

Fall (2005)
Adobe Photoshop

Maxim Savva
Shape magazine (2010)
Adobe Illustrator

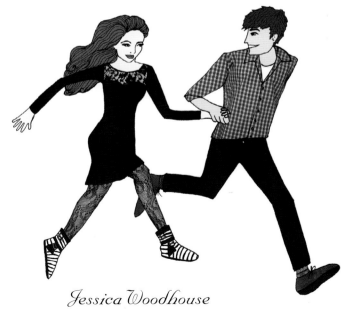

Ellen van Engelen
Spring (2010)
Pen and ink, Adobe Photoshop

Jessica Woodhouse
Thumbelina and Tom Thumb Get Away (2009)
Pen, Adobe Photoshop

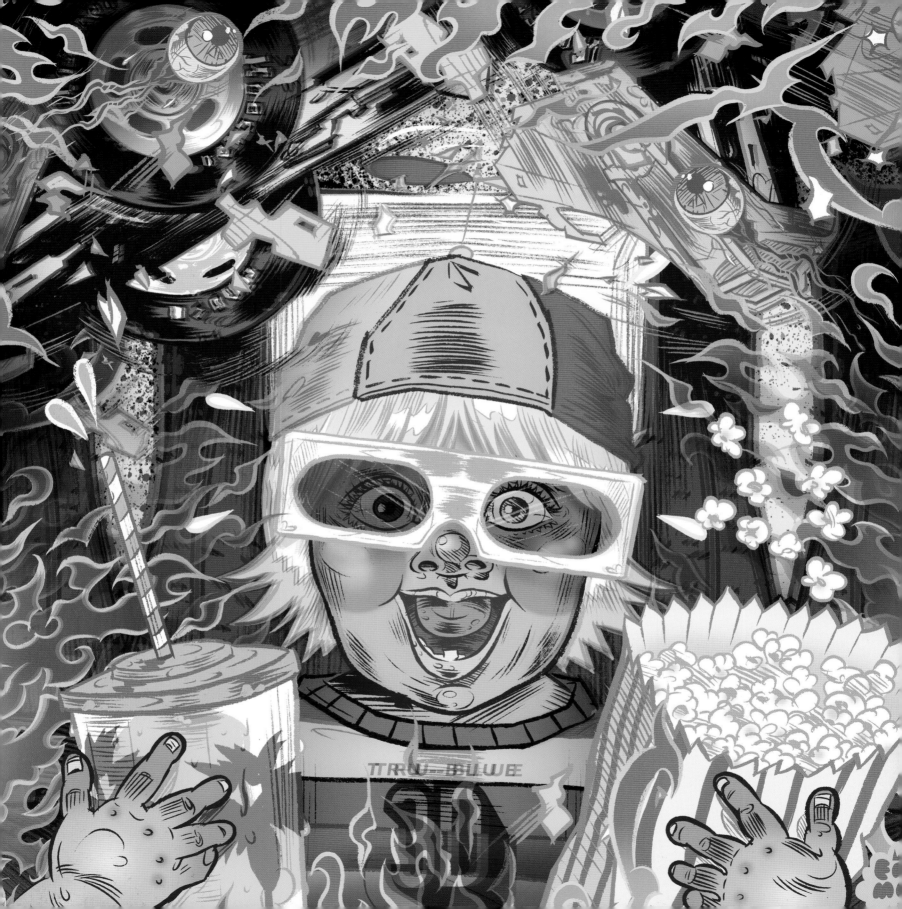

Children

previous page:

Eamo Donnelly
Complex magazine: Final Destination 3D (2009)
Pencil sketches, hand inked with brush on paper, Adobe Photoshop

Satomi Ichikawa
Family (2008)
Acrylic, gouache

Finna Leibenguth
Parents (2007)
Paper, fabric, Adobe Photoshop

Maxim Savva
Cosmopolitan Pregnancy magazine (2009)
Adobe Illustrator

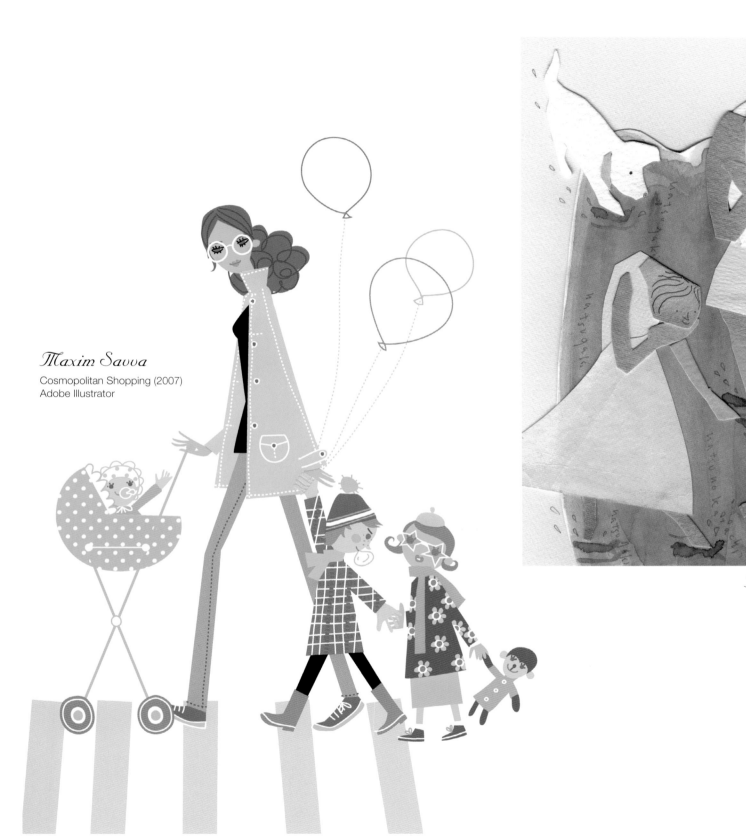

Maxim Savva
Cosmopolitan Shopping (2007)
Adobe Illustrator

Megumi Mitsuda
Summer Vacation (2004)
Watercolour, paper collage

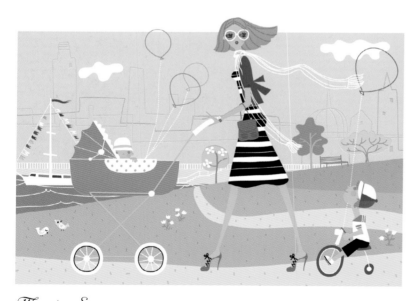

Maxim Savva

Cosmopolitan Pregnancy magazine (2009)
Adobe Illustrator

Charlene Chua

Father (2009)
Adobe Illustrator

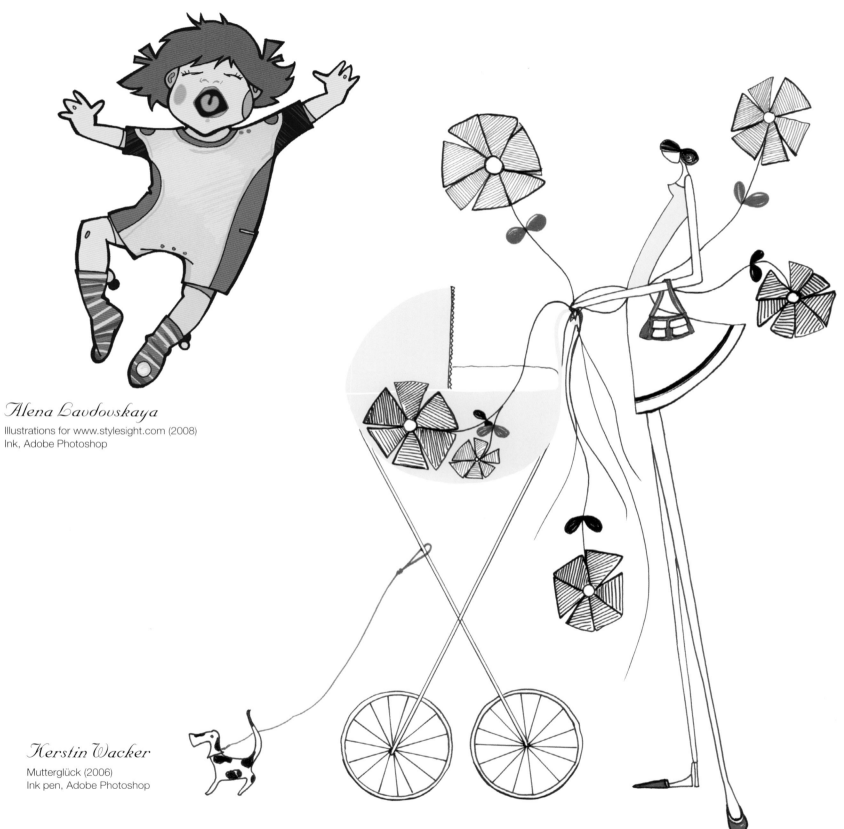

Alena Lavdovskaya
Illustrations for www.stylesight.com (2008)
Ink, Adobe Photoshop

Kerstin Wacker
Mutterglück (2006)
Ink pen, Adobe Photoshop

175

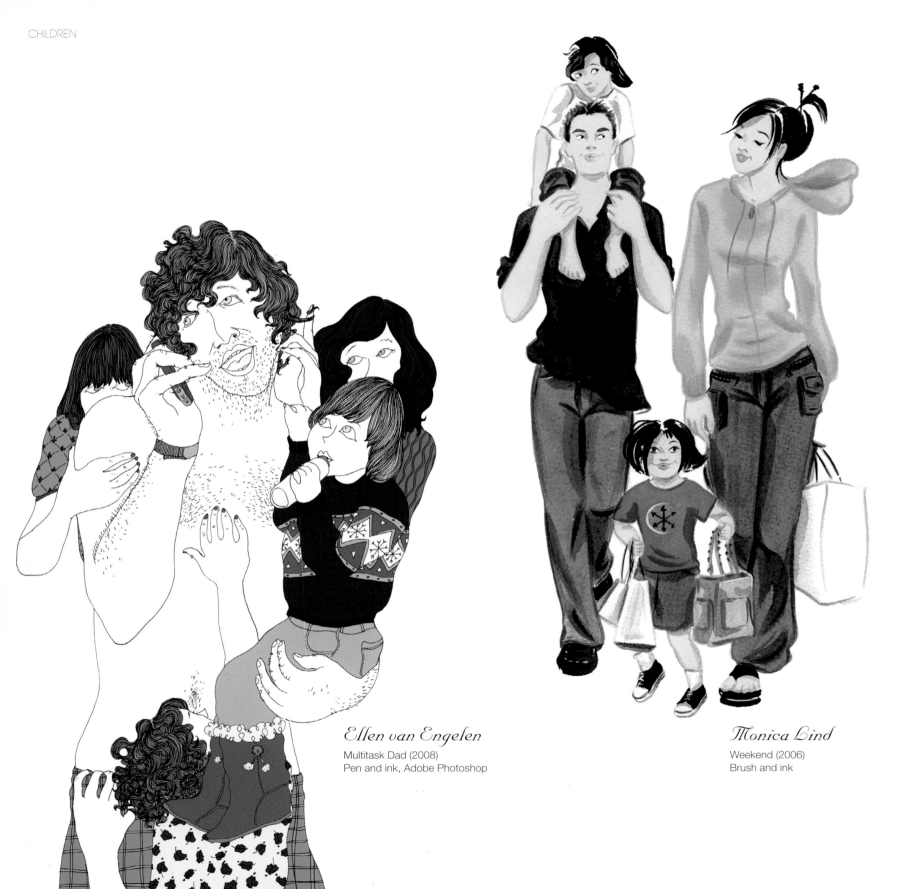

Ellen van Engelen
Multitask Dad (2008)
Pen and ink, Adobe Photoshop

Monica Lind
Weekend (2006)
Brush and ink

Masha D'yans

Baby in Toys (2005)
Watercolour

Arthur Mount

POZ magazine: Valerie & Eliza (2005)
Adobe Illustrator

Grzegorz Domaradzki

PZU i
Oil pastels, Adobe Photoshop

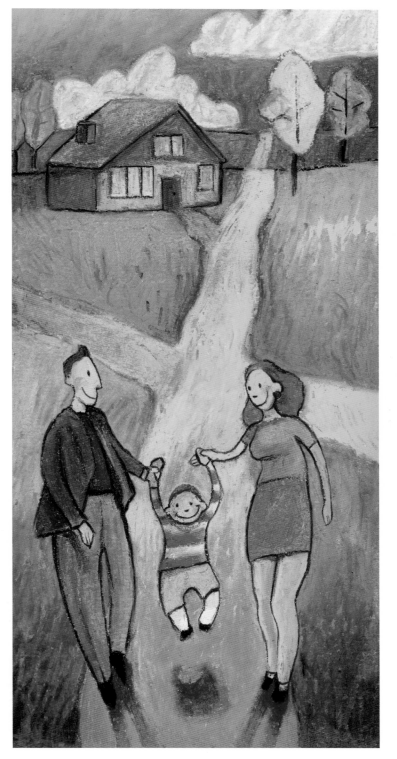

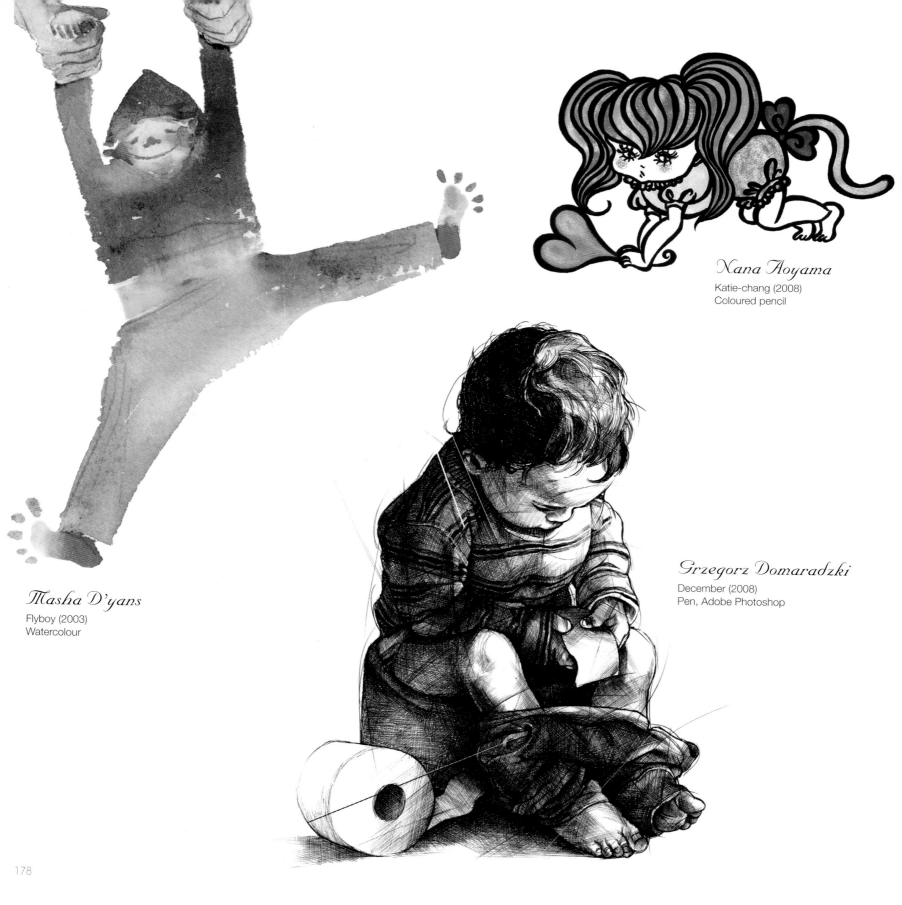

Nana Aoyama

Katie-chang (2008)
Coloured pencil

Grzegorz Domaradzki

December (2008)
Pen, Adobe Photoshop

Masha D'yans

Flyboy (2003)
Watercolour

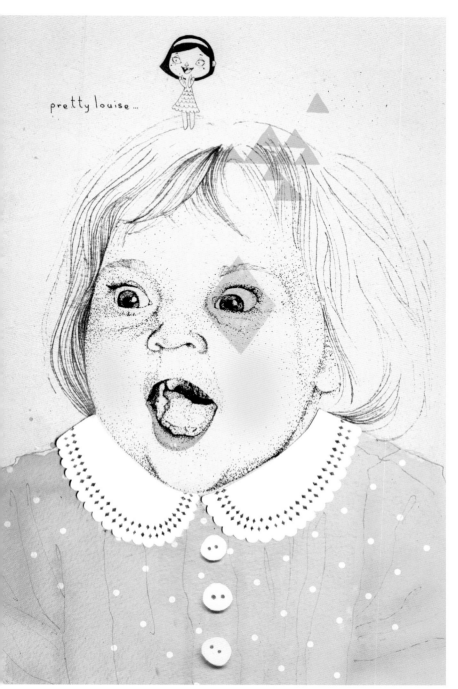

Pierre-Paul Pariseau

Asian Kid (2008)
Collage, watercolour, Adobe Photoshop

Élodie Nadreau

Louise (2009)
Pencil, watercolour, cutout, Adobe Photoshop

Amose

MacÈo (2006)
Adobe Photoshop, Adobe Illustrator

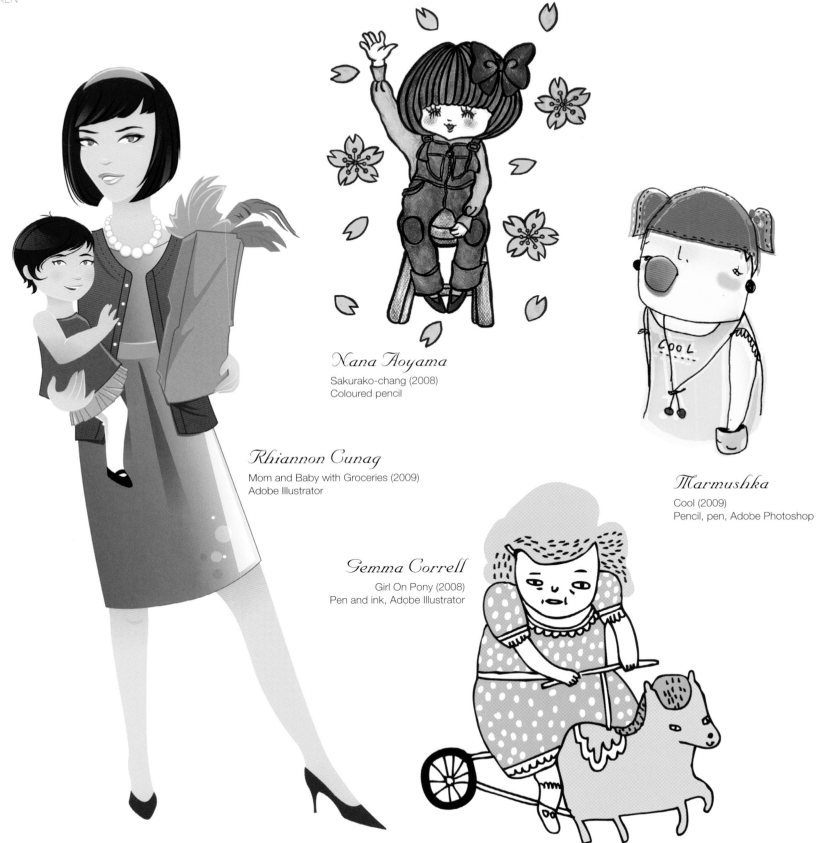

Nana Aoyama

Sakurako-chang (2008)
Coloured pencil

Rhiannon Cunag

Mom and Baby with Groceries (2009)
Adobe Illustrator

Marmushka

Cool (2009)
Pencil, pen, Adobe Photoshop

Gemma Correll

Girl On Pony (2008)
Pen and ink, Adobe Illustrator

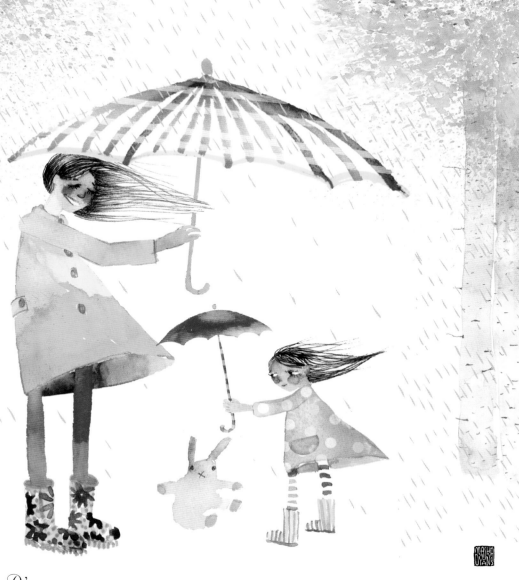

Masha D'yans
Momumbrella (2008)
Watercolour

Samuel Andrew Jones
Lolita Fashion Girl 2 (2010)
Adobe Illustrator

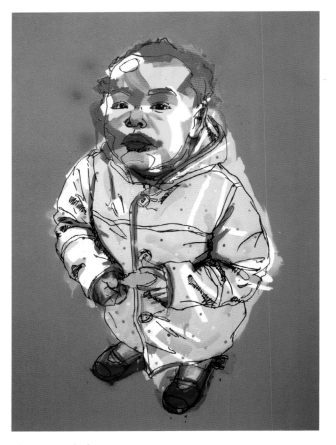

Rowan Newton

Olesia (2009)
Acrylic and spray paint on canvas

Licínio Vieira Alves Florêncio

Kid (2006)
Macromedia FREEHAND, Adobe Photoshop

Grzegorz Domaradzki

Kids (2008)
Adobe Illustrator, Adobe Photoshop

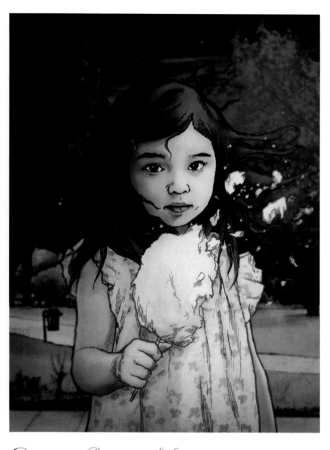

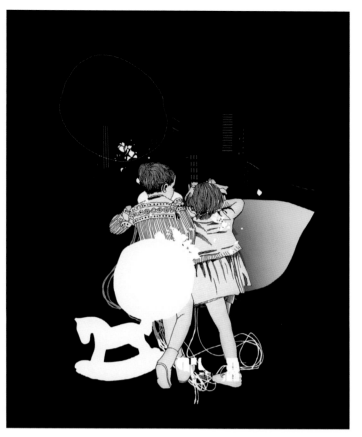

Grzegorz Domaradzki
Cotton (2008)
Adobe Photoshop

Cityabyss Illustration
Popshot Magazine: Us&Them (2009)
Hand drawn, Adobe Photoshop

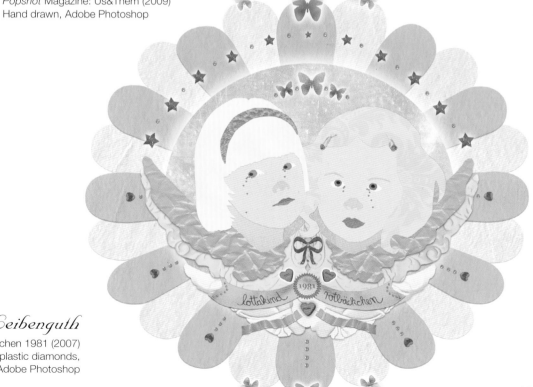

Finna Leibenguth
Lottakind & Rotbaeckchen 1981 (2007)
Paper, fabric, felt pen, sugar hearts, plastic diamonds,
glitterstickers, Adobe Photoshop

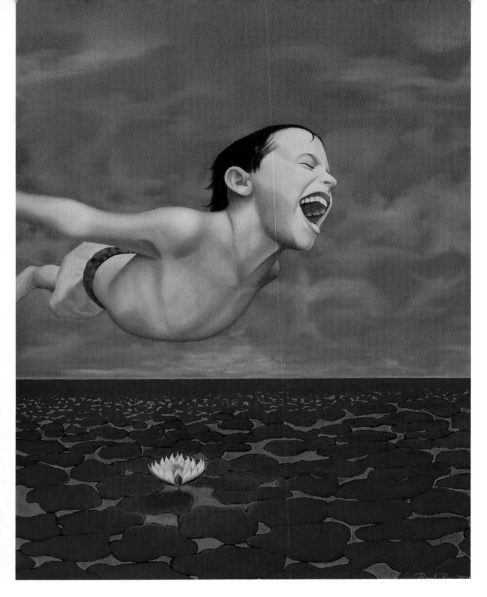

Pascal Roy
La Decouverte (2004)
Oil on canvas

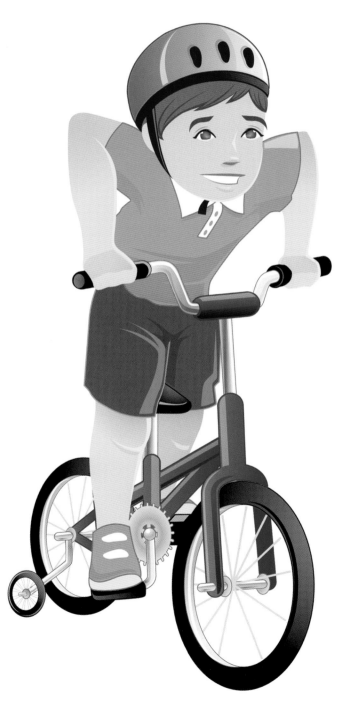

Rhiannon Cunag
Boy on Bike (2009)
Adobe Illustrator

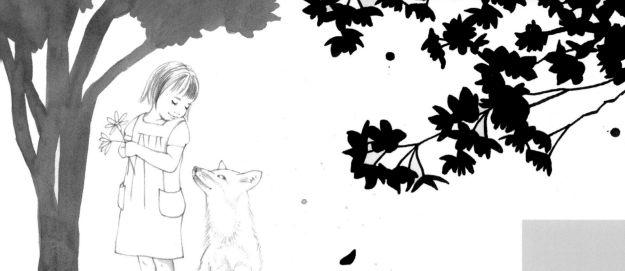

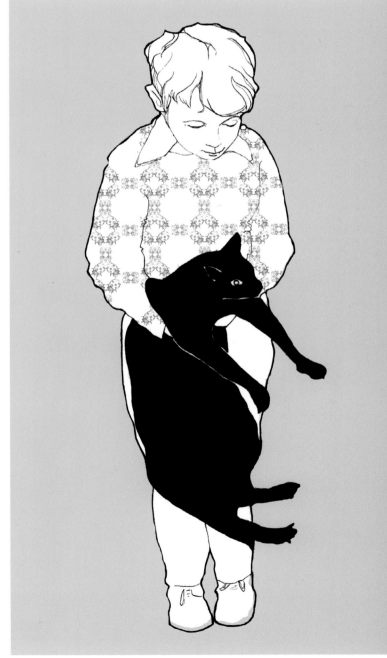

Genna Campton

Cat Love (2009)
Acrylic, pen and ink

Yumi Imai

Personal Work (2008)
Powdered mineral pigments, hide glue

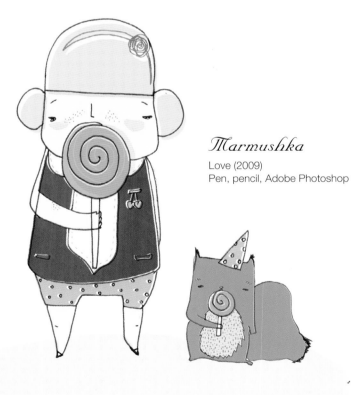

Marmushka

Love (2009)
Pen, pencil, Adobe Photoshop

Selina Rumaisha

Jingle Jungle (2010)
Adobe Illustrator

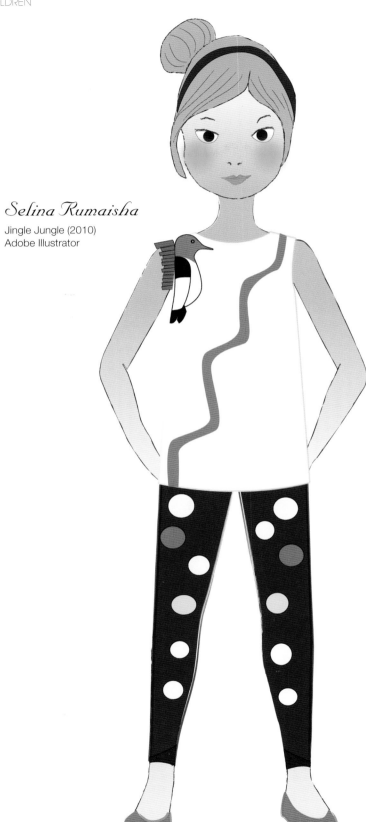

Renee Reeser Zelnick

A Little Flower (2009)
Prismacolour pencil, Adobe Photoshop

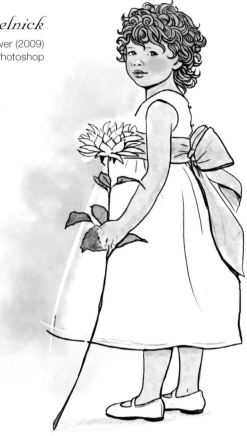

Genna Campton

Amor (2009)
Acrylic, pen and ink

Daniel Hyun Lim

Fawn Fruits Fashion Tokyo Girl (2010)
Pencil, Adobe Photoshop

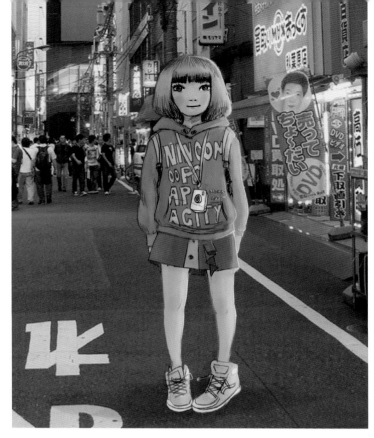

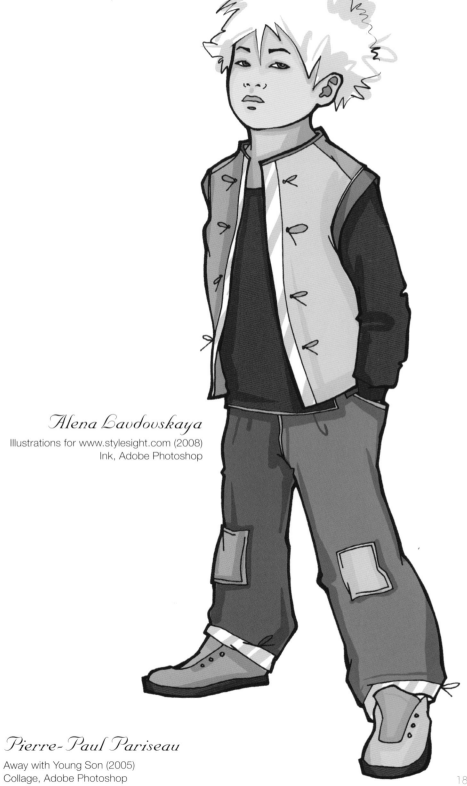

Alena Lavdovskaya

Illustrations for www.stylesight.com (2008)
Ink, Adobe Photoshop

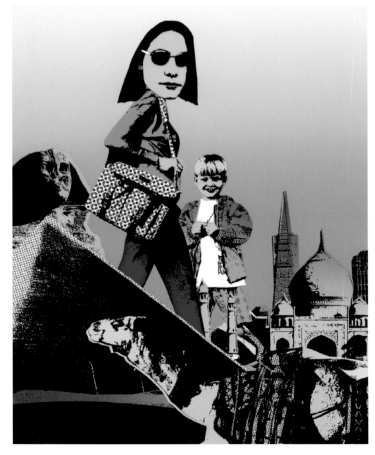

Pierre-Paul Pariseau

Away with Young Son (2005)
Collage, Adobe Photoshop

187

secret
stash

Marmushka
I Want Candy (2010)
Pencil, pen, Adobe Photoshop

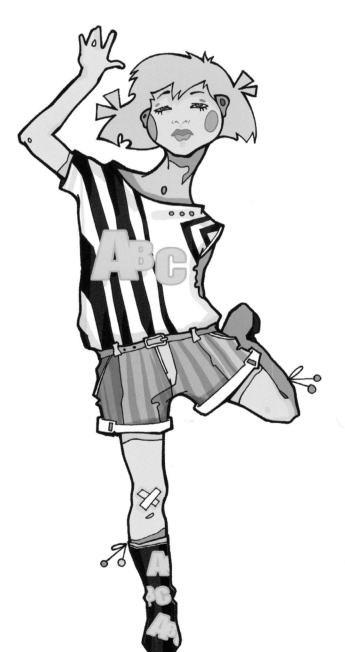

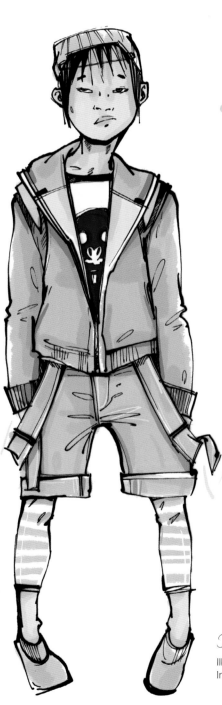

Alena Lavdovskaya
Illustrations for www.stylesight.com (2008)
Ink, Adobe Photoshop

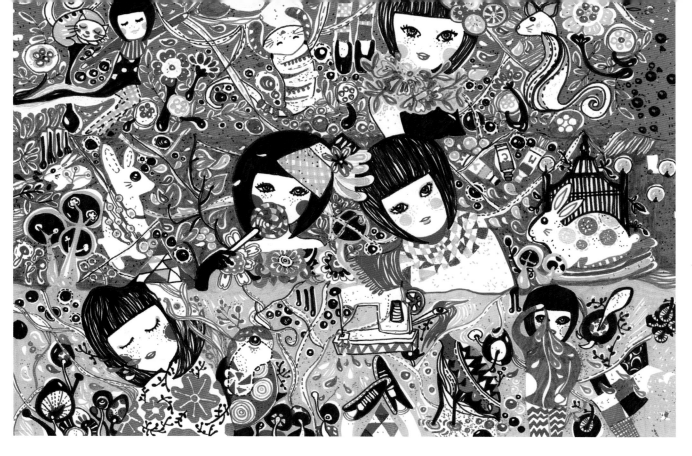

Nani Puspasari
Coloring Days (2009)
Felt-tip pen

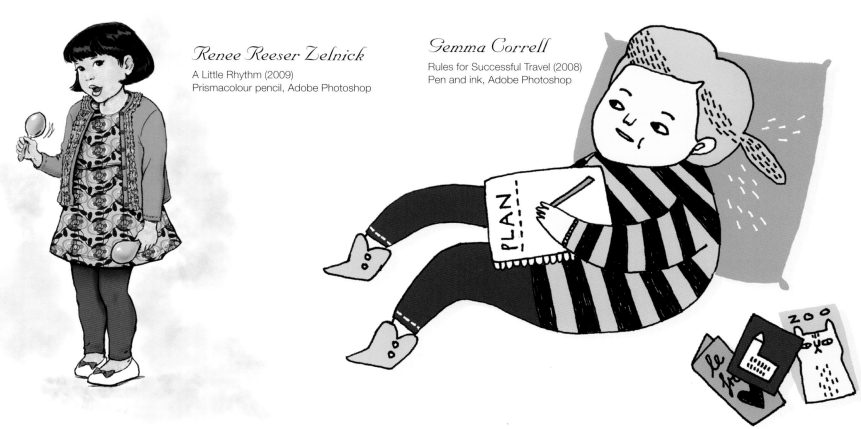

Renee Reeser Zelnick
A Little Rhythm (2009)
Prismacolour pencil, Adobe Photoshop

Gemma Correll
Rules for Successful Travel (2008)
Pen and ink, Adobe Photoshop

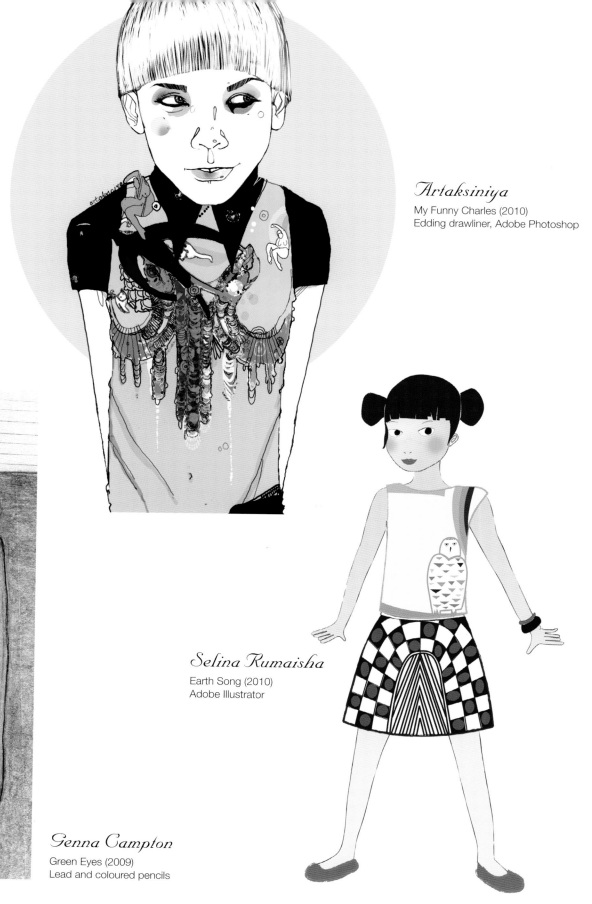

Artaksiniya

My Funny Charles (2010)
Edding drawliner, Adobe Photoshop

Selina Rumaisha

Earth Song (2010)
Adobe Illustrator

Genna Campton

Green Eyes (2009)
Lead and coloured pencils

Genna Campton

The Family (2009)
Pen, ink, Adobe Photoshop

Esther Kim

London Boy (2010)
Pen, pencil, watercolour

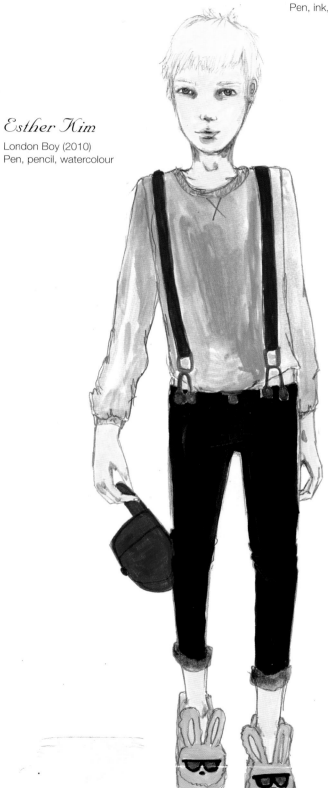

Wendy Ding

Hyein (2007)
Pen, marker

Mark Todd

Classroom (2007)
Ink, Adobe Photoshop

Arthur Mount

Advocate magazine: Teen Idols (2009)
Adobe Illustrator

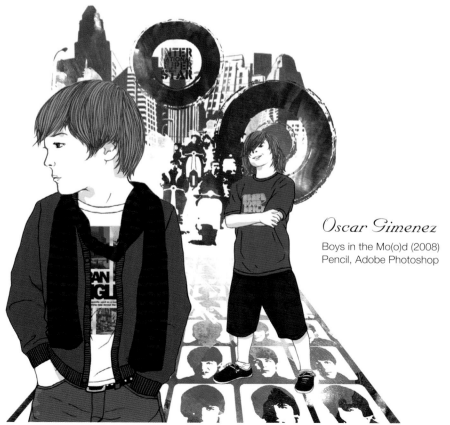

Oscar Gimenez

Boys in the Mo(o)d (2008)
Pencil, Adobe Photoshop

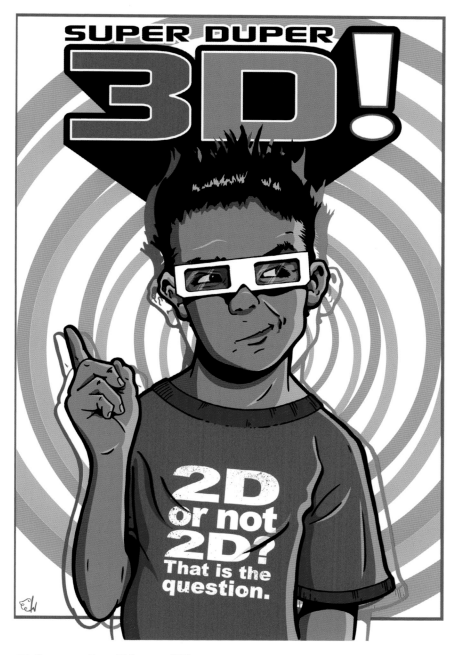

Christopher 'Wing' King

Super Duper 3D (2010)
Pen and ink, Adobe Illustrator

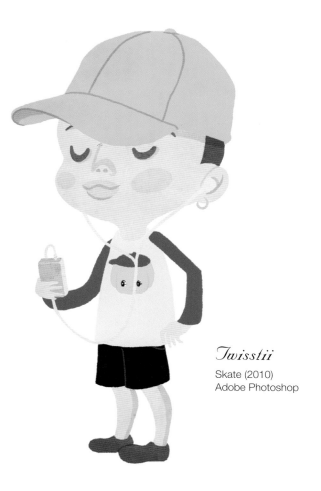

Twisstii

Skate (2010)
Adobe Photoshop

Licínio Vieira Alves Florêncio

Attack (2005)
Macromedia FREEHAND, Adobe Photoshop

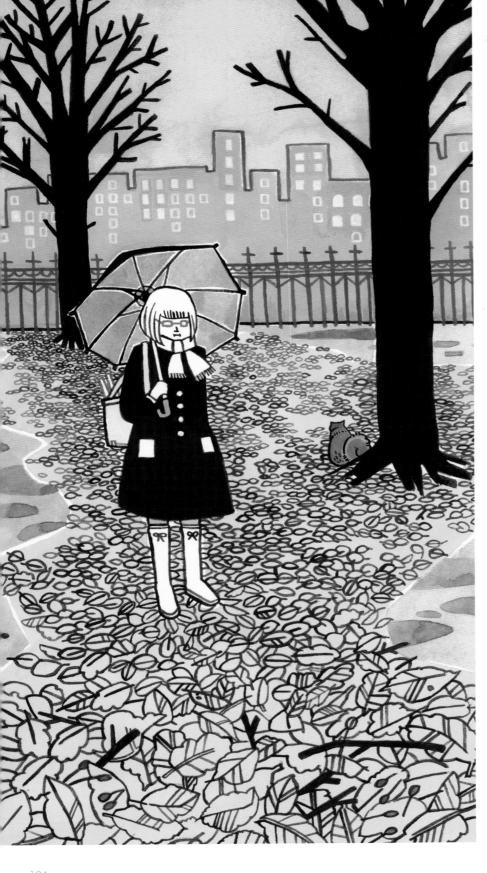

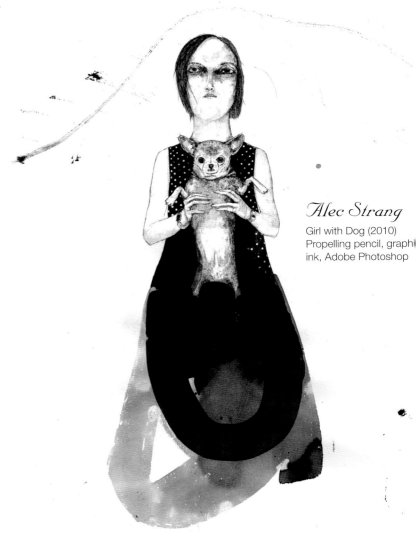

Alec Strang
Girl with Dog (2010)
Propelling pencil, graph
ink, Adobe Photoshop

Gemma Correll
Recorder Girl (2009)
Pen, watercolour

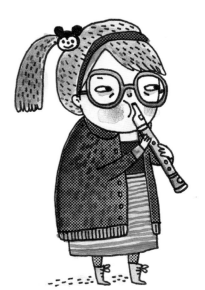

Eika
Rain and City (2009)
Gouache

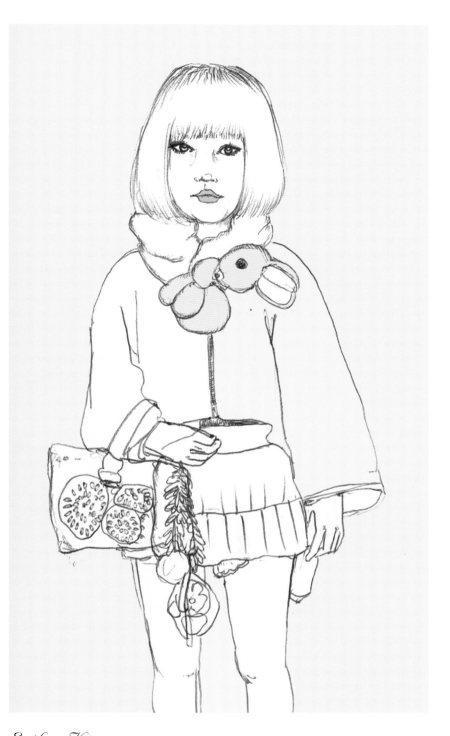

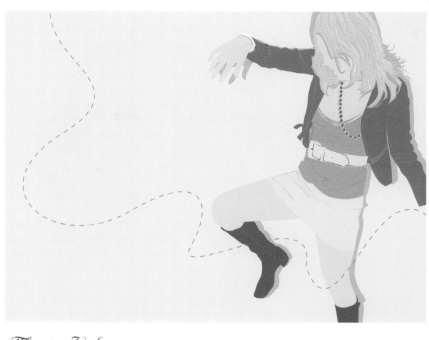

Monica Velasquez
The Still (2008)
Adobe Photoshop, Adobe Illustrator

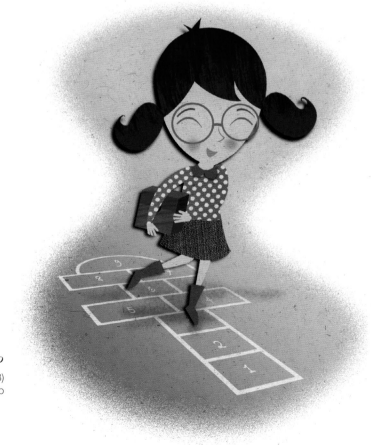

Esther Kim
Bunny Scarf (2010)
Pen, pencil, Adobe Photoshop

Luis Tinoco
Euro RSCG: The Red Box Fairy Tale (2008)
Adobe Photoshop

195

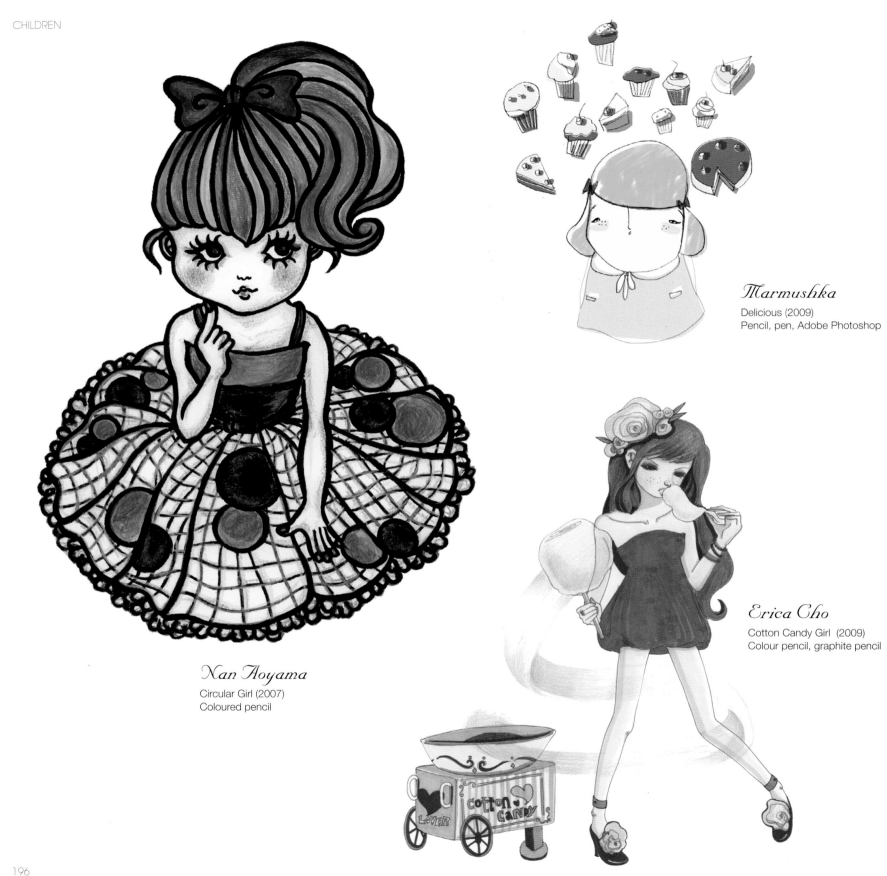

Marmushka

Delicious (2009)
Pencil, pen, Adobe Photoshop

Erica Cho

Cotton Candy Girl (2009)
Colour pencil, graphite pencil

Nan Aoyama

Circular Girl (2007)
Coloured pencil

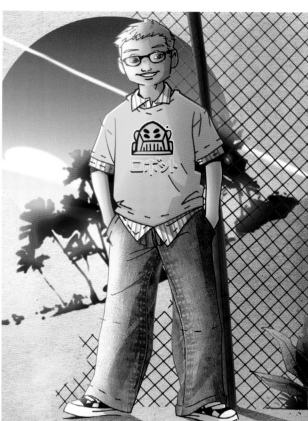

Carl Pearce
Sam (2006)
Pencil, pen and ink, Adobe Photoshop

Renee Reeser Zelnick
Little Jammer (2009)
Prismacolour pencil, Adobe Photoshop

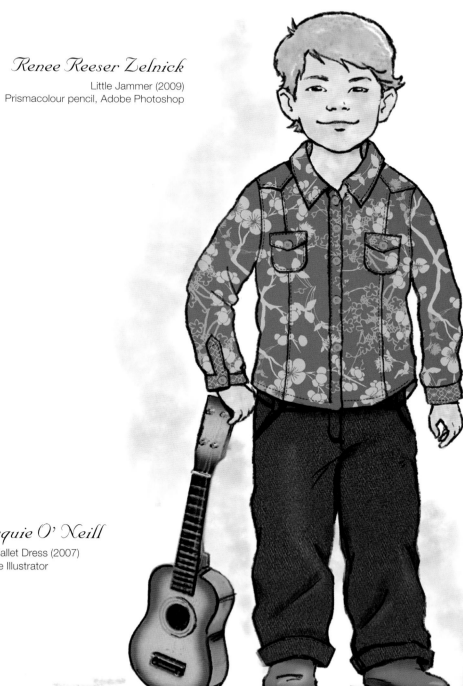

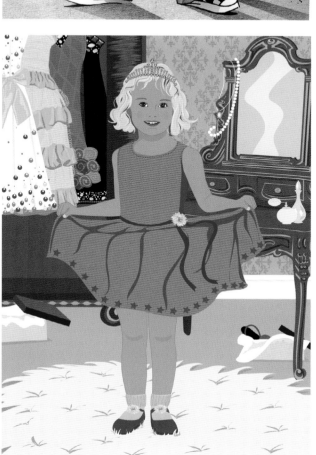

Jacquie O' Neill
The Ballet Dress (2007)
Adobe Illustrator

Greg Paprocki
Cherry Bombs Pool Girls (2008)
Adobe Illustrator

Alena Lavdovskaya
Illustrations for www.stylesight.com (2008)
Ink, Adobe Photoshop

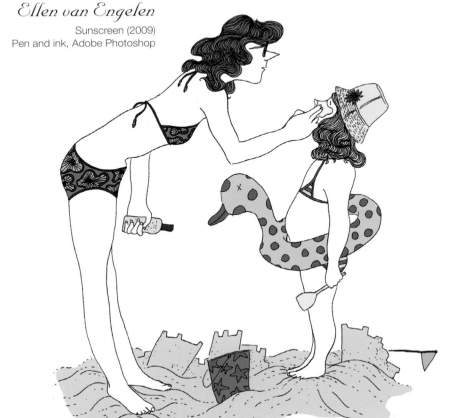

Ellen van Engelen
Sunscreen (2009)
Pen and ink, Adobe Photoshop

Maxim Savva

Pacific magazines: Total Girl Diary (2008)
Adobe Illustrator

Twisstii

Little Red (2010)
Adobe Photoshop

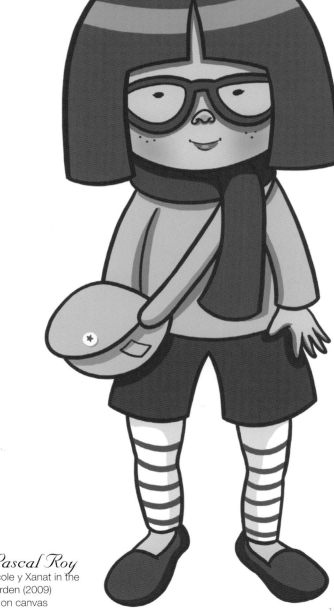

Pascal Roy

Nicole y Xanat in the
Garden (2009)
Oil on canvas

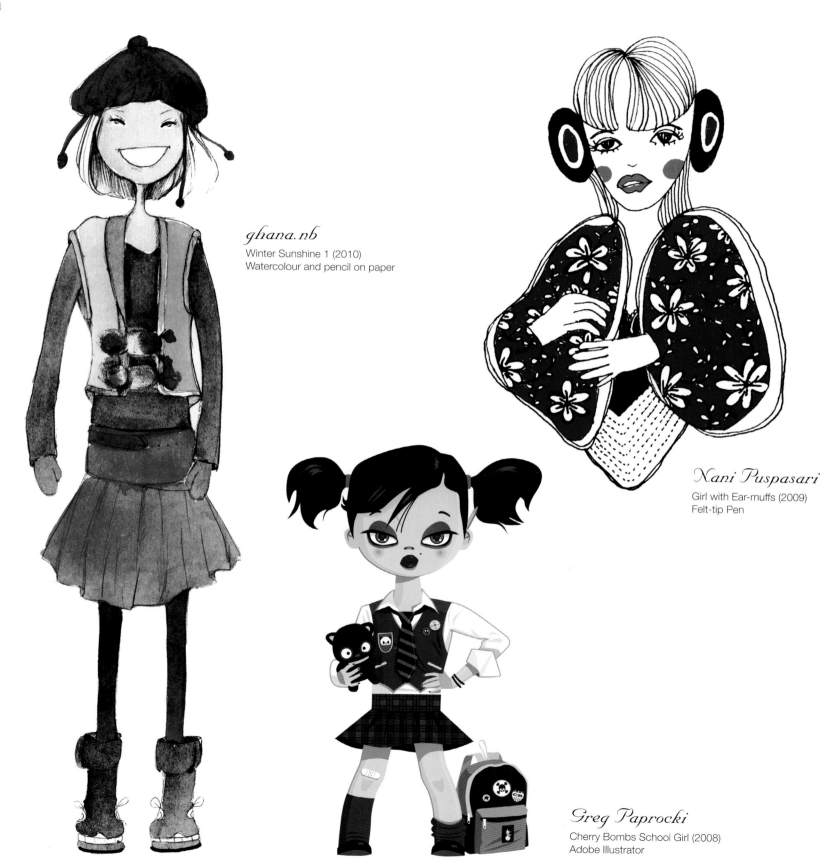

ghana.nb
Winter Sunshine 1 (2010)
Watercolour and pencil on paper

Nani Puspasari
Girl with Ear-muffs (2009)
Felt-tip Pen

Greg Paprocki
Cherry Bombs School Girl (2008)
Adobe Illustrator

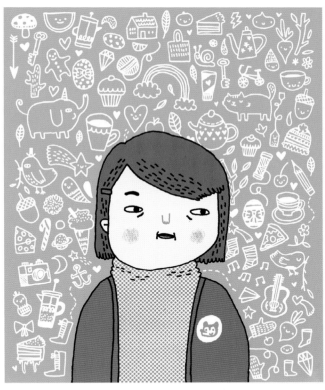

Gemma Correll
Blackboard Dreams (2009)
Pen and ink, Adobe Photoshop

Katie Rodgers
Jean Paul Gaultier Girl (2009)
Watercolour, ink

Pierre-Paul Pariseau
Blue Girl (2006)
Collage, watercolour, Adobe Photoshop

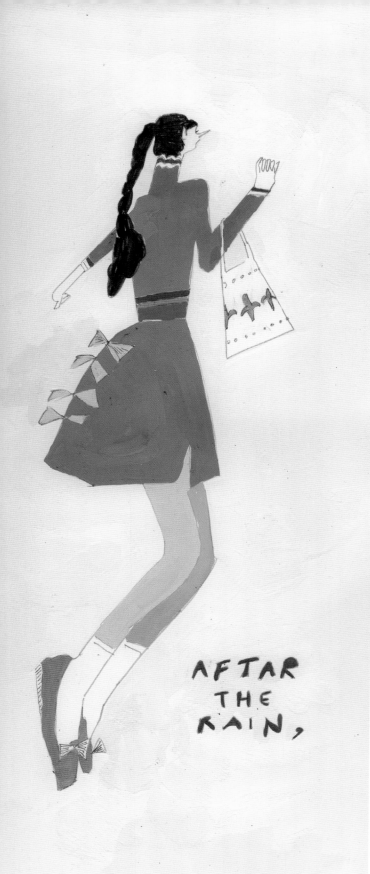

AFTAR
THE
RAIN,

Makiko Noda

After the Rain (2010)
Pencil, coloured pencil, gouache

Nana Aoyama

Jump Rope of Love (2008)
Coloured pencil

Pierre-Paul Pariseau

Jump (2005)
Collage, Adobe Photoshop

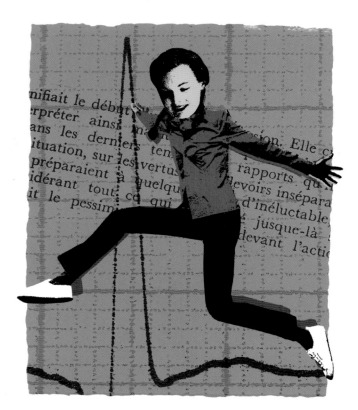

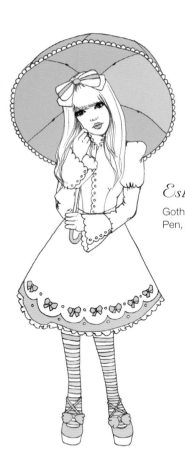

Esther Kim

Gothic Lolita (2008)
Pen, pencil, Adobe Photoshop

ghana.nb

Winter Sunshine 2 (2010)
Watercolour, pencil

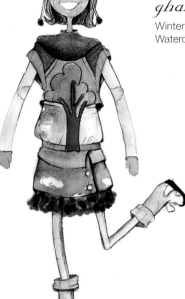

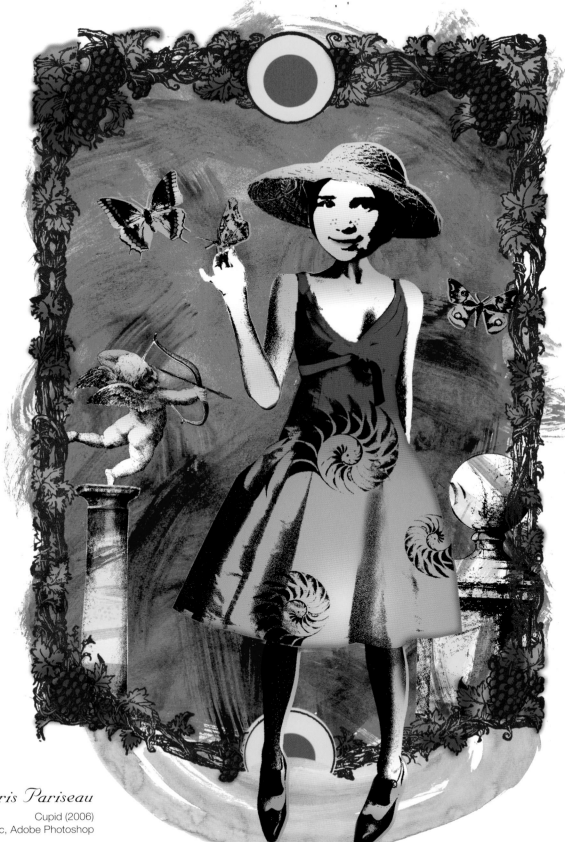

Pierre-Paris Pariseau

Cupid (2006)
Collage, watercolour, acrylic, Adobe Photoshop

Katie Rodgers

Innocent Tavi (2010)
Watercolour, ink

Twisstii

Miss Square (2010)
Adobe Photoshop

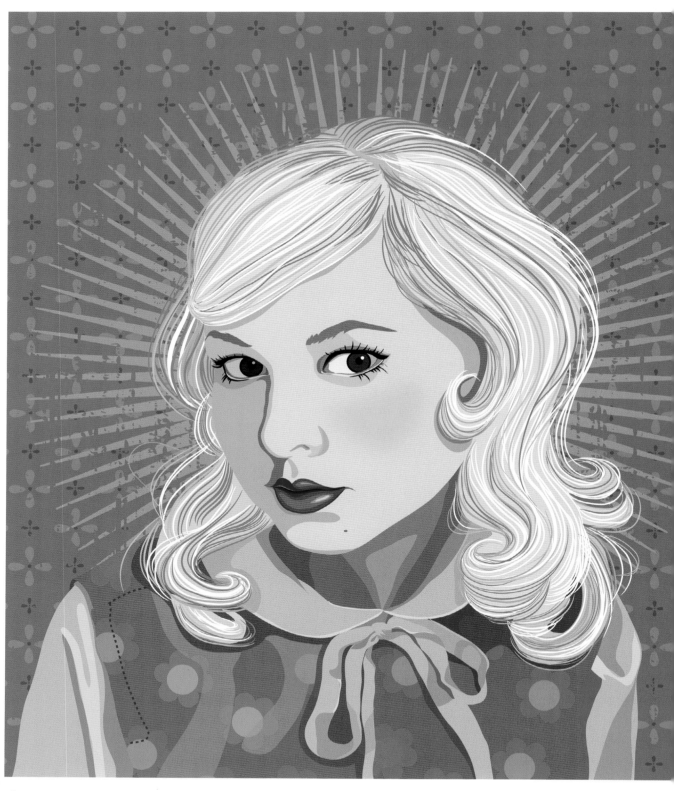

Maria Danalakis

Vintage Girl (2009)
Adobe Illustrator

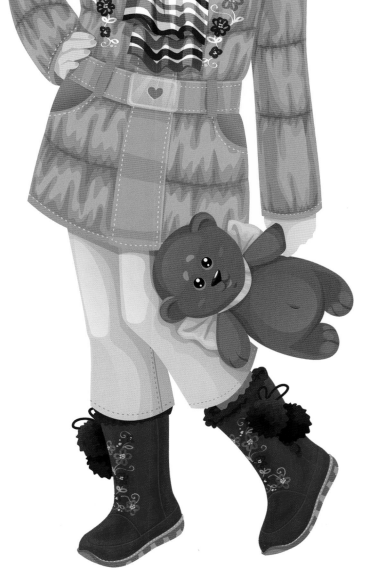

Svetlana Makarova
Little Girl (Character for Shoes' House 'Forum', Russia) (2009)
CorelDRAW

Twisstii
Beats (2010)
Adobe Photoshop

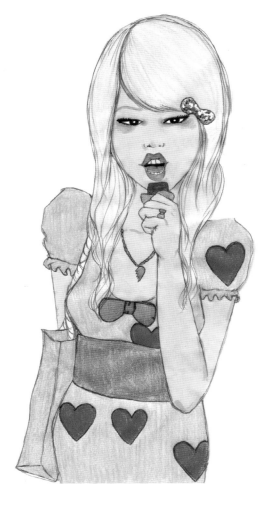

Esther Kim
Glitter Bow (2007)
Colour pencil, pen, pencil, glitter, watercolour

Eika

In the Forest (2009)
Gouache

Katie Rodgers

Melissa Tashiro (2009)
Watercolour, ink

Maxim Savva

Cosmopolitan SHOPPING (2008)
Adobe Illustrator

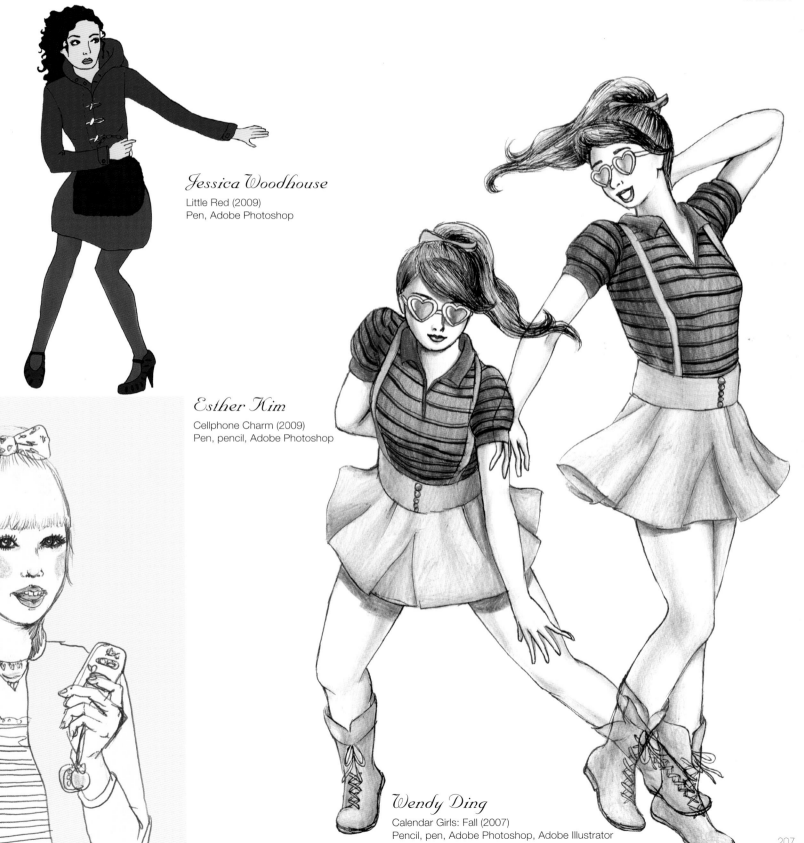

Jessica Woodhouse

Little Red (2009)
Pen, Adobe Photoshop

Esther Kim

Cellphone Charm (2009)
Pen, pencil, Adobe Photoshop

Wendy Ding

Calendar Girls: Fall (2007)
Pencil, pen, Adobe Photoshop, Adobe Illustrator

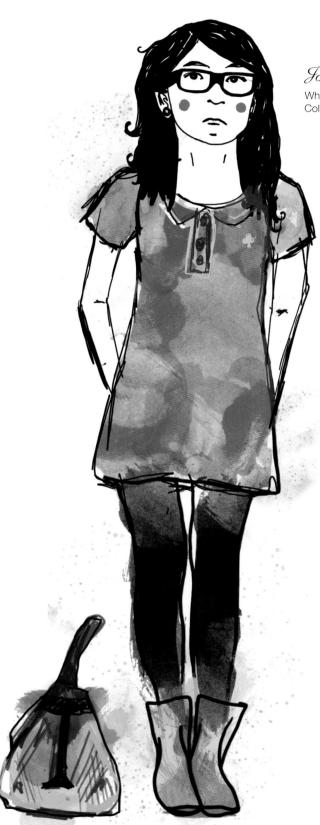

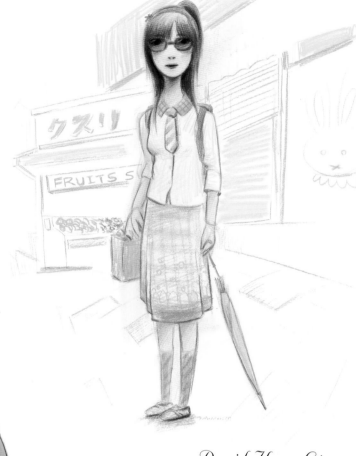

Jo Cheung

What I Wore Today (2010)
Collage, Adobe Photoshop

David Hyun Lim

Sweet Streets Days (2009)
Colour pencil

Daniel Hyun Lim

Fawn Fruits Fashion Red Hoodie (2010)
Pencil, Adobe Photoshop

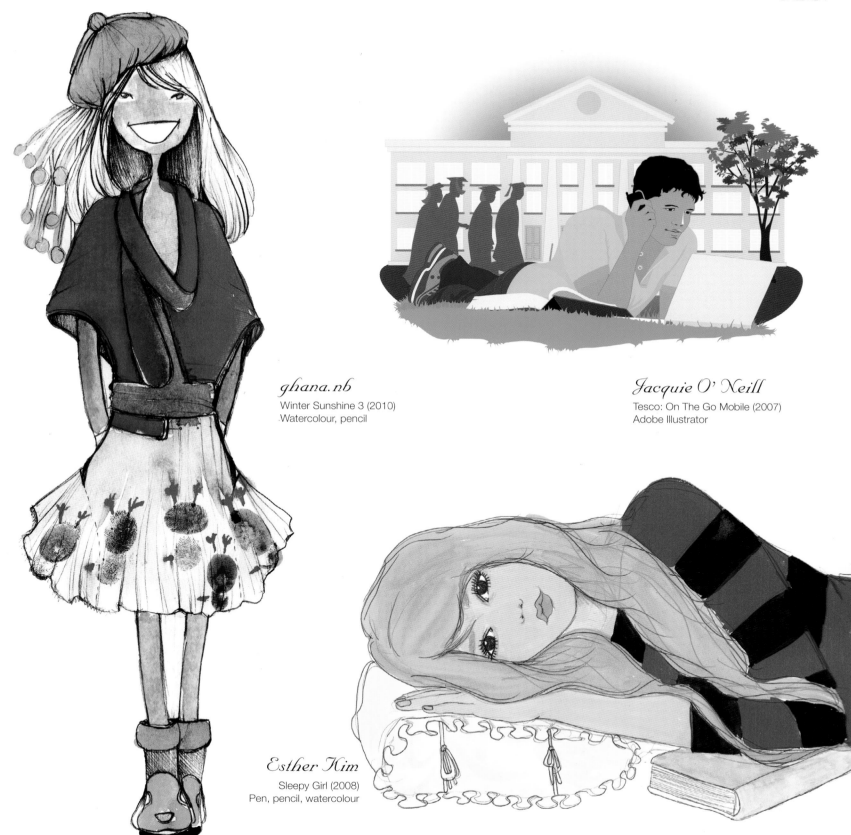

ghana.nb
Winter Sunshine 3 (2010)
Watercolour, pencil

Jacquie O' Neill
Tesco: On The Go Mobile (2007)
Adobe Illustrator

Esther Kim
Sleepy Girl (2008)
Pen, pencil, watercolour

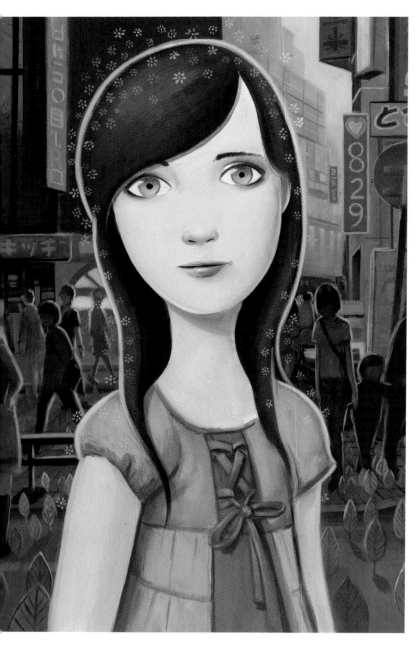

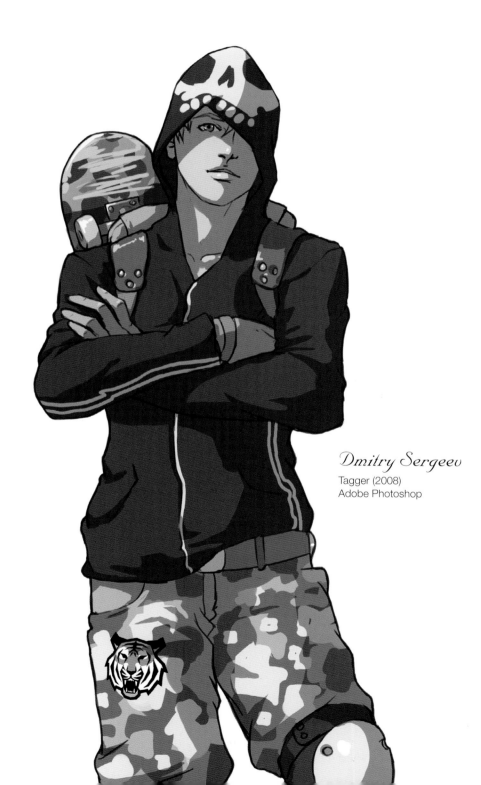

Daniel Hyun Lim
29th of August (2009)
Acrylic on canvas

Dmitry Sergeev
Tagger (2008)
Adobe Photoshop

Rowan Newton

Sluuurp (2008)
Acrylic and spray paint on canvas

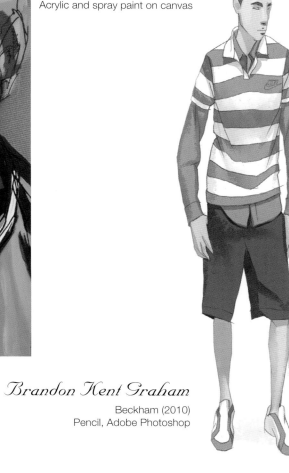

Brandon Kent Graham

Beckham (2010)
Pencil, Adobe Photoshop

David Pfendler

Flip (2009)
Adobe Photoshop

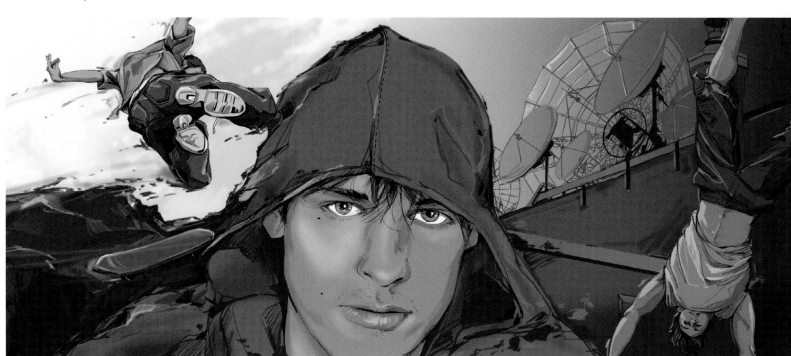

211

Daniel Hyun Lim
20th of January (2009)
Acrylic on canvas

Daniel Hyun Lim
Sweetstreet Days 2 (2009)
Colour pencil

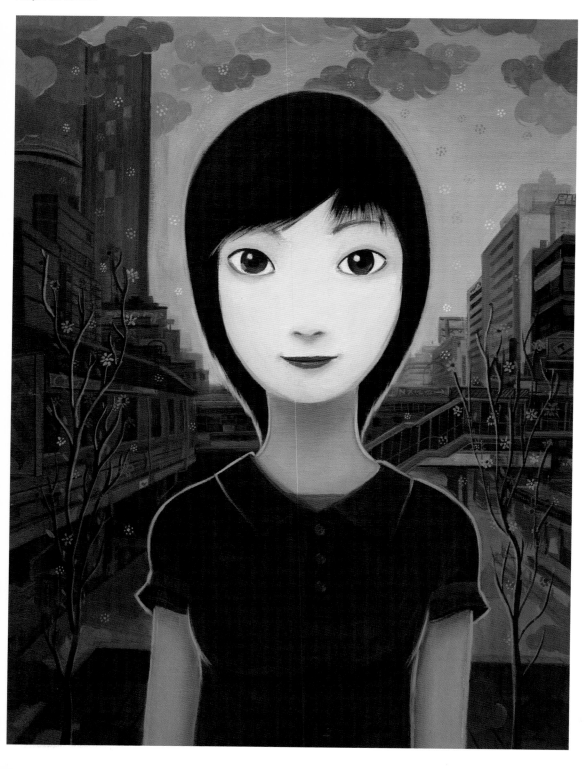

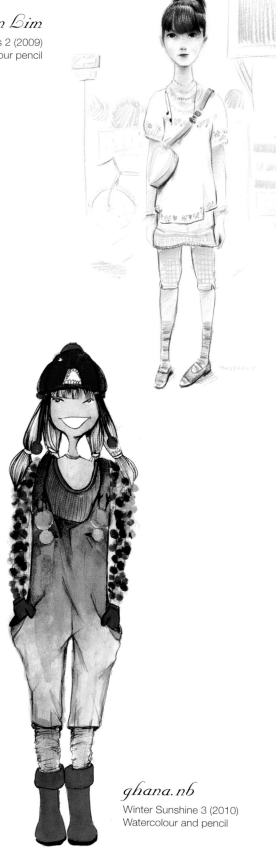

ghana.nb
Winter Sunshine 3 (2010)
Watercolour and pencil

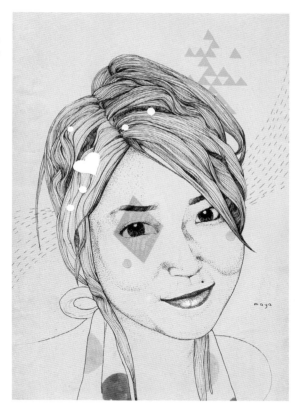

Ëlodie Nadreau
Maya (2009)
Pencil, watercolour, Adobe Photoshop

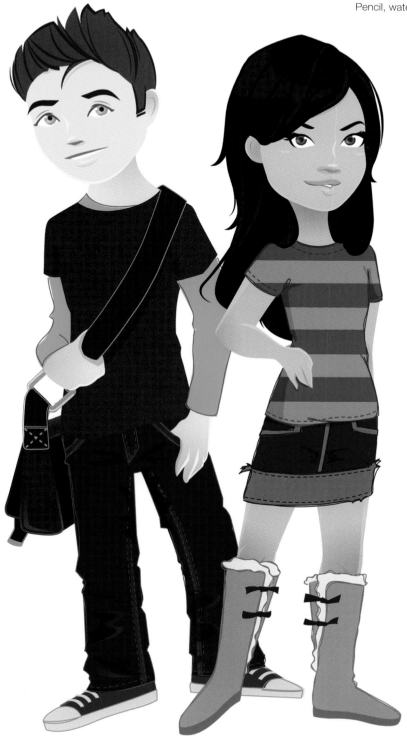

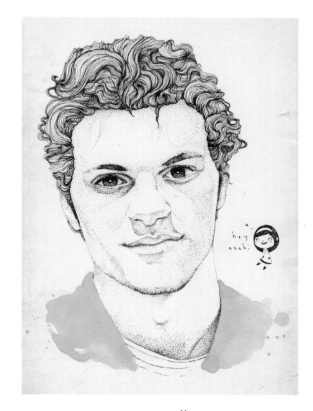

Rhiannon Cunag
Little Passports: Sam and Sofia (2009)
Adobe Illustrator

Ëlodie Nadreau
Asahi (2009)
Pencil, watercolour, Adobe Photoshop

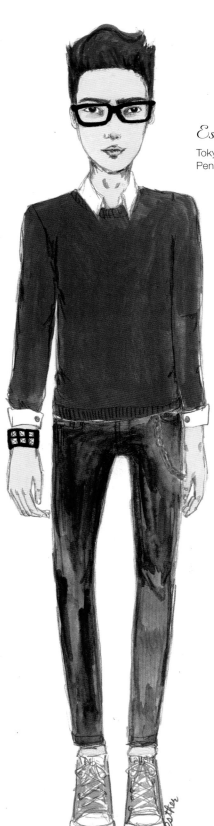

Esther Kim

Tokyo Boy (2010)
Pen, pencil, watercolour

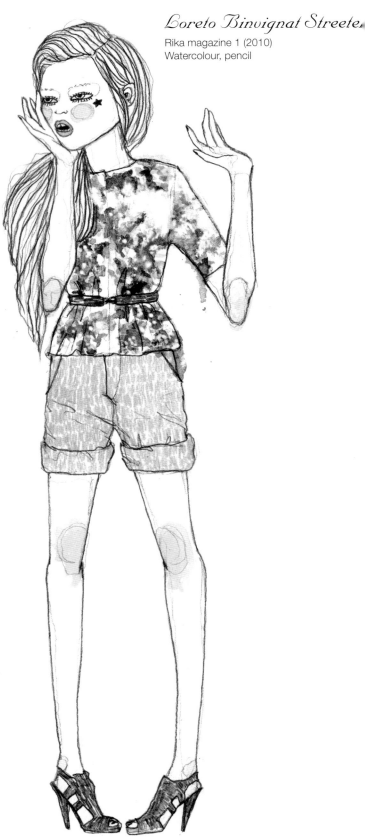

Loreto Binvignat Streeter

Rika magazine 1 (2010)
Watercolour, pencil

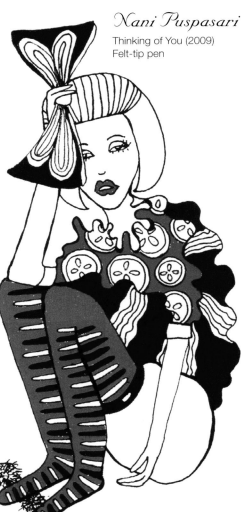

Nani Puspasari

Thinking of You (2009)
Felt-tip pen

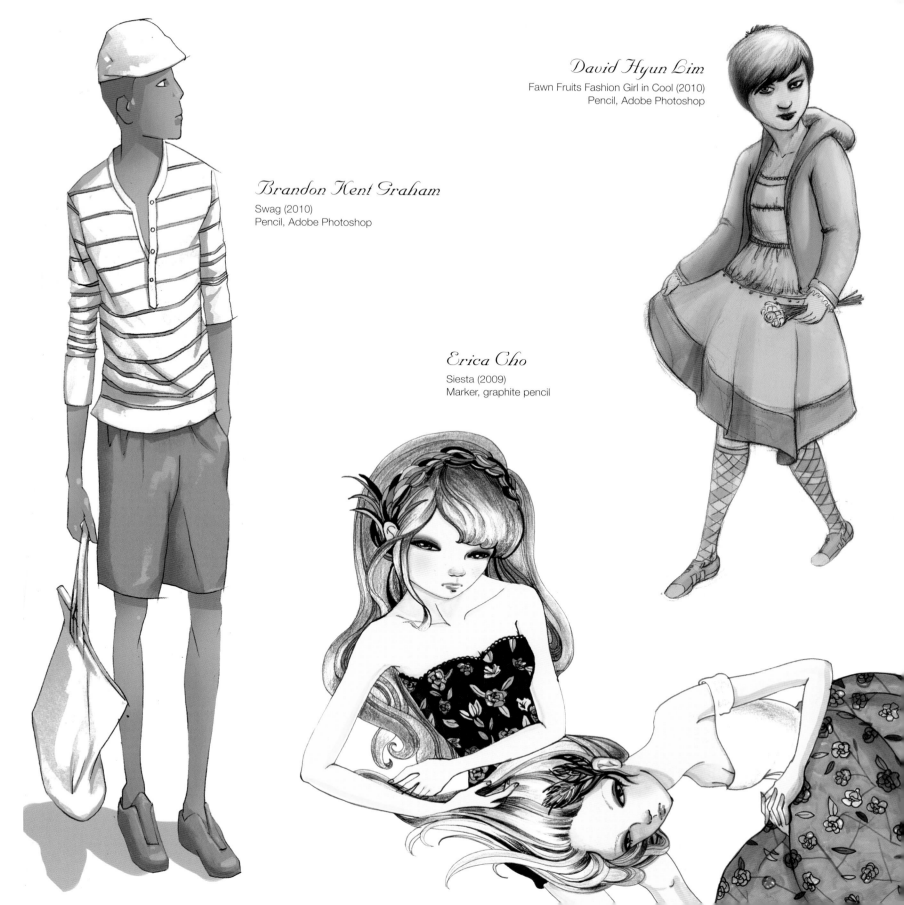

Brandon Kent Graham

Swag (2010)
Pencil, Adobe Photoshop

David Hyun Lim

Fawn Fruits Fashion Girl in Cool (2010)
Pencil, Adobe Photoshop

Erica Cho

Siesta (2009)
Marker, graphite pencil

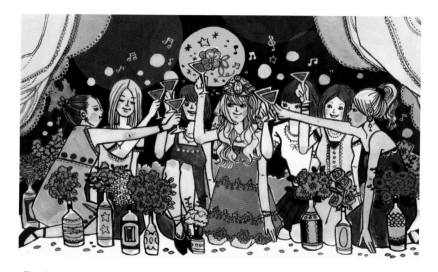

Eika

Bachelorette Party (2008)
Gouache

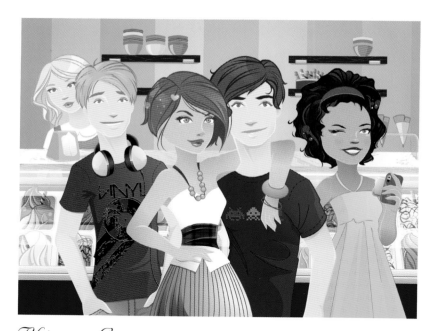

Rhiannon Cunag

Gelato Gang (2009)
Adobe Illustrator

Svetlana Makarova

Teen Boy (character for online project "Ktolubit.ru") (2009)
Adobe Illustrator

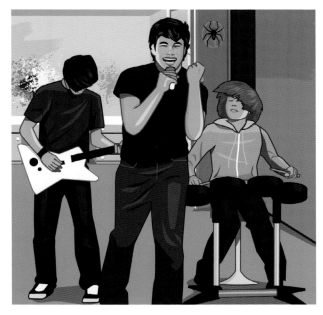

Greg Paprocki

Youth Jam (2008)
Adobe Illustrator

Rhiannon Cunag

Bop magazine: Jonas Bros (2009)
Adobe Illustrator

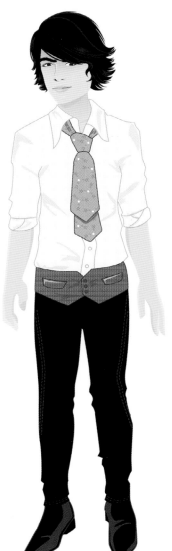

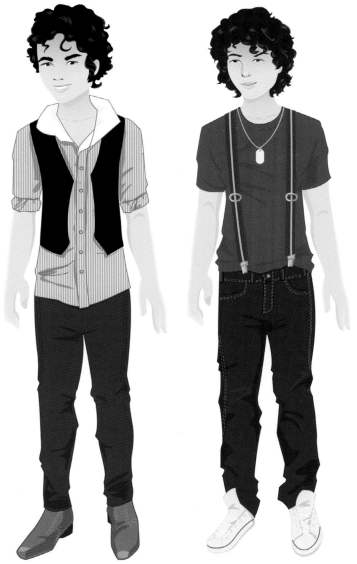

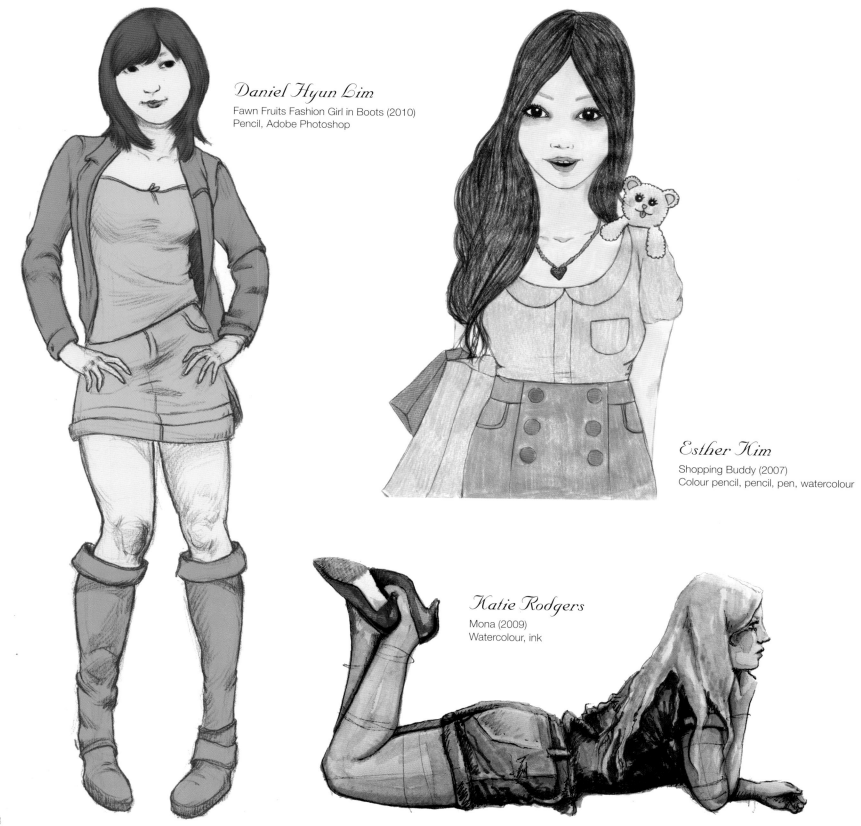

Daniel Hyun Lim
Fawn Fruits Fashion Girl in Boots (2010)
Pencil, Adobe Photoshop

Esther Kim
Shopping Buddy (2007)
Colour pencil, pencil, pen, watercolour

Katie Rodgers
Mona (2009)
Watercolour, ink

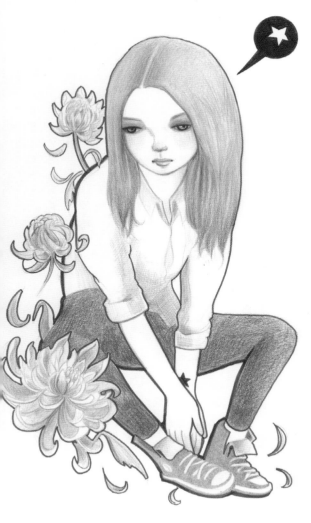

Erica Cho

Forever Converse (2010)
Colour pencil, graphite pencil

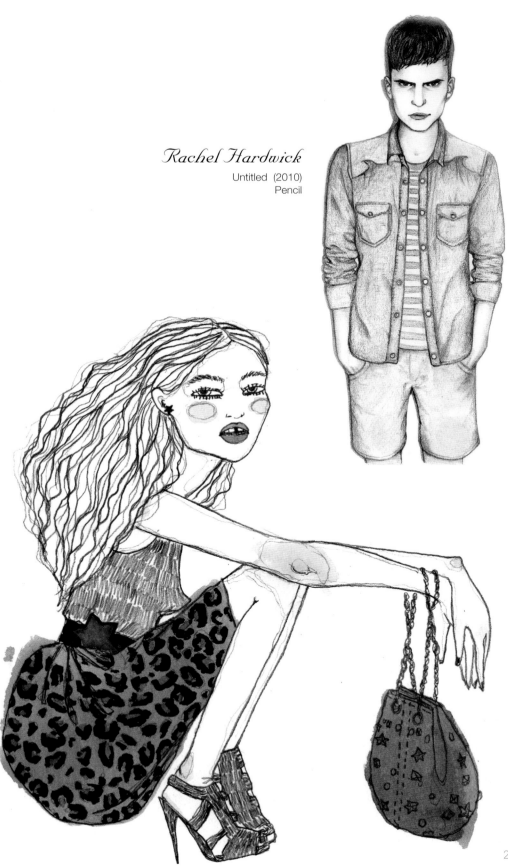

Rachel Hardwick

Untitled (2010)
Pencil

Loreto Binvignat Streeter

Rika Magazine 2 (2010)
Watercolour, pencil

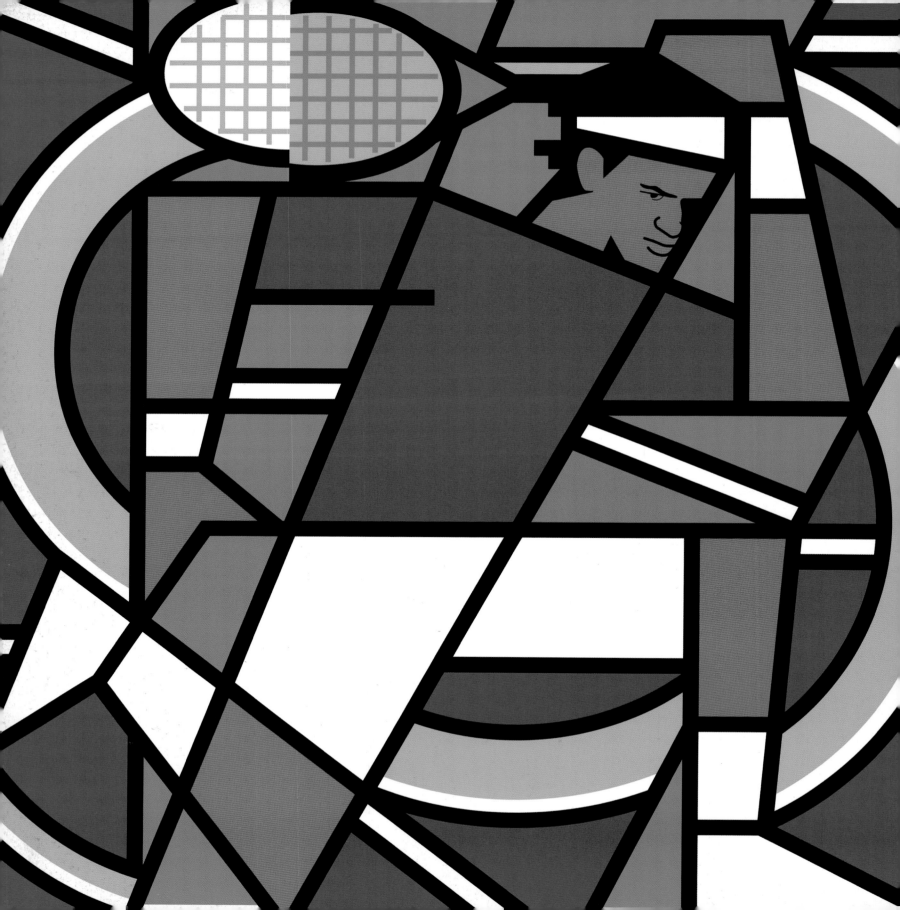

Sports & Leisure

previous page:

Bob Kessel

Roger Federer (2007)
Adobe Illustrator

Annelie Carlström

Flumaholics (2010)
Pencil, Adobe Photoshop

Jacquie O'Neill

Now Magazine: Bikini Bootcamp 2 (2008)
Adobe Illustrator

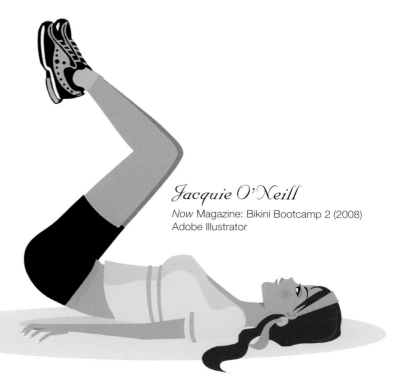

Jacquie O'Neill

Now Magazine: Bikini Bootcamp 1 (2008)
Adobe Illustrator

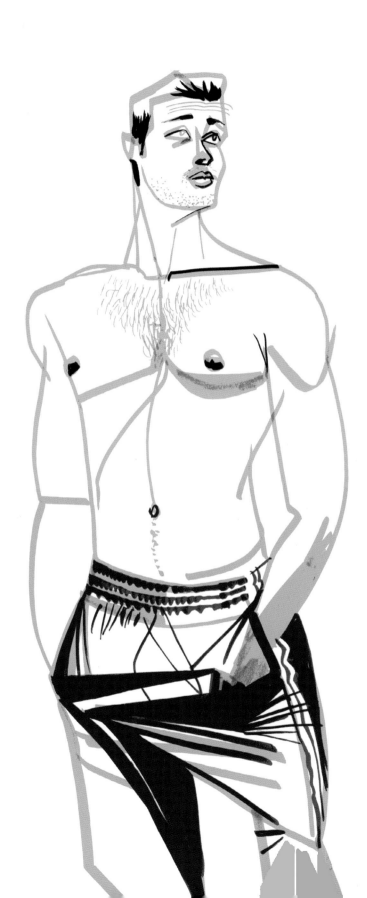

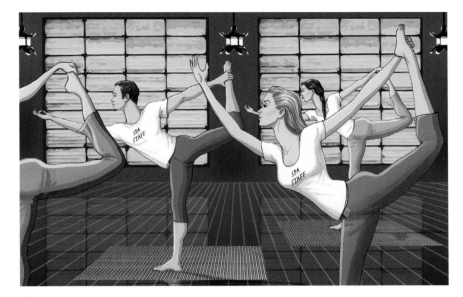

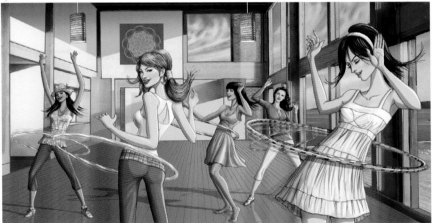

Rob De Bank

American Spa magazine: Hula Hoop Spa (2008)
Pen and ink, Adobe Photoshop

Rob De Bank

American Spa magazine: Yoga Spa Staff (2007)
Pen and ink, Adobe Photoshop

Carlos Aponte

Ridge I (2009)
Ink on paper

Jacquie O'Neill

Now magazine: WorkOut 1 (2008)
Adobe Illustrator

Luis Tinoco

VIVE magazine (Spain): Gym (2008)
Adobe Photoshop

Jacquie O'Neill

Now magazine: WorkOut 2 (2008)
Adobe Illustrator

Alena Lavdovskaya
Illustrations for www.stylesight.com (2009)
Pencil, markers

Jacquie O'Neill
Me Moi Yoga Socks (2008)
Adobe Illustrator

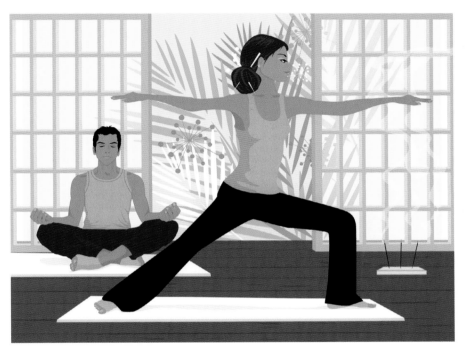

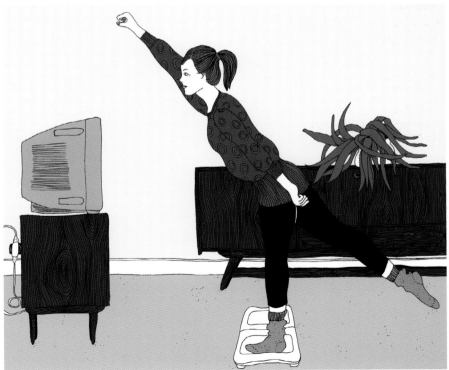

Ellen van Engelen
Wii Fit (2008)
Pen and ink, Adobe Photoshop

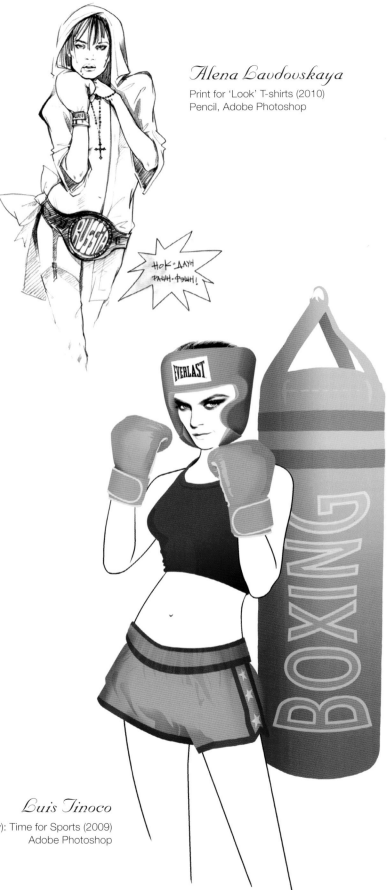

Alena Lavdovskaya

Print for 'Look' T-shirts (2010)
Pencil, Adobe Photoshop

НОК-ДАУН
РАШН-ФЭШН!

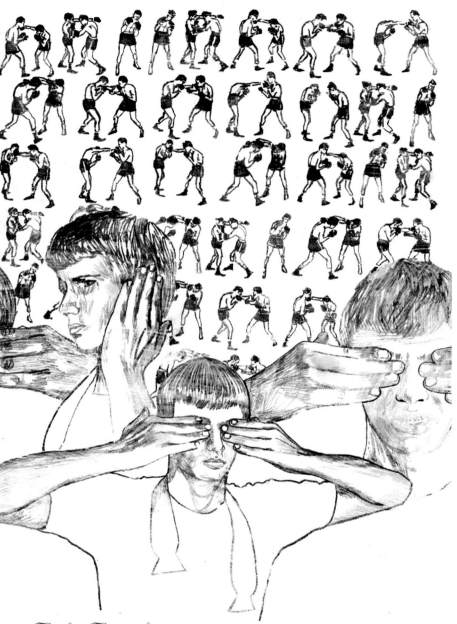

André Azevedo

Box (2009)
Pencil

Luis Tinoco

Glamour magazine (Germany): Time for Sports (2009)
Adobe Photoshop

Michael Pfleghaar
Spring Training (The Haves and Have Nots) (2004)
Oil on canvas

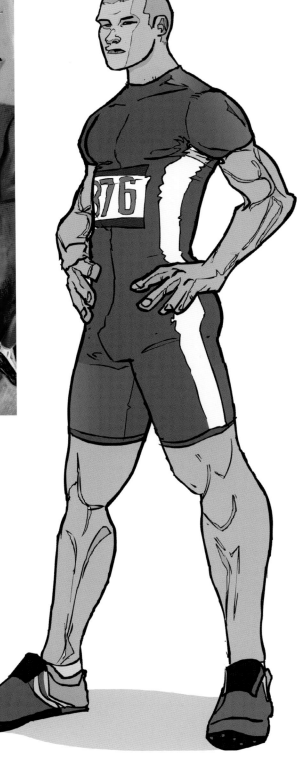

Richard James
Athlete 13 (2002)
Adobe Flash

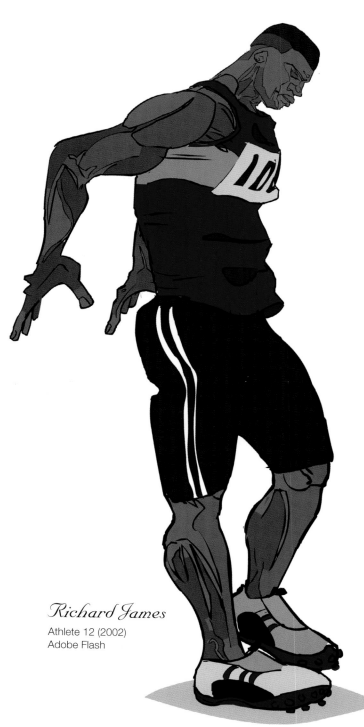

Amose

Run (2006)
Adobe Photoshop, Adobe Illustrator

Richard James

Kurt Resting (2002)
Adobe Flash

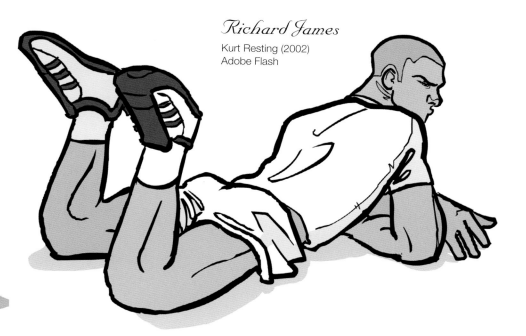

Richard James

Athlete 12 (2002)
Adobe Flash

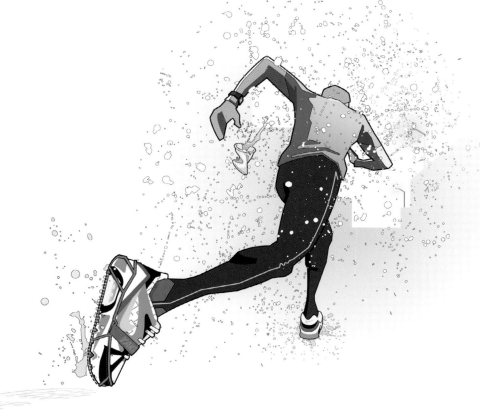

James Frank Robert Sneddon

Maxim (US) Winter Runner (2008)
Macromedia FREEHAND, Adobe Illustrator

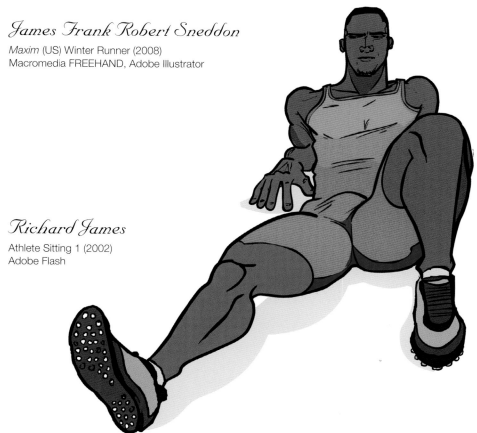

Richard James

Athlete Sitting 1 (2002)
Adobe Flash

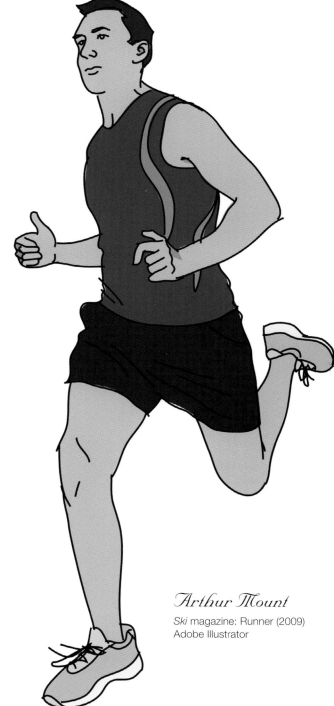

Arthur Mount

Ski magazine: Runner (2009)
Adobe Illustrator

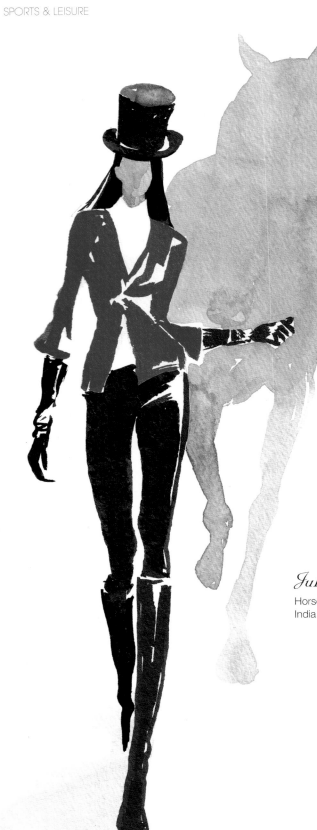

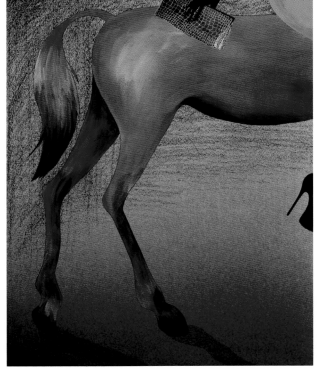

Odile van der Stap
Rider and Horse (2009)
Corel Painter X

Julie Johnson

Horsewoman (2006)
India ink, watercolour on paper

Katie van Harreveld
La Vie en Rose magazine: Editorial Illustration (2007)
Pencil, acrylic, ink, photo collage, Adobe Photoshop

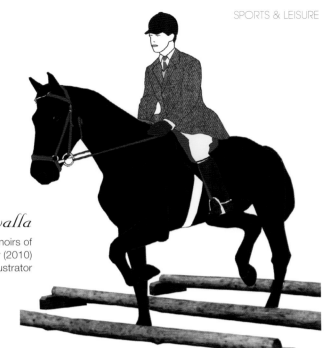

Hormazd Geve Narielwalla

Henry Wynmalen (commissioned for the memoirs of
Michael Skinner, Master Tailor of Dege & Skinner (2010)
Adobe Photoshop, Adobe Illustrator

Kerstin Wacker

Horse Dealer (2007)
Watercolour, ink pen, Adobe Photoshop

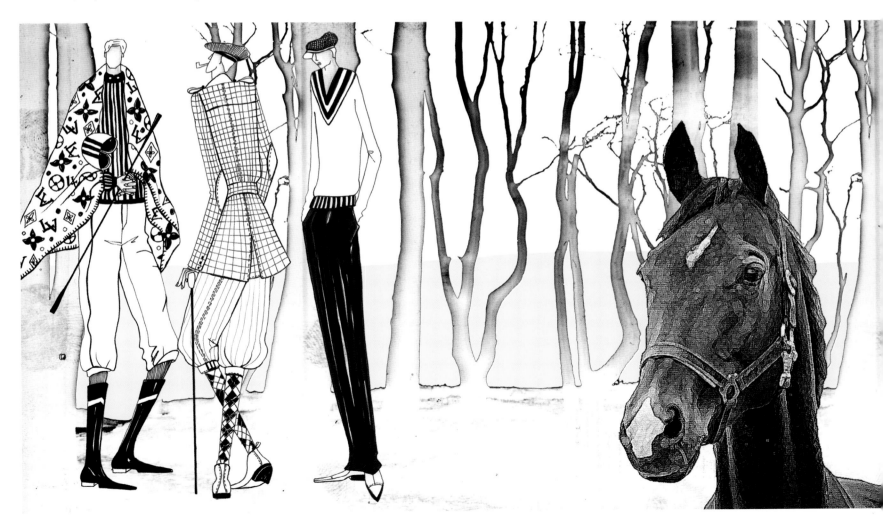

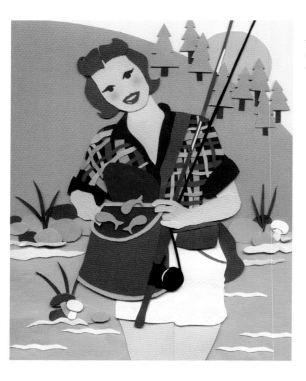

Maria Danalakis

Gone Fishing (2003)
Collage on paper

Charlene Chua

Golf (2006)
Adobe Illustrator

Greg Paprocki

Cherry Bombs Golf Girl (2008)
Adobe Illustrator

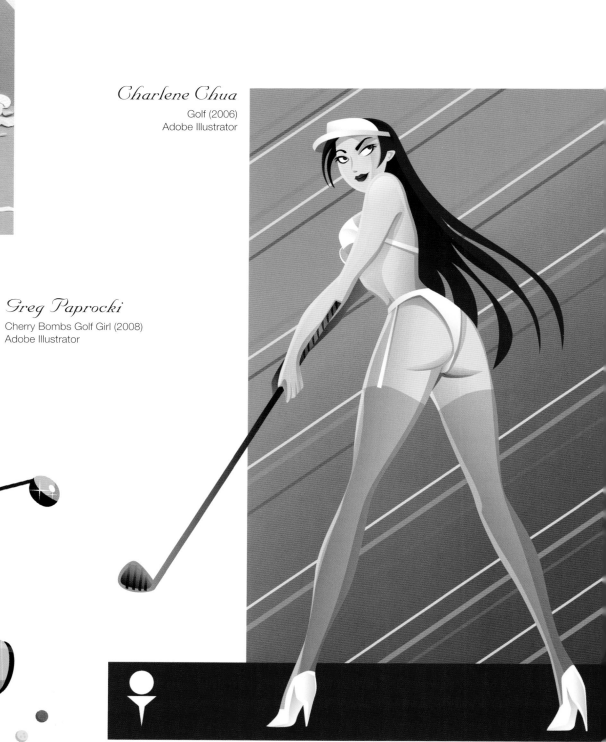

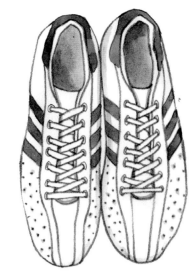
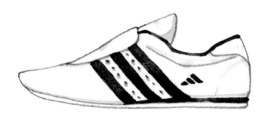
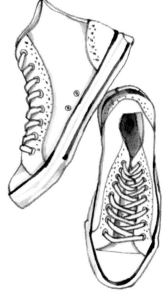
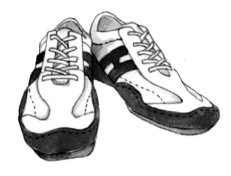

Yumi Imai

Personal Work (2008)
Powdered mineral pigments, hide glue

Christian Borstlap

Adidas (2002)
Adobe Illustrator, Adobe Photoshop

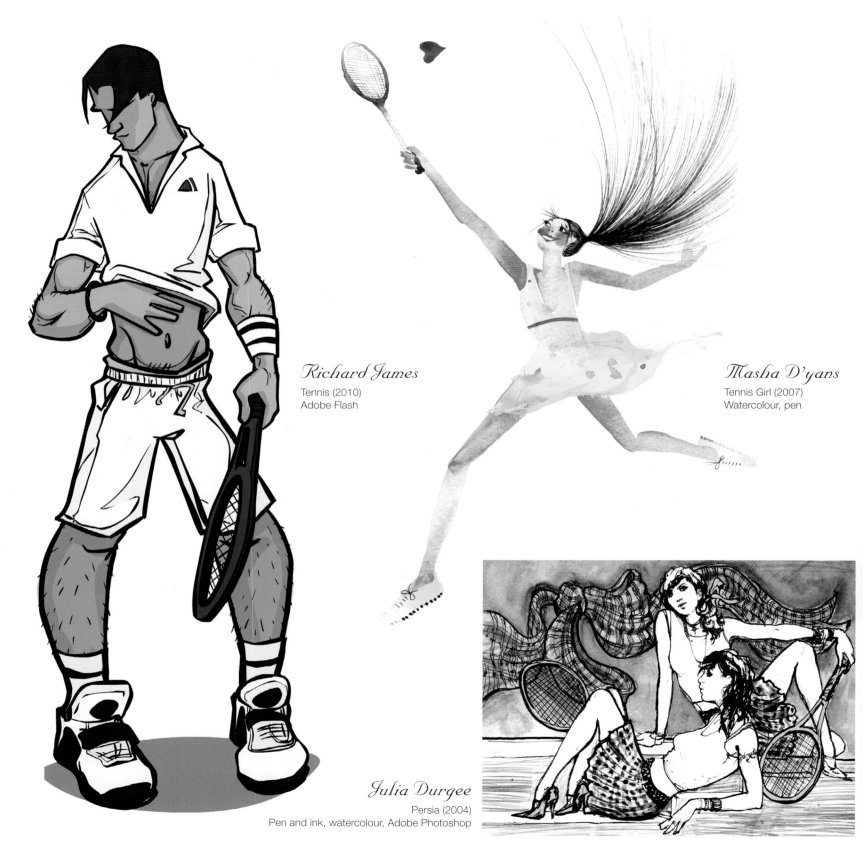

Richard James

Tennis (2010)
Adobe Flash

Masha D'yans

Tennis Girl (2007)
Watercolour, pen

Julia Durgee

Persia (2004)
Pen and ink, watercolour, Adobe Photoshop

Maria Cardelli

Tennis (2009)
Adobe Photoshop

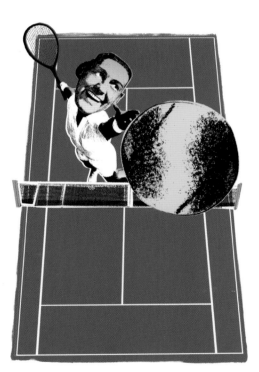

Pierre-Paul Pariseau

Tennis in My Mind (2006)
Collage, Adobe Photoshop

ufho

Tennis (Spirit Series) (2008)
Adobe Photoshop

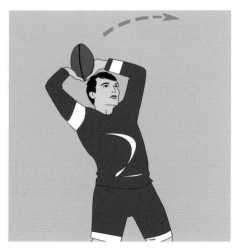

Maria Cardelli

Rugby (2009)
Adobe Photoshop

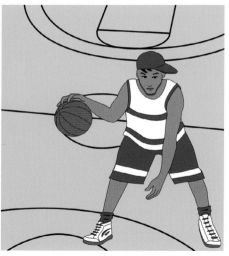

Maria Cardelli

Basketball (2009)
Adobe Photoshop

Maria Cardelli

Volleyball (2009)
Adobe Photoshop

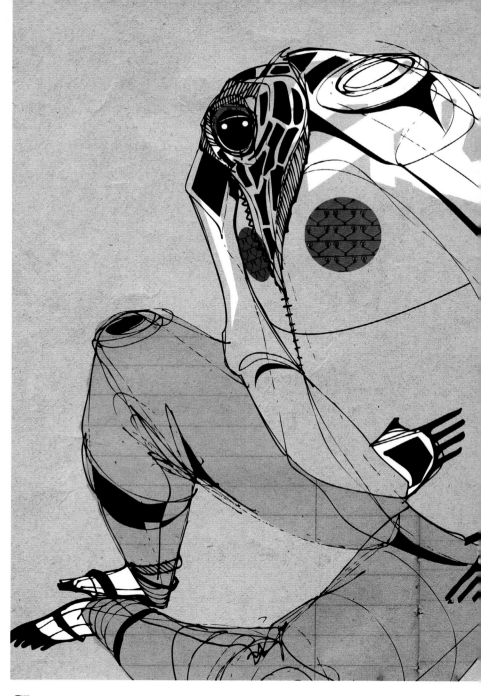

Amose

HasnÈze (2008)
Adobe Photoshop, Adobe Illustrator

Richard James
Cesc Fàbregas (2010)
Adobe Flash

Simon Elson
Premiership (2010)
Adobe Illustrator, Adobe Photoshop

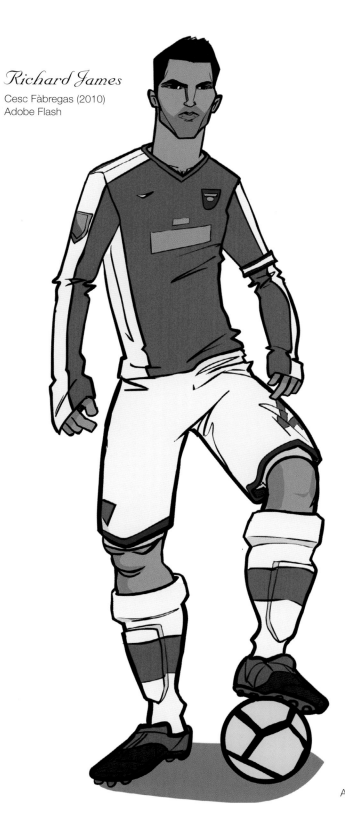

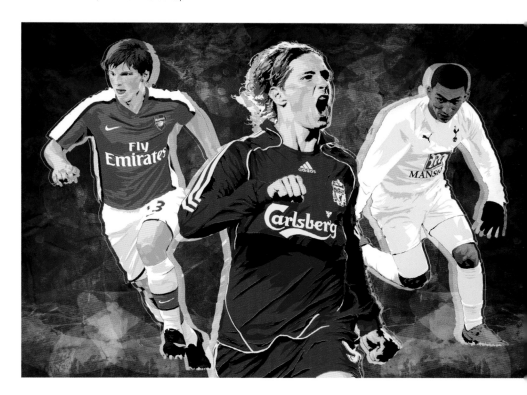

Gormax
Soccer (2008)
Adobe Illustrator, Adobe Photoshop

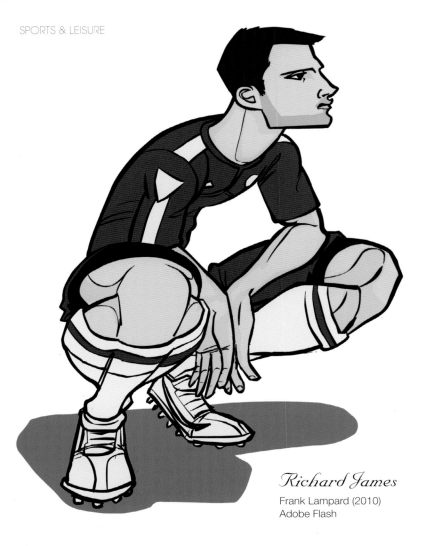

Richard James

Frank Lampard (2010)
Adobe Flash

ufho

Soccer (Spirit Series) (2008)
Adobe Photoshop

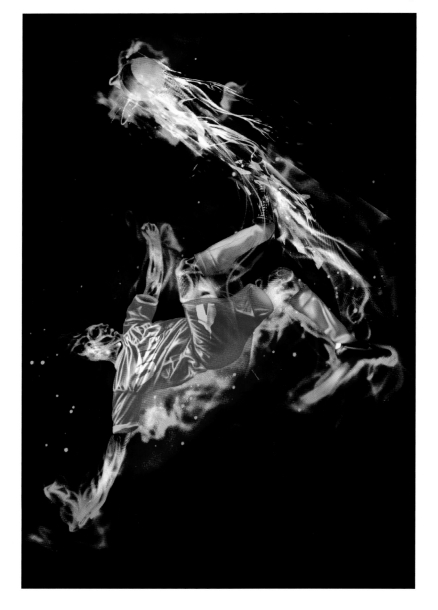

Phil McCollam

Philrules.com Rookie Card (2009)
Adobe Illustrator

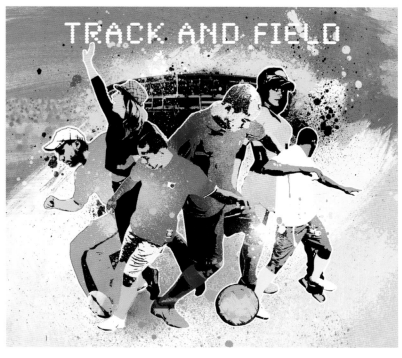

Henry Obasi
Track and Field CD (2009)
Spray paint, Adobe Photoshop

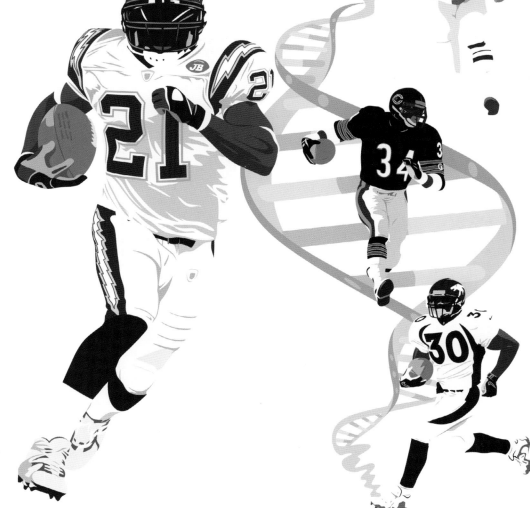

Arthur Mount
Play magazine: LaDainian Tomlinson's DNA (2006)
Adobe Illustrator

Andrew Painter

Quarterback (2008)
Adobe Illustrator

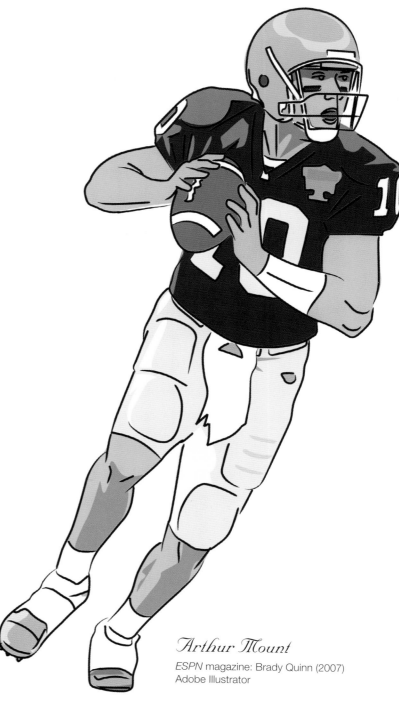

Arthur Mount

ESPN magazine: Brady Quinn (2007)
Adobe Illustrator

Luis Tinoco

Top magazine (UK): Rugby (2009)
Watercolour, Adobe Photoshop

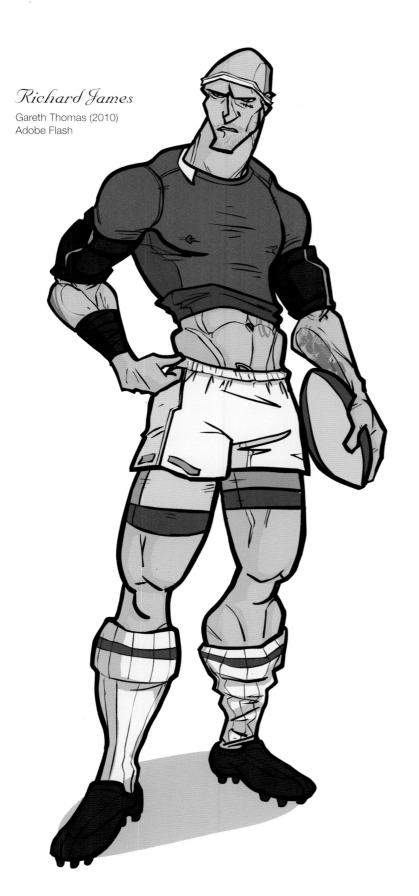

Richard James
Gareth Thomas (2010)
Adobe Flash

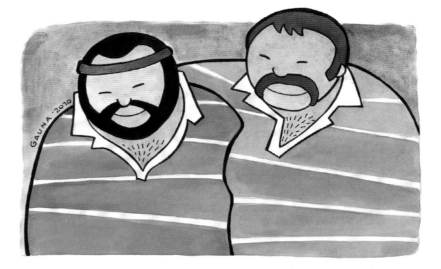

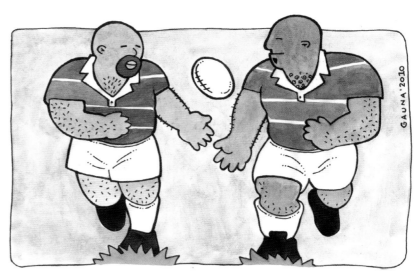

Ruben Gauna
Bearlentine: Rugby 01 (2010)
Watercolours, ink

Laurence Whiteley
Skiers (2008)
Adobe Photoshop

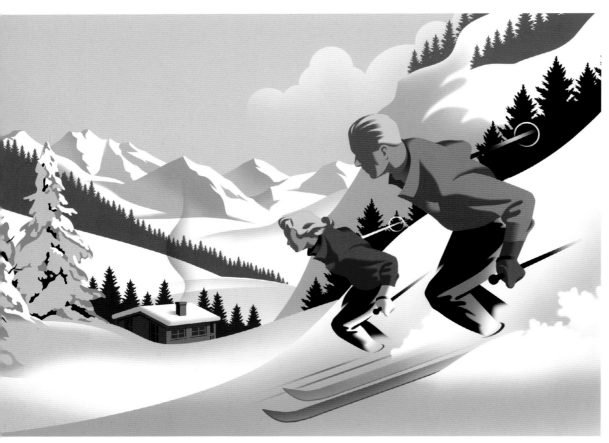

Arthur Mount
High Jump (2002)
Adobe Illustrator

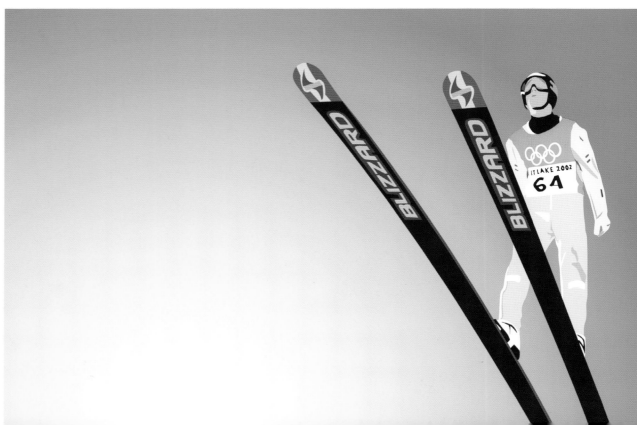

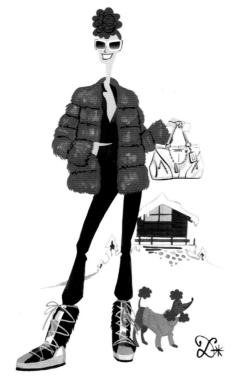

James Dignan
Icon magazine (Germany) (2009)
Gouache

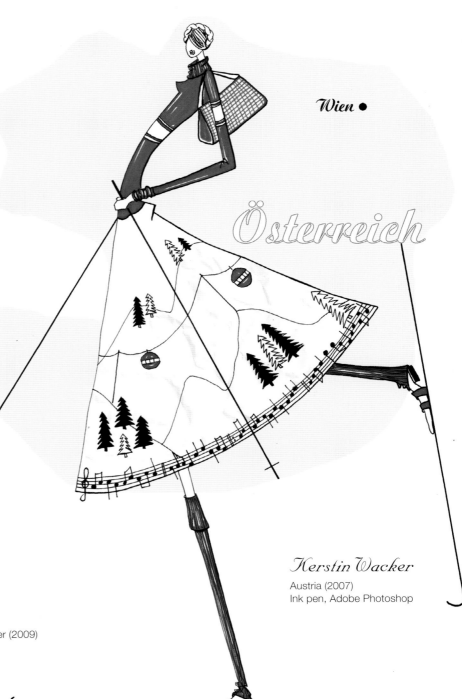

Wien ●

Österreich

Kerstin Wacker
Austria (2007)
Ink pen, Adobe Photoshop

Jacquie O'Neill
Penguin Early Readers: Figure Skater (2009)
Adobe Illustrator

243

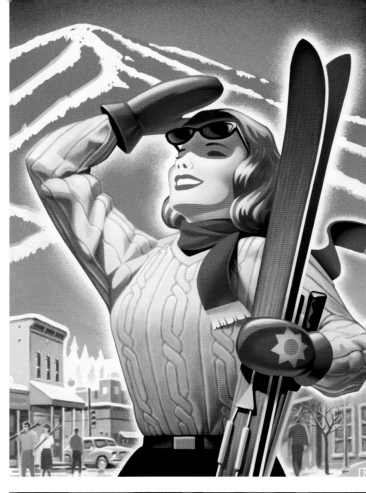

Gary Newman
Ski Girl Year (2009)
Adobe Illustrator

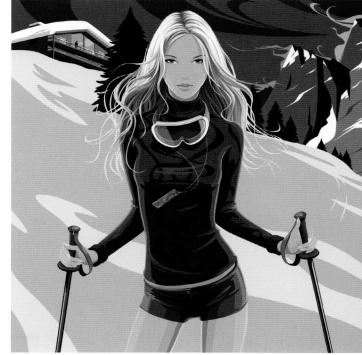

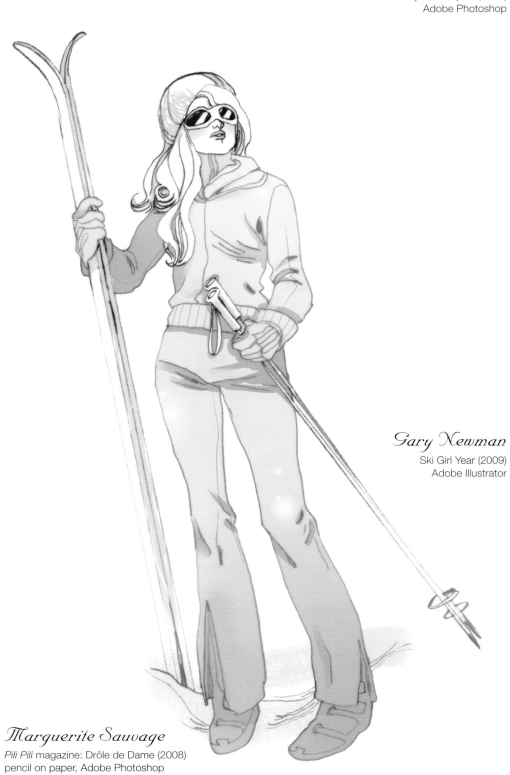

Marguerite Sauvage
Pili Pili magazine: Drôle de Dame (2008)
pencil on paper, Adobe Photoshop

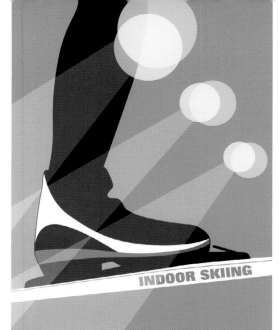

Kari Moden

Indoor Skiing (2006)
Adobe Illustrator

INDOOR SKIING

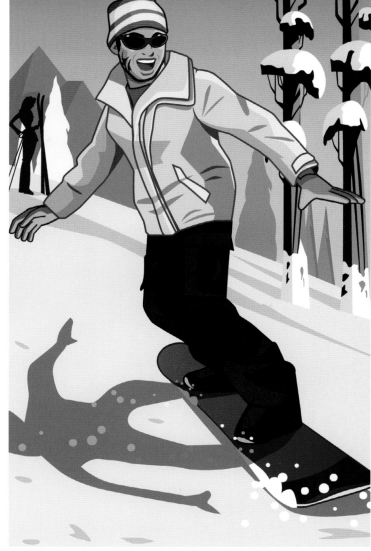

Greg Paprocki

Snowboarder (2008)
Adobe Illustrator

Rob De Bank

Skier (Western Airlines) (1985)
Semi transparent inks, acrylic and
gouache paints on CIBA chrome

245

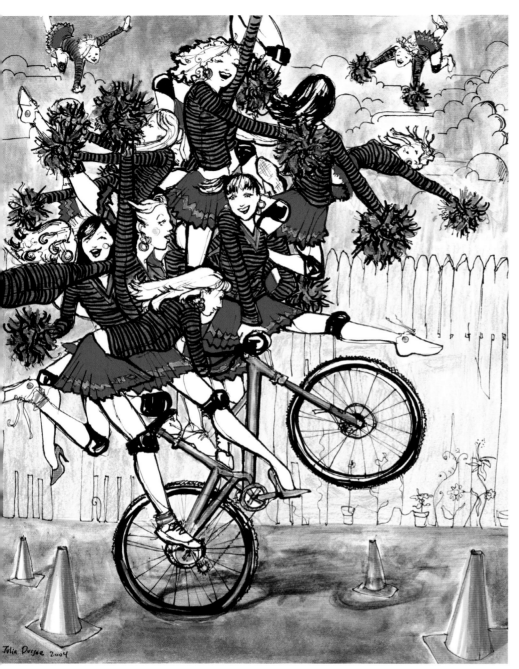

Julia Durgee

Spirit Bike (2004)
Pen and ink, watercolour, coloured pencil, Adobe Photoshop

Greg Paprocki

Girl On Bike (2005)
Adobe Illustrator

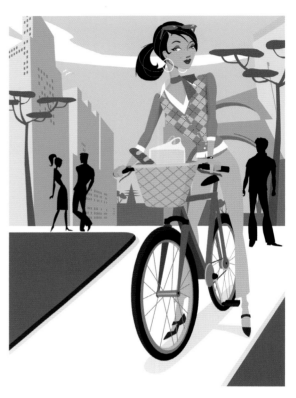

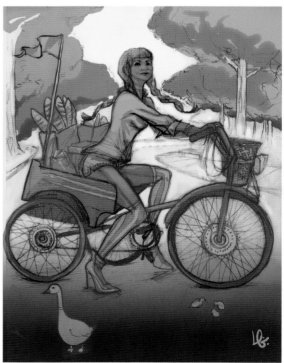

Laura Galbraith

Bike Bread Delivery (2007)
pencil, Adobe Photoshop

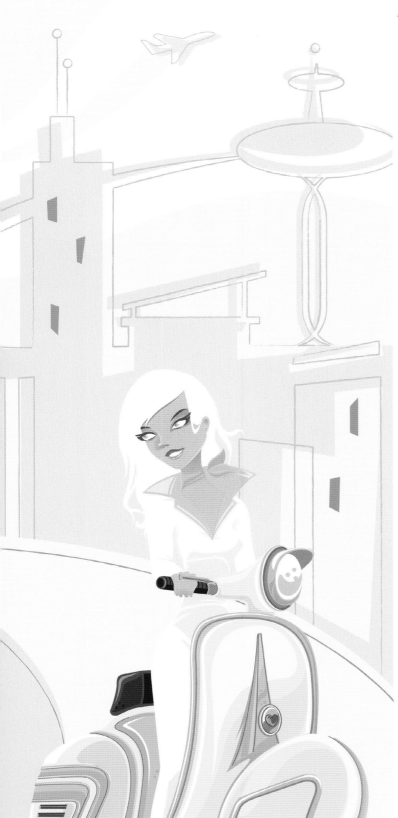

Rhiannon Cunag
Vespa (2007)
Adobe Illustrator

Arthur Mount
The London Times: Cycling Fitness (2008)
Adobe Illustrator

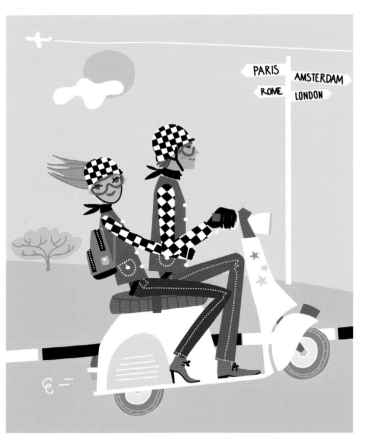

Maxim Savva

Horoscope: Gemini (2009)
Adobe Illustrator

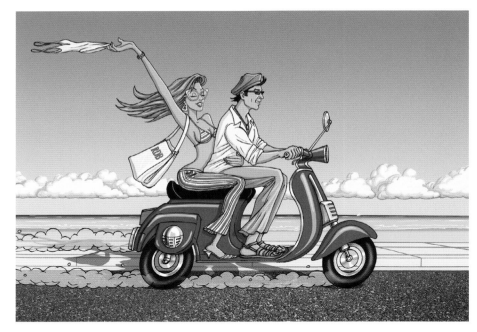

Rob De Bank

Vespa Couple (2000)
Pen and ink, Adobe Photoshop

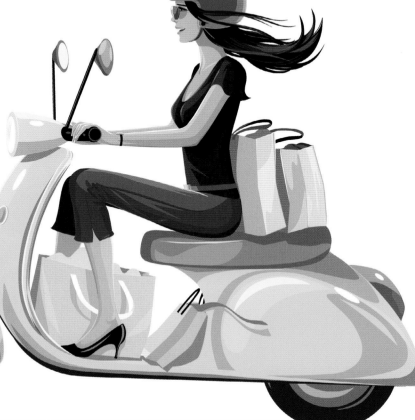

Gary Newman

Shopping Girl Year (2009)
Adobe Illustrator

Ivan Kasaj

Retrogirl Vespa (2007)
Adobe Illustrator

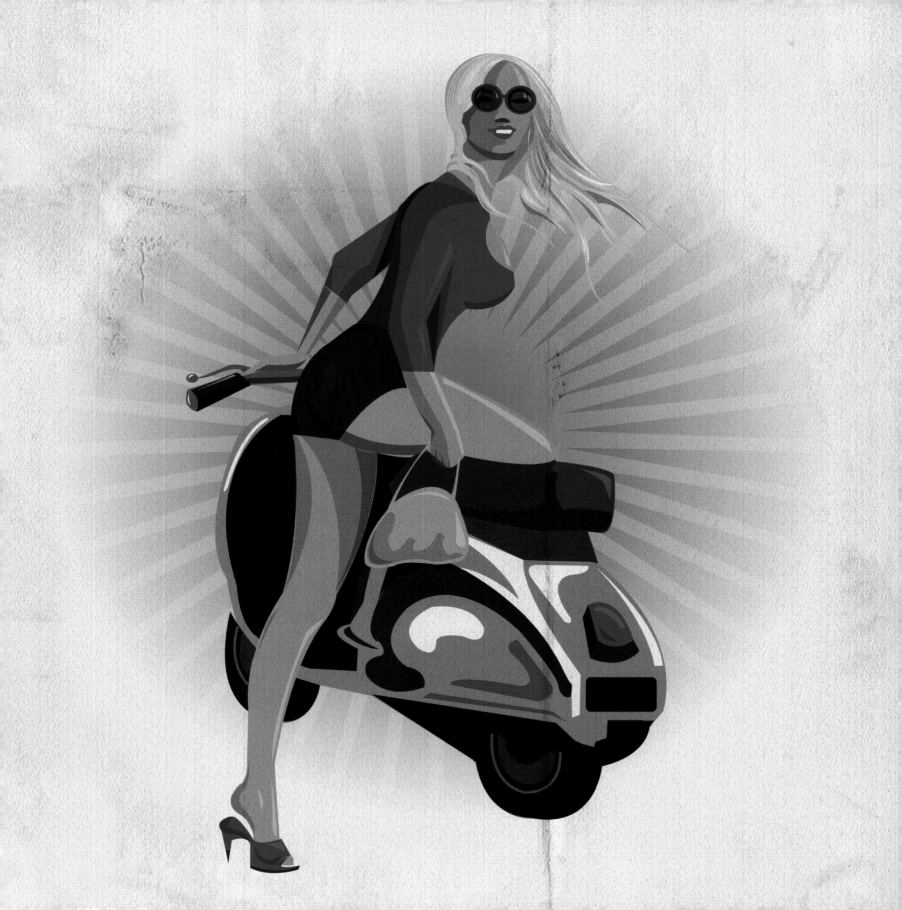

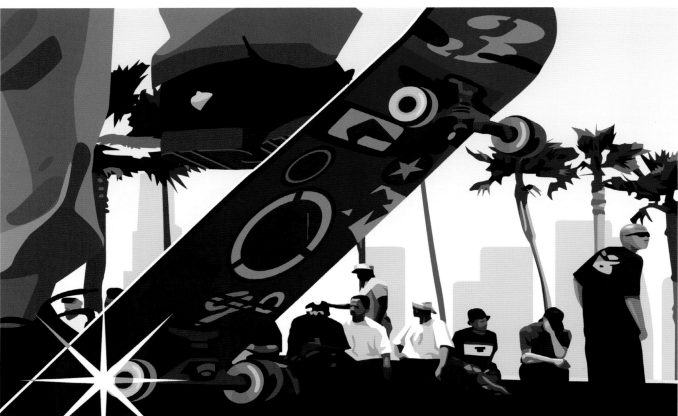

Greg Paprocki
Urban Skaters (2008)
Adobe Illustrator, Adobe Photoshop

Greg Paprocki
Skater Riding the Rail (2008)
Adobe Illustrator

Amose
Mele Pele (2009)
Ink and glued paper on paper

David Pfendler
Loop (2008)
Adobe Photoshop

Clare Nicholas
Street Surfers (2009)
Adobe Photoshop

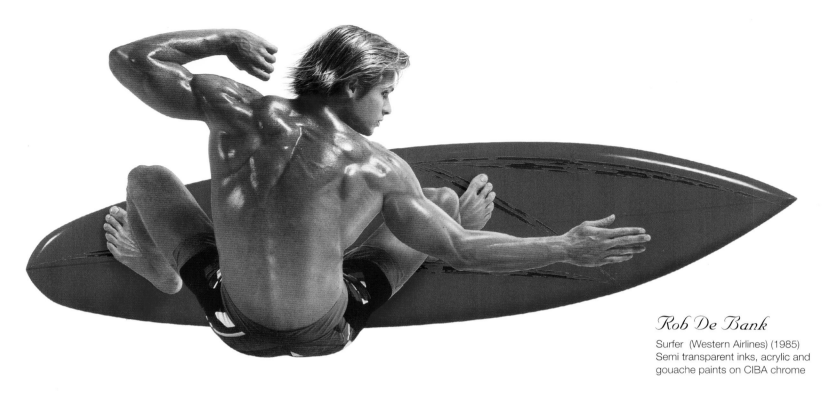

Rob De Bank

Surfer (Western Airlines) (1985)
Semi transparent inks, acrylic and
gouache paints on CIBA chrome

Ivan Kasaj

Forest Surfer (2009)
Adobe Illustrator

Christopher 'Wing' King

Surf Now, Apocalypse Later (2010)
Pen and ink, Adobe Illustrator

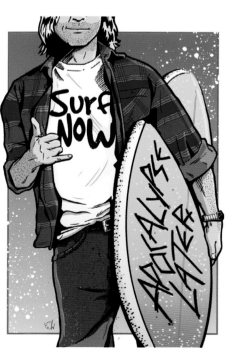

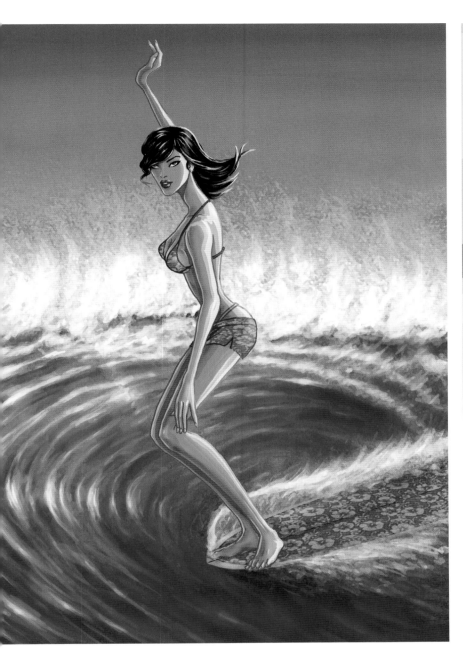

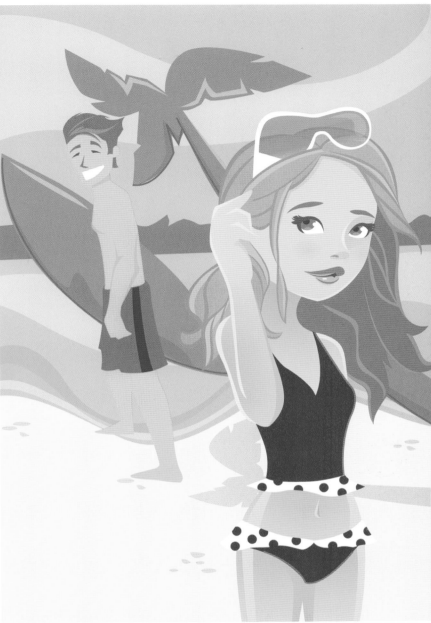

Rob De Bank
Surf Babe (2002)
Pen and ink, Adobe Photoshop

Rhiannon Cunag
GL magazine: Summer Crush (2008)
Adobe Illustrator

Kari Moden
Scuba (2007)
Adobe Illustrator

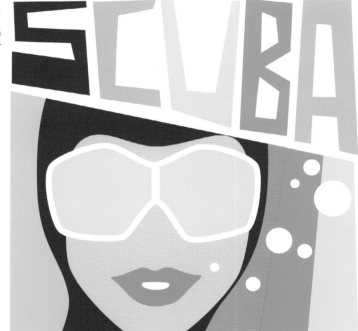

Richard James
Fast Suit (2002)
Adobe Flash

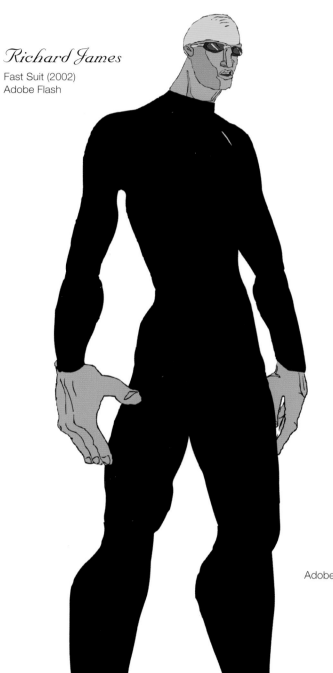

Jeffrey Herrero
Watercube (2008)
Adobe Photoshop, Adobe Illustrator

Maria Cardelli

By the Pool (2005)
Adobe Photoshop, Adobe Illustrator

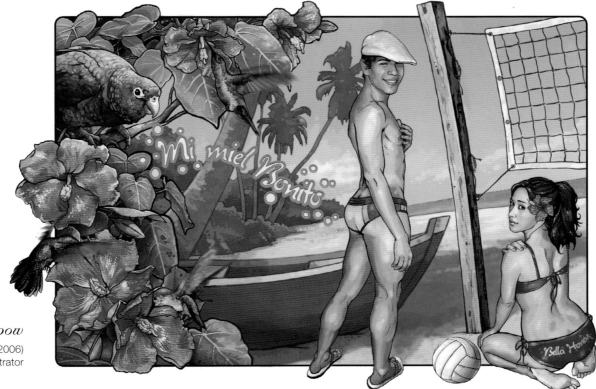

Dustin Papow

Mi Miel Bonito (2006)
Adobe Photoshop, Adobe Illustrator

Autumn Whitehurst
Leo (2009)
Adobe Photoshop, Adobe Illustrator, Corel Painter

Luis Tinoco
Vive magazine (SPAIN): Sunblock (2008)
Adobe Photoshop

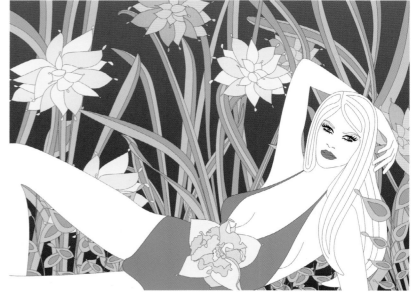

Maria Cardelli
In the Garden (2006)
Adobe Photoshop, Adobe Illustrator

Kenji Nuñez

Kboi Sugar-free Treats: Limeboi (2009)
Pencil, Adobe Photoshop

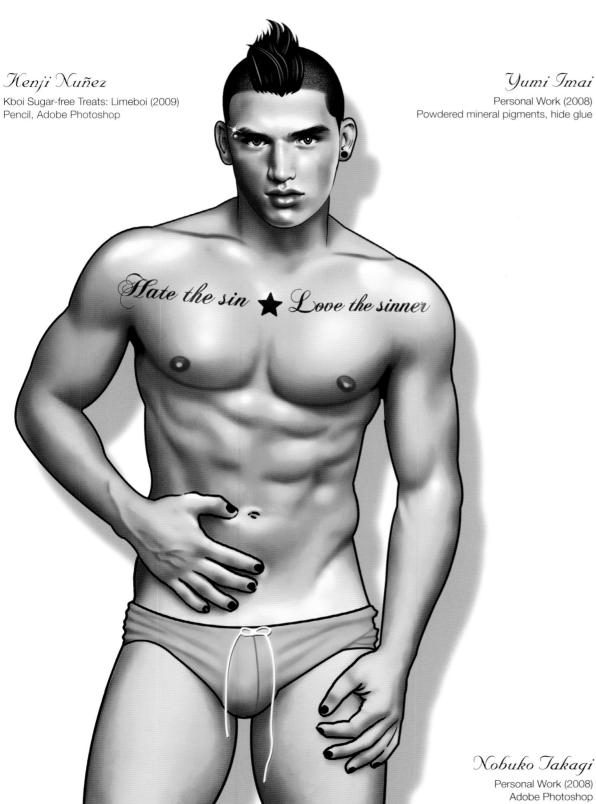

Yumi Imai

Personal Work (2008)
Powdered mineral pigments, hide glue

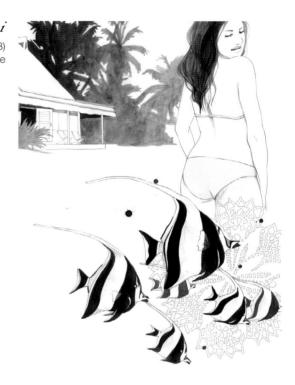

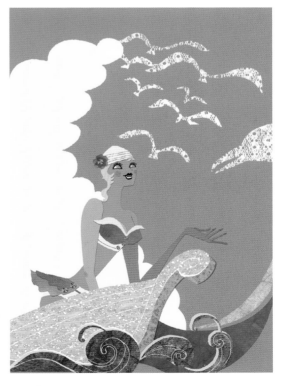

Nobuko Takagi

Personal Work (2008)
Adobe Photoshop

Robert Tirado

Lora Lamour (2008)
Adobe Photoshop, Adobe Illustrator

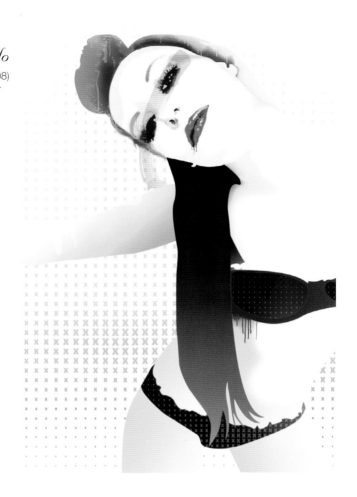

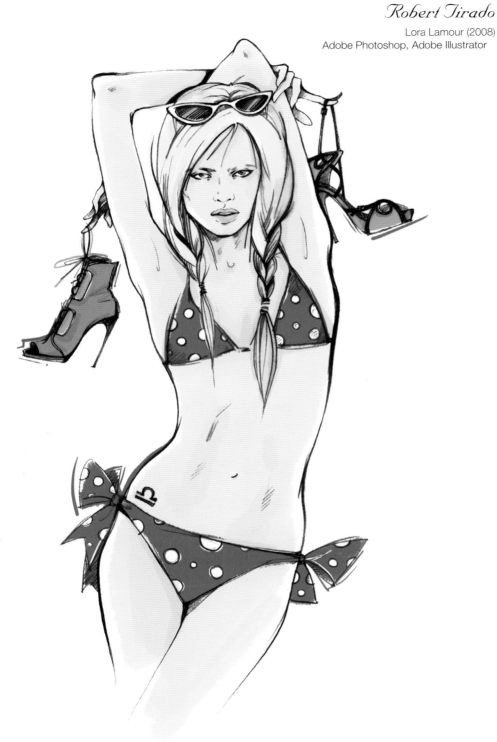

Alena Lavdovskaya

Elle (Russia): Summer Horoscope (2010)
Pencil, Adobe Photoshop

Esther Kim

Beach Girls (2008)
Pen, pencil, watercolour

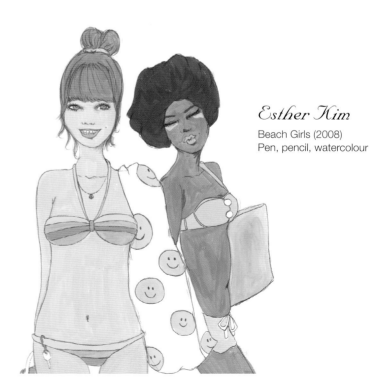

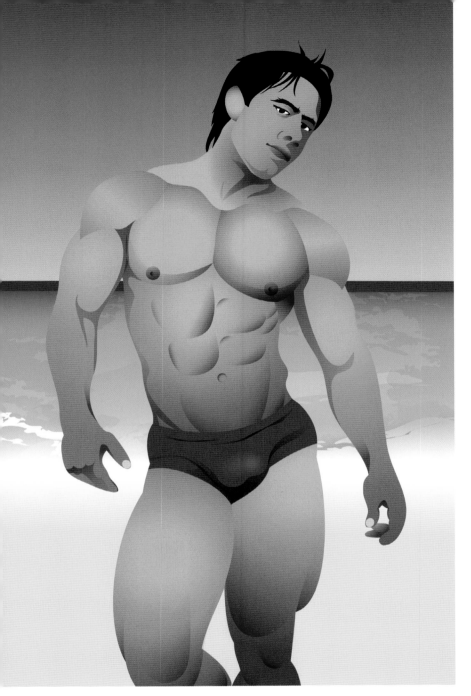

Gormax
Beach Boy (2010)
Adobe Illustrator

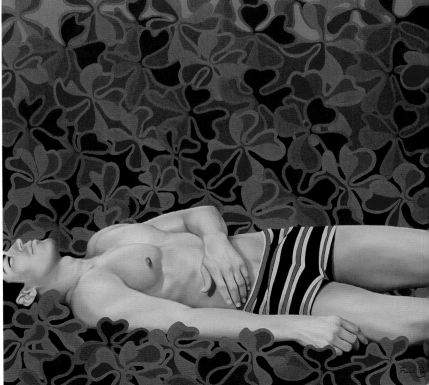

Pascal Roy
Lying Peacefully (2004)
Oil on canvas

Brine
Ron in Orange (2004)
Coloured pencil

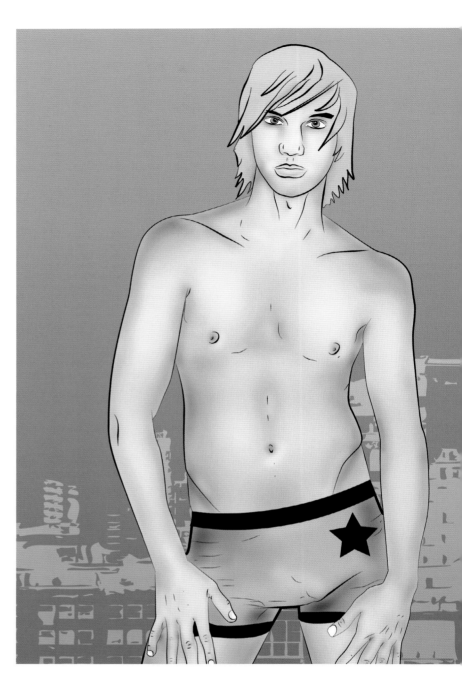

Jeffrey Herrero
Verano del 82 (2008)
Adobe Photoshop, Adobe Illustrator

Gary Coleman
White Man's Burden (2001)
Oil on canvas

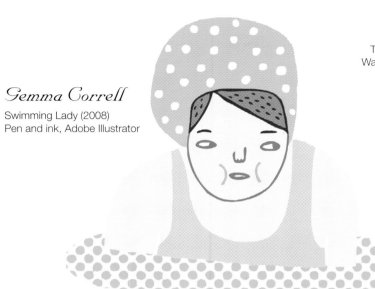

Gemma Correll

Swimming Lady (2008)
Pen and ink, Adobe Illustrator

Wendy Plovmand

This Seasons Musthave Bikini (2008)
Watercolour, pencil, Adobe Photoshop

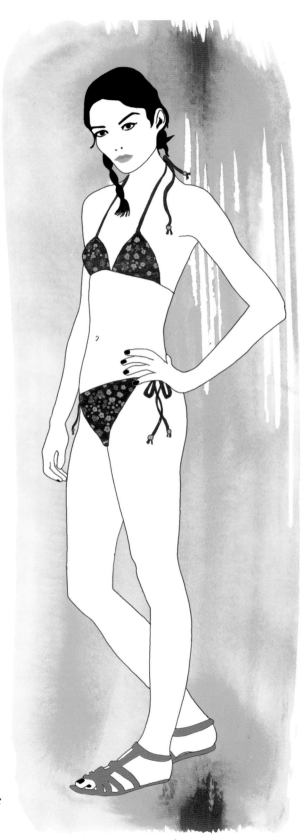

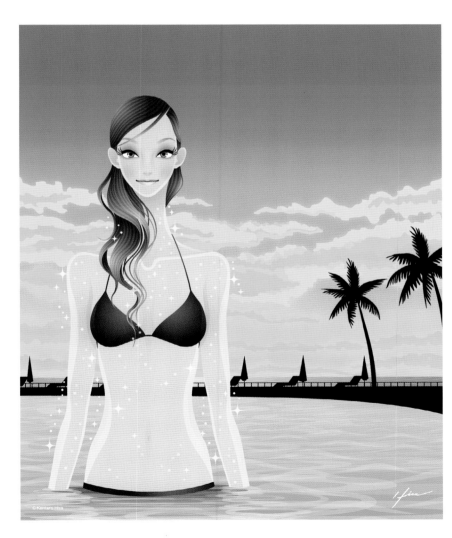

Kentaro Hisa

Personal Work (2006)
Adobe Illustrator

Shingo Shimizu

Fashion 4 (2009)
Adobe Illustrator

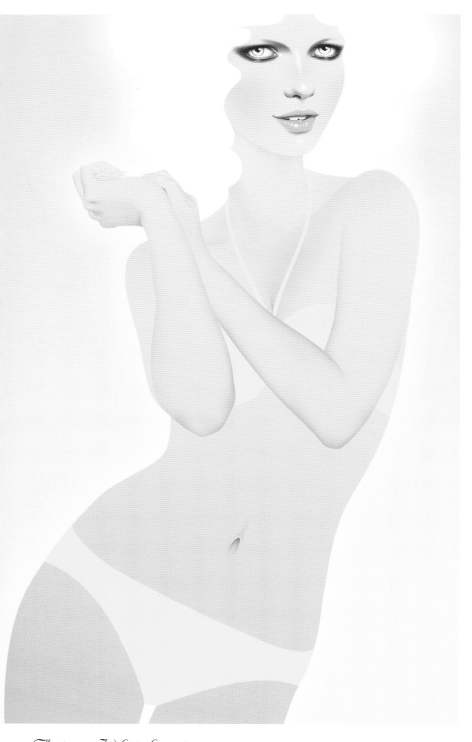

Autumn Whitehurst

New Fake Tan (2007)
Adobe Photoshop, Adobe Illustrator, Corel Painter

Maxim Savva

Independent Media Sanoma Magazine:
Cosmopolitan Shopping (2007)
Adobe Illustrator

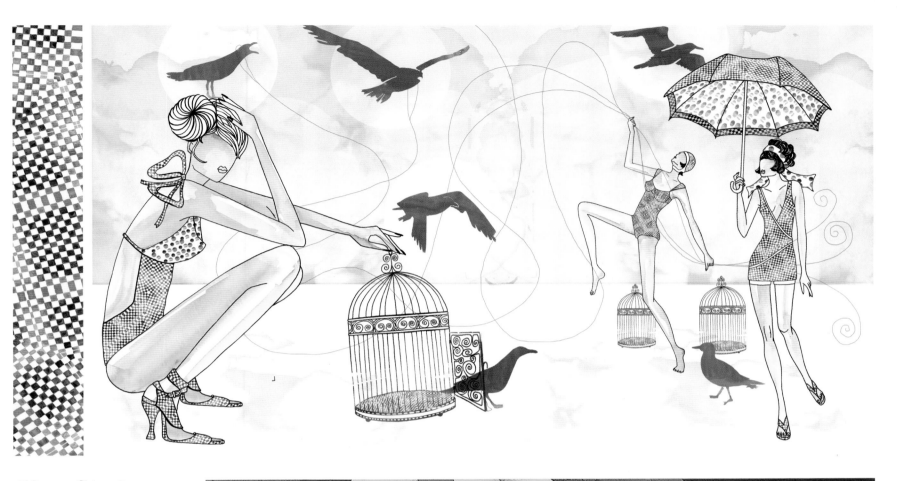

Kerstin Wacker

La Plage (2009)
Watercolour, ink pen, Adobe Photoshop

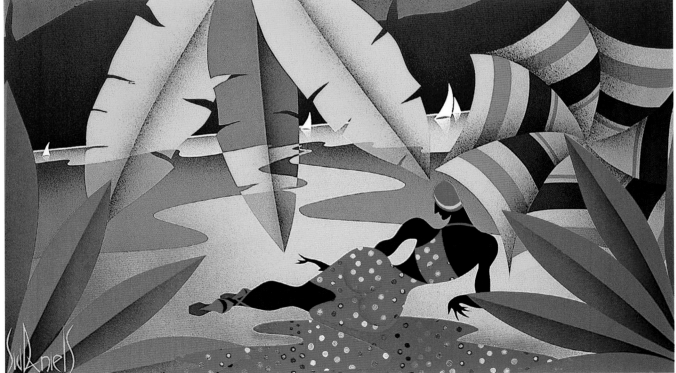

Sid Daniels

Bossa Nova Beach (2004)
Acrylic on canvas

Takiko Noda

Big Hats (2009)
Pencil, coloured pencil, gouache

Sid Daniels

Havana Heaven (1985)
Acrylic on canvas

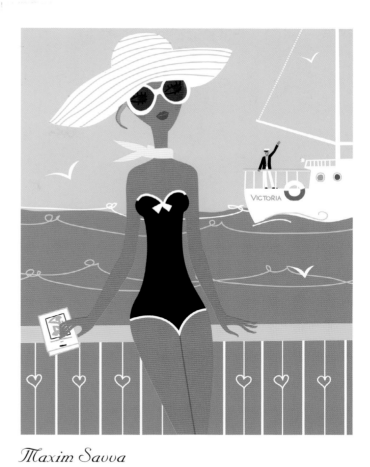

Maxim Savva

Horoscope: Virgo (2009)
Adobe Illustrator

Hanako Komachi

Personal Work (2007)
Acrylic

Atsushi Hara

Miki magazine: Coverpage
Pencil, Adobe Photoshop

Charlene Chua

Pool (2008)
Adobe Illustrator, Adobe Photoshop

Christian Borstlap

Editorial Line magazine (2000)
Adobe Illustrator, Adobe Photoshop

Alessandra Scandella

Hotel in Italy (Io Donna Rizzoli) (2009)
Corel Painter

Lisa Plaskett

Black Maillot (2008)
Charcoal, Adobe Illustrator

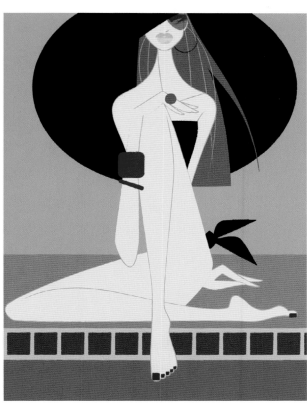

Greg Paprocki

Woman Attracting Attention (2009)
Adobe Illustrator

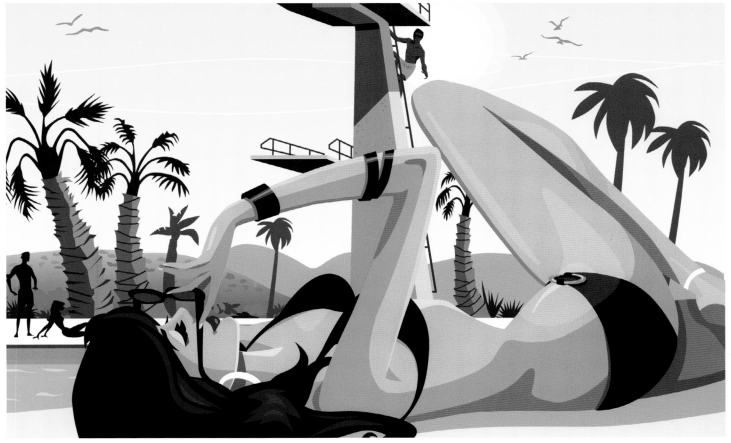

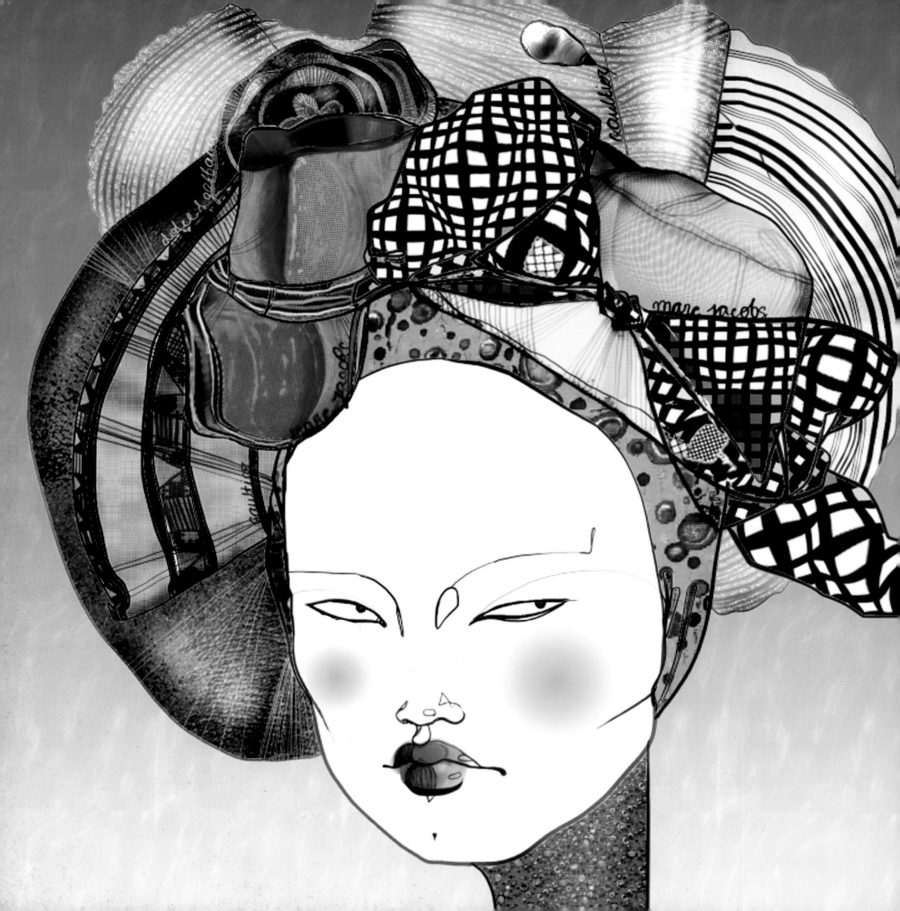

Accessories

previous page:

Artaksiniya

The Hatty (2008)
Corel Painter

Yumi Imai

Personal Work (2008)
Powdered mineral pigments, hide glue

Maria Cardelli

The Red Rose (2006)
Ink, Adobe Photoshop

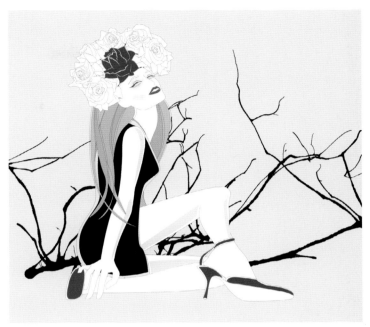

Maria Cardelli

Red Shoes (2004)
Ink, Adobe Photoshop

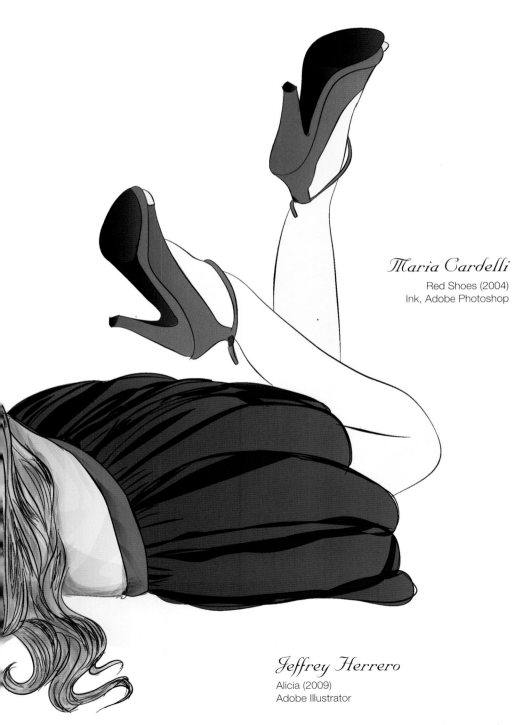

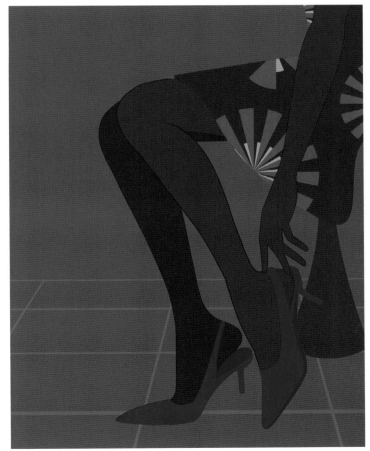

Jeffrey Herrero

Alicia (2009)
Adobe Illustrator

271

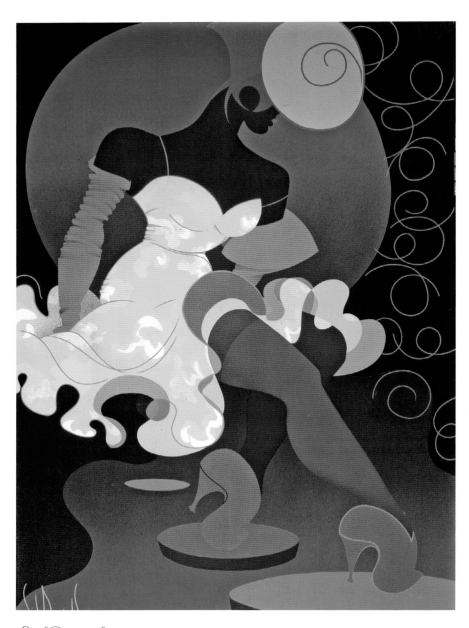

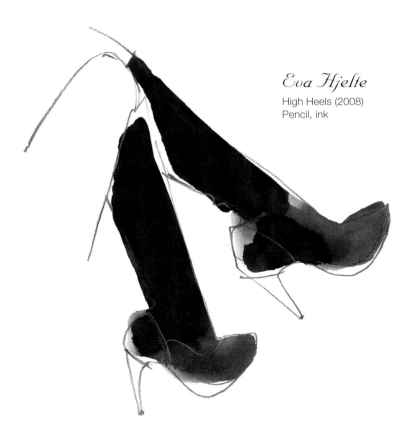

Eva Hjelte
High Heels (2008)
Pencil, ink

Sid Daniels
Brazillian Follies (1988)
Acrylic on canvas

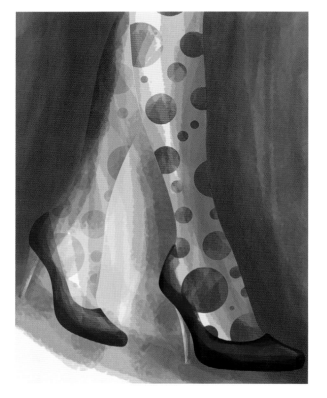

Maria Cardelli
Stockings (2008)
Ink, Adobe Photoshop

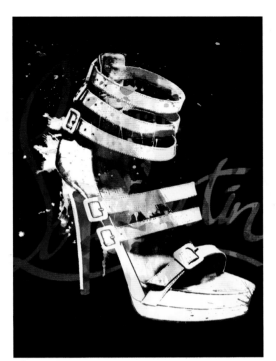

Luis Tinoco

Top magazine (UK): Christian Louboutin for Rodarte (2009)
Watercolour, Adobe Photoshop

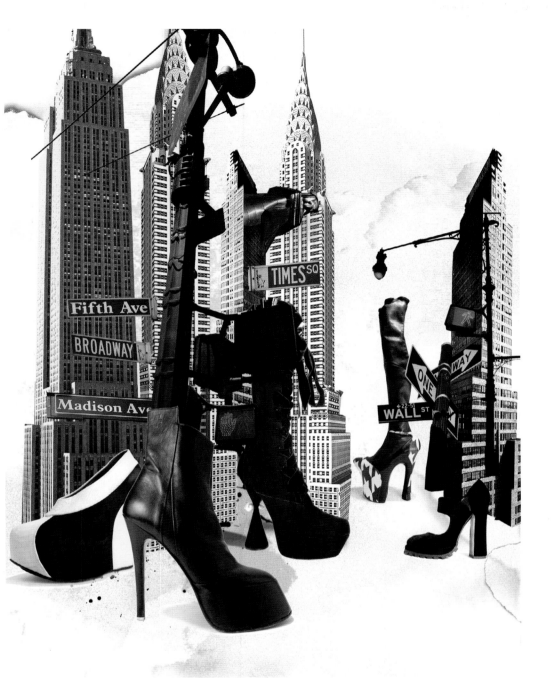

Cityabyss Illustration

Muse magazine (boots)/*The FashionArt* magazine: New York City Theme (2009)
Photography: Nicolas Clerc / Styling: Davina Lubelski
Collage, Adobe Photoshop

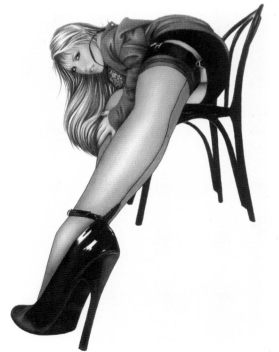

Barbara Jensen

Slammin Gams (2008)
Watercolour, coloured pencils, inks, charcoal

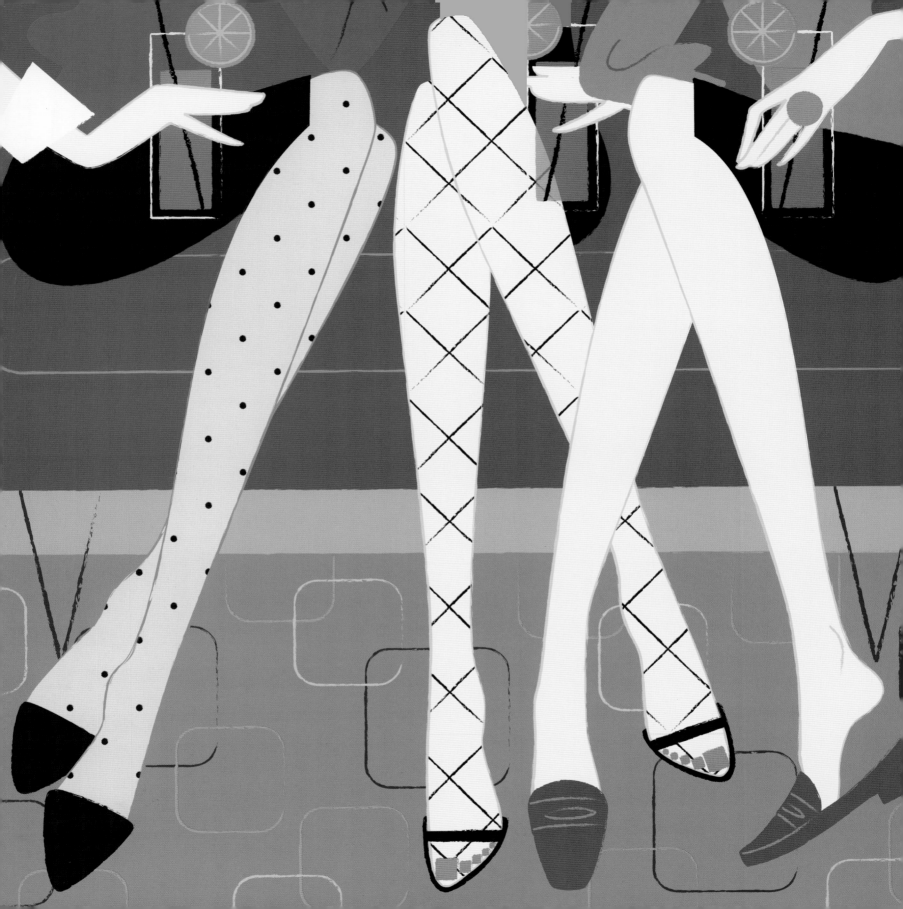

Alessandra Scandella

Black Shoes (2010)
Watercolour, collage, handmade paper

Luis Tinoco

Top magazine (UK): Rodarte (2009)
Watercolour, Adobe Photoshop

Lisa Plaskett

Suburbia (2008)
Charcoal, Adobe Illustrator

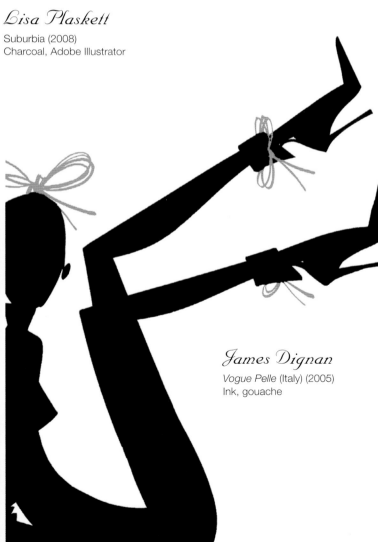

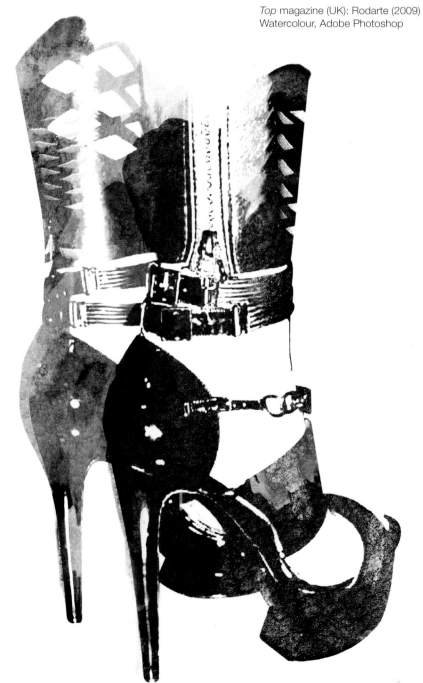

James Dignan

Vogue Pelle (Italy) (2005)
Ink, gouache

Jill Tovey

Ballet Shoes (2009)
Watercolour, photography, acrylics, pencil,
pen, oils, Adobe Photoshop, Corel Painter X

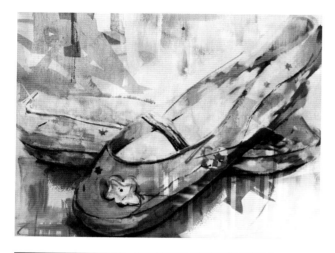

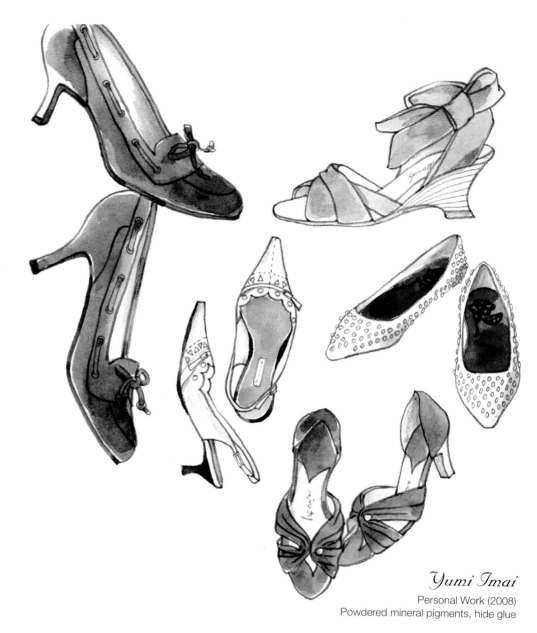

Yumi Imai

Personal Work (2008)
Powdered mineral pigments, hide glue

Piet Paris

Vogue (Japan): Schiaparelli (2003)
Pastels, stencil

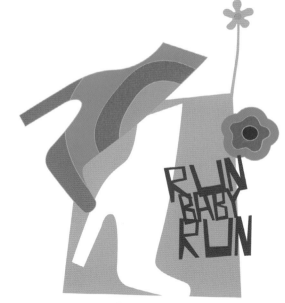

Kari Moden

Run Baby Run (2008)
Adobe illustrator

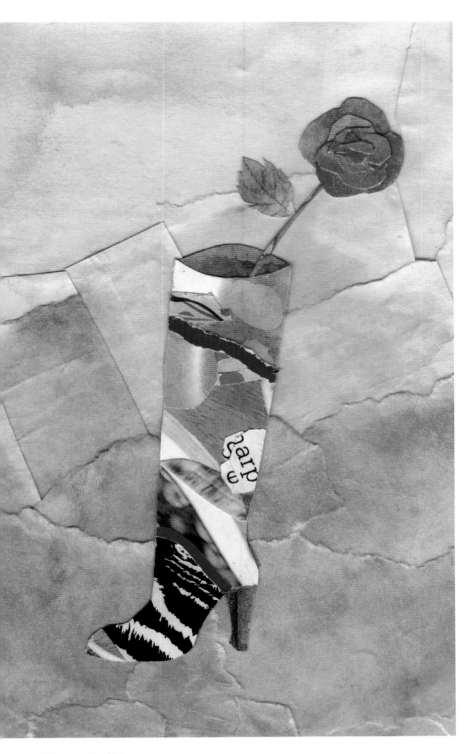

Tomoko Hanamoto

Personal Work (2009)
Collage with watercoloured and printed papers

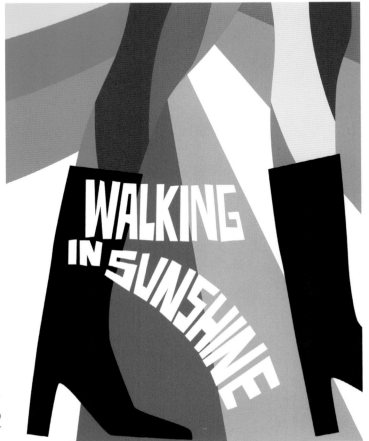

Kari Moden

Walking (2003)
Adobe illustrator

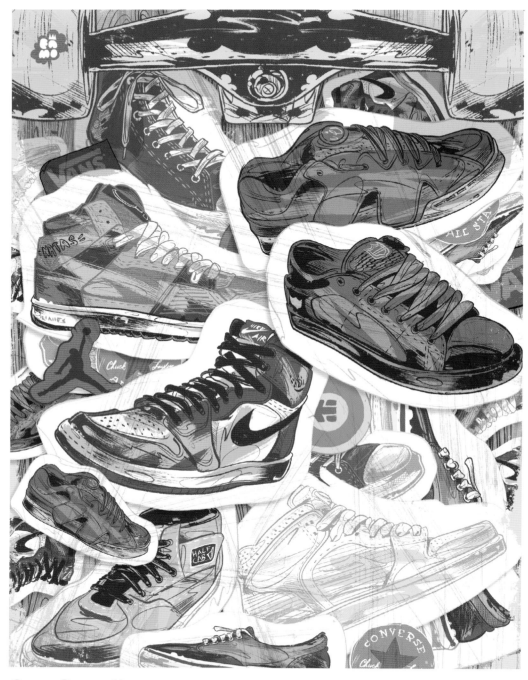

Eamo Donnelly

Complex magazine: History of Skate Shoes (2008)
Pencil sketches, hand inked with brush on paper, Adobe Photoshop

Sherine Hazim

A Stroll Through Brooklyn (2010)
Adobe Photoshop

Christian Borstlap

Adidas (2000)
Adobe Illustrator, Adobe Photoshop

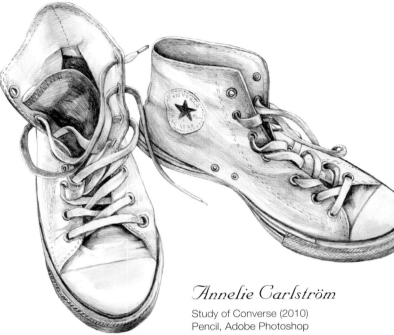

Annelie Carlström

Study of Converse (2010)
Pencil, Adobe Photoshop

Kari Moden

Soles (2004)
Adobe illustrator

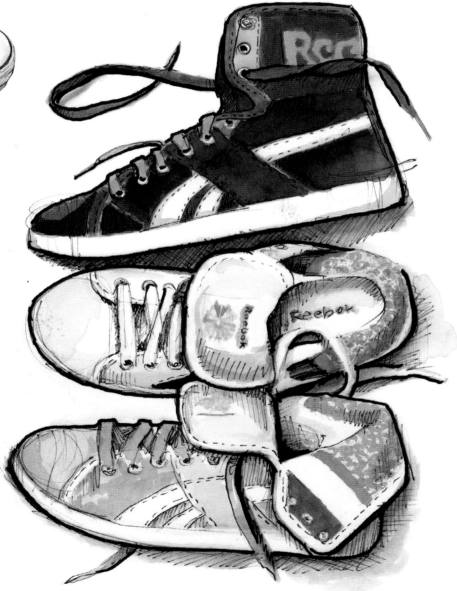

Katie Rodgers

Reebok Topdowns (2009)
Watercolour, ink

Jessica Woodhouse

Six Point Noughts (2010)
Pen, collage

Jessica Woodhouse

Blazers (2010)
Pen, collage

Jessica Woodhouse

Air Force Ones (2010)
Pen, collage

Christian Borstlap

Adidas (2002)
Adobe Illustrator, Adobe Photoshop

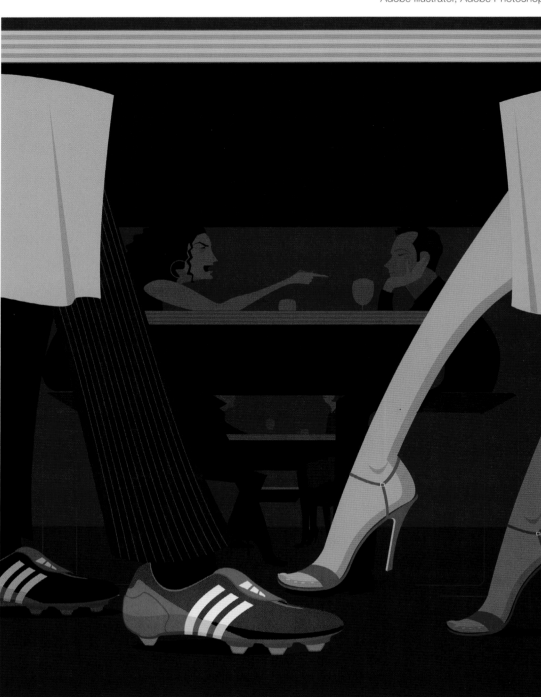

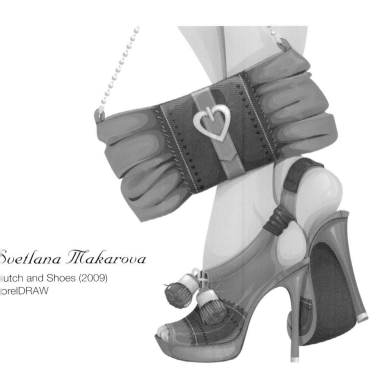

Svetlana Makarova

Clutch and Shoes (2009)
CorelDRAW

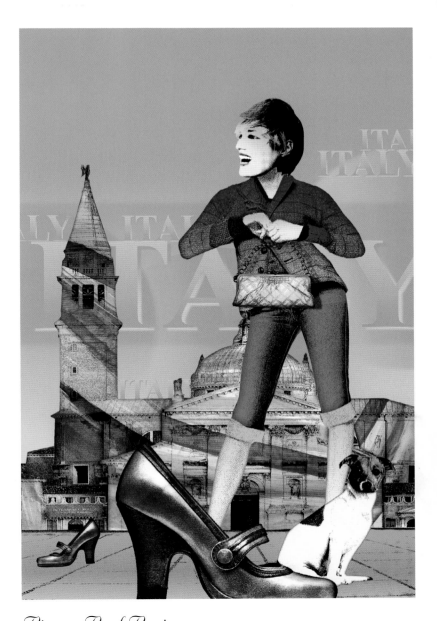

Pierre-Paul Pariseau

Milan, Italy (2007)
Collage, watercolour, Adobe Photoshop

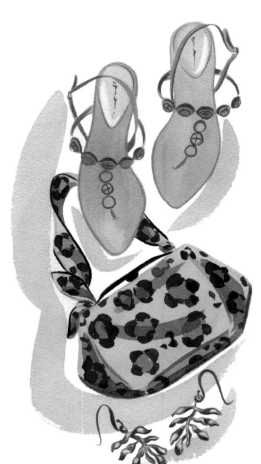

Monica Lind

Summer (2007)
Brush and ink

281

Julia Durgee
Group Envy print (2005)
Pen and ink, Adobe Photoshop

Laurence Whiteley
Milan (2004)
Adobe Photoshop

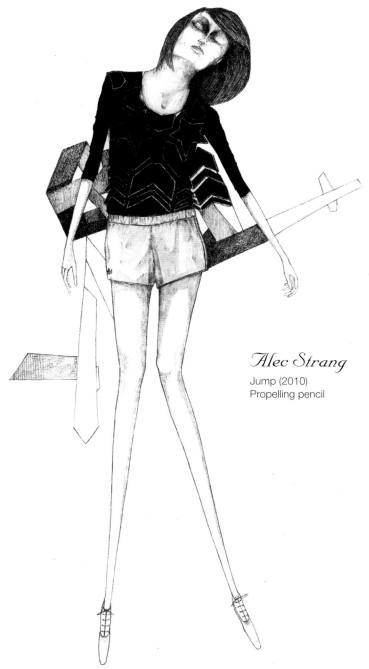

Alec Strang
Jump (2010)
Propelling pencil

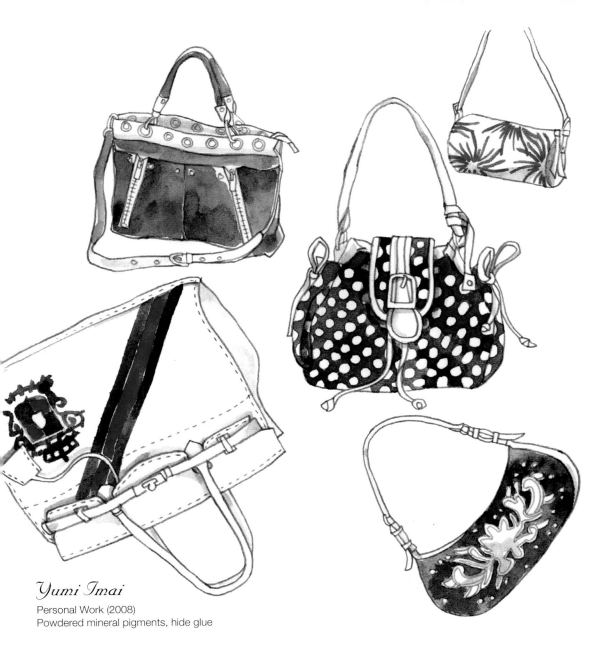

Yumi Imai

Personal Work (2008)
Powdered mineral pigments, hide glue

Paloma Spaeth

I Am Ready (2009)
Adobe Illustrator

Alessandra Scandella

Lady With Handbag (Piemme) (2010)
Watercolour, collage, handmade paper

Eva Hjelte

Black Bag (2009)
Pencil, ink, acetone

Lauren Bishop

Fake Fur (2005)
Pencil, scanned objects, Adobe Photoshop

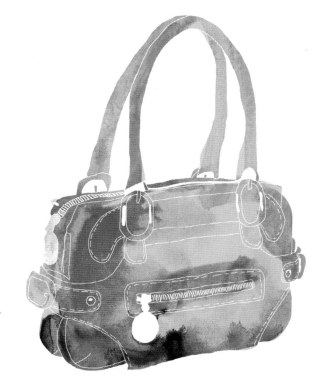

Wendy Plovmand

Bag (2008)
Watercolour, Adobe Photoshop

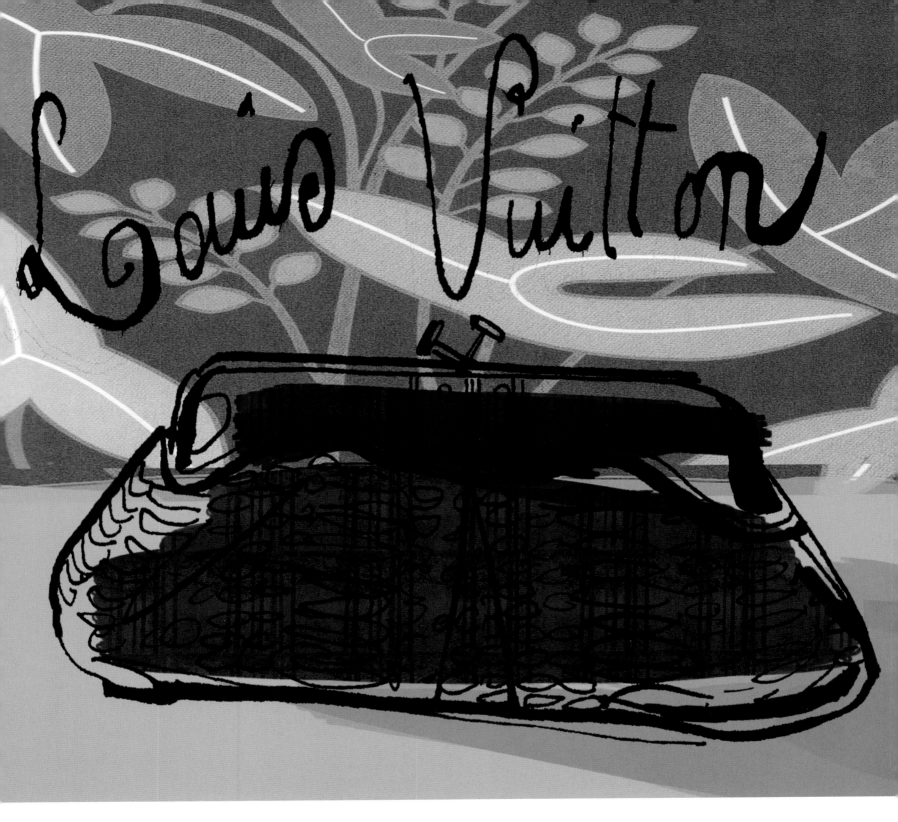

Alessandra Scandella

Blue Handbag (2010)
Watercolour, collage, handmade paper

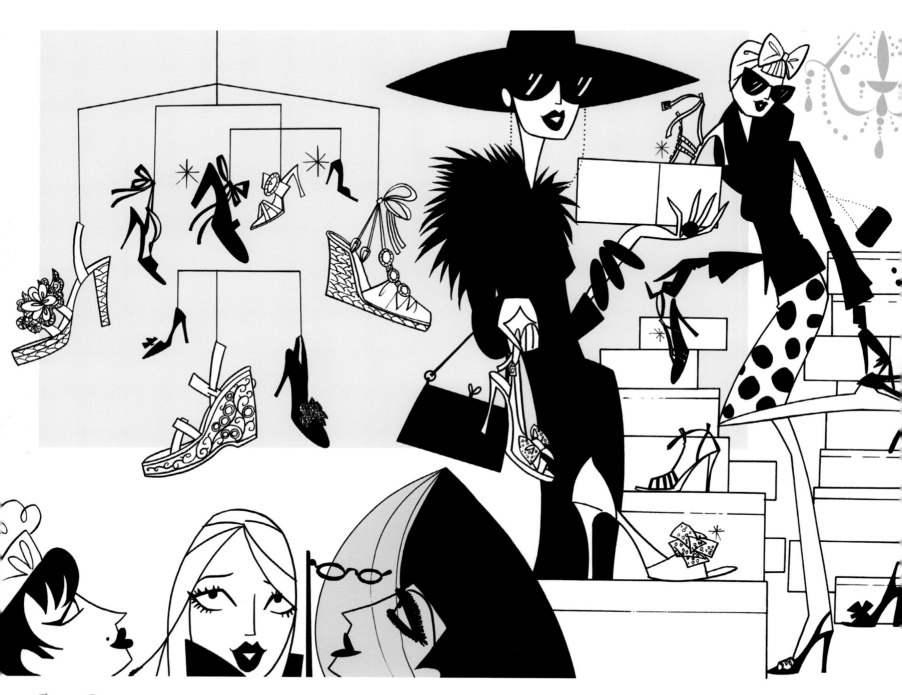

James Dignan
Vogue Pelle (Italy) (2007)
Ink, Adobe Photoshop

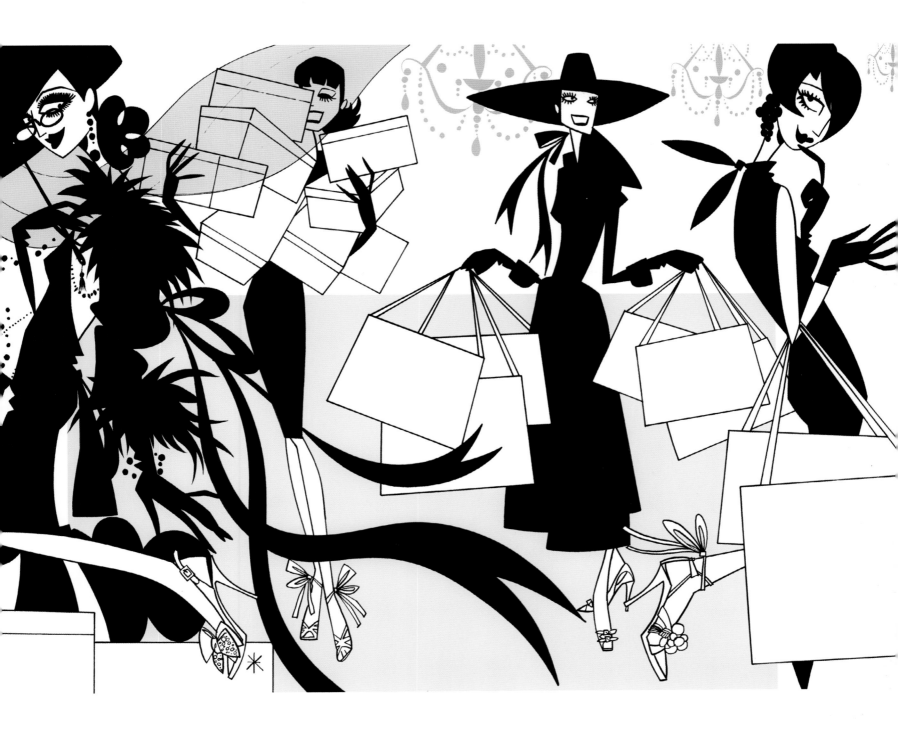

Nobuko Takagi
Personal Work (2004)
Adobe Photoshop

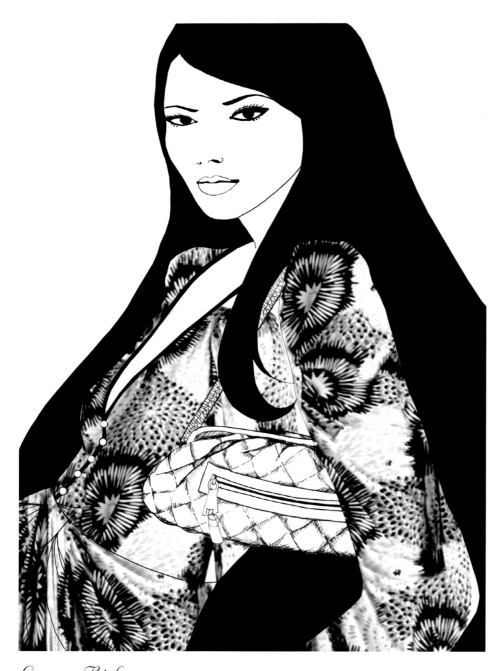

Lauren Bishop
Marc Jacobs Bag (2005)
Pencil, pen, scanned objects, Adobe Photoshop

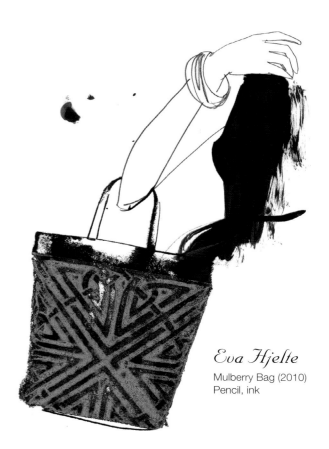

Eva Hjelte
Mulberry Bag (2010)
Pencil, ink

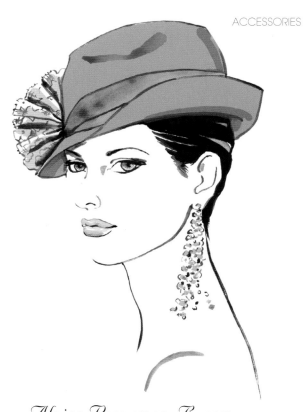

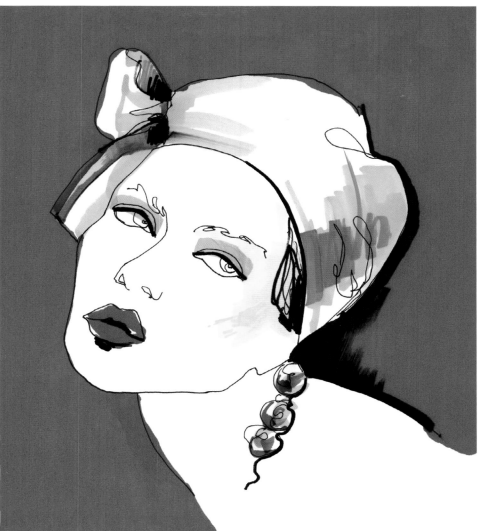

Alcine Perryman-Burow
Sash Hat (2009)
Brush line drawing, Adobe Photoshop

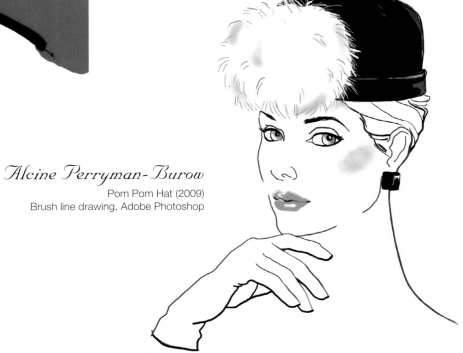

Baiba Ladiga
Red (2009)
Gel ink pen, markers, Adobe Photoshop

Alcine Perryman-Burow
Pom Pom Hat (2009)
Brush line drawing, Adobe Photoshop

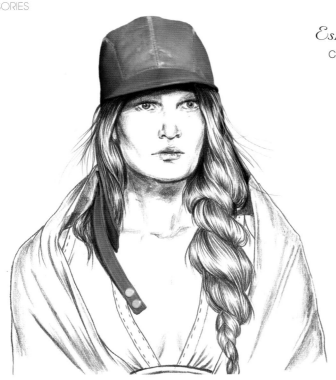

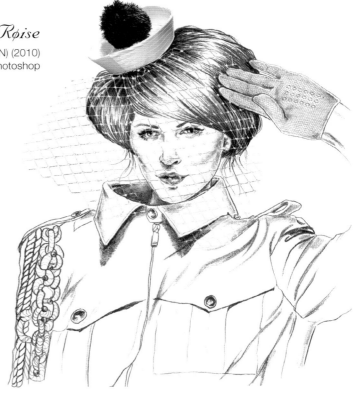

Esra Caroline Røise

Castelbajac (for NYLON) (2010)
Pencil, Adobe Photoshop

Esra Caroline Røise

Alex Wang (for NYLON) (2010)
Pencil, Adobe Photoshop

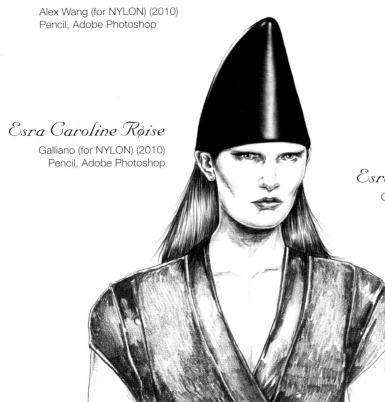

Esra Caroline Røise

Galliano (for NYLON) (2010)
Pencil, Adobe Photoshop

Esra Caroline Røise

Givenchy (for NYLON) (2010)
Pencil, Adobe Photoshop

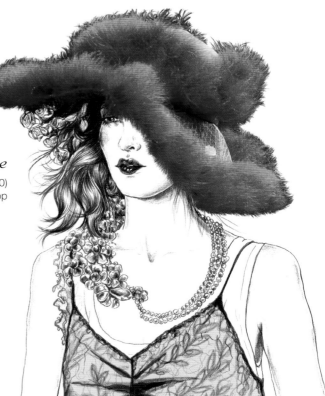

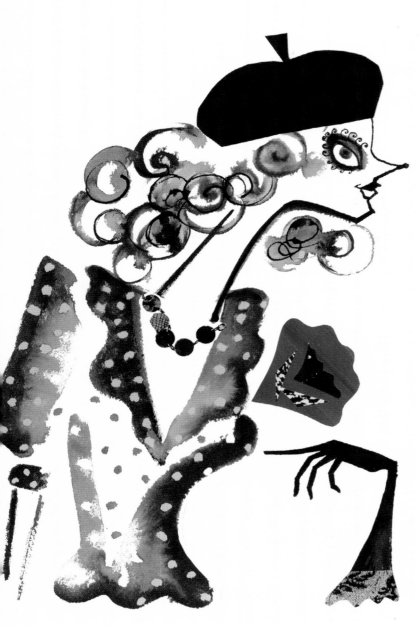

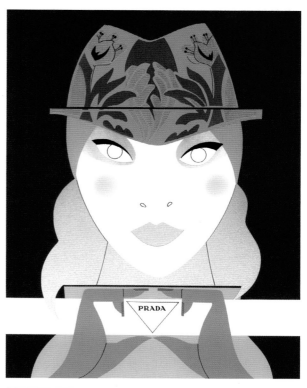

Piet Paris

Elle (UK): Prada Girl (2003)
Stencil, pastel, paint, paper
cutting

Nobuko Takagi

Personal Work (2004)
Adobe Photoshop

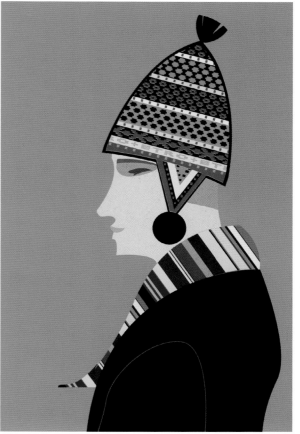

Christian Borstlap

Selfrides Spring Campaign (2000)
Adobe Illustrator, Adobe Photoshop

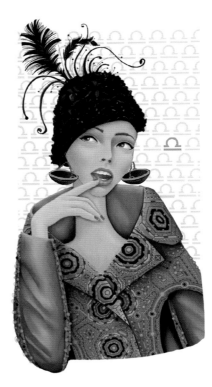

Lyubov Dubina

Elle (Ukraine): Libra (2008)
Corel Painter

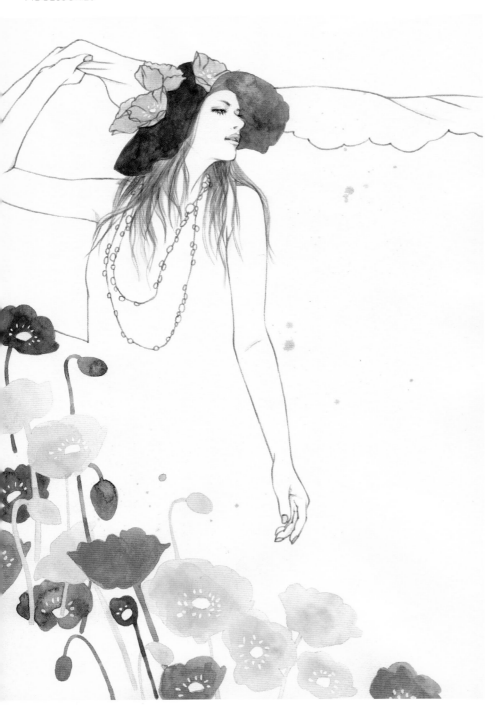

Yumi Imai

Personal Work (2009)
Powdered mineral pigments, hide glue

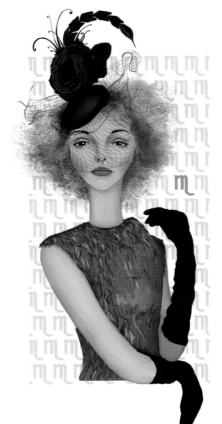

Lyubov Dubina

Elle (Ukraine): Scorpio (2008)
Corel Painter

Satomi Ichikawa

Hats (2008)
Acrylic, gouache

Esther Kim

Coffee and Pen (2008)
Pen, pencil, watercolour

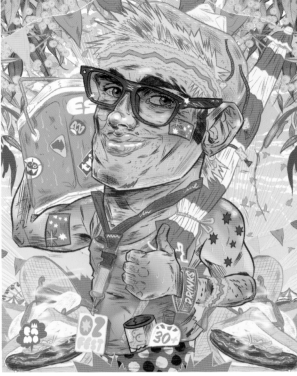

Eamo Donnelly
20 Bands You Must See This
Summer (2010)
Pencil, hand-inked with brush
on paper, Adobe Photoshop

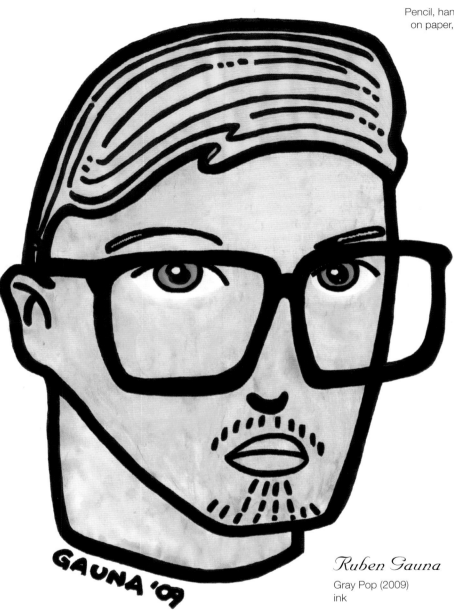

Ruben Gauna
Gray Pop (2009)
ink

Artaksiniya
Olivier (2010)
Edding drawliner, Adobe Photoshop

ulia Durgee
ma Optique (2005)
n and ink, watercolour, Adobe Photoshop

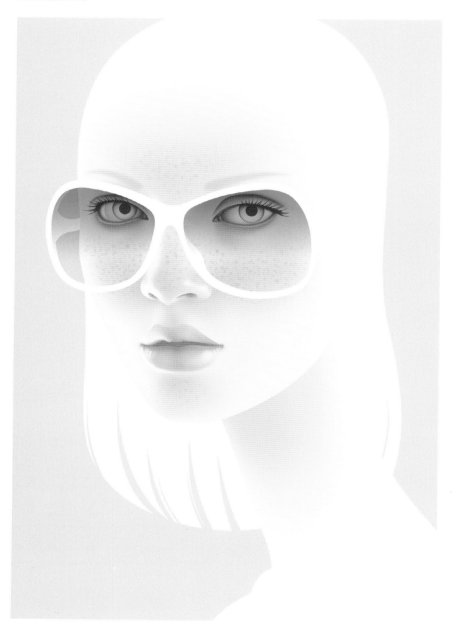

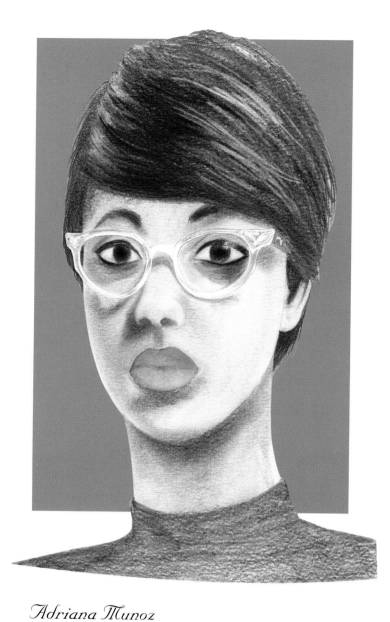

Adriana Munoz

Blue (2008)
Pencil, watercolour, Adobe Photoshop

Autumn Whitehurst

Sunprotection (2007)
Adobe Photoshop, Adobe Illustrator, Corel Painter

Jill Tovey
Lemon (2009)
Watercolour, photography, acrylics, pencil,
pen, oils, Adobe Photoshop, Corel Painter X

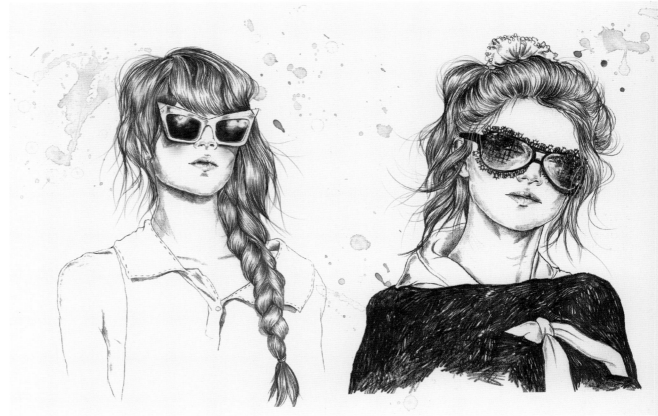

Esra Caroline Røise
Rewind (2009)
Pencil, watercolour

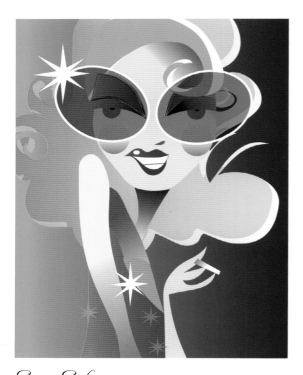

Gary Goh
Monique (2009)
Adobe Illustrator

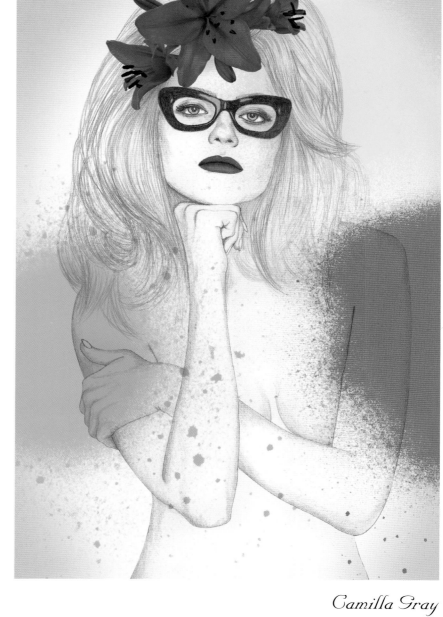

Camilla Gray
Color Blind (2009)
Pencil, watercolour, Adobe Photoshop

Jesse Auersalo
Mind Fuck (2008)
Macromedia FREEHAND, Adobe Photoshop

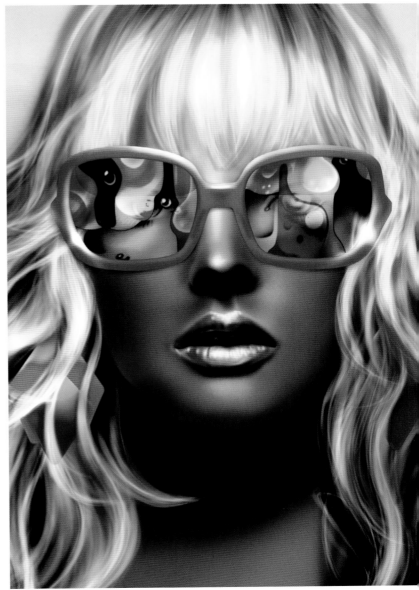

Kittozutto

Hawaii (2008)
Adobe Photoshop, Macromedia FREEHAND

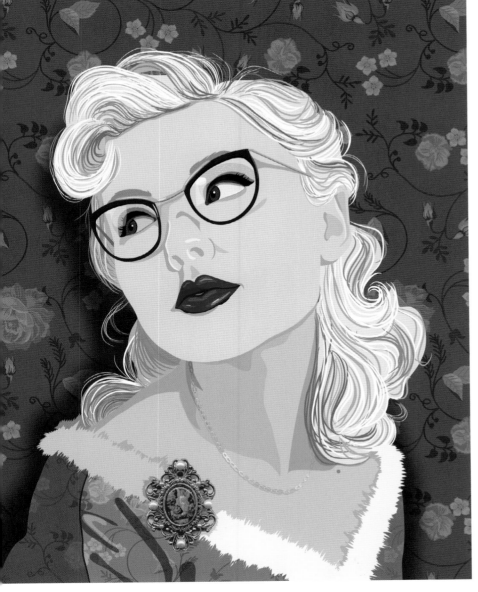

Maria Danalakis

Elegance (2009)
Adobe Illustrator

299

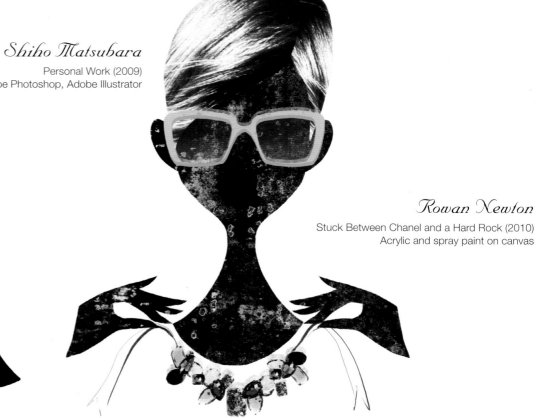

Shiho Matsubara
Personal Work (2009)
Adobe Photoshop, Adobe Illustrator

Rowan Newton
Stuck Between Chanel and a Hard Rock (2010)
Acrylic and spray paint on canvas

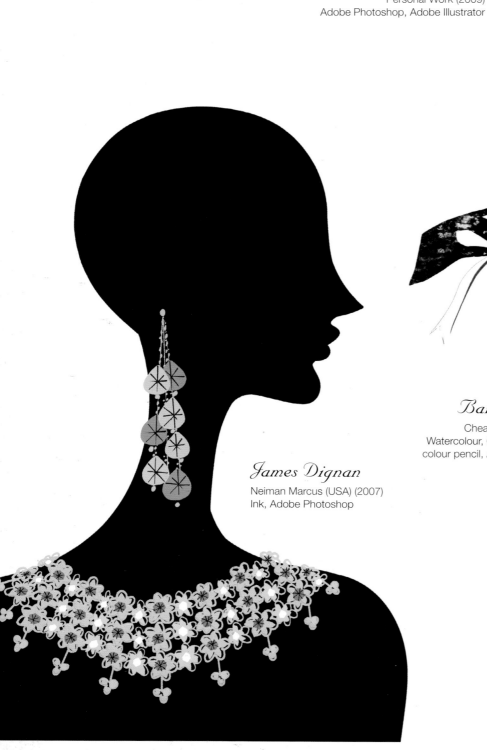

Baiba Ladiga
Cheap and Chic (2009)
Watercolour, China ink, collage,
colour pencil, Adobe Photoshop

James Dignan
Neiman Marcus (USA) (2007)
Ink, Adobe Photoshop

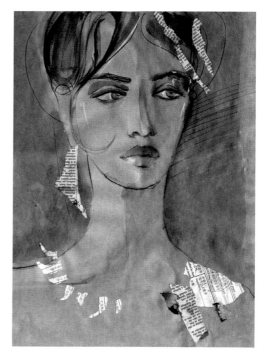

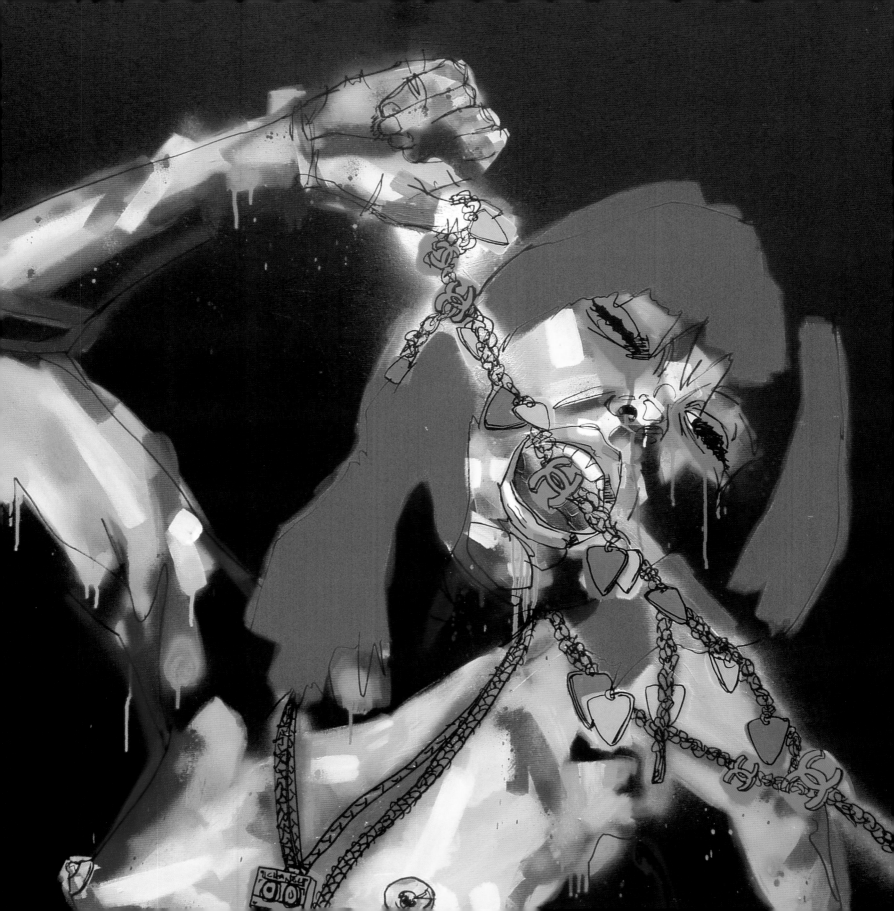

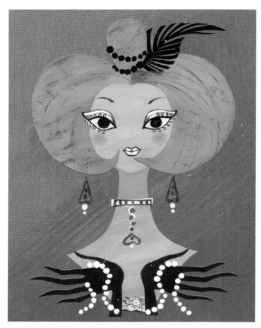

Nobuko Takagi

Personal Work (2004)
Adobe Photoshop

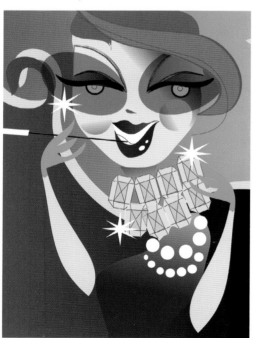

Gary Goh

Mdm Wang (2009)
Adobe Illustrator

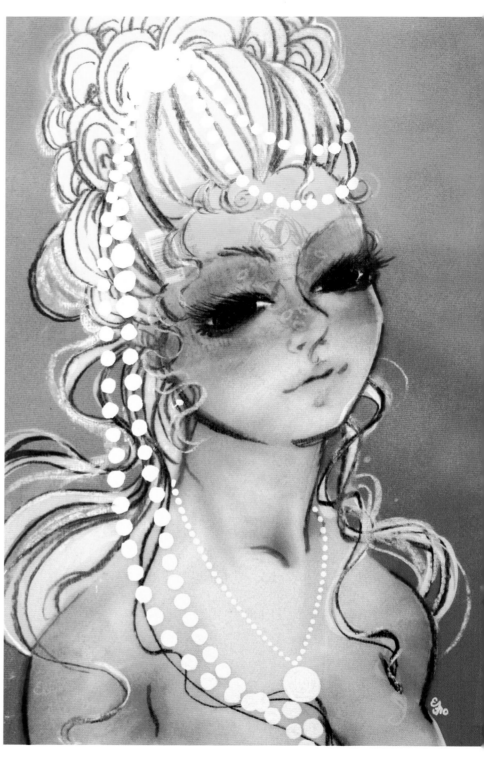

Eliza Frye

Portrait of Lady Death (2010)
Gouache, pastel and found paper on vellum

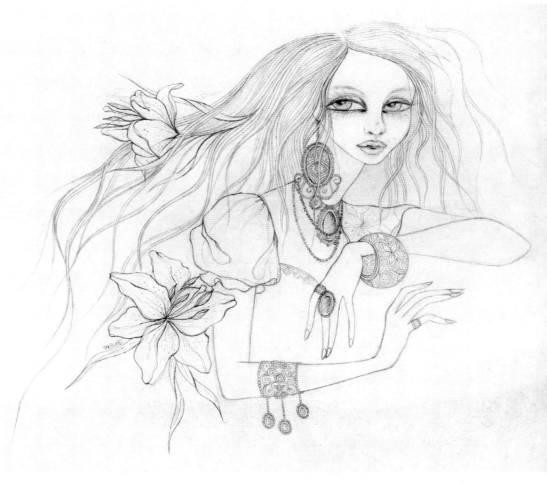

Mariya Paskovsky
Beautiful You (2009)
Graphite pencil

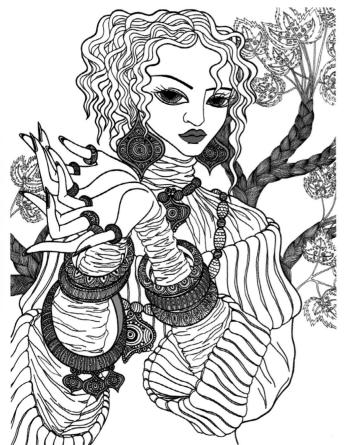

Mariya Paskovsky
Girl with Bangles (2007)
Black ink, Adobe Photoshop

Lisa Plaskett
Red Beads (2008)
Charcoal, Adobe Illustrator

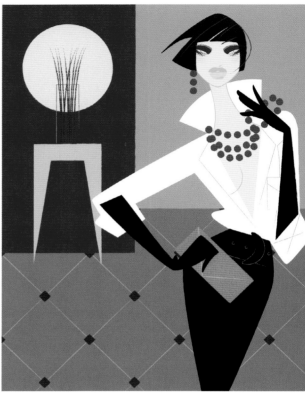

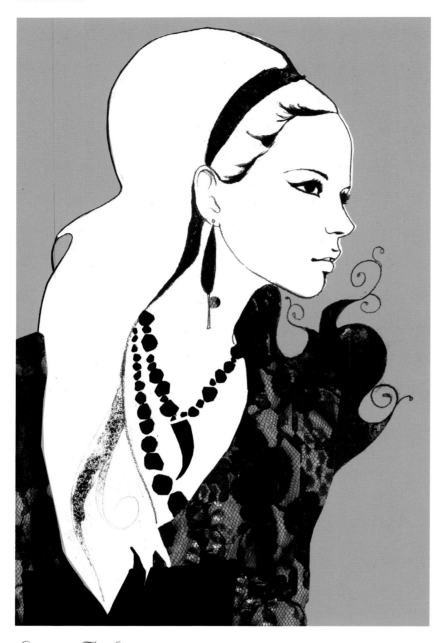

Lauren Bishop

Gothic Punk (2006)
Pencil, pen, ink, scanned objects, Adobe Photoshop

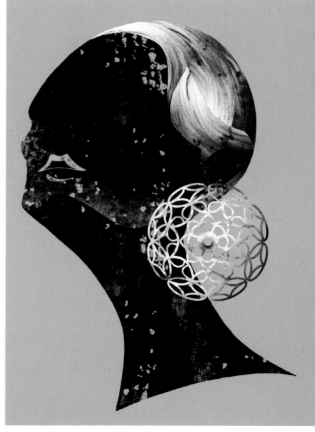

Shiho Matsubara
Personal Work (2010)
Adobe Photoshop, Adobe Illustrator

Kari Moden

Shine Baby Shine (2008)
Adobe Illustrator

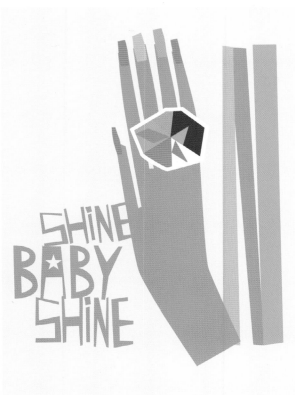

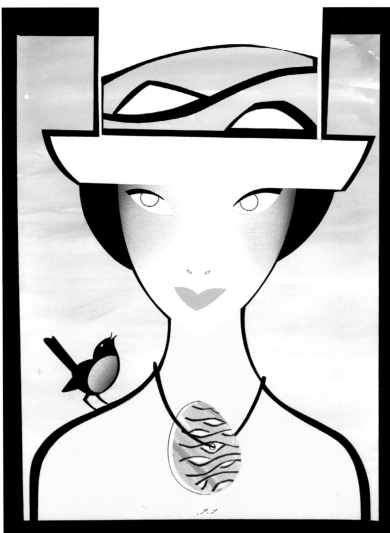

Piet Paris

W Korea Advertisement: Bird (2007)
Paint, paper cutting, spray paint

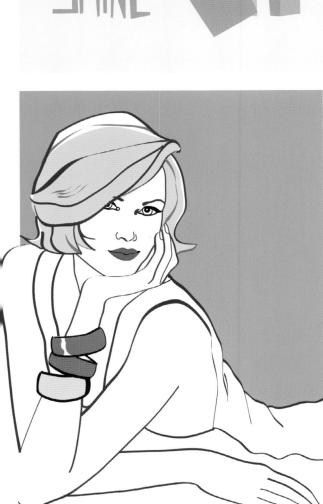

Alcine Perryman-Burow

Jewellery Lady (2009)
Adobe Illustrator

305

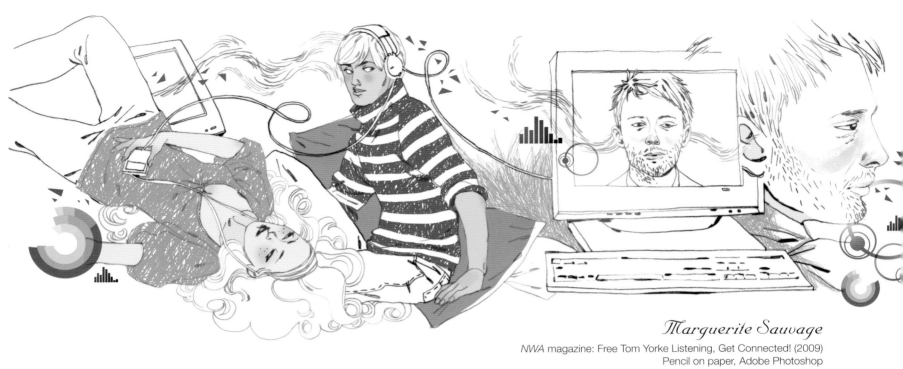

Marguerite Sauvage
NWA magazine: Free Tom Yorke Listening, Get Connected! (2009)
Pencil on paper, Adobe Photoshop

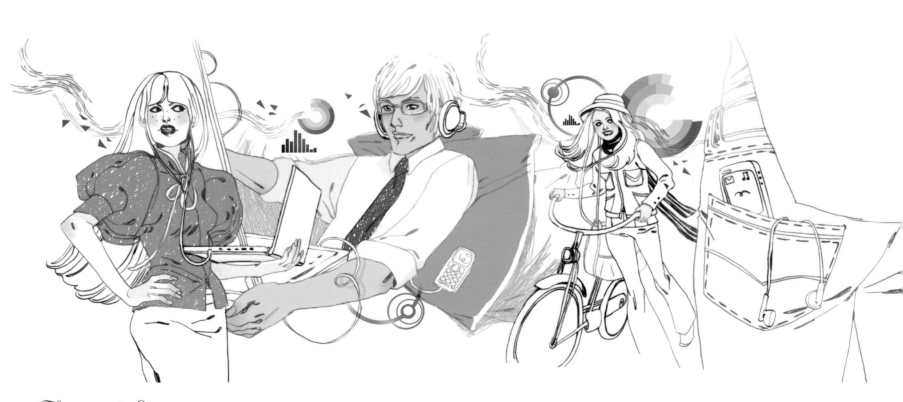

Marguerite Sauvage
NWA magazine: Free Mp3, Get Connected! (2009)
Pencil on paper, Adobe Photoshop

Rob De Bank

American Spa magazine: My Space Spa (2008)
Adobe Photoshop

Rhiannon Cunag

GL magazine: Computer Crush (2009)
Adobe Illustrator

Shingo Shimizu

Scholastic Classroom magazine: Gadgets (2008)
Adobe Illustrator

Greg Paprocki
Guy Playing XBox (2008)
Adobe Illustrator

Tim Degner
Hello (2007)
Pen, Adobe Illustrator

Puntoos Design & Illustration Studio
Skype – Phone Revolution (2006)
Adobe Illustrator

Robert Tirado

Pierrot Dancer (2008)
Adobe Photoshop, Adobe Illustrator

Gary Newman

Girl (2009)
Adobe Illustrator

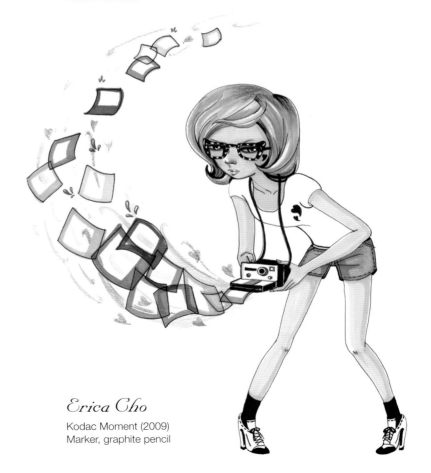

Erica Cho

Kodac Moment (2009)
Marker, graphite pencil

309

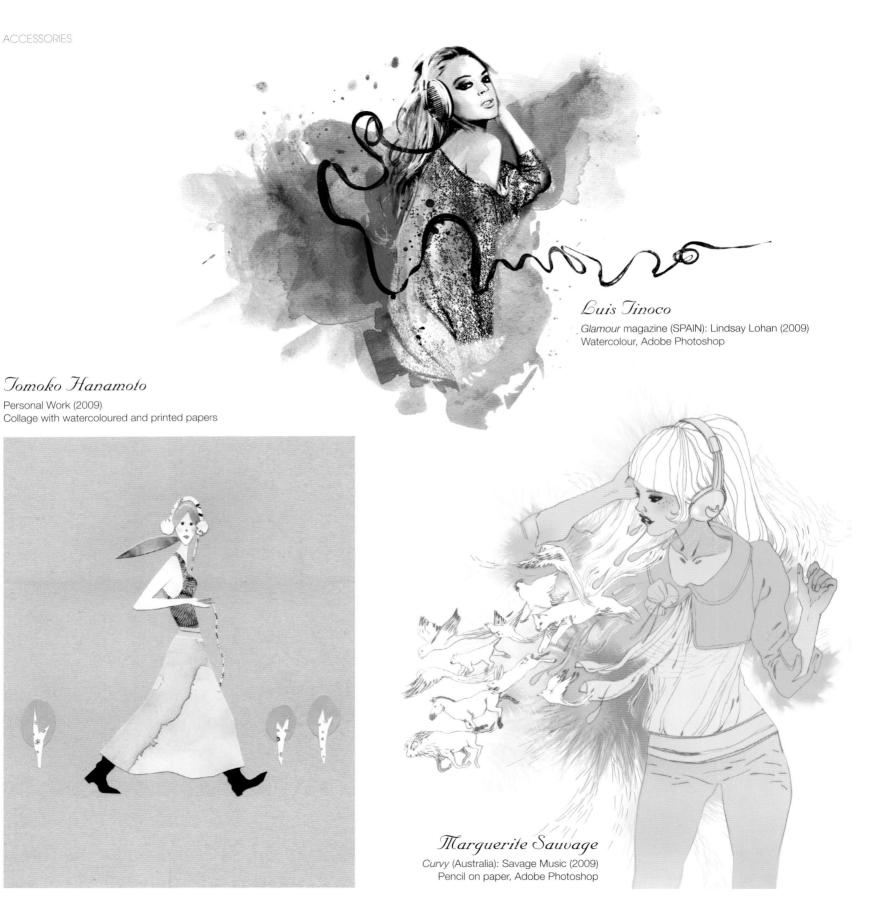

Luis Tinoco
Glamour magazine (SPAIN): Lindsay Lohan (2009)
Watercolour, Adobe Photoshop

Tomoko Hanamoto
Personal Work (2009)
Collage with watercoloured and printed papers

Marguerite Sauvage
Curvy (Australia): Savage Music (2009)
Pencil on paper, Adobe Photoshop

Gary Newman

Jogging Girl (2010)
Adobe Illustrator

Gormax

Iphone (2010)
Adobe Illustrator

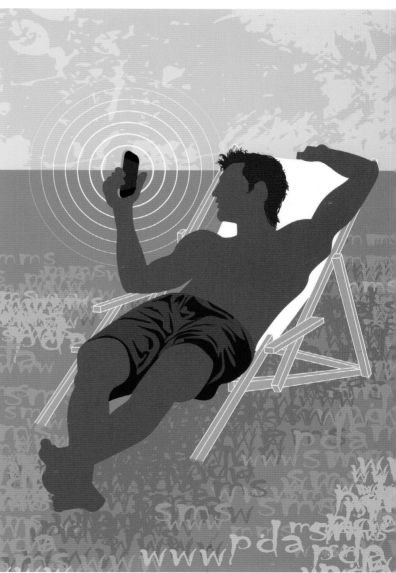

Jacquie O'Neill

IPod Aqua (2005)
Adobe Illustrator

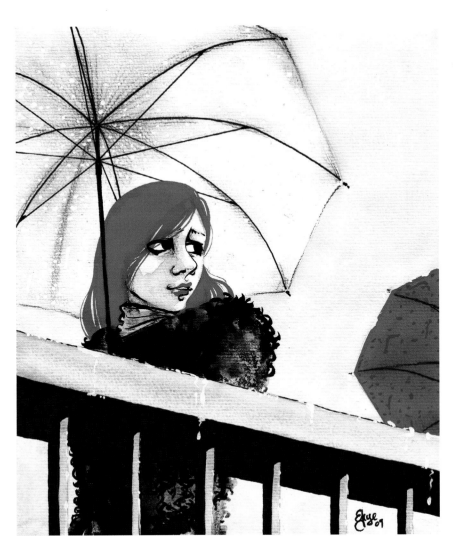

Eliza Frye
Rendezvous (2009)
Gouache, pastel

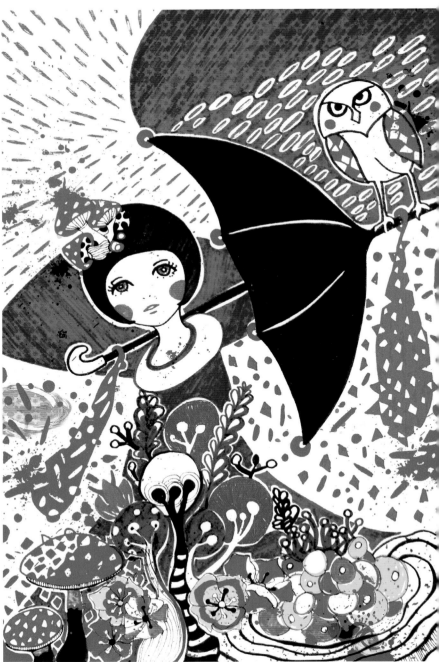

Nani Puspasari
The Umbrella (2009)
Felt-tip pen

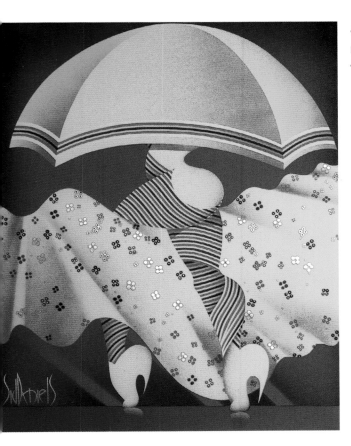

Sid Daniels
Footlight Parade (2008)
Acrylic on canvas

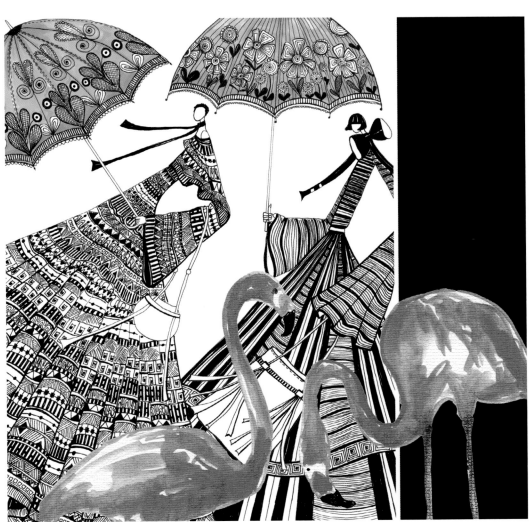

Kerstin Wacker
Miami (2008)
Watercolour, ink pen, Adobe Photoshop

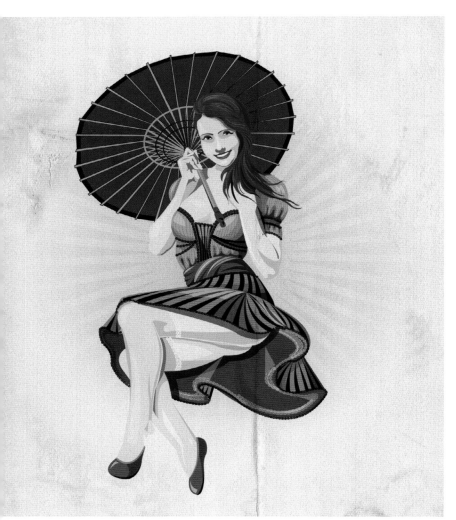

Ivan Kasaj
Retrogirl Jugendstil (2007)
Adobe Illustrator

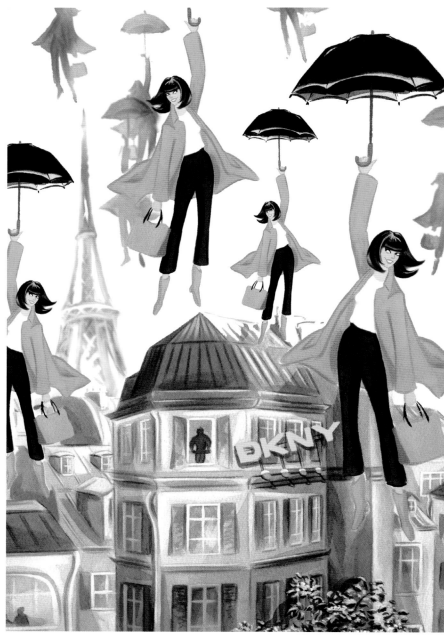

Monica Lind
It's Raining... (2005)
Brush and ink

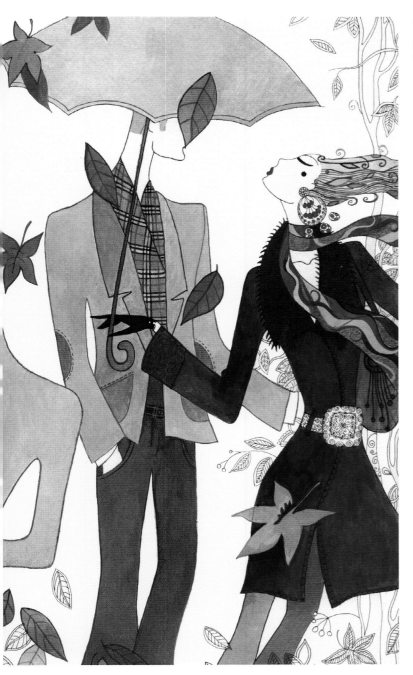

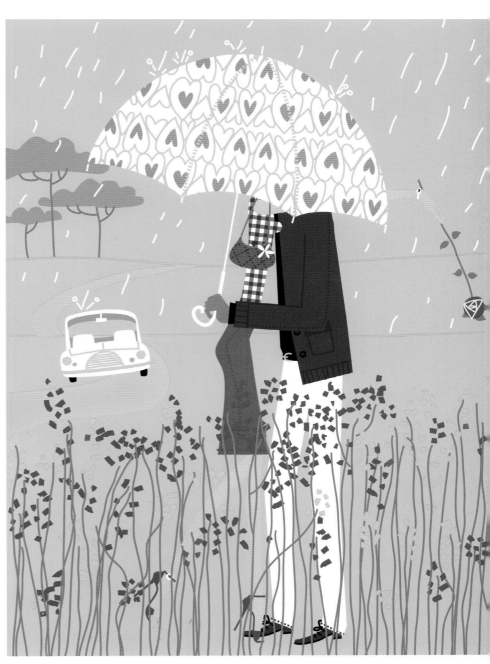

Daria Jabenko
Fall Romance (2009)
Gouache, watercolour, ink

Maxim Savva
Horoscope: Aquarius (2009)
Adobe Illustrator

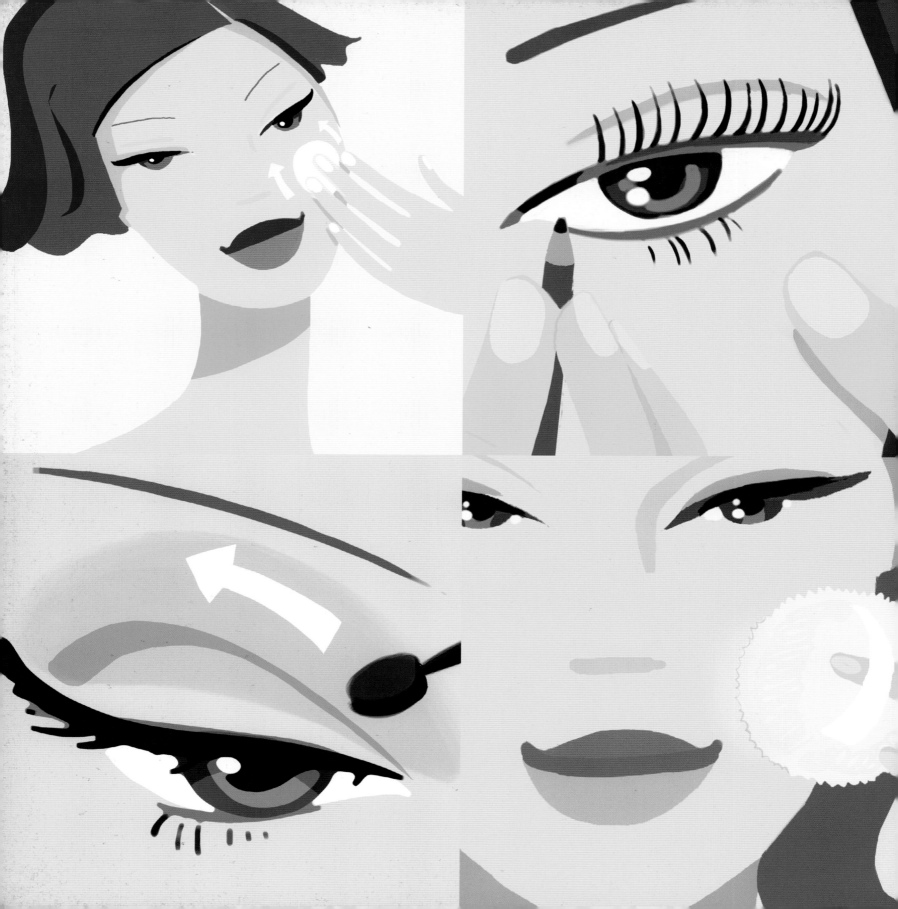

Beauty & Glamour

previous page:
Alessandra Scandella
Hello Kitty (2009)
Adobe Photoshop

Rob De Bank
American Spa magazine: Yoga Spa (2006)
Pen and ink, Adobe Photoshop

Jacquie O'Neill
Michael (2010)
Adobe Illustrator

Kerstin Wacker

Zodiac Signs: Aquarius (2006)
Ink pen, Adobe Photoshop

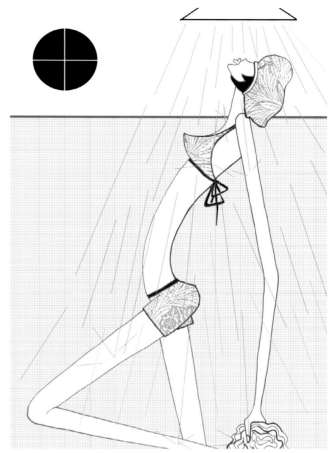

Gormax

Tub (2008)
Adobe Photoshop

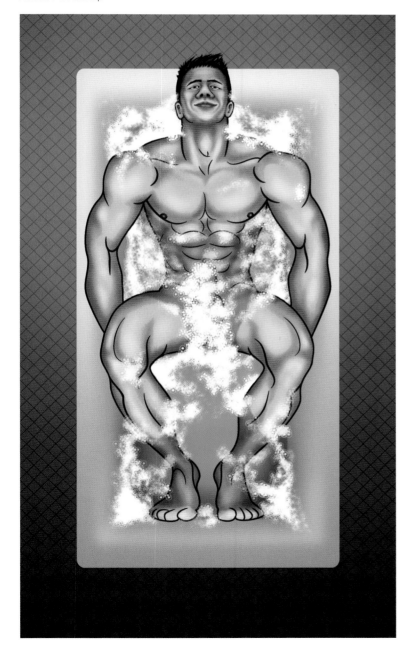

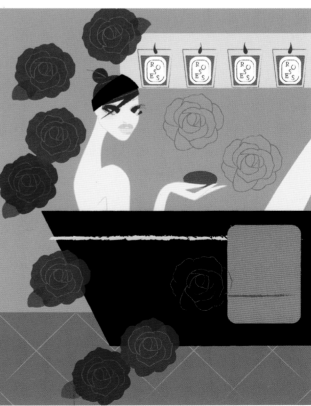

Lisa Plaskett

Rose Girl (2008)
Charcoal, Adobe Illustrator

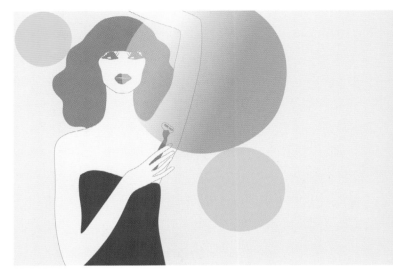

Kari Moden
Shaving Arms (2010)
Adobe Illustrator

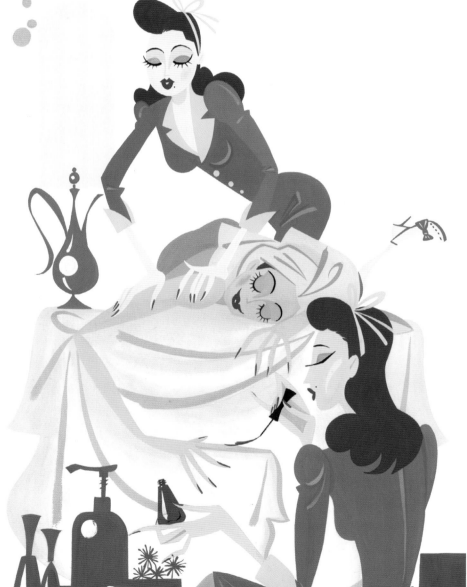

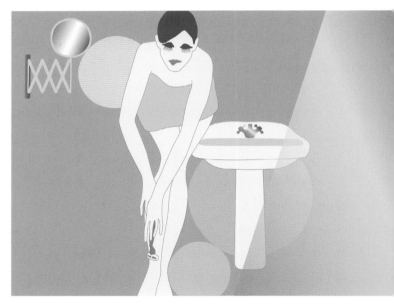

Kari Moden
Shaving Legs (2010)
Adobe Illustrator

James Dignan
Avant Garde magazine (Netherlands) (2008)
Gouache

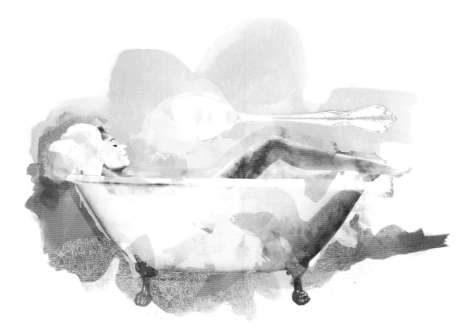

Luis Tinoco

Clara magazine (SPAIN): Health Care Tips (2009)
Watercolour, Adobe Photoshop

Rob De Bank

American Spa magazine: Waxing Room (2004)
Pen and ink, Adobe Photoshop

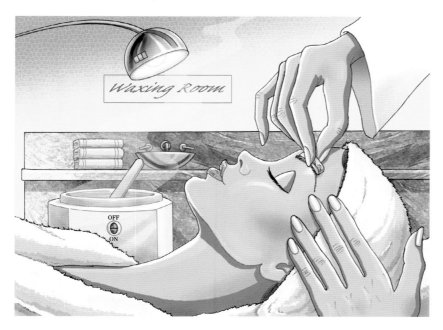

Lisa Plaskett

Spa Girl (2010)
Charcoal, Adobe Illustrator

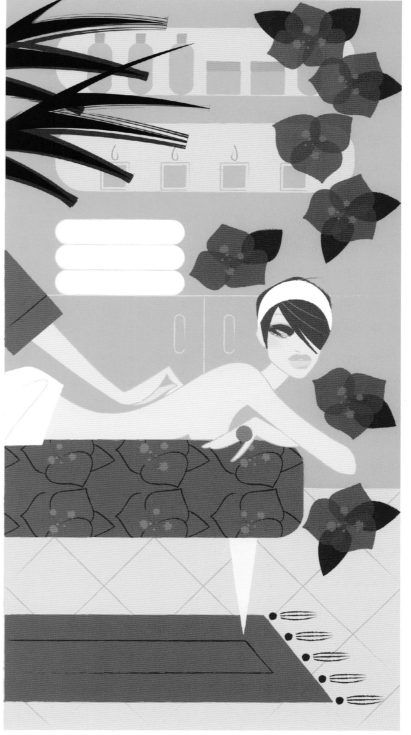

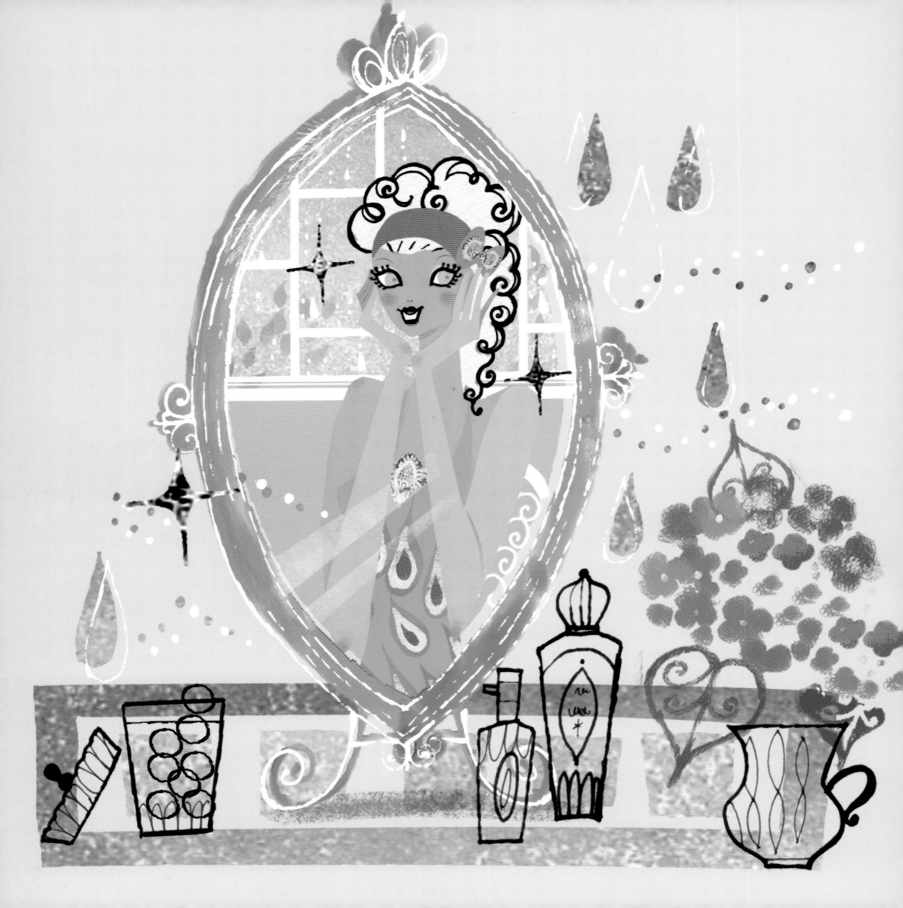

Nobuko Takagi
Spur magazine: Lady in Mirror (2008)
Adobe Photoshop

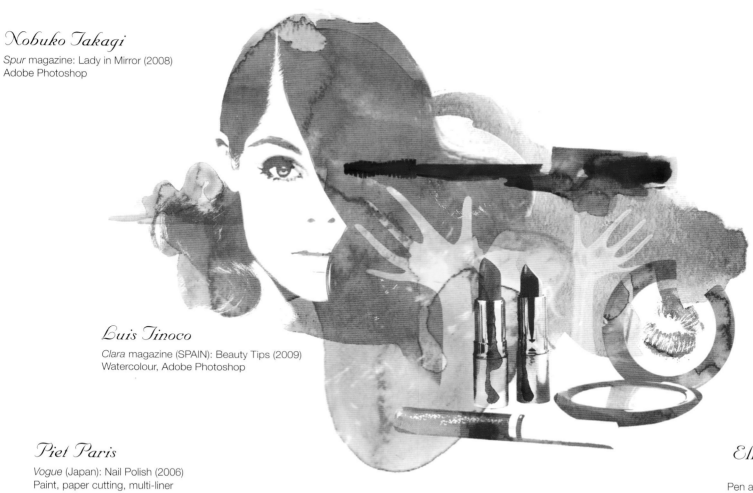

Luis Tinoco
Clara magazine (SPAIN): Beauty Tips (2009)
Watercolour, Adobe Photoshop

Piet Paris
Vogue (Japan): Nail Polish (2006)
Paint, paper cutting, multi-liner

Ellen van Engelen
Music (2009)
Pen and ink, Adobe Photoshop

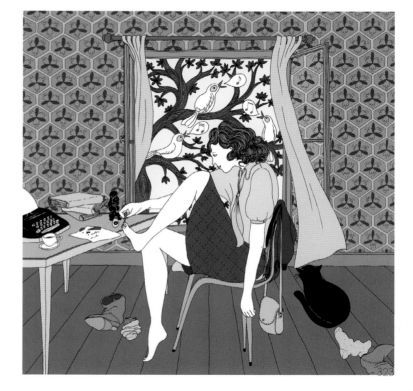

Maxim Savu
Independent Media Sanoma magazine: Cosmopolitan Shopping (200
Adobe Illustrat

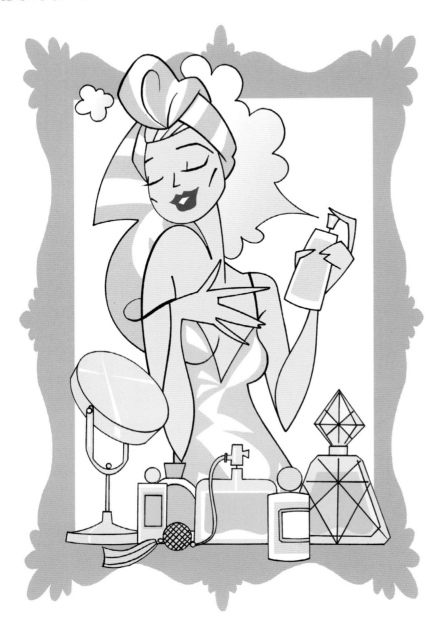

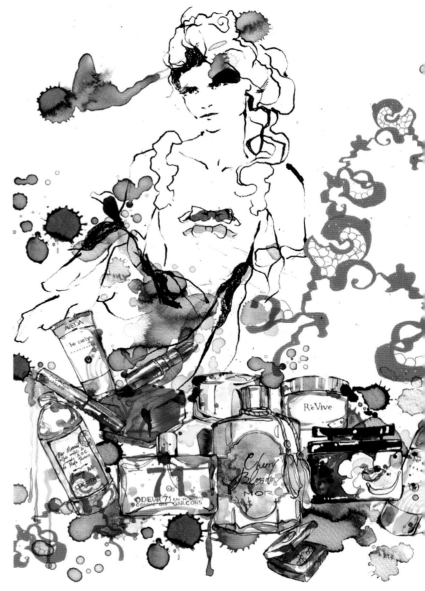

James Dignan
InStyle (Germany) 10th Year Anniversary Campaign in Association
with Peek & Cloppenberg Department Store (2009)
Ink, Adobe Photoshop

Rebecca Wetzler
Oyster magazine: Marie Antoinette (2008)
Charcoal, watercolour, ink, felt-tip pens

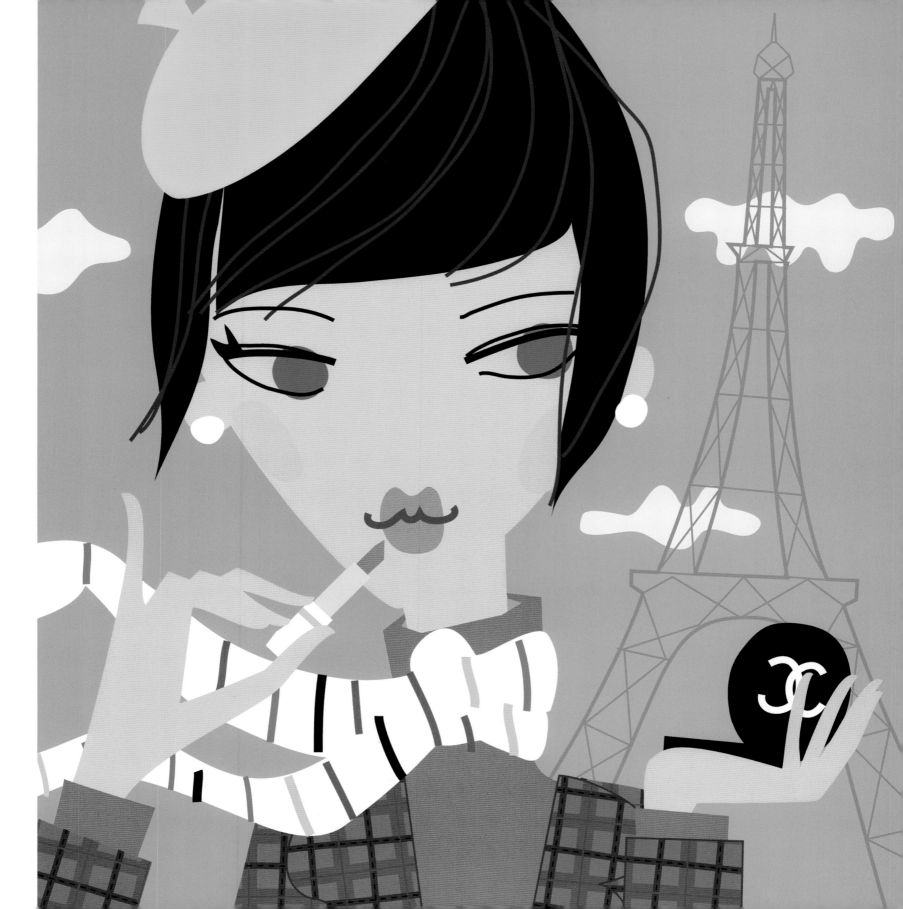

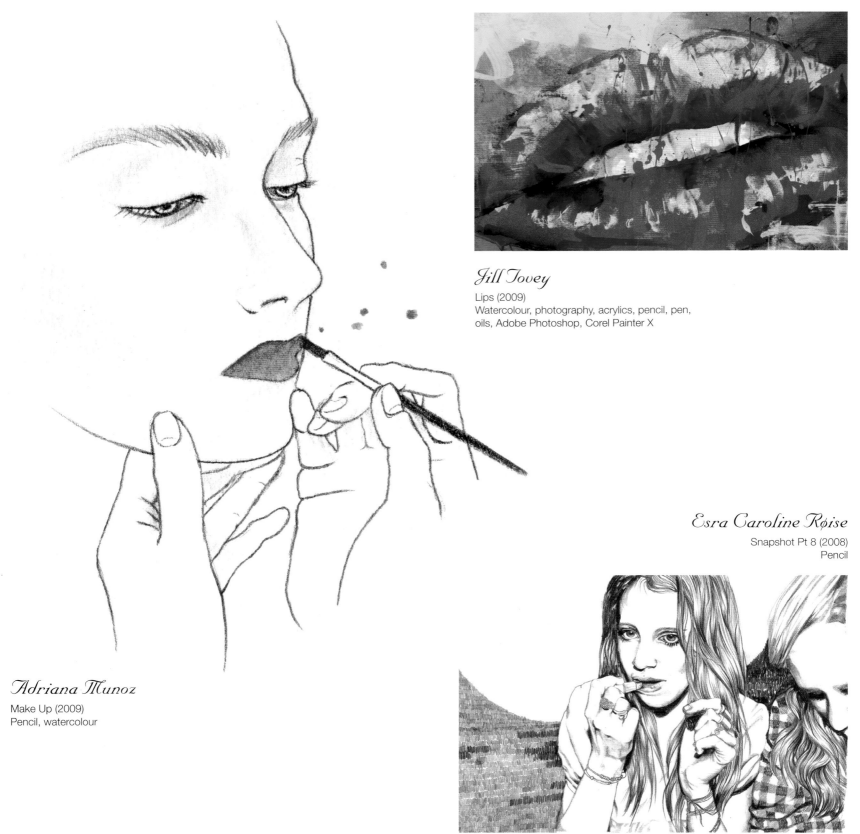

Jill Tovey

Lips (2009)
Watercolour, photography, acrylics, pencil, pen, oils, Adobe Photoshop, Corel Painter X

Esra Caroline Røise

Snapshot Pt 8 (2008)
Pencil

Adriana Munoz

Make Up (2009)
Pencil, watercolour

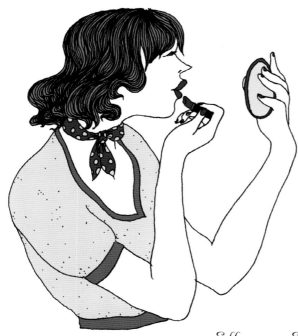

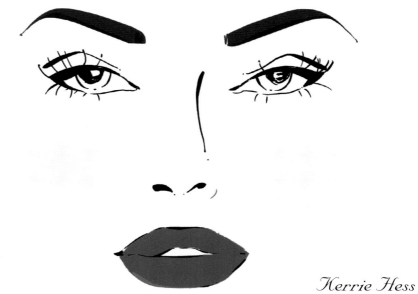

Ellen van Engelen

Lipstick (2009)
Pen and ink, Adobe Photoshop

Kerrie Hess

Neiman Marcus Beauty (2010)
Pen and ink, Adobe Photoshop

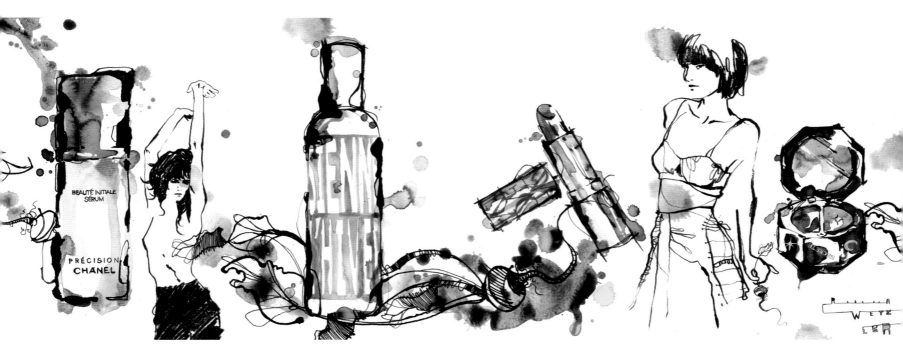

Rebecca Wetzler

Nylon magazine: Beauty Page (2008)
Charcoal, ink

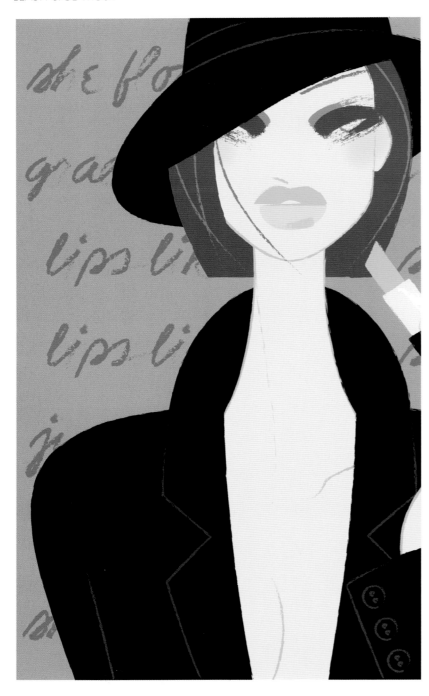

Lisa Plaskett

Lipstick (2008)
Charcoal, Adobe Illustrator

Ellen van Engelen

Eye Shadow (2009)
Pen and ink, Adobe Photoshop

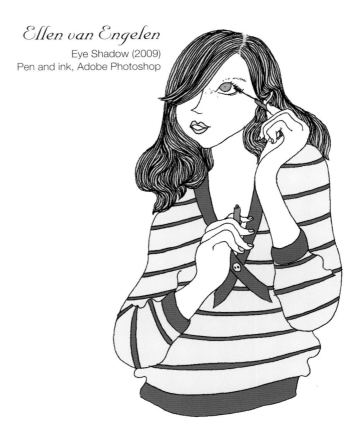

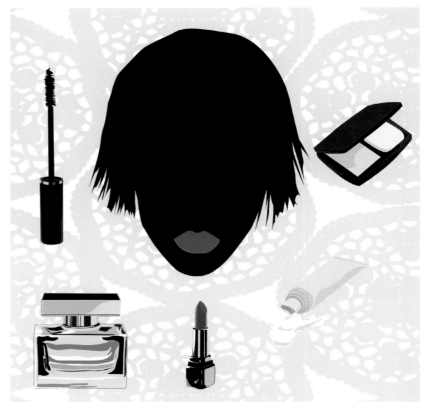

Puntoos Design & Illustration Studio

Cosmetics (2008)
Adobe Illustrator

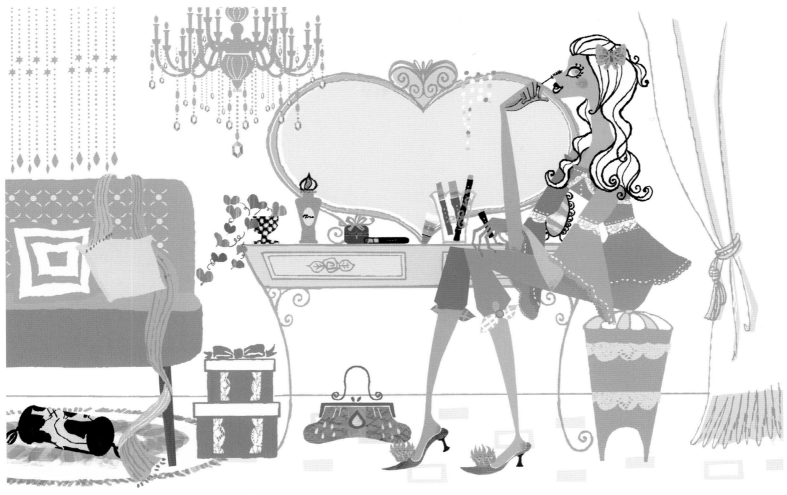

Nobuko Takagi

Koji Honpo website: Eye Make-up (2006)
Adobe Photoshop

Ellen van Engelen

Eye Creme (2009)
Pen and ink, Adobe Photoshop

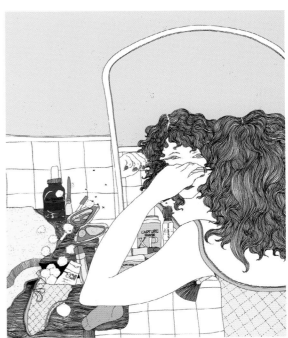

Esra Caroline Røise

Spill (2009)
Pencil, watercolour

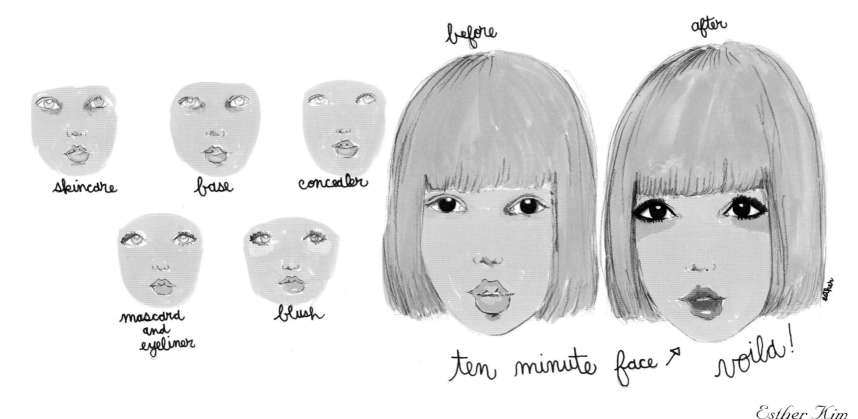

before

after

skincare

base

concealer

mascara and eyeliner

blush

ten minute face ↗ voilà!

Esther Kim

Ten-Minute Face (2009)
Pen, pencil, watercolour

Alessandra Scandella

Numerò (Rizzoli) (2009)
Adobe Photoshop

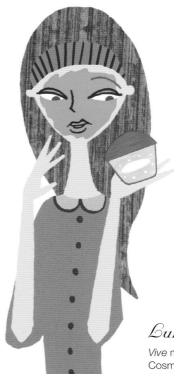

Luis Tinoco

Vive magazine (SPAIN): How to Use
Cosmetics (2008)
Adobe Photoshop

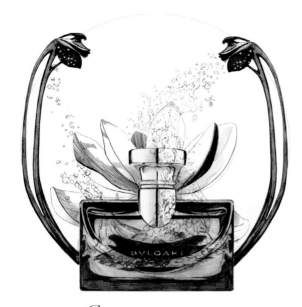

Coco

Bulgari Perfume (2009)
Watercolour, Adobe Photoshop

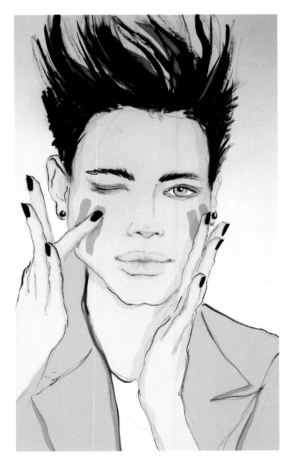

Monica Lind

Mmmmm ...! (2007)
Brush and ink

Fiona Maclean

Fashion Warrior (2010)
Pencil, gouache, Adobe Illustrator

331

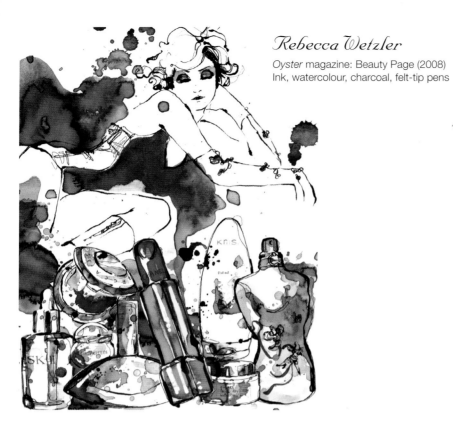

Rebecca Wetzler

Oyster magazine: Beauty Page (2008)
Ink, watercolour, charcoal, felt-tip pens

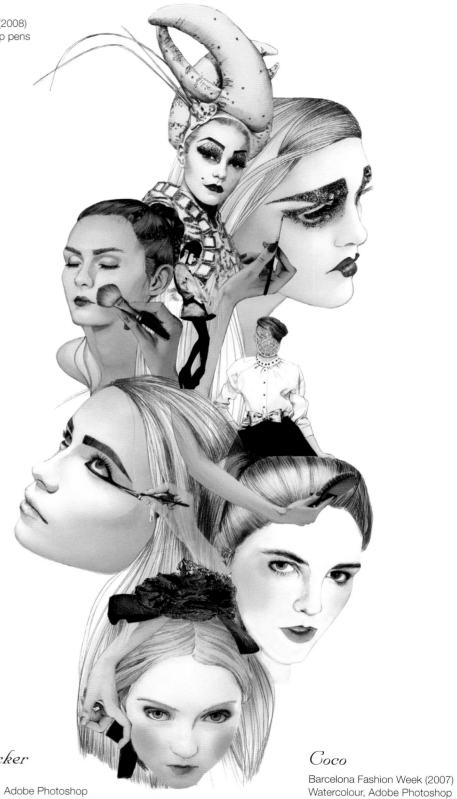

Kerstin Wacker

Beauty (2010)
Watercolour, ink pen, Adobe Photoshop

Coco

Barcelona Fashion Week (2007)
Watercolour, Adobe Photoshop

Coco

Galiano Perfume (2008)
Watercolour, Adobe Photoshop

Jo Cheung

In My Bag ….. (2009)
Collage, Adobe Photoshop

Kerstin Wacker

Boudoir (2009)
Watercolour, ink pen, Adobe Photoshop

Maxim Savva

Make Up: book illustrations (2007)
Adobe Illustrator

Kentaro Hisa

Personal Work (2008)
Adobe Illustrator

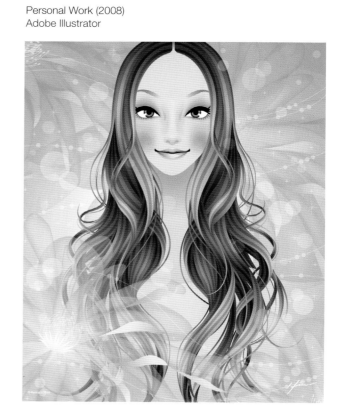

Kari Moden

Hairspray (2006)
Adobe illustrator

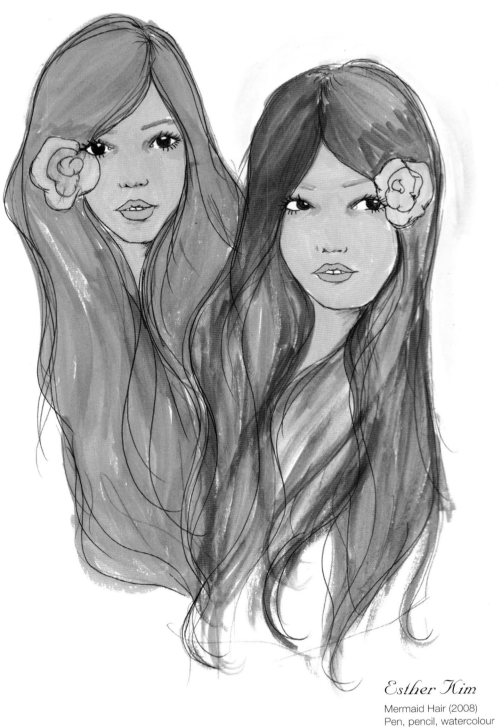

Alena Lavdovskaya

Illustrations for online forecast service
www.beautystreams.com (2010)
Pencil, Adobe Photoshop

Esther Kim

Mermaid Hair (2008)
Pen, pencil, watercolour

Zhuzhu

Sweet Thing (2008)
Adobe Photoshop

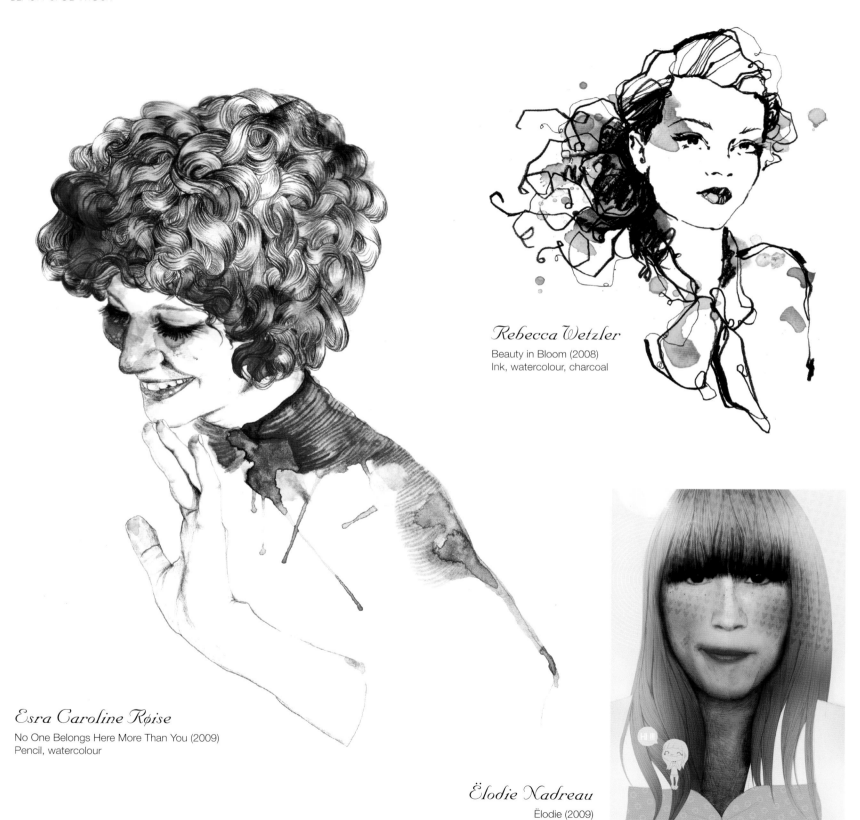

Rebecca Wetzler

Beauty in Bloom (2008)
Ink, watercolour, charcoal

Esra Caroline Røise

No One Belongs Here More Than You (2009)
Pencil, watercolour

Ëlodie Nadreau

Ëlodie (2009)
Pencil, Adobe Photoshop

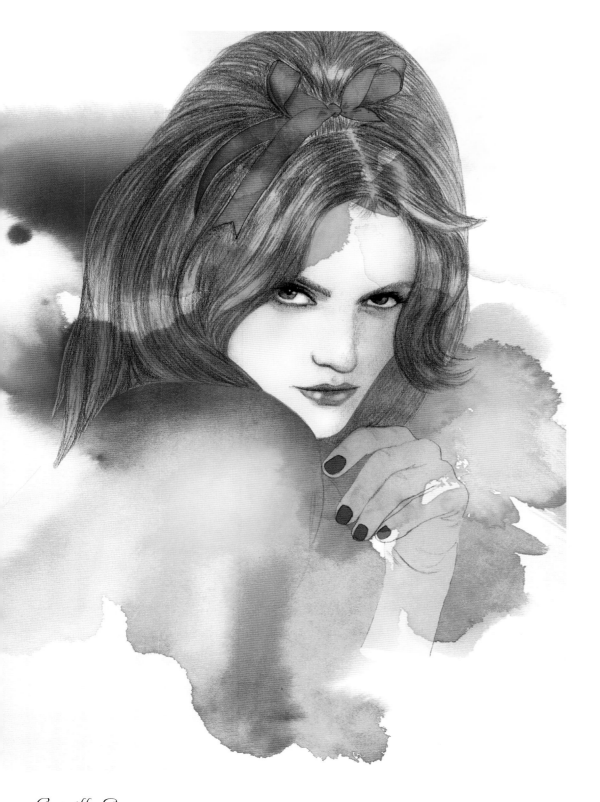

Jo Cheung
Untitled (2010)
Collage, Adobe Photoshop

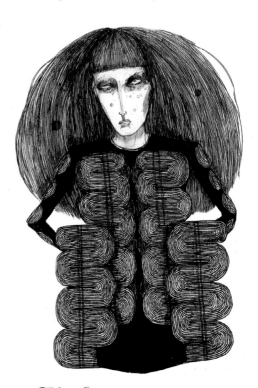

Camilla Gray
Sexy/Innocent (2009)
Pencil, watercolour, Adobe Photoshop

Alec Strang
Flyer for Derek Lawlor A/W 09/10 (2009)
Propelling pencil

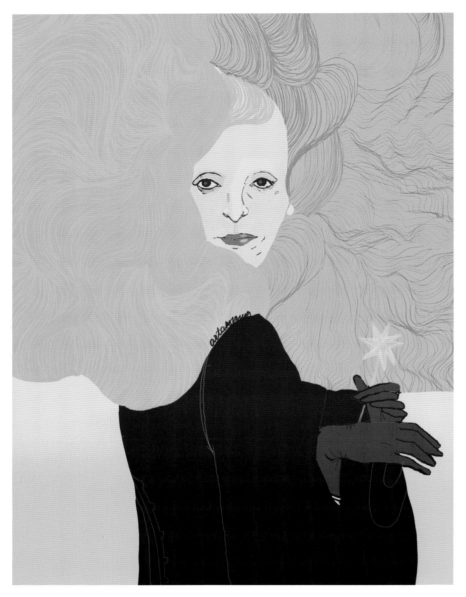

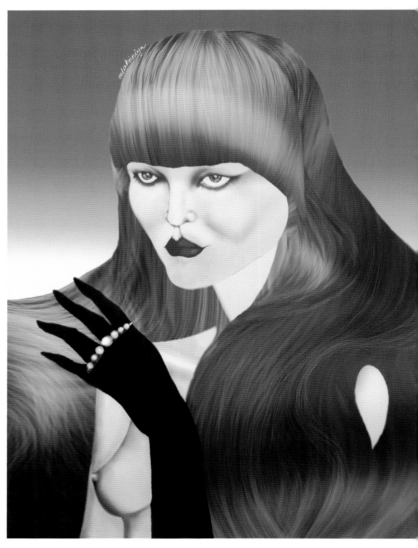

Artaksiniya
Grace Coddington (2009)
Edding drawliner, Adobe Photoshop

Artaksiniya
That Ring, Betony V (2009)
Adobe Photoshop

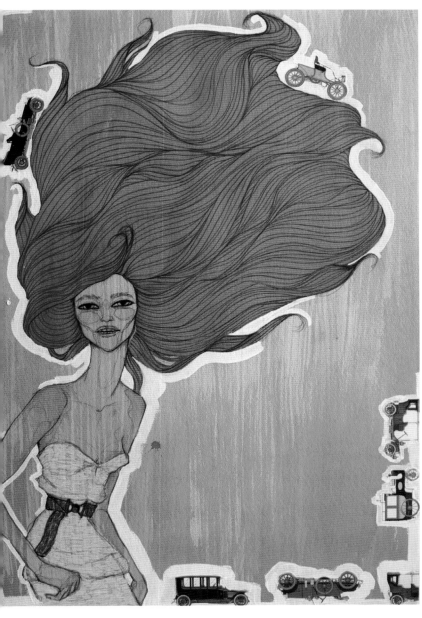

Loreto Binvignat Streeter

Beep Beep I'm Running Late 1 (2009)
Watercolour, acrylic, pencil, collage on paper

Robert Tirado

Lady Ice Cream (2008)
Adobe Photoshop,
Adobe Illustrator

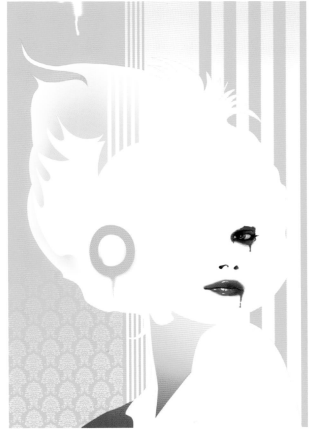

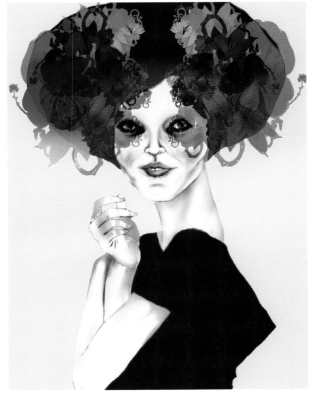

Artaksiniya

The Autumn (2010)
Adobe Photoshop

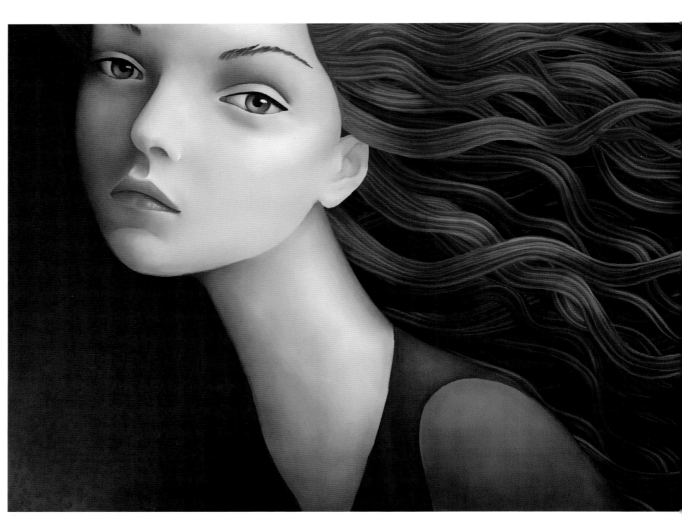

Lyubov Dubrina
My Botticelli's Muse (2010)
Corel Painter

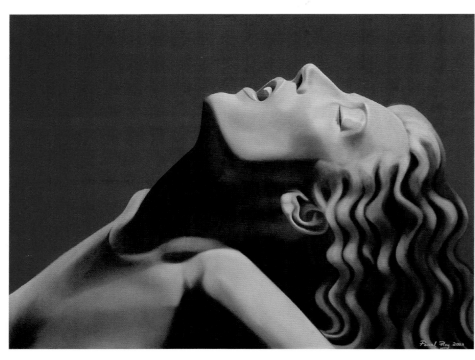

Pascal Roy
Extase (2003)
Oil on canvas

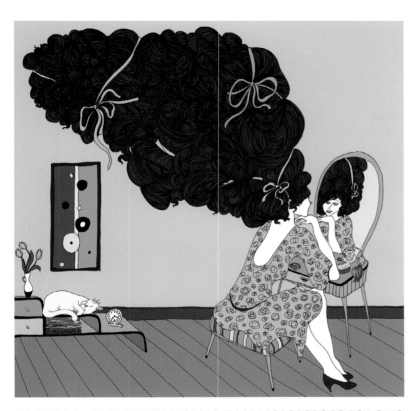

Ellen van Engelen

Styling (2009)
Pen and ink, Adobe Photoshop

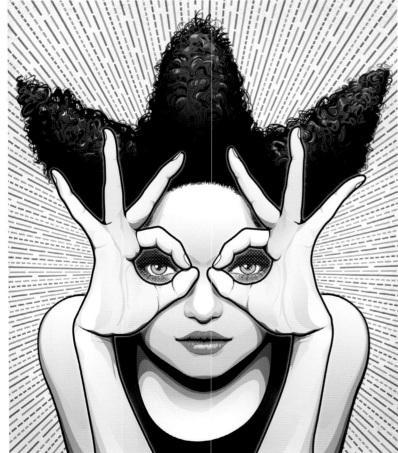

Shingo Shimizu

Web magazine: www Girl (2005)
Adobe Illustrator

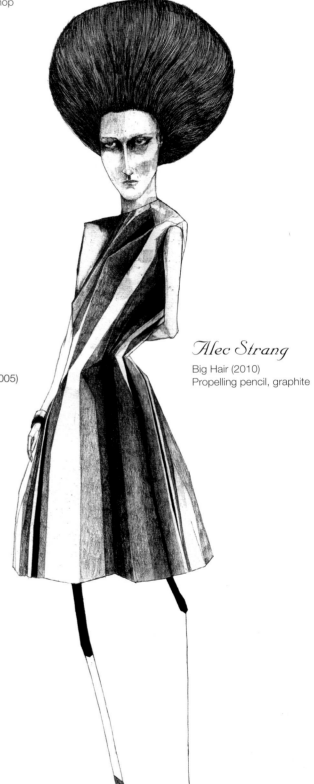

Alec Strang

Big Hair (2010)
Propelling pencil, graphite

Robert Tirado

Christine (2009)
Adobe Photoshop, Adobe Illustrator

Mariya Paskovsky

Butterfly Girl (2006)
Black ink, Adobe Photoshop

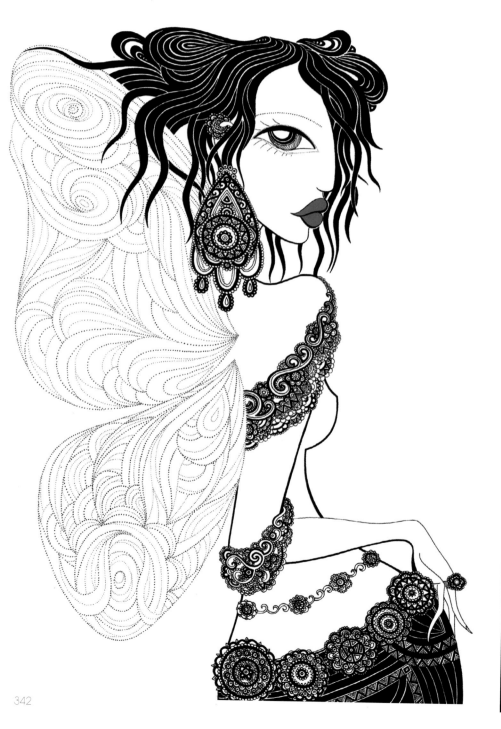

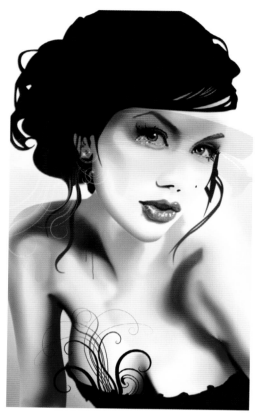

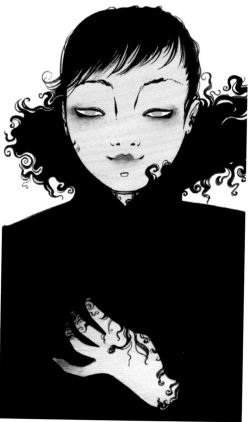

Eliza Frye

Big Lizard (2010)
Gouache, pastel on wood

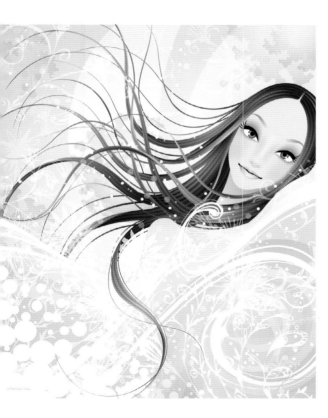

Kentaro Hisa
Personal Work (2008)
Adobe Illustrator

Artaksiniya
I Miss You, Gareth (2010)
Pencil, watercolour, Adobe Photoshop

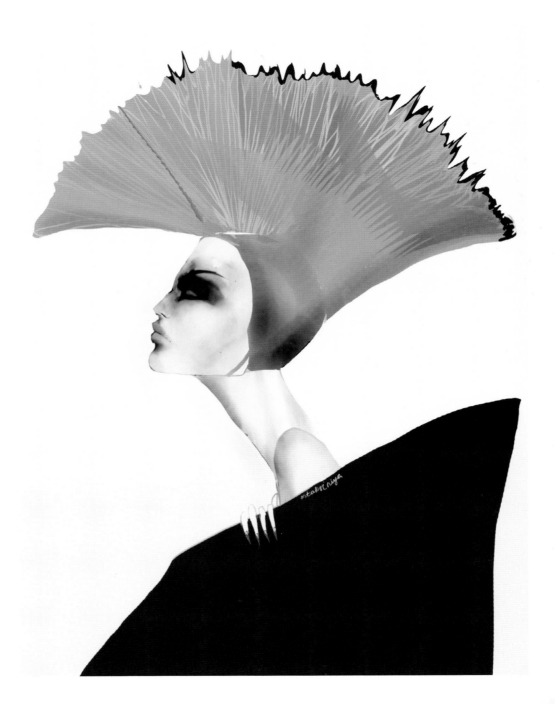

Svetlana Makarova
Undine (2009)
Adobe Illustrator

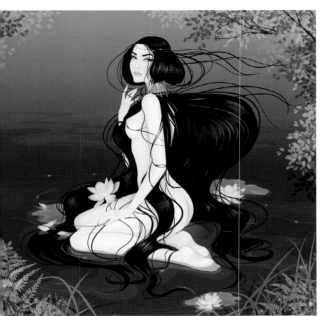

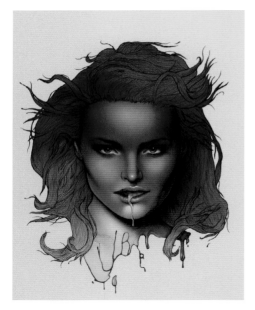

Grzegorz Domaradzki

Pleasure I (2009)
Pencil, Adobe Photoshop

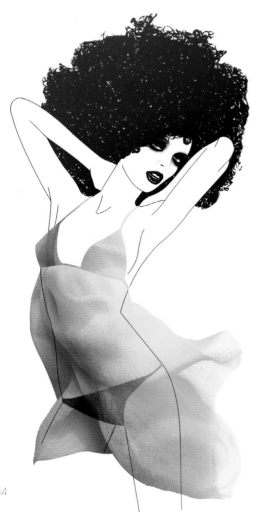

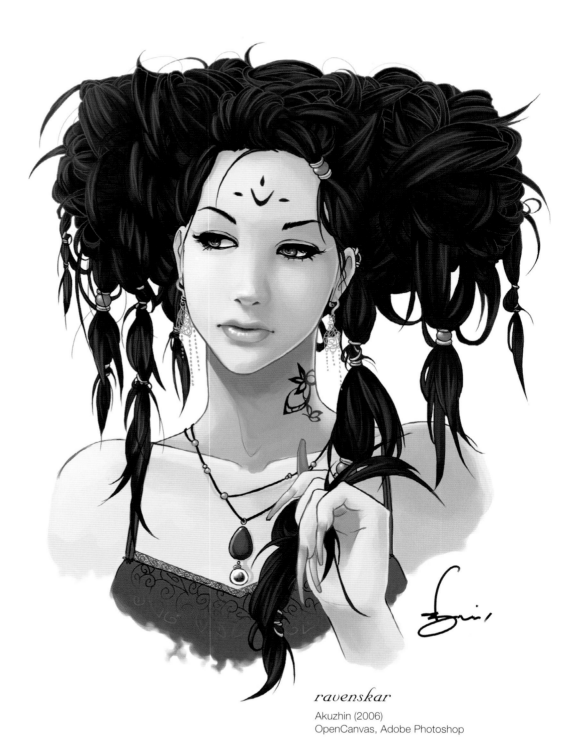

ravenskar

Akuzhin (2006)
OpenCanvas, Adobe Photoshop

Luis Tinoco

Glamour magazine (GERMANY): Time for Intense Feelings (2008)
Collage, Adobe Photoshop

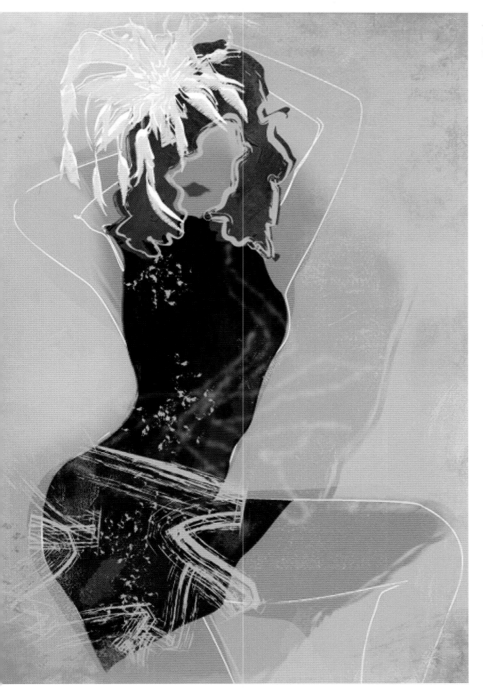

Monica Velasquez

Feathers (2008)
Pencil, Adobe Illustrator, Adobe Photoshop

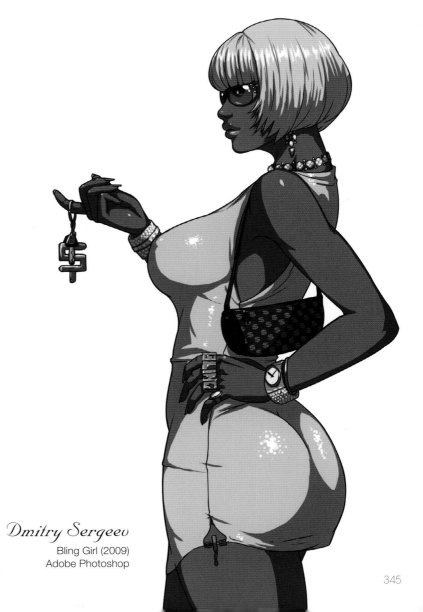

Dmitry Sergeev

Bling Girl (2009)
Adobe Photoshop

Robert Tirado

Smell Like an Angel (2009)
Adobe Photoshop, Adobe Illustrator

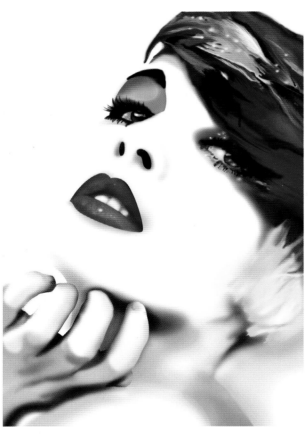

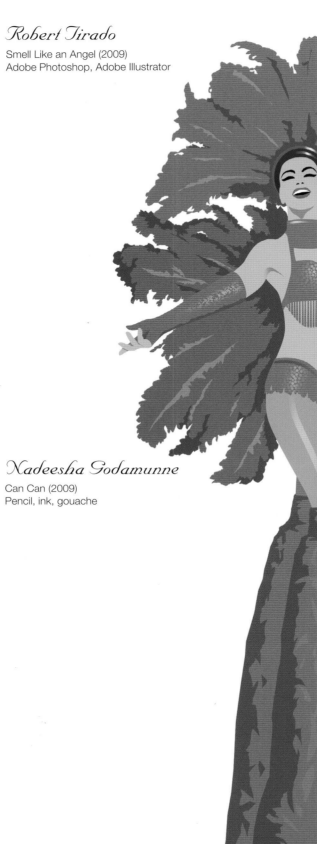

Nadeesha Godamunne

Can Can (2009)
Pencil, ink, gouache

Laurence Whiteley

Carnival (2005)
Adobe Photoshop

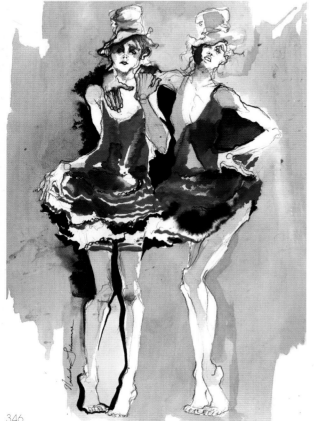

Barbara Rosin

Red Lips (200)
Adobe Illustrator, Adobe Photosh

346

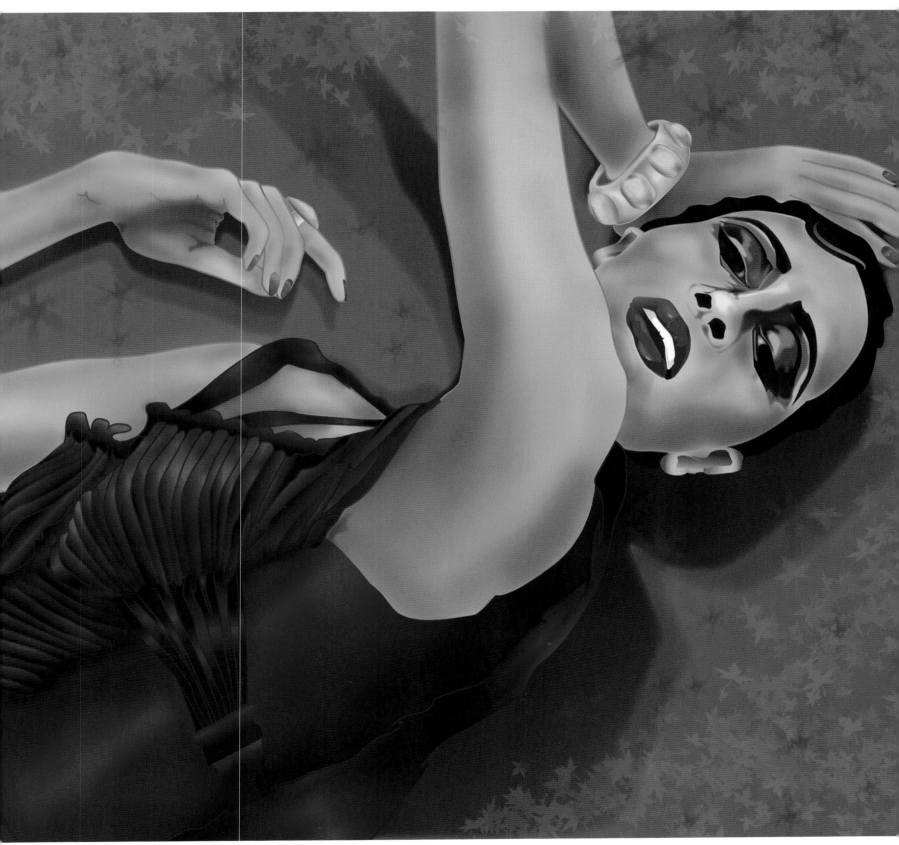

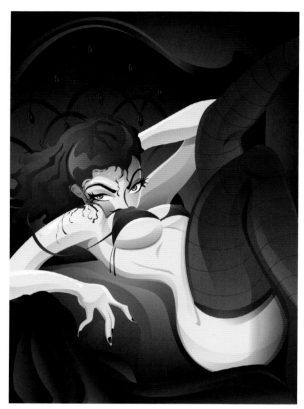

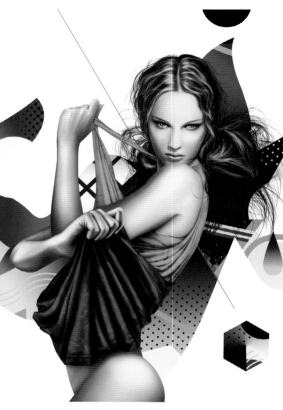

Kittozutto

Poise (2009)
Adobe Photoshop

Robert Tirado

Draft Glamour Muse (2008)
Adobe Photoshop, Adobe Illustrator

Charlene Chua

Sex Girl (2006)
Adobe Illustrator

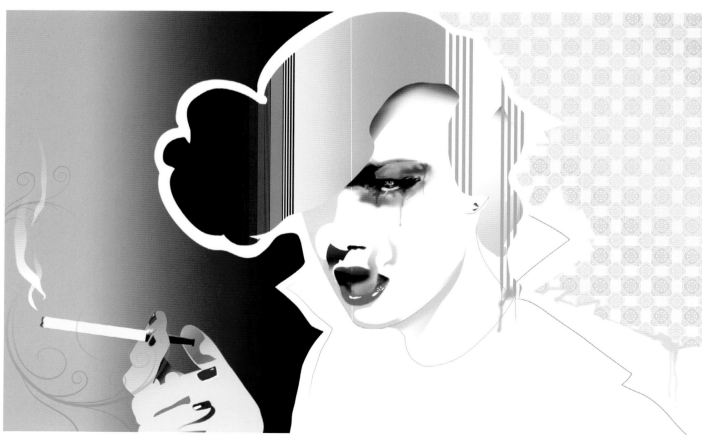

Zhuzhu
Binding (2008)
Adobe Photoshop

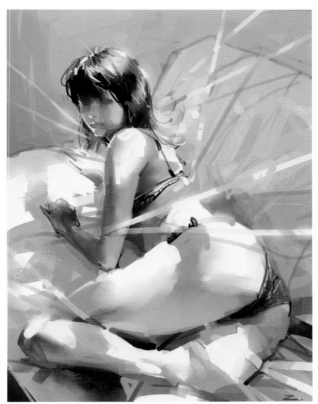

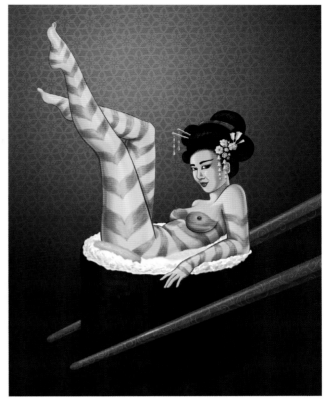

Wendy Ding
Food Girls Series: Sushi Girl (2007)
Adobe Photoshop, Adobe Illustrator

Marguerite Sauvage
Grafuck: Mellow Dream (2008)
Pencil on paper, Adobe Photoshop

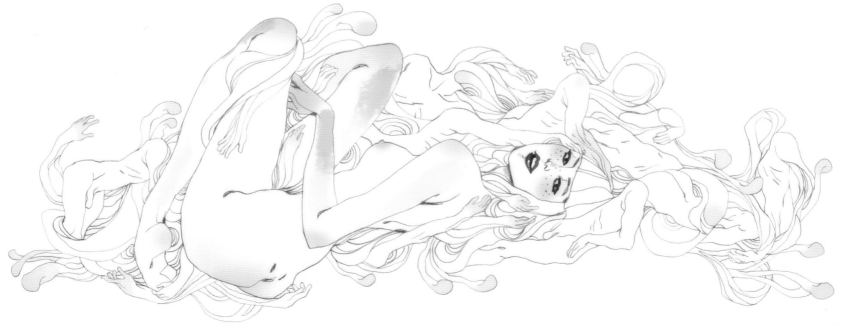

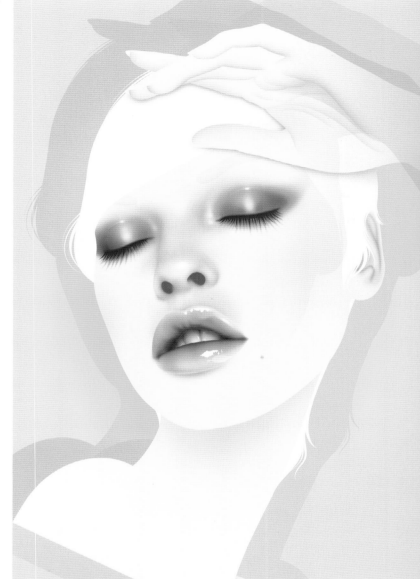

Autumn Whitehurst

Psychodermatology (2007)
Adobe Photoshop, Adobe Illustrator, Corel Painter

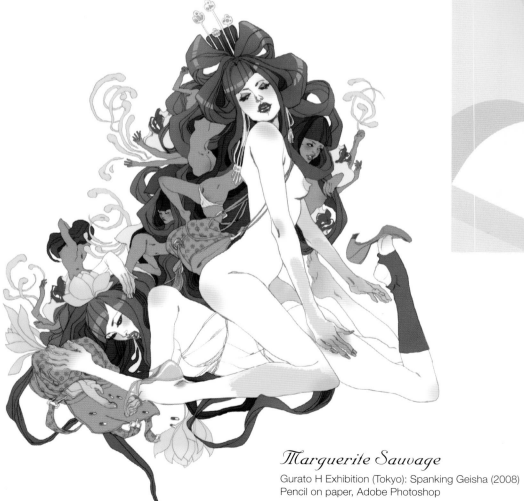

Marguerite Sauvage

Gurato H Exhibition (Tokyo): Spanking Geisha (2008)
Pencil on paper, Adobe Photoshop

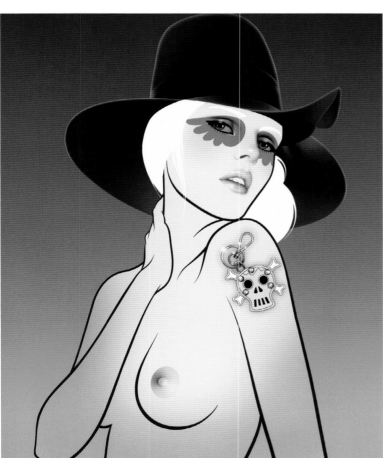

Autumn Whitehurst

Vuitton Hat (2005)
Adobe Photoshop, Adobe Illustrator, Corel Painter

Eliza Frye

Little Dragon (2010)
Gouache and pastel on wood

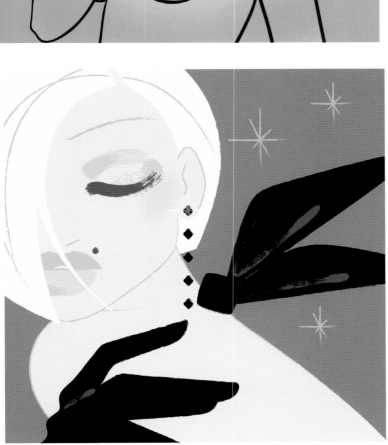

Lisa Plaskett

Diamante (2008)
Charcoal, Adobe Illustrator

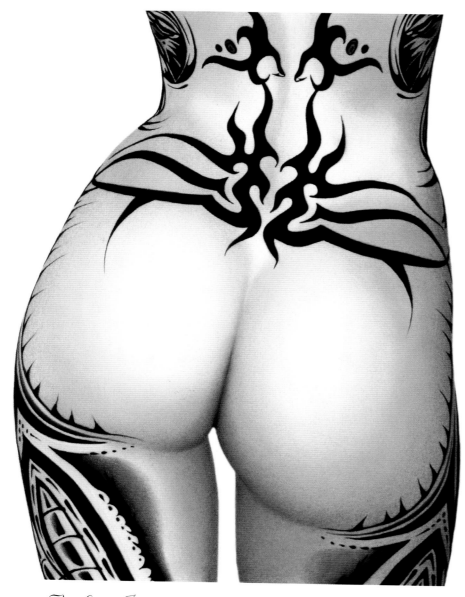

Barbara Jensen

Going Tribal (2008)
Watercolour, coloured pencils, inks, charcoal

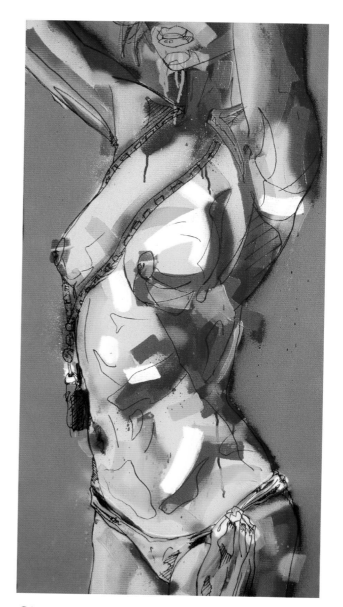

Rowan Newton

A Bit of Bling n Ting (2009)
Acrylic and spray paint on canvas

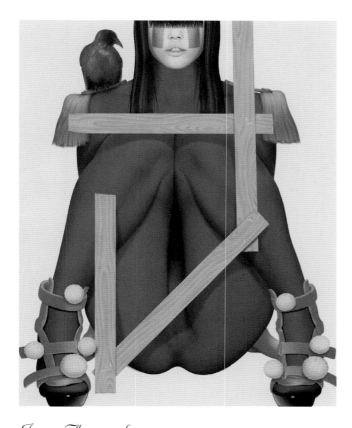

Jesse Auersalo

Purple Wolf (2010)
Macromedia FREEHAND, Adobe Photoshop

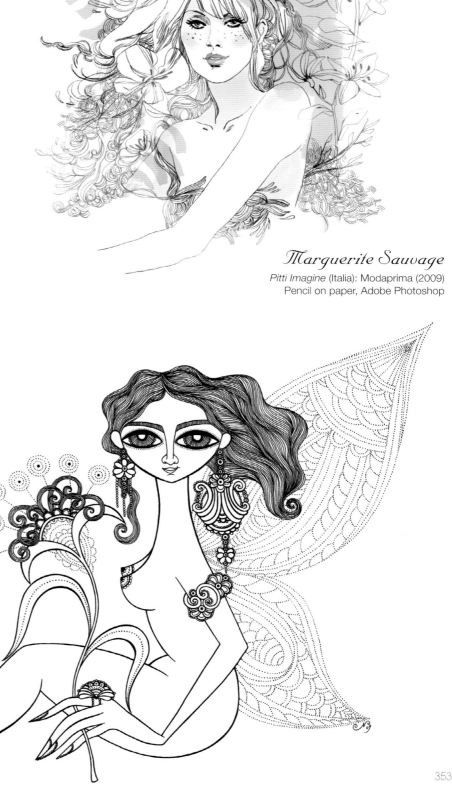

Marguerite Sauvage

Pitti Imagine (Italia): Modaprima (2009)
Pencil on paper, Adobe Photoshop

Mariya Paskovsky

Nymph (2009)
Black ink

353

Jo Cheung

Camp Slag & Drag (2006)
Collage, Adobe Photoshop

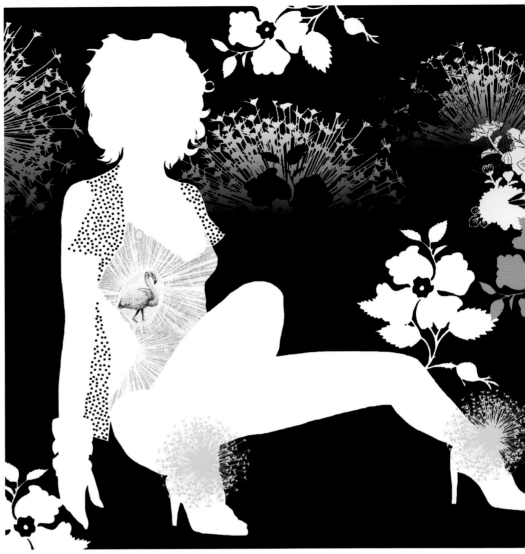

Wendy Plovmand

FemaleFantasies 02 (2006)
Acrylic, Adobe Photoshop, mixed media

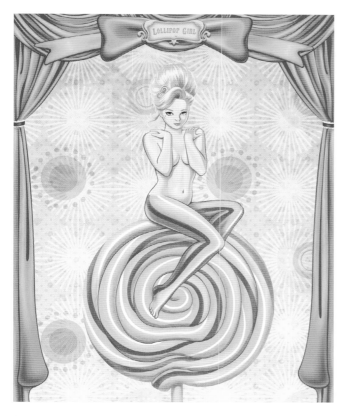

Wendy Ding

Food Girls Series: Lollipop Girl (2009)
Adobe Photoshop, Adobe Illustrator

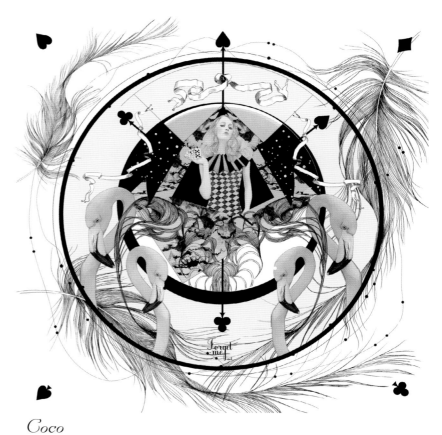

Coco

Forget Me Not Scarves, Wonderland Collection (2010)
Watercolour, Adobe Photoshop

Oscar Gimenez

Red Sofa Miss Lara (2006)
Ink, Adobe Photoshop

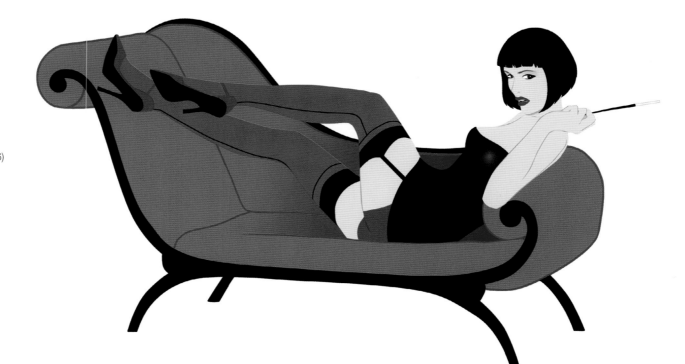

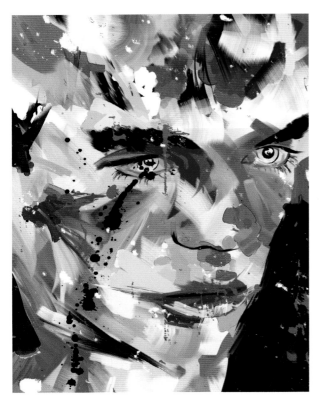

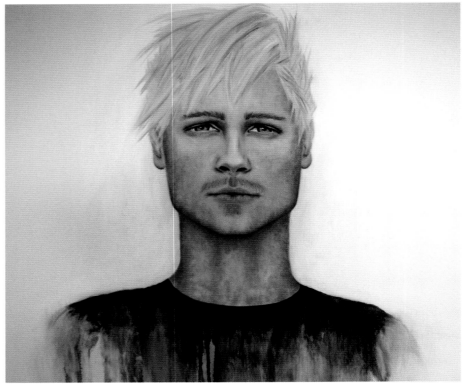

Jill Tovey

Blue (2009)
Watercolour, photography, acrylics, pencil,
pen, oils, Adobe Photoshop, Corel Painter X

Fiona Maclean

Blondie (2010)
Oil on canvas

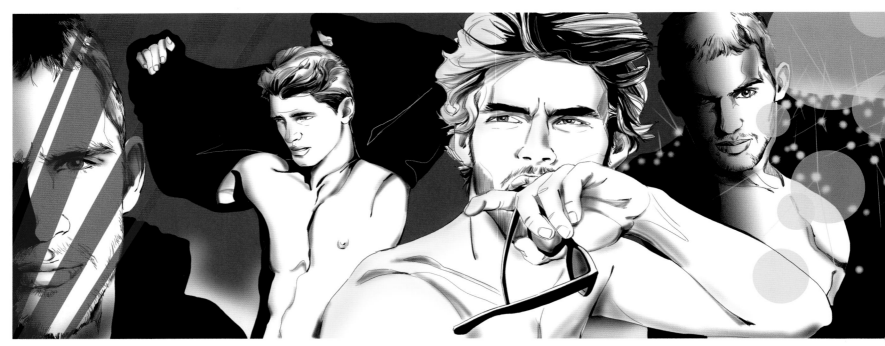

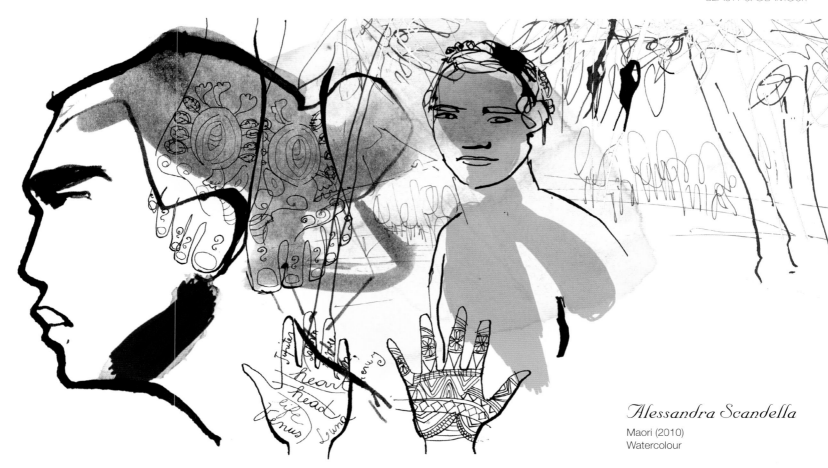

Alessandra Scandella
Maori (2010)
Watercolour

Dustin Papow
Habibi (2007)
Adobe Photoshop

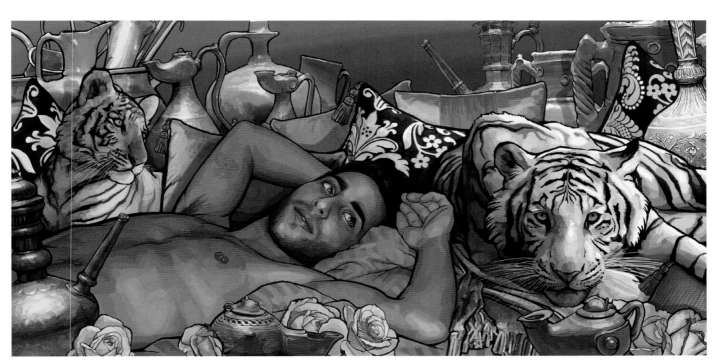

avid Pfendler
tes (2010)
obe Photoshop

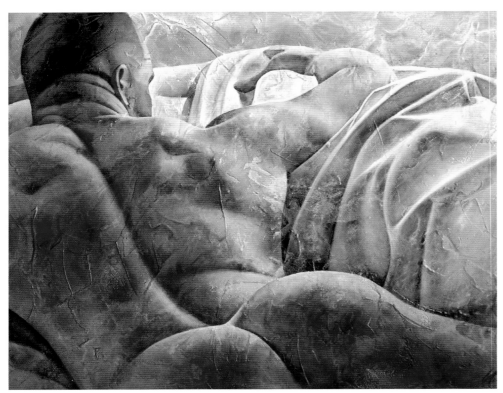

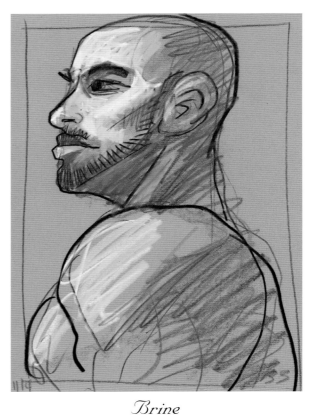

Chris Lopez

Sunday Morning (2007)
Acrylic and stucco on canvas

Brine

Erwin (2006)
Coloured Pencil

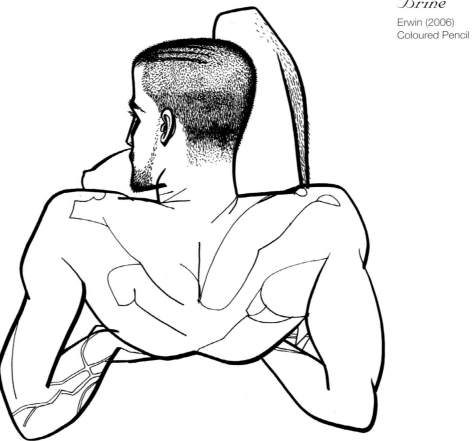

Carlos Aponte

Ridge II (2009)
Ink on paper

Gormax
Tropical Guy (2007)
Adobe Illustrator

Jeffrey Herrero
Blue XS (2008)
Adobe Photoshop, Adobe Illustrator

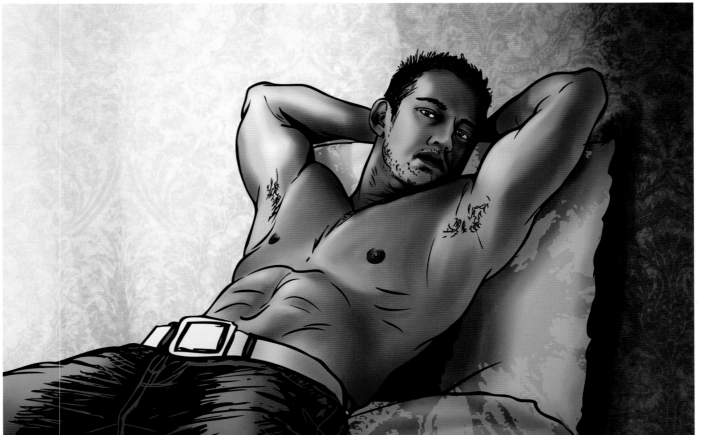

Gormax
Shirtless (2010)
Corel Painter

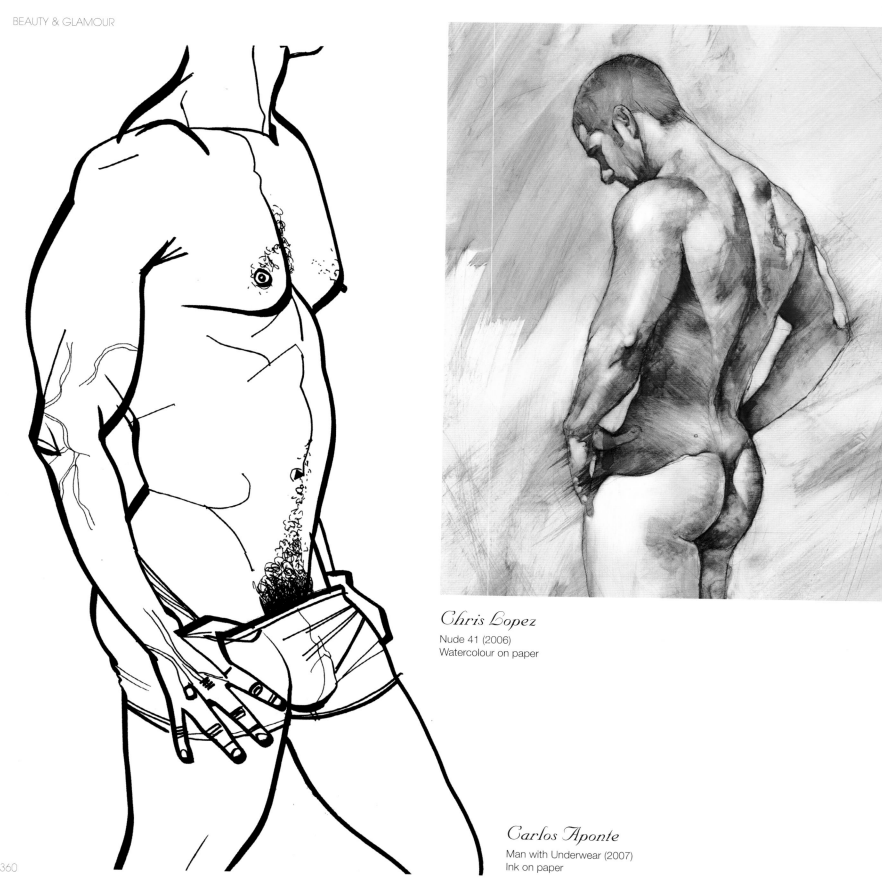

Chris Lopez
Nude 41 (2006)
Watercolour on paper

Carlos Aponte
Man with Underwear (2007)
Ink on paper

Jason Siew
Strength (2009)
Watercolour

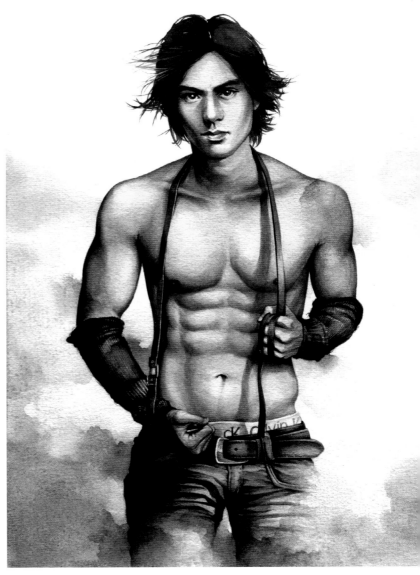

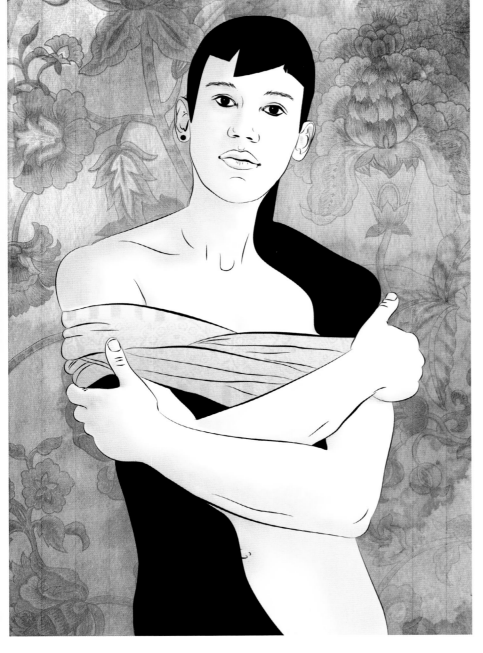

Jeffrey Herrero
Fred 'La Joven Moderna' (2009)
Adobe Photoshop, Adobe Illustrator

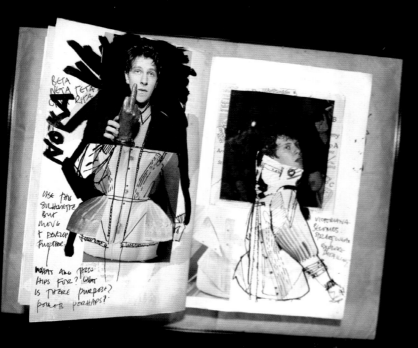

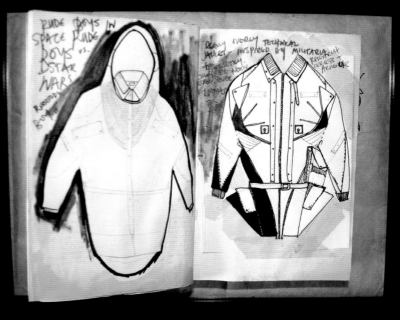

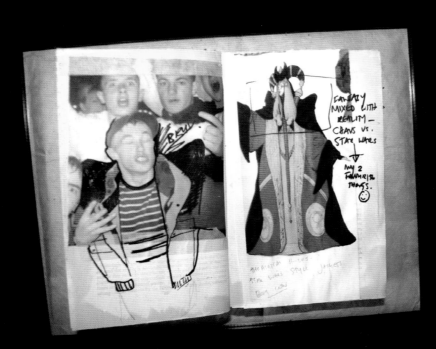

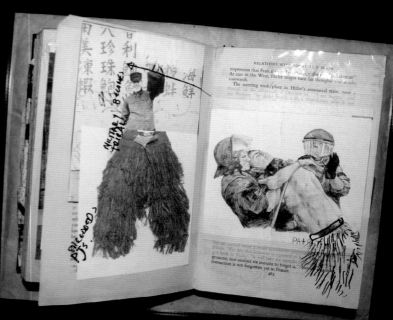

Sketchbook

previous page:

Courtney McWilliams

Yard Days Aren't Over (Long Live Buttoned
Shirts and Whiskey) (2009)
Printed paper collage, paint, ink, masking
tape, recycled book

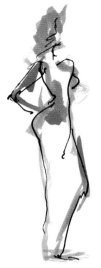
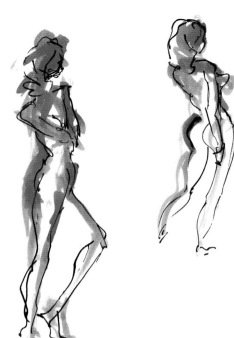

Ivan Pols

Sarah (2008)
Ink

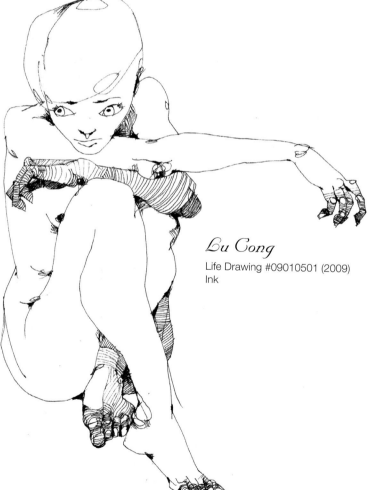

Lu Cong

Life Drawing #09010501 (2009)
Ink

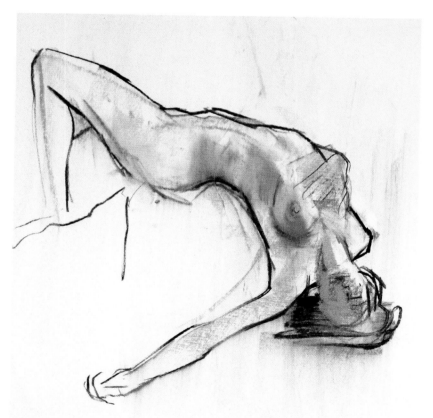

Mark Adlington

Falling (2008)
Charcoal, conté

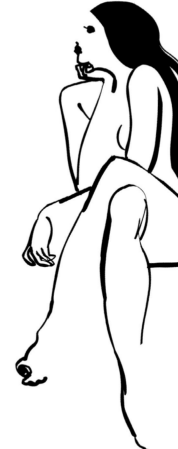

Kyle T. Webster

Ruminate (2009)
Adobe Illustrator

Victoria Kim

Passion (2009)
Pencil, pastel

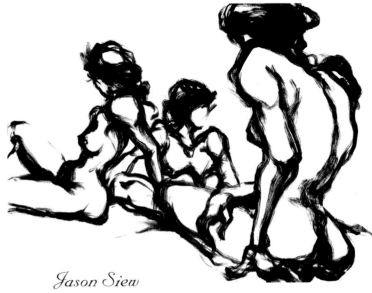

Jason Siew

Three (2006)
Chinese ink

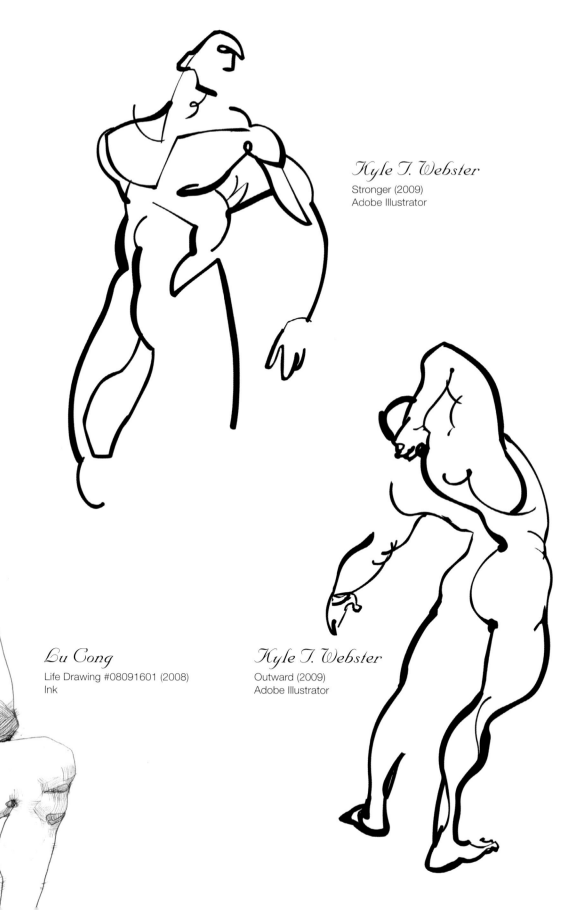

Kyle T. Webster
Stronger (2009)
Adobe Illustrator

Lu Cong
Life Drawing #08091601 (2008)
Ink

Kyle T. Webster
Outward (2009)
Adobe Illustrator

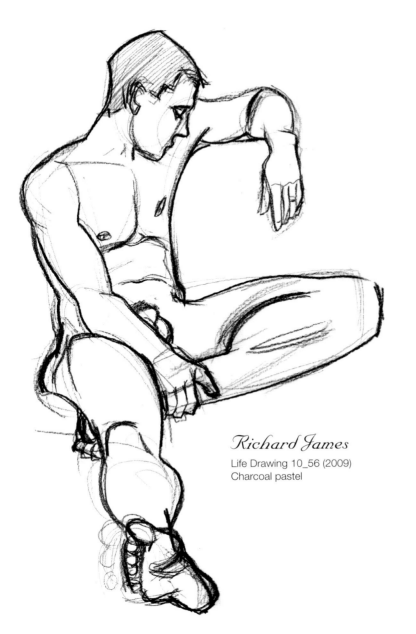

Brine

Kiric (2009)
Coloured pencil

Richard James

Life Drawing 10_56 (2009)
Charcoal pastel

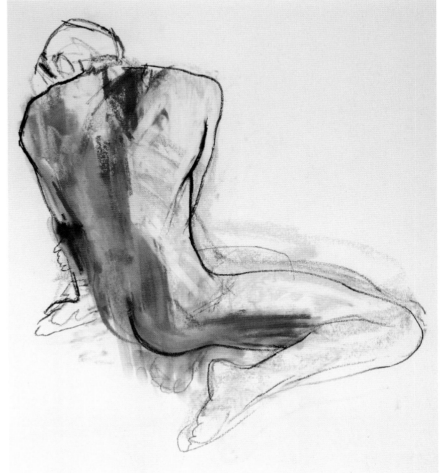

Mark Adlington

Danny (Seated, Turning Away) (2009)
Charcoal, conté

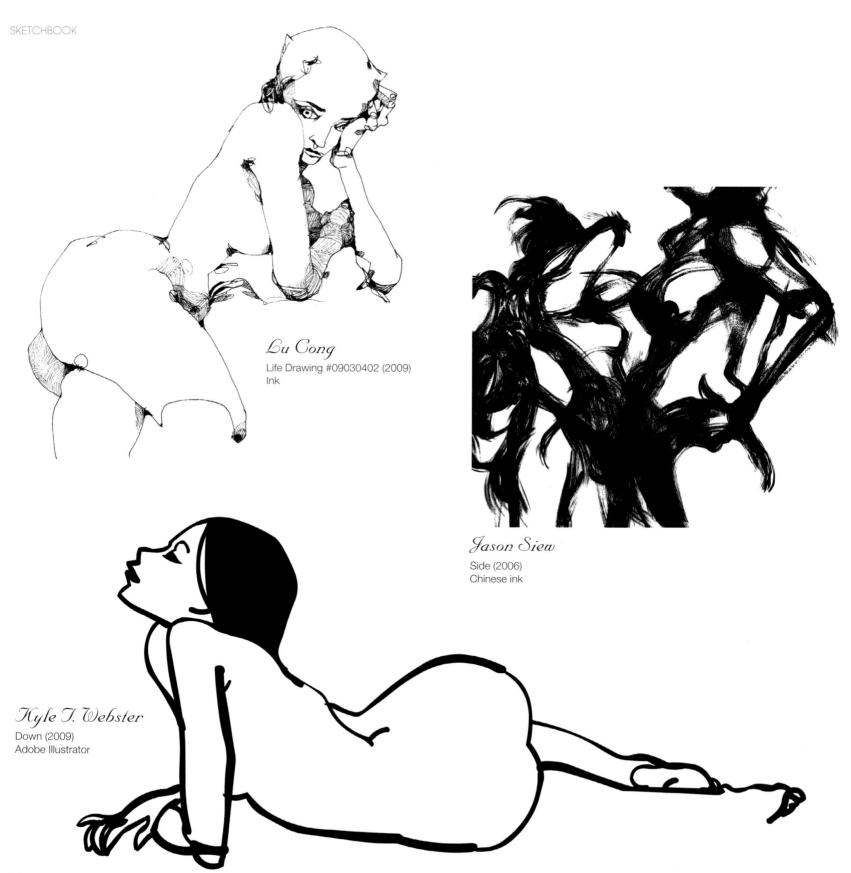

Lu Cong

Life Drawing #09030402 (2009)
Ink

Jason Siew

Side (2006)
Chinese ink

Kyle T. Webster

Down (2009)
Adobe Illustrator

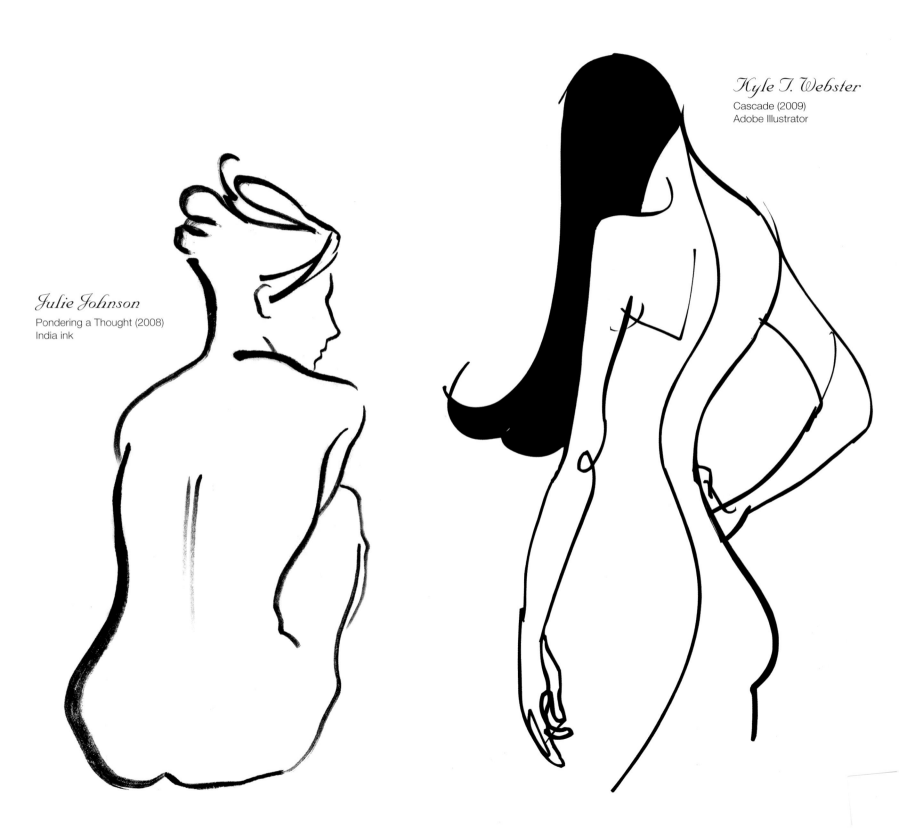

Julie Johnson

Pondering a Thought (2008)
India ink

Kyle T. Webster

Cascade (2009)
Adobe Illustrator

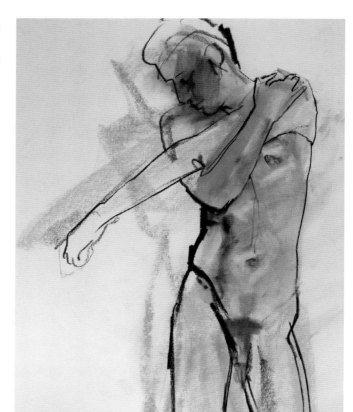

Mark Adlington
Arm Outstretched (2009)
Charcoal, conté

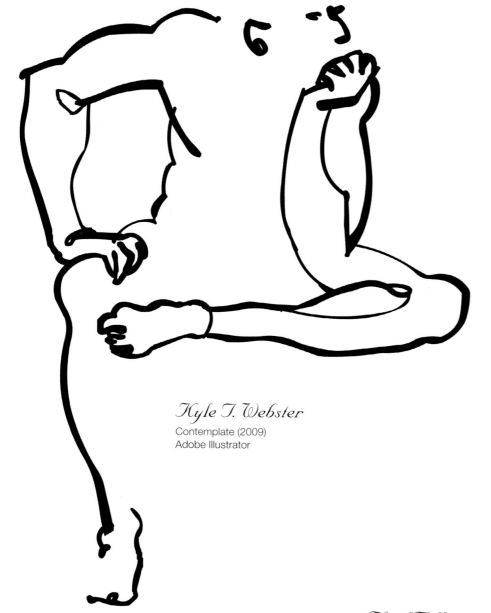

Kyle T. Webster
Contemplate (2009)
Adobe Illustrator

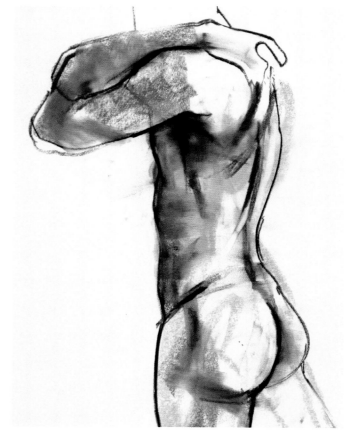

Mark Adlington
Danny (2009)
Charcoal, conté

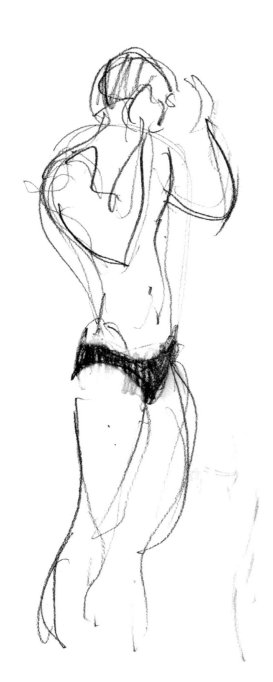

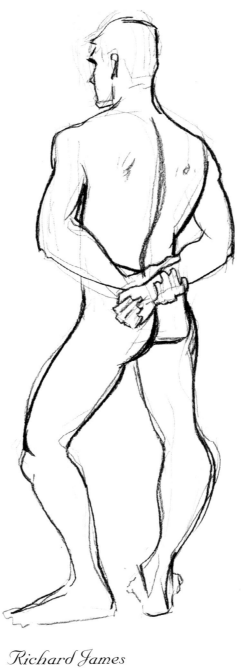

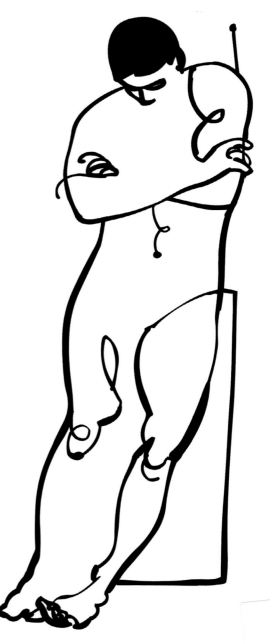

Kyle T. Webster

Predator (2009)
Adobe Illustrator

Richard James

Freestyle Concept 13 (1998)
Pencil

Richard James

Life Drawing 10_54 (2009)
Charcoal pastel

Ivan Pols
Seven Sins (2009)
Ink

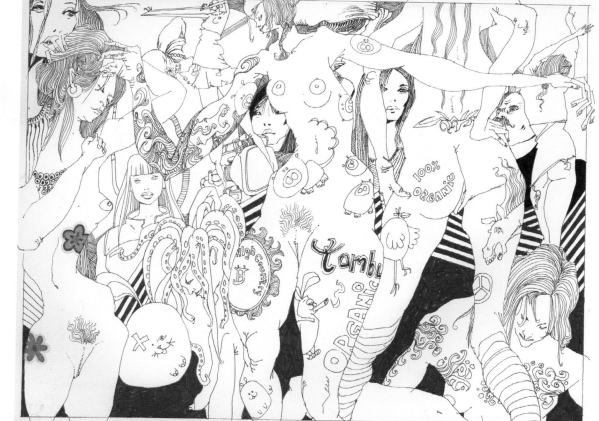

John Mahoney
She Loves You Yeah Yeah Yeah (2009)
Ink

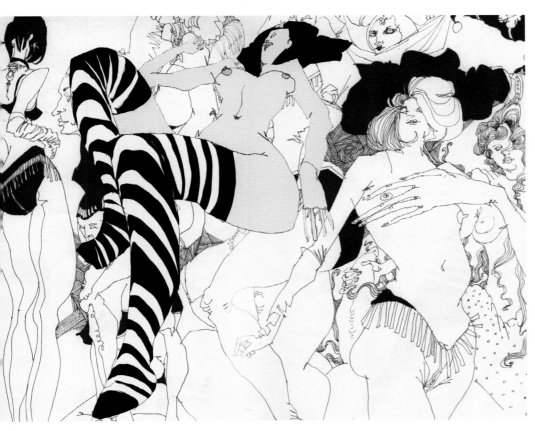

John Mahoney
'hillin' (2009)
k, Adobe Photoshop

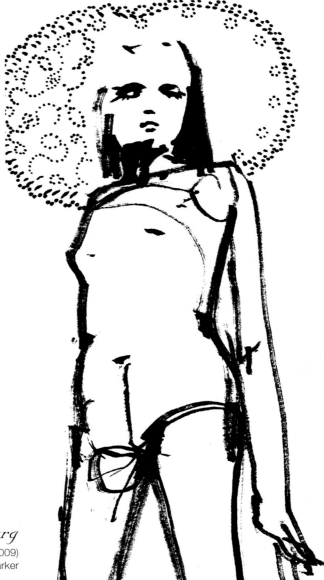

Petra Lunenburg
Dutch Folkloric, in Commission of Dutch Zuiderzee Museum (2009)
Marker

Charlene Chua
Sketches (undated)
Pencil

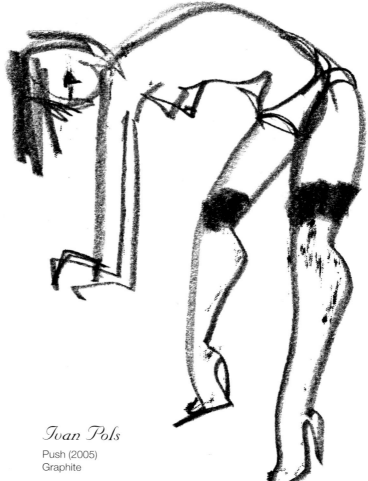

Ivan Pols
Push (2005)
Graphite

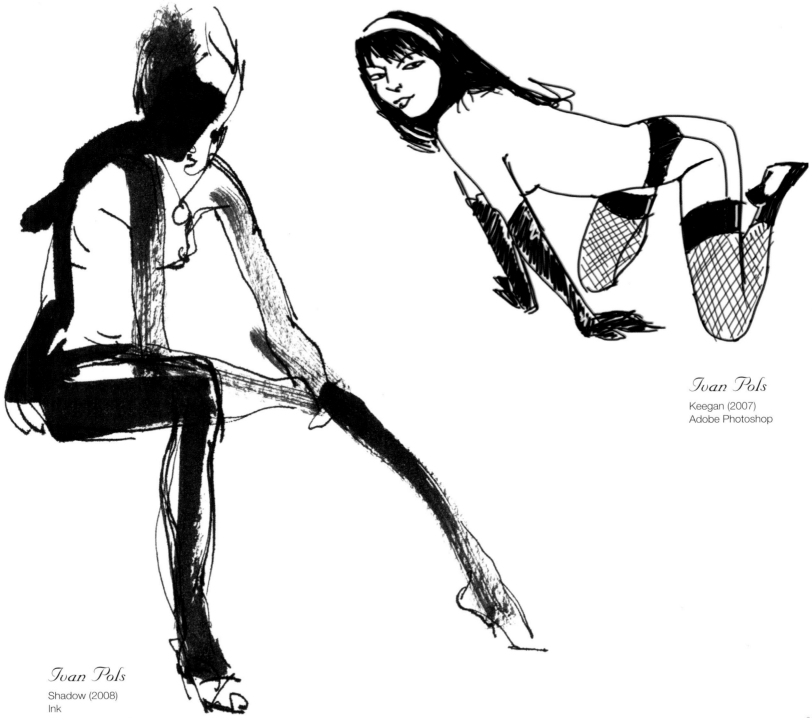

Ivan Pols

Keegan (2007)
Adobe Photoshop

Ivan Pols

Shadow (2008)
Ink

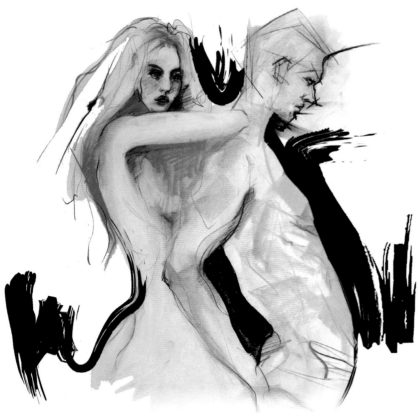

Victoria Kim

Lovers 2 (2007)
Pastel

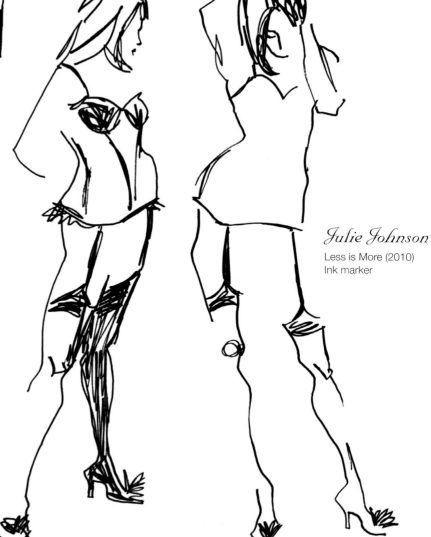

Julie Johnson

Less is More (2010)
Ink marker

Julie Johnson

Corset and Stockings (2010)
Ink marker

Rebecca Wetzler

Mimco Fashion Week Program 1/3 (2005)
Charcoal, ink

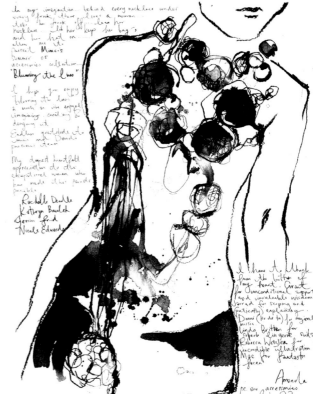

Ivan Pols

Edged (2004)
Ink

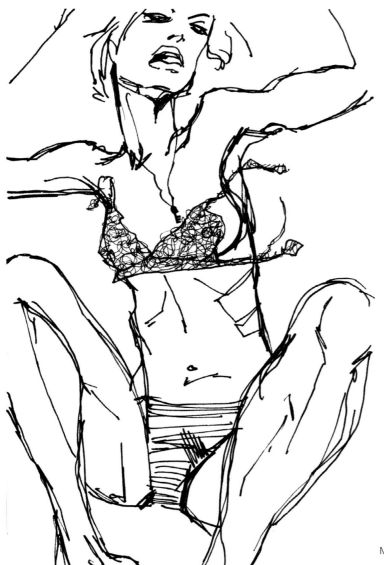

Rebecca Wetzler

Mimco Window Display (2008)
Charcoal, ink

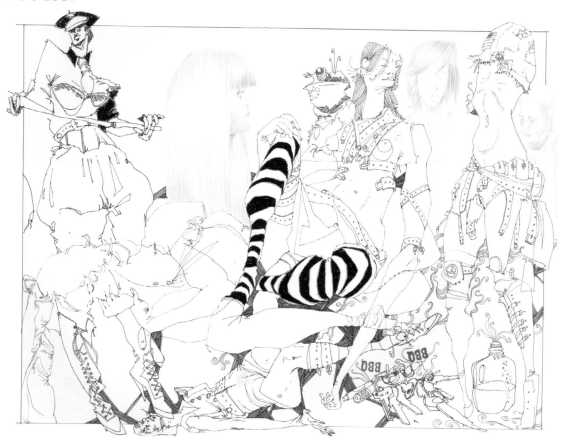

John Mahoney

Monster Mash (2009)
Ink

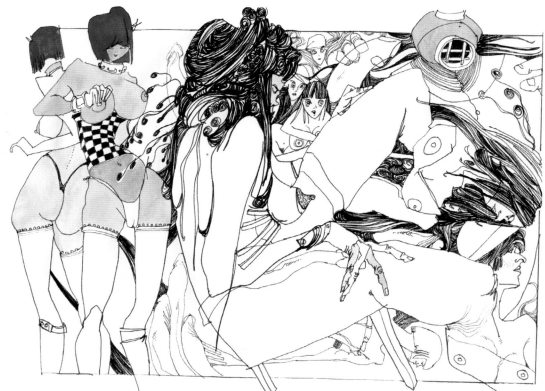

John Mahoney

Party Girls (2009)
Ink, watercolour

Richard James
Freestyle Concepts 17 & 18 (1998)
Watercolour

Victoria Kim
Movement 1 (2008)
Conté

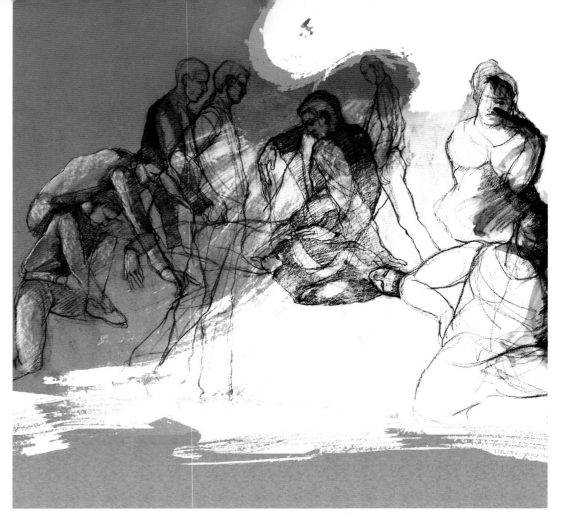

Julie Johnson
Leisha in a Headband (2009)
Black pitt pen on moleskin journal paper

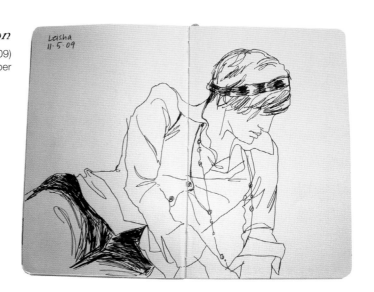

Marsha Riti
Seated Model in Stripes (2008)
Graphite

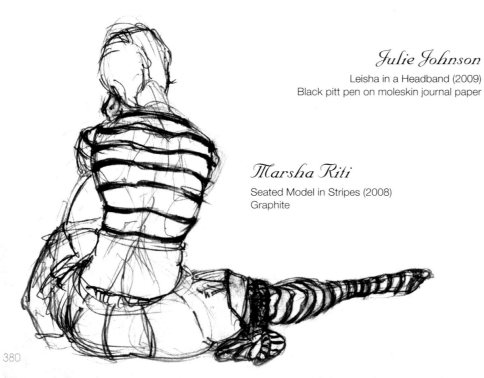

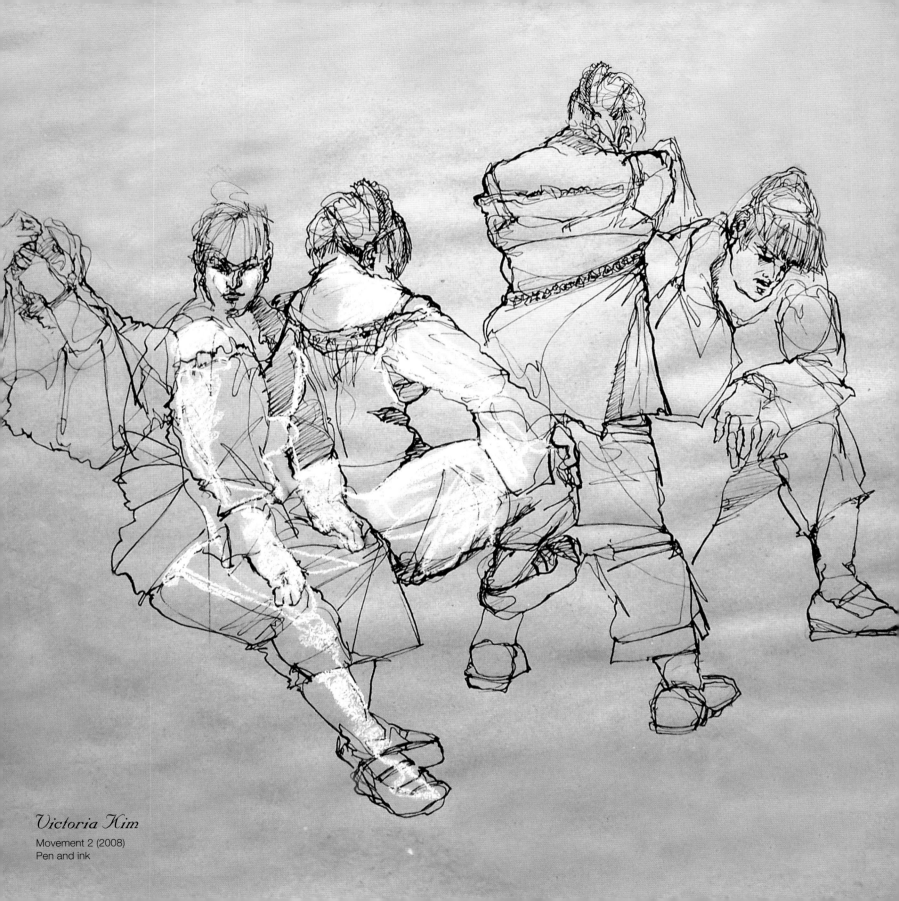

Victoria Kim

Movement 2 (2008)
Pen and ink

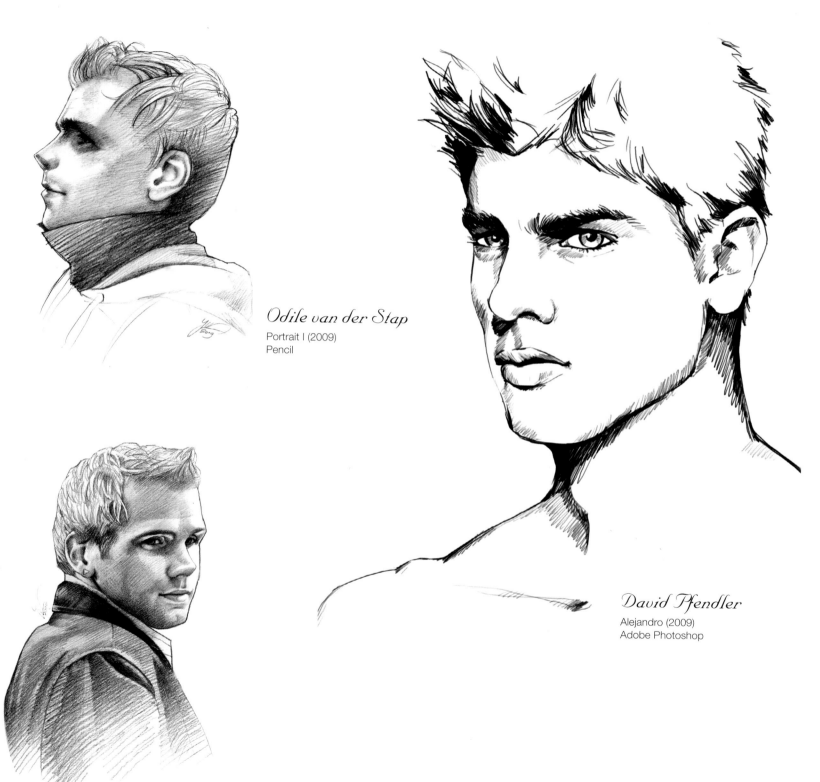

Odile van der Stap
Portrait I (2009)
Pencil

David Pfendler
Alejandro (2009)
Adobe Photoshop

Odile van der Stap
Portrait I (2009)
Pencil

Brine

Ricardo (2004)
Coloured Pencil

Brine

Fabio (2006)
Coloured Pencil

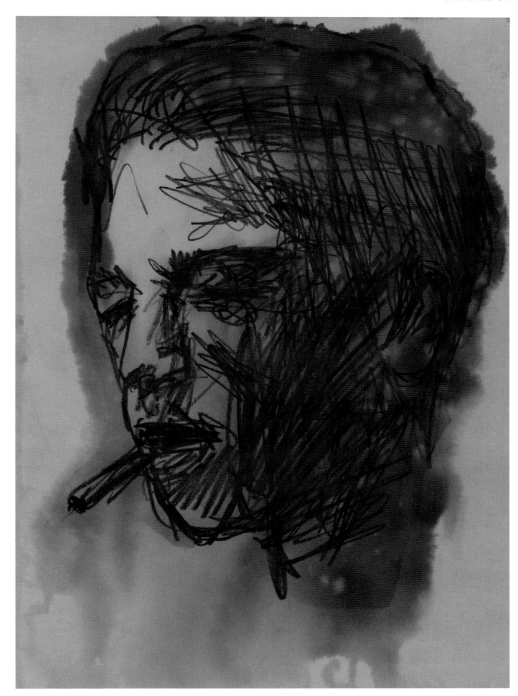

André Azevedo

Five Minutes (2009)
Pencil drawing, Aquarelle paint

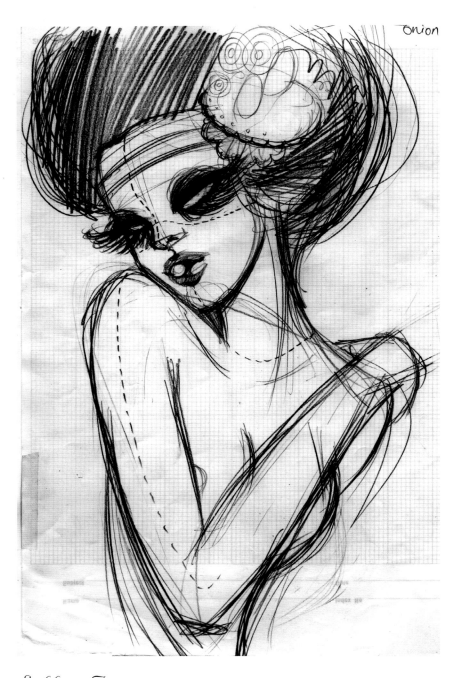

Sokkuan Tye

Sophie Black – Licking Good (2010)
Pencil

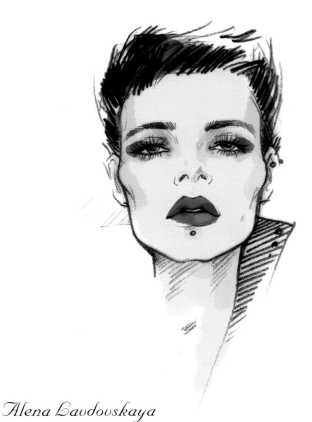

Alena Lavdovskaya

Illustrations for Online Forecast Service www.beautystreams.com (2010)
Pencil, Adobe Photoshop

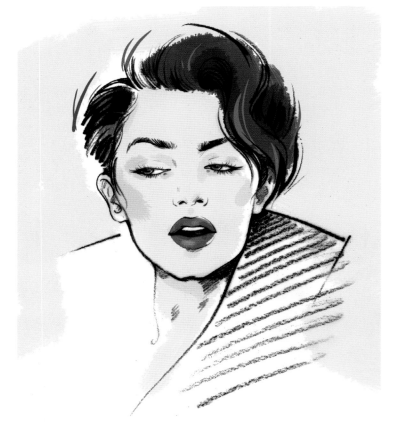

Alena Lavdovskaya

Illustrations for Online Forecast Service www.beautystreams.com (2010)
Pencil, Adobe Photoshop

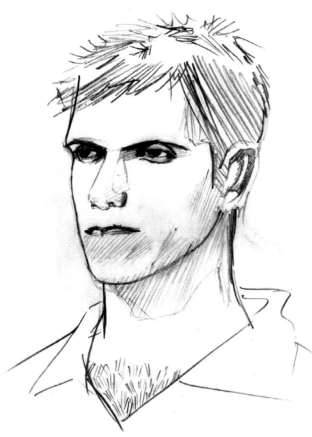

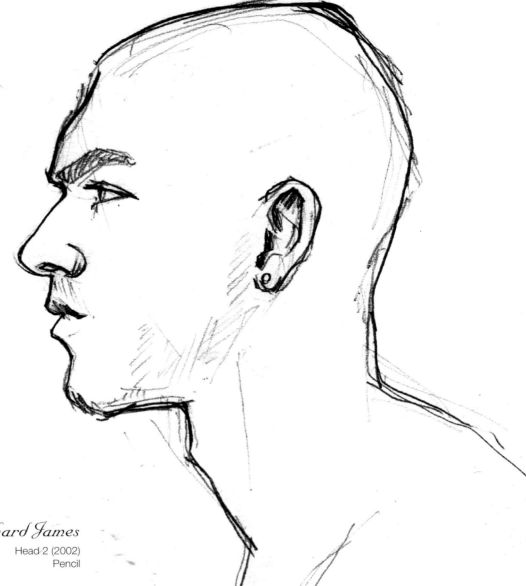

Richard James

David Beckham (2002)
Pencil

Richard James

Head 2 (2002)
Pencil

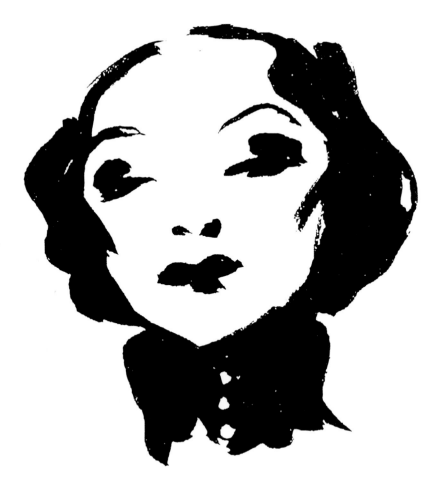

Kyle T. Webster
She (2009)
Brush and ink

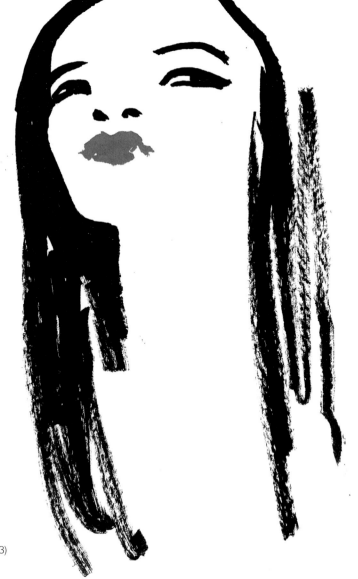

Julie Johnson
Things Are Looking Up (2003)
India ink, Dr. Martin's dyes

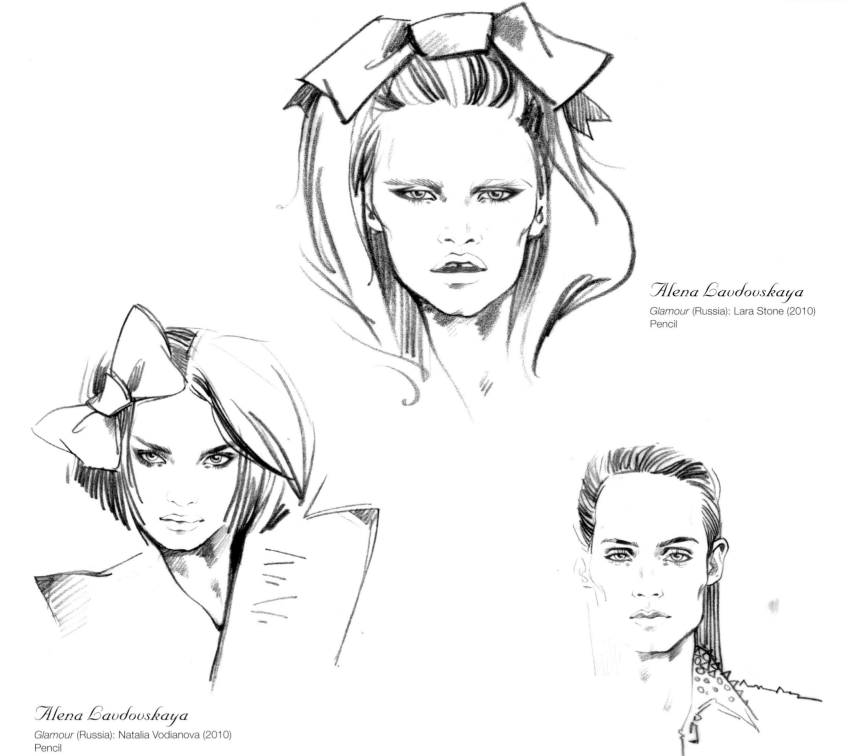

Alena Lavdovskaya
Glamour (Russia): Lara Stone (2010)
Pencil

Alena Lavdovskaya
Glamour (Russia): Natalia Vodianova (2010)
Pencil

Alena Lavdovskaya
Glamour (Russia): Amber Valetta (2010)
Pencil

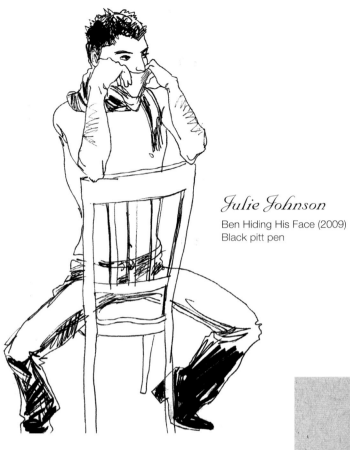

Julie Johnson
Ben Hiding His Face (2009)
Black pitt pen

Julie Johnson
Pensive Ben (2009)
Black pitt pen on toned paper

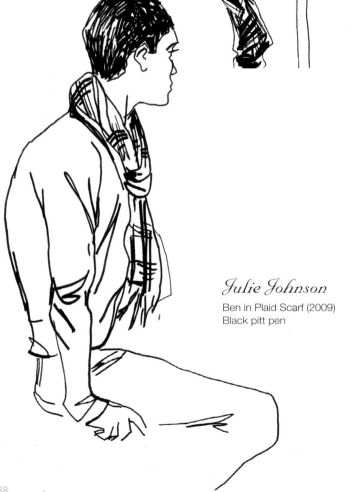

Julie Johnson
Ben in Plaid Scarf (2009)
Black pitt pen

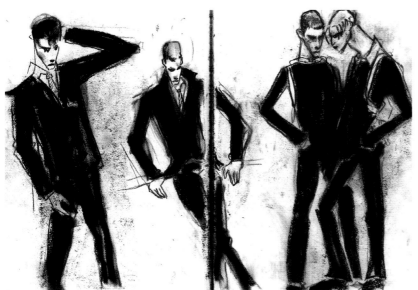

Richard James

Studs Concept 3 (2000)
Charcoal

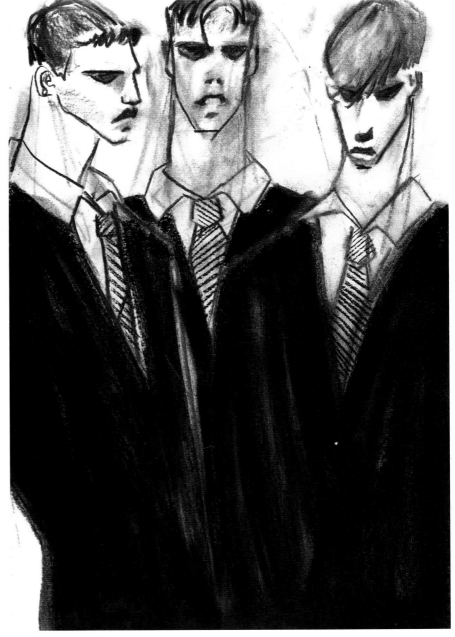

Richard James

Studs Concept 4 (2000)
Charcoal

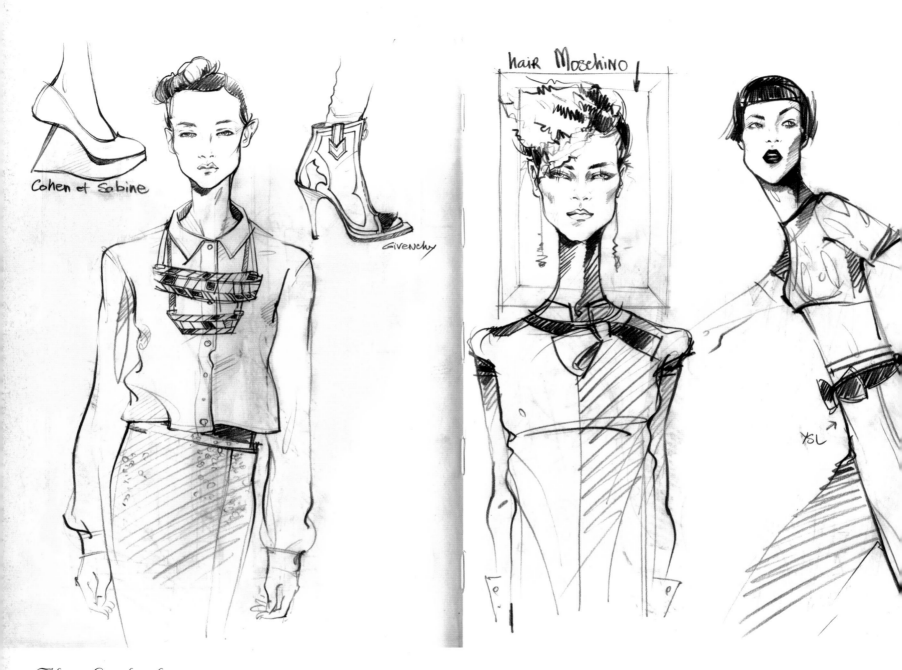

Cohen et Sabine

Givenchy

hair Moschino

YSL

Alena Lavdovskaya
Sketchbook Drawings from Runways and Editorials (2009)
Pencil

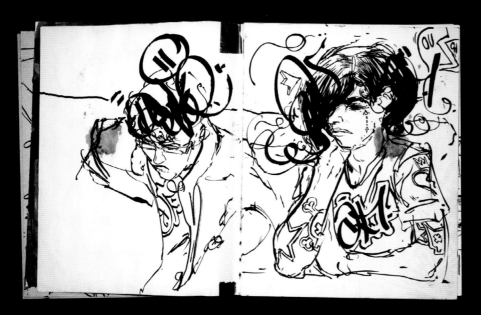

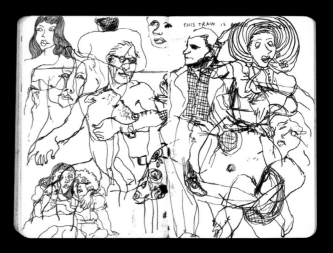

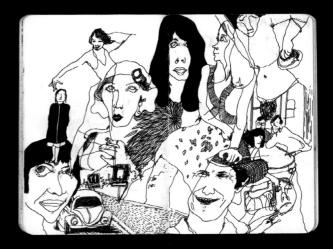

Dennis Brown

Dumpster Funk (2005)
Pen and ink

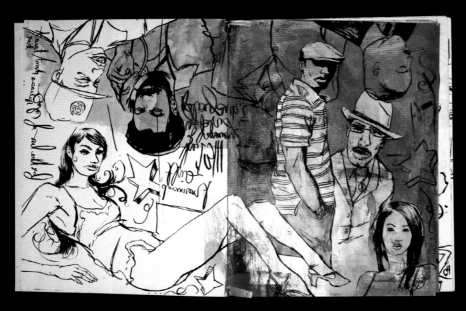

Dennis Brown

These People You Know… (2005)
Pen and ink

Ellen van Engelen

Sketchbook (2007–2009)
Pen and ink

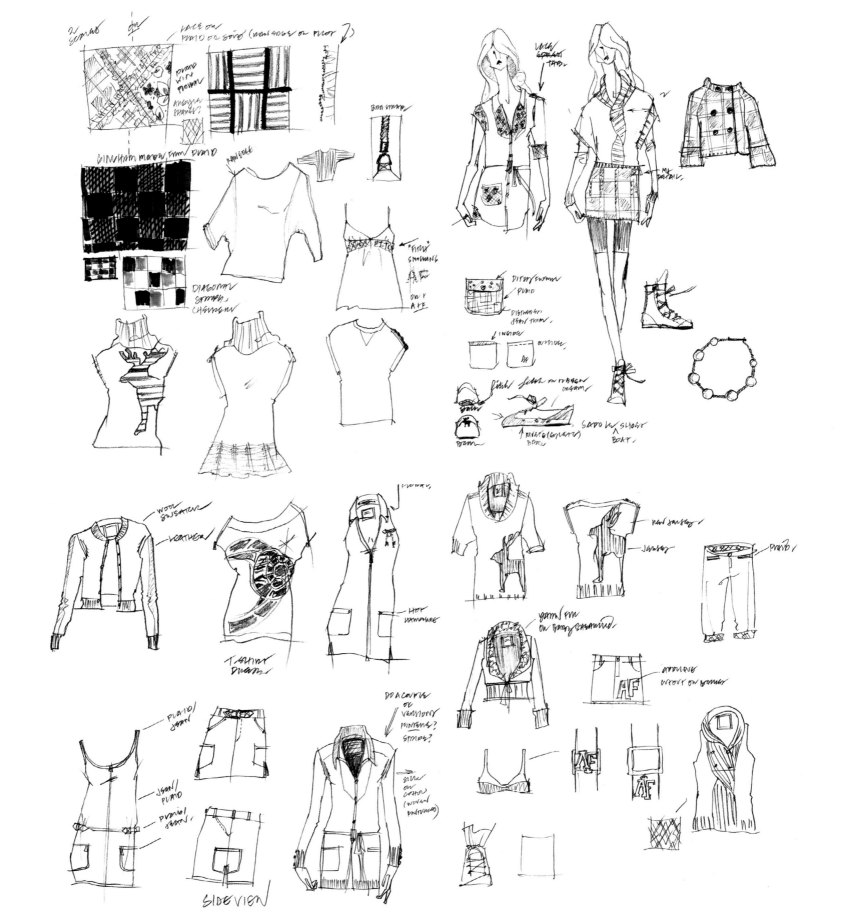

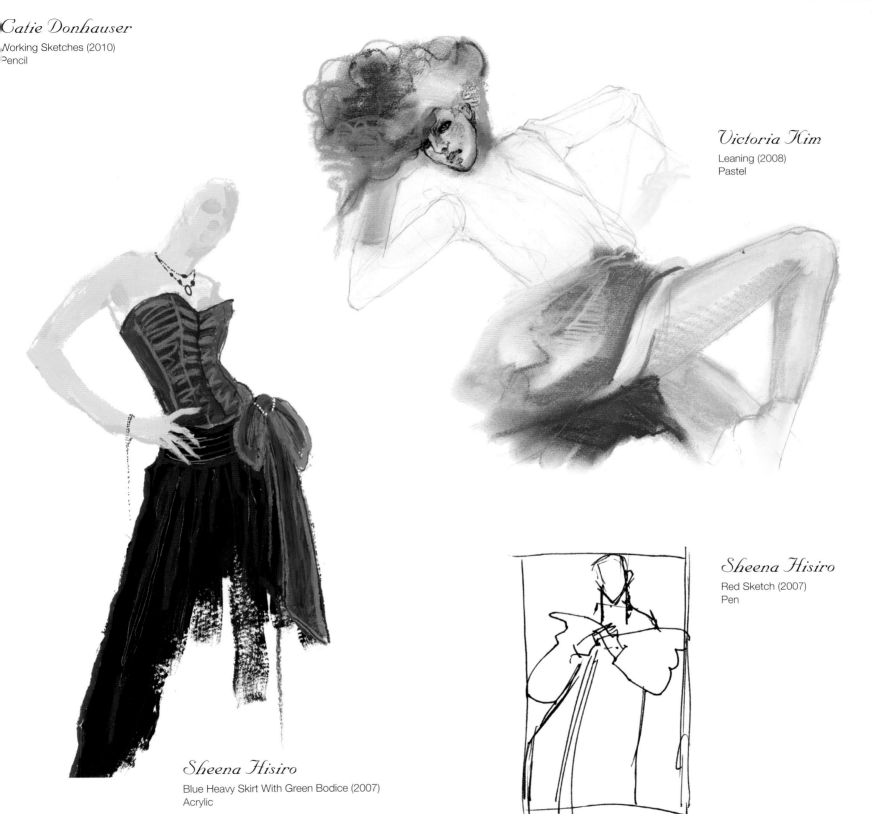

Catie Donhauser
Working Sketches (2010)
Pencil

Victoria Kim

Leaning (2008)
Pastel

Sheena Hisiro

Red Sketch (2007)
Pen

Sheena Hisiro

Blue Heavy Skirt With Green Bodice (2007)
Acrylic

393

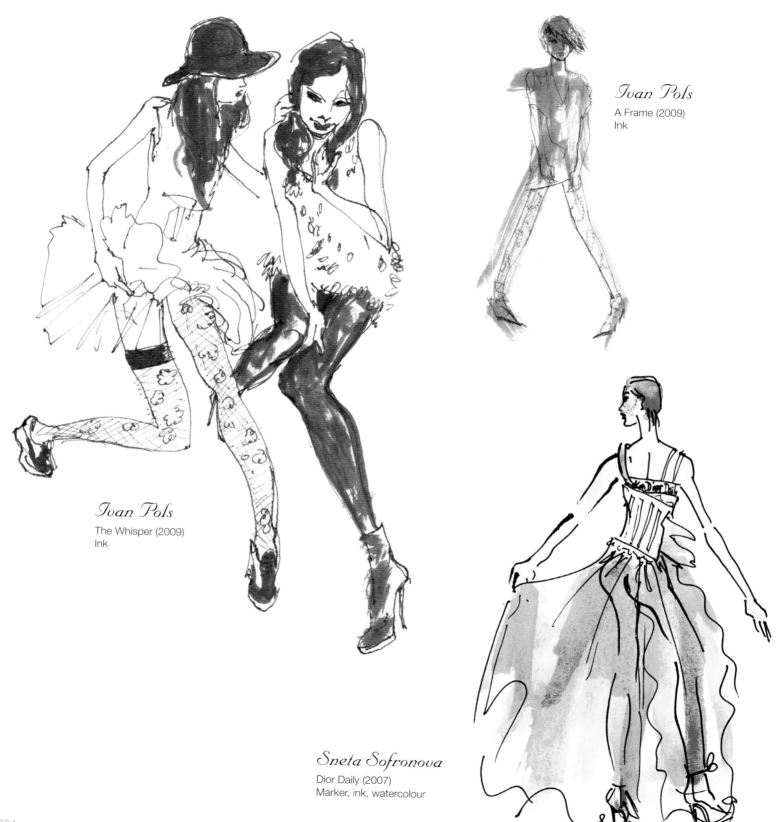

Ivan Pols
A Frame (2009)
Ink

Ivan Pols
The Whisper (2009)
Ink

Sneta Sofronova
Dior Daily (2007)
Marker, ink, watercolour

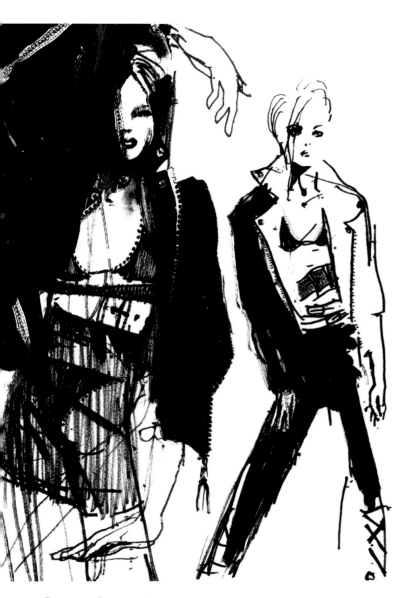

Petra Lunenburg
Elle Style Guide (Holland): Distressed (2010)
Marker, Adobe Photoshop

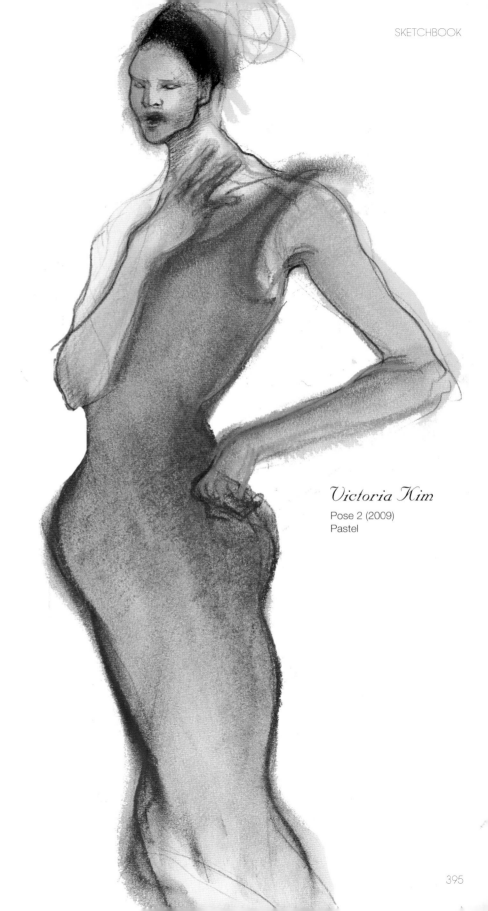

Victoria Kim
Pose 2 (2009)
Pastel

395

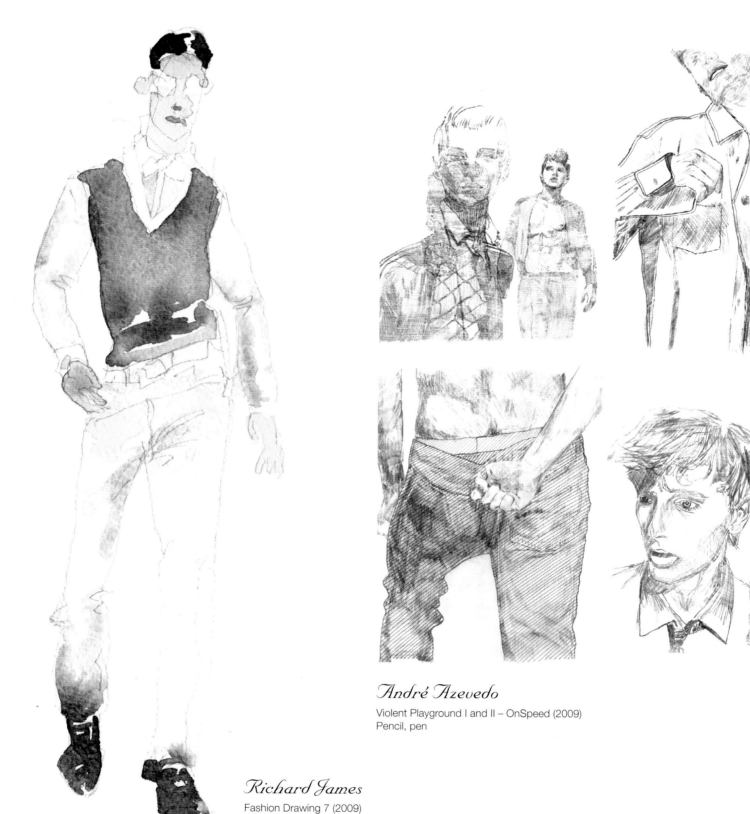

Richard James
Fashion Drawing 7 (2009)
Watercolour

André Azevedo
Violent Playground I and II – OnSpeed (2009)
Pencil, pen

Victoria Kim
Shopping (2007)
Conté crayon, watercolour

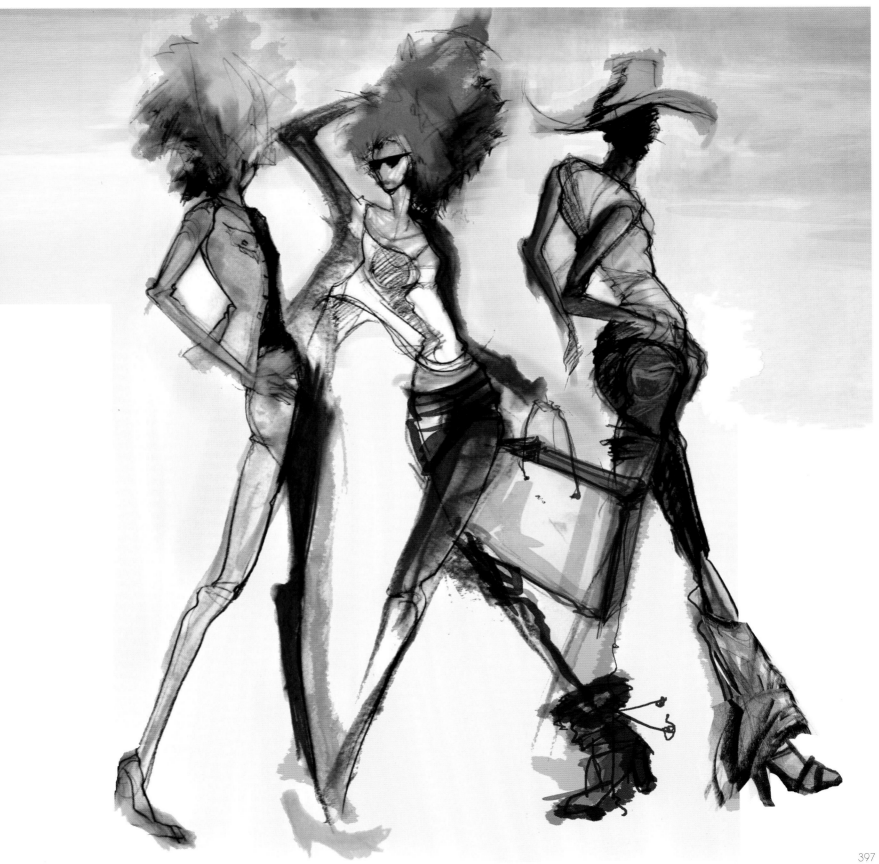

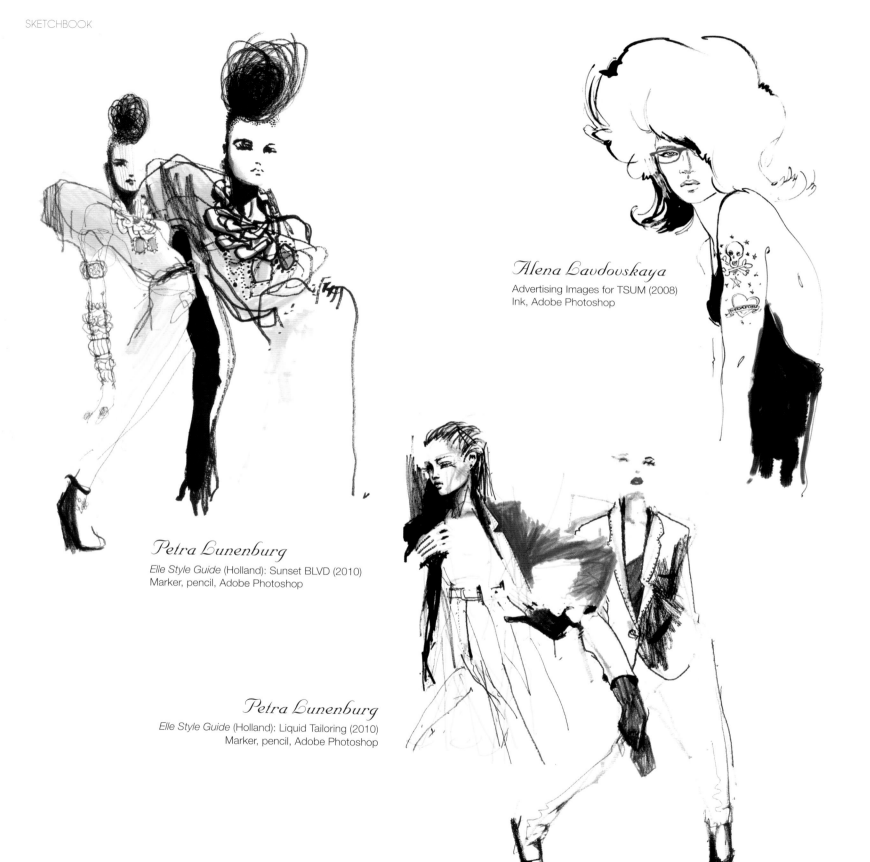

Alena Lavdovskaya
Advertising Images for TSUM (2008)
Ink, Adobe Photoshop

Petra Lunenburg
Elle Style Guide (Holland): Sunset BLVD (2010)
Marker, pencil, Adobe Photoshop

Petra Lunenburg
Elle Style Guide (Holland): Liquid Tailoring (2010)
Marker, pencil, Adobe Photoshop

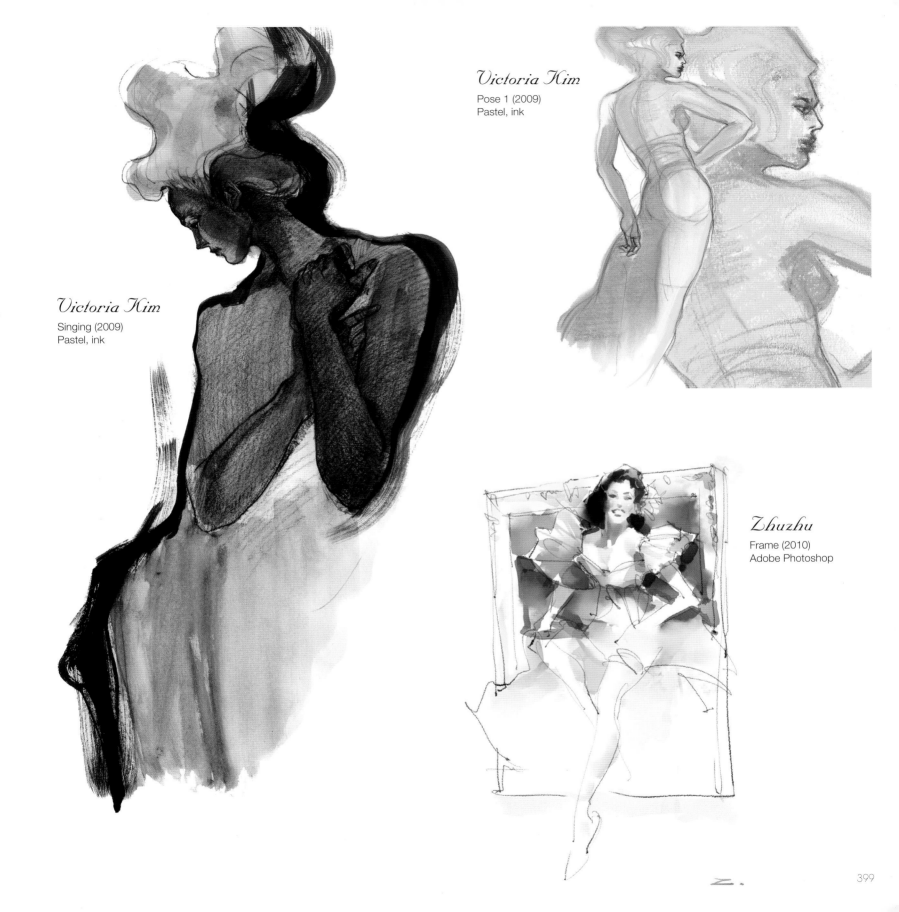

Victoria Kim

Singing (2009)
Pastel, ink

Victoria Kim

Pose 1 (2009)
Pastel, ink

Zhuzhu

Frame (2010)
Adobe Photoshop

399

Julie Johnson
Megan #1–#4 (2009)
Prismacolour pencil, oil pastel

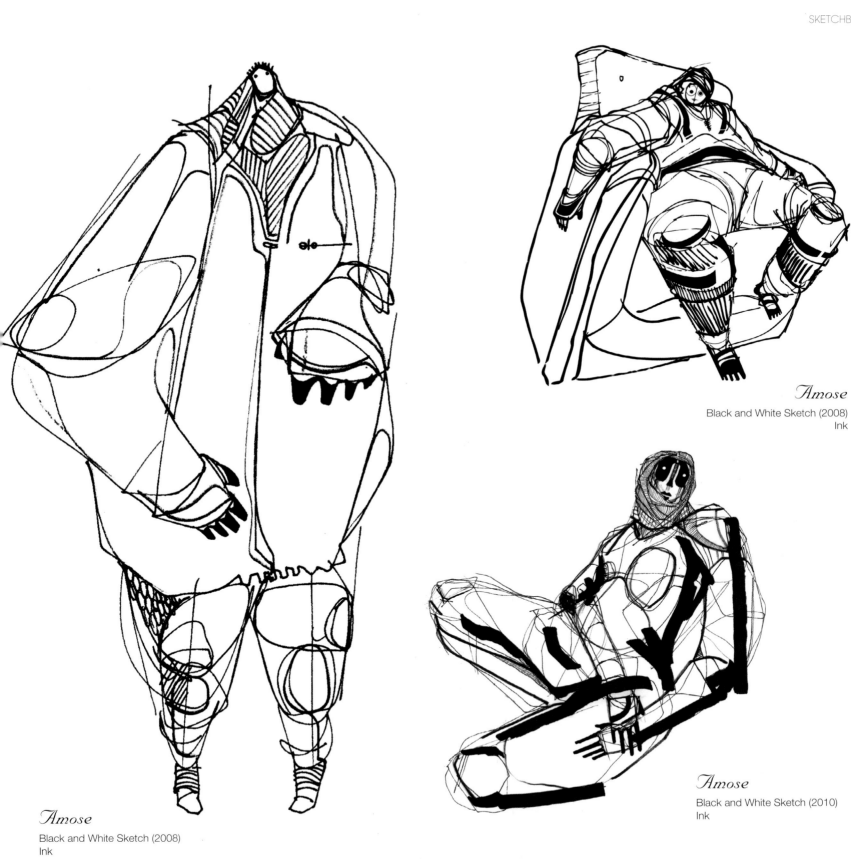

Amose

Black and White Sketch (2008)
Ink

Amose

Black and White Sketch (2010)
Ink

Amose

Black and White Sketch (2008)
Ink

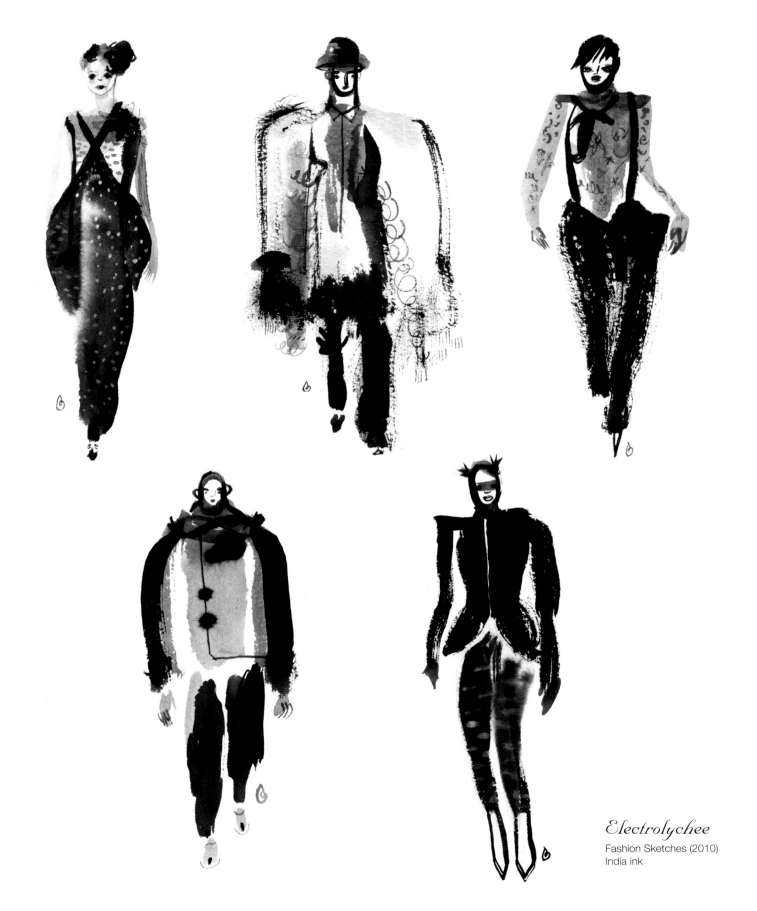

Electrolychee
Fashion Sketches (2010)
India ink

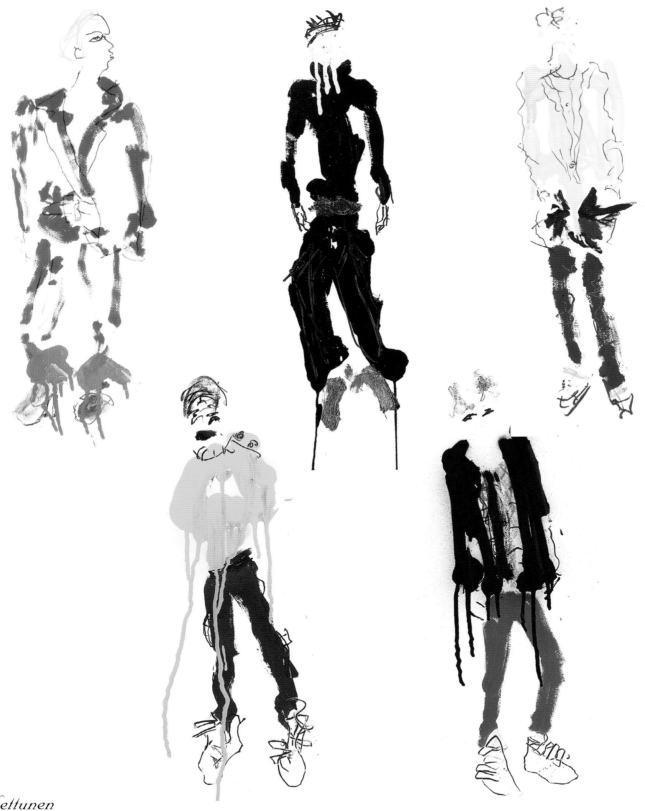

Jarno Kettunen
Backstage Action Drawings (2007–2008)
Oil, spray paint, gouache, varnish, glitter gel, iridescent acrylic, pastel, lead pencil

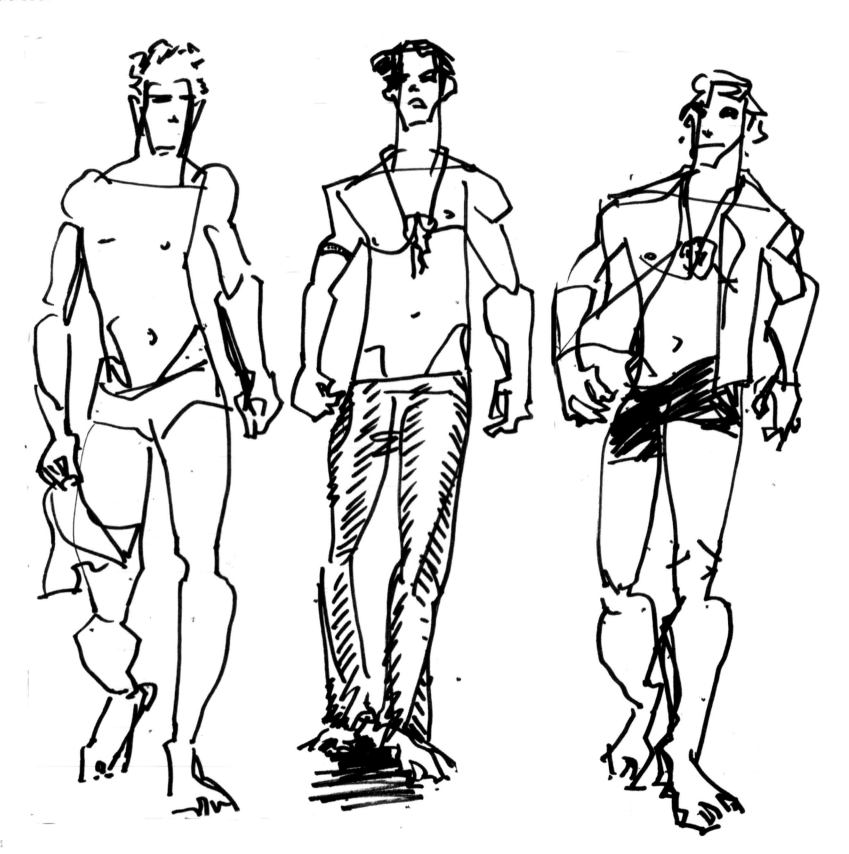

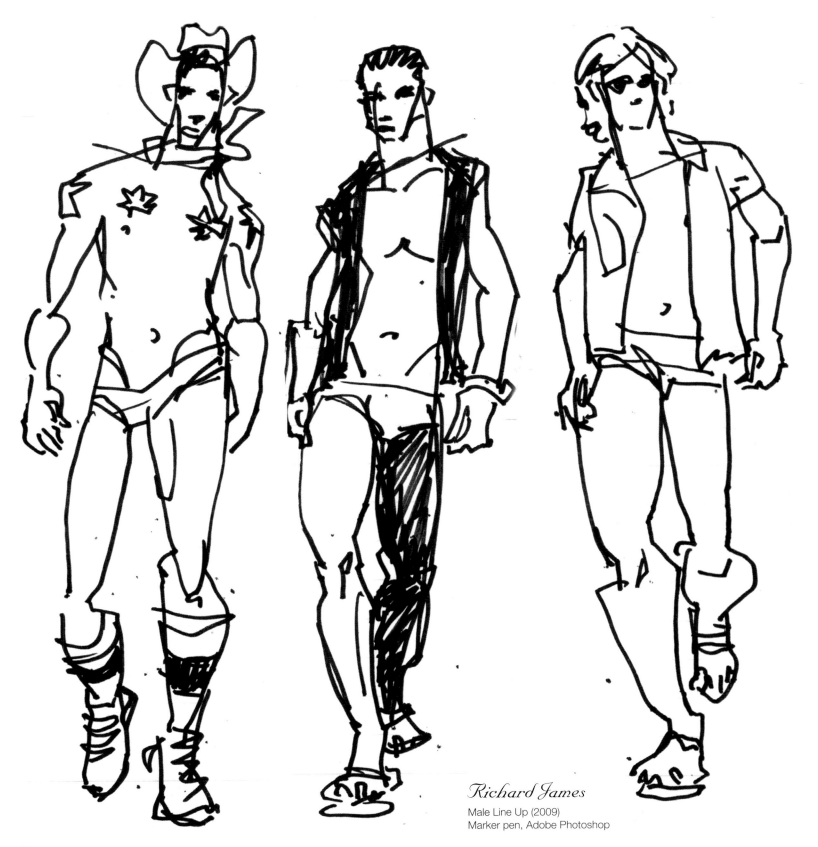

Richard James
Male Line Up (2009)
Marker pen, Adobe Photoshop

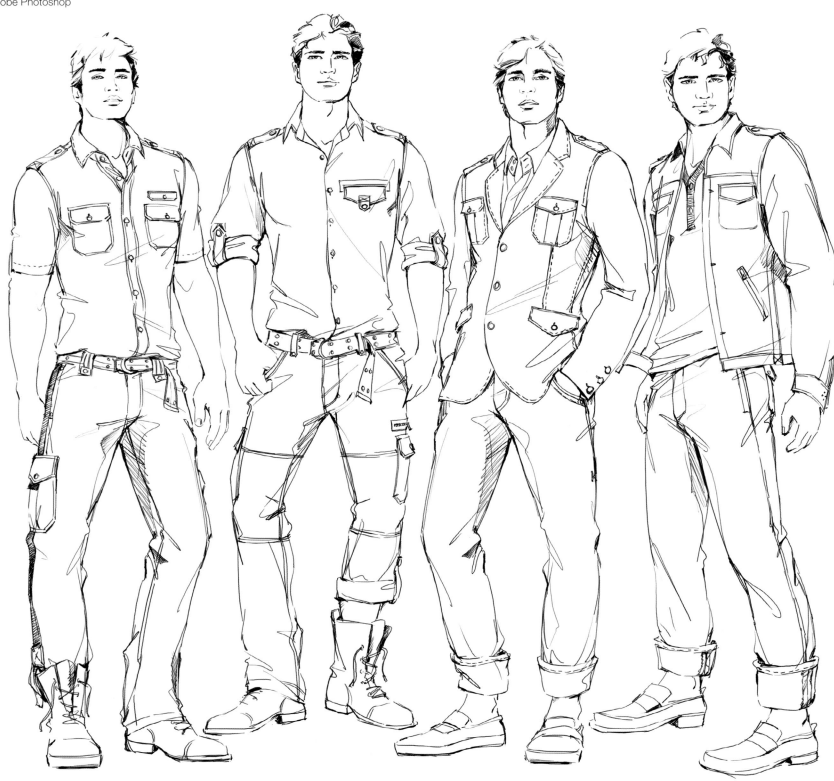

David Pfendler
Lineup (2007)
Adobe Photoshop

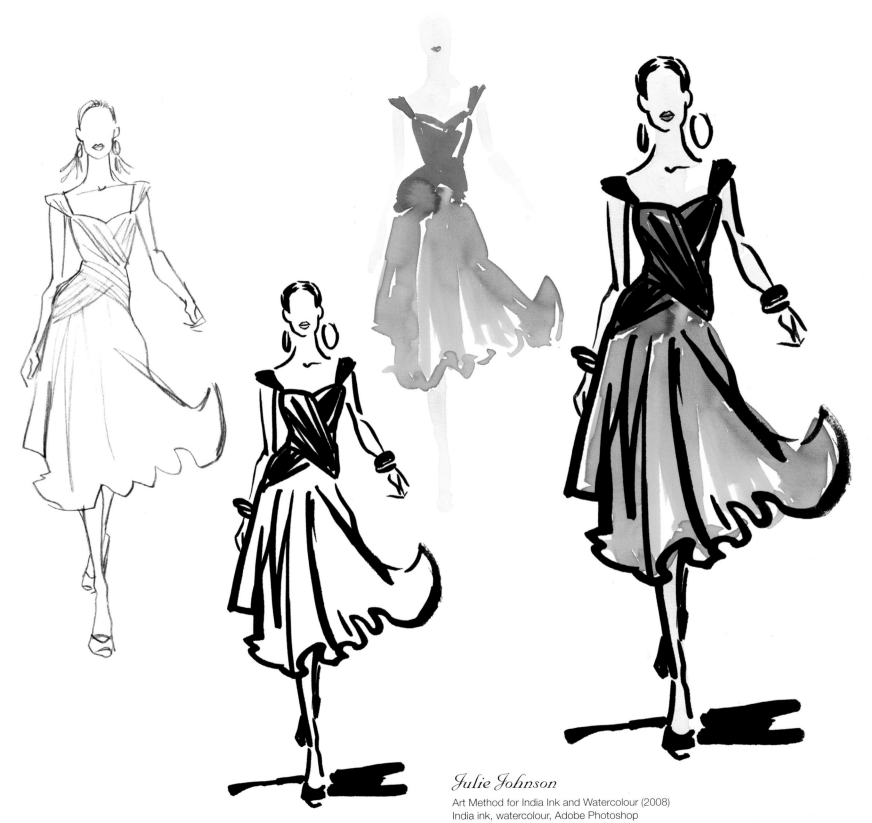

Julie Johnson
Art Method for India Ink and Watercolour (2008)
India ink, watercolour, Adobe Photoshop

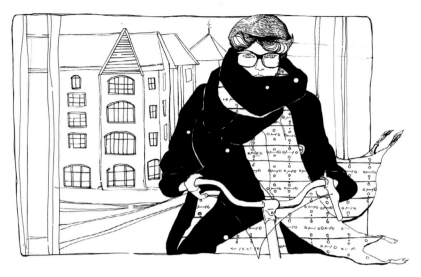

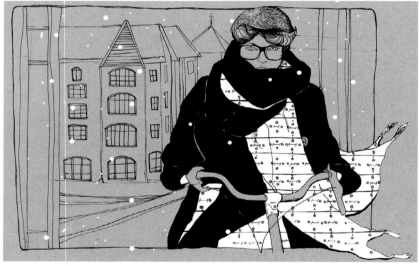

Genna Campton

Concept Rough (2009)
Pencil, pen, ink, Adobe Photoshop

Sokkuan Tye

Sophie Black for Sybil Domond (2009)
Pen, Adobe Photoshop

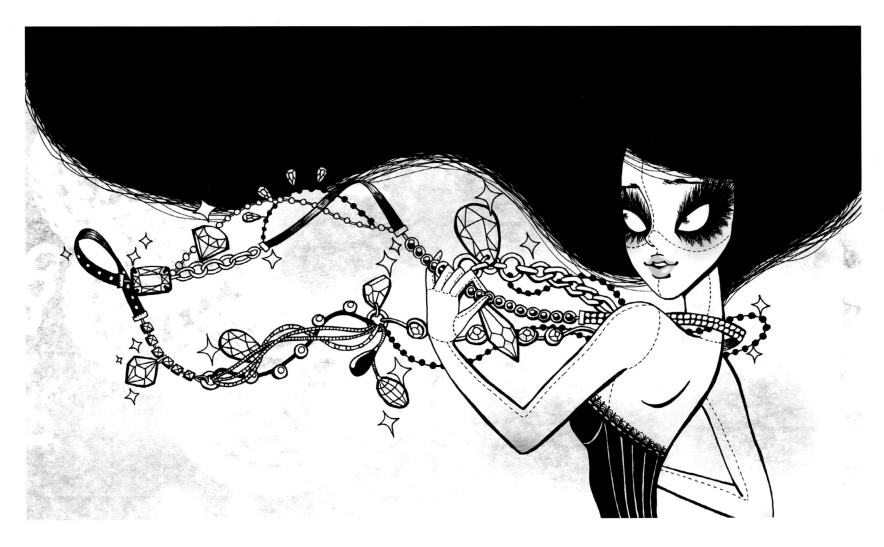

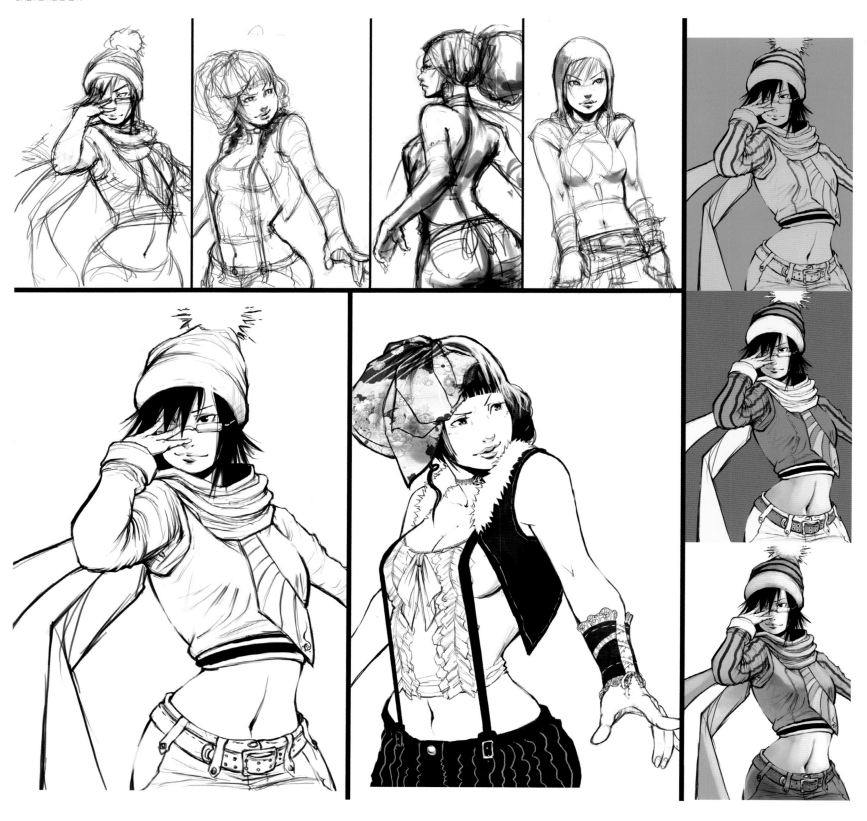

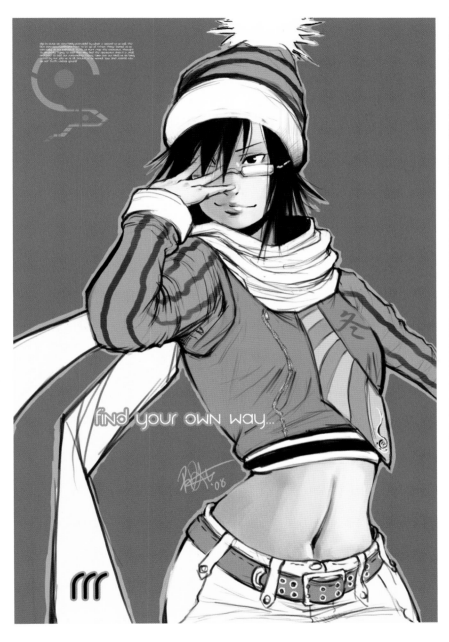

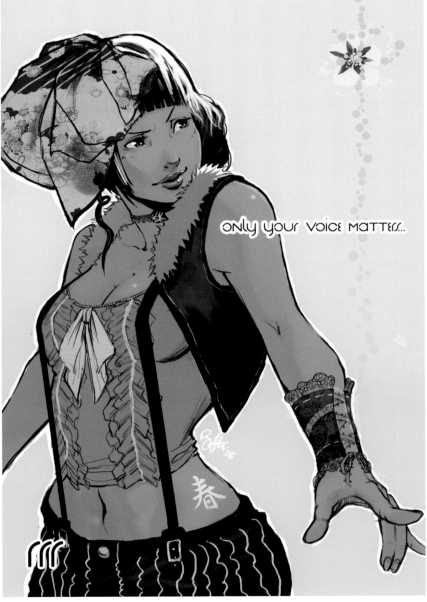

RéJean Dubois

Winter (2008)
Adobe Photoshop

RéJean Dubois

Spring (2008)
Adobe Photoshop

RéJean Dubois

Kiseki Hagaki Roughs (2008)
Adobe Photoshop

Artist Contact Details

Adlington, Mark
e-mail: mark@markadlington.com
www.markadlington.com

Aksiniya, Missyutah
e-mail: artaksiniya@gmail.com
telephone: +79060666926
www.artaksiniya.com

Amose, Sagnier Amaury
e-mail: amose@hotmail.fr
telephone: 06 82 22 45 05
http://amose.free.fr

Aoyama, Nana
e-mail: marie@directions.co.jp
telephone: 83 5467 0650
www.directions.co.jp/marie/

Aponte, Carlos
e-mail: caponte@earthlink.net
telephone: 6462807701
www.art-dept.com

Auersalo, Jesse
e-mail: jesse@jesseauersalo.com
www.jesseauersalo.com
agent: www.bigactive.com

Azevedo, André
e-mail: atalho.andre@gmail.com
telephone: 55 41 3524.0184
www.andreazevedoart.blogspot.com

De Bank, Rob
e-mail: robdebank@cox.net
telephone: 310 519 1357
www.robdebank.com

Bishop, Lauren
e-mail: info@laurenbishopillustration.co.uk
telephone: 07753 743 800
www.laurenbishopillustration.co.uk

Bonan, Isaac
e-mail: contact@isaacbonan.com
www.isaacbonan.com
Agent: www.eiko-studio.com

Booton, Amy
e-mail: amy.booton@googlemail.com
telephone: 07758269648
www.metzypants.etsy.com

Borstlap, Christian
e-mail: hello@christianborstlap.com
telephone: 0031 641151661
www.christianborstlap.com

brine
e-mail: brineb@gmail.com
telephone: 1-732-947-1129
http://homepage.mac.com/brineb/Basement_Scribbles/Menu12.html
http://flickr.com/photos/52593768@N00/

Brown, Dennis
e-mail: bagger43@gmail.com
telephone: 210-240-2504
www.bagger43.com

Bui, Viet-My
e-mail: ravenskar@gmail.com
www.vm-bui.com

Cade, Ana
e-mail: ana@rainbowcade.com
telephone: 07896709591
www.rainbowcade.com

Campton, Genna
e-mail: genna.c@hotmail.com
telephone: +61 3 95315751
www.gennacampton.com/

Cardelli, Maria
e-mail: mcardelli-illustrator@earthlink.net
www.mariacardelli.com

Carlström, Annelie
e-mail: annelie@woo.se
telephone: +46 708 12 91 94
www.anneliecarlstrom.se

Cheung, Jo
e-mail: info@jocheung.com
telephone: 07966775126
www.jocheung.com

Cho, Erica
e-mail: yelee1207@hotmail.com
telephone: 310 339 7243
www.sweetvanityproject.com

Chua, Charlene
e-mail: charlene@charlenechua.com
telephone: +1 647 351 8878
www.charlenechua.com

Cimato, Heike
e-mail: heike@freshlypoured.com
telephone: 0040308430112
www.freshlypoured.com

coco
e-mail: coco@cocopit.biz
telephone: +44 0 207 254 3706
www.cocopit.biz

Coleman, Gary
e-mail: garioski@pacbell.net
telephone: 408 266-4656
www.garycolemanartist.com

Cong, Lu
e-mail: andrew@galleryhenoch.com
telephone: 917-305-0003
www.galleryhenoch.com

Correll, Gemma
e-mail: gemmacorrell@gmail.com
telephone: +447986294333
www.gemmacorrell.com

Cunag, Rhiannon
e-mail: rhiannoncunag@gmail.com
telephone: 602-466-8783
www.rhiannoncunag.com

Danalakis, Maria
e-mail: MDanalakis@gmail.com
telephone: 917 873-5812
www.mariartist.blogspot.com

Daniels, Sid
e-mail: sid@siddaniels.com
telephone: 305 673 4329
www.siddaniels.com

Degner, Tim
e-mail: TimDegner@gmail.com
telephone: 312.909.6445
www.PrettyDept.com

Di, Mengjie
e-mail: mengjie.di@gmail.com
telephone: 678-334-8216
www.mengjiedi.blogspot.com

Dignan, James
e-mail: james@jamesdignan.com
telephone: +61 422 931 075
www.jamesdignan.com
Agent in Japan: artliaison
e-mail: mail@art-liaison.com
telephone: +81-(0)3-6413-5502
www.art-liaison.com
Agent in Australia: The Illustration Room
e-mail: katie@illustrationroom.com.au
Agent in USA: Traffic Creative Management
e-mail: info@trafficnyc.com
Agent in Europe: Unit Creative Management Amsterdam
e-mail: info@unit.nl
Agent in Germany: Office 36 Photographers Management
e-mail: info@office36.com

Ding, Wendy
e-mail: info@wendyding.com
telephone: +1 416-826-6811
www.wendyding.com

Grzegorz Domaradzki
e-mail: grzegorz.domaradzki@gmail.com
telephone: +48 604529597
www.iamgabz.com

Donhauser, Catie
e-mail: CatieDonhauser@gmail.com
telephone: 646.286.9392
www.CatieDonhauser.com

Donnelly, Eamo
e-mail: eamo@eamo.com.au www.eamo.com.au

Dubina, Lyubov
e-mail: giasemi@mail.ru
telephone: 0038 063 7735537
www.lyubovdubina.com

Dubois, RéJean
e-mail: re.jean@yahoo.com
www.signalburst.org/rejean
www.lejean.blogspot.com

Durgee, Julia
e-mail: juliadurgee@gmail.com
telephone: 9176644778
www.juliadurgee.com

D'yans, Masha
e-mail: info@masha.com
telephone: 617 968 1819
www.masha.com

Eika
e-mail: mail@eikaweb.com
telephone: 81-90-9870-1449
www.eikaweb.com

Electrolychee
e-mail: electrolychee@yahoo.com
www.electrolychee.com

Elson, Simeon
e-mail: info@simeonelson.co.uk
telephone: +44 0785 539 6215
www.simeonelson.co.uk

Engelen, Ellen van
e-mail: info@ellenvanengelen.be
telephone: +32 486 16 07 50
www.ellenvanengelen.be
Agent: Agent 002
e-mail: sophie@agent002.com
telephone: +33 1 40 21 03 48
www.agent002.com

Florêncio, Licínio Vieira Alves
e-mail: geral@licinioflorencio.com
telephone: +351 918123800
www.licinioflorencio.com

Foster, Jeff
e-mail: jemp@aracnet.com
www.jefffoster.com

Frye, Eliza
e-mail: mail@elizafrye.com
telephone: 310 806 2574
www.elizafrye.com

Galbraith, Laura
e-mail: inulg@lauragalbraith.com
telephone: +1 443 413 1728
www.lauragalbraith.com

Gauna, Ruben
e-mail: rubengaun@gmail.com
telephone: 00 54 911 6295 9638
www.gaunabeart.blogspot.com
www.flickr.com/photos/gaunaruben
Agent: Martina Mazieres
e-mail: martina.mazieres@gmail.com
telephone: 00 54 911 5655 2043

ghana.nb
e-mail: ghananb@gmail.com
telephone: +65-84900737
www.ghananb.com

Gibson, Andrew
e-mail: me@andrewgibson.co.uk
telephone: 07984 182640
www.andrewgibson.co.uk

Gimenez, Oscar
e-mail: info@oscargimenez.com
www.oscargimenez.com
Agent in UK: www.organisart.co.uk
Agent in US: www.fredascott.com

Godamunne, Nadeesha
e-mail: godamunne@gmail.com
telephone: +64 21 263 4052
Agent e-mail: carla@internationalrescue.com
telephone: +64 9 360 3366
http://www.internationalrescue.com

Goh, Gary
e-mail: virgoh35@yahoo.com.sg
telephone: +65 98303580

Gormax,
e-mail: gormax@netcologne.de
telephone: 049 221 2948326
www.gormax-illustration.blogspot.com

Graham, Brandon Kent
e-mail: brandon@WouldYouRockThis.com
telephone: 347 743 0921
www.WouldYouRockThis.com

Gray, Camila
e-mail: camisgsm@hotmail.com
telephone: 55 11 8272-0642
www.behance.net/myking

Haibo, Zhu 'zhuzhu'
e-mail: zhuhaibo1974@163.com
telephone: 86-13901694095
www.zhuzhu.deviantart.com

Hahn, Samantha
e-mail: samanthahahn@gmail.com
telephone: 845 304 4043
www.samanthahahn.com

Hanamoto, Tomoko
e-mail: mail@hana.rossa.cc
telephone: 81 0 3 3421 7791
www.hana.rossa.cc/
Agent: artliaison
e-mail: mail@art-liaison.com
telephone: +81 0 3 6413 5502
www.art-liaison.com

Hara, Atsushi
Agent: artliaison
e-mail: mail@art-liaison.com
telephone: +81 0 3 6413 5502
http://www.art-liaison.com

Hardwick, Rachel
e-mail: rachel.louise.hardwick@gmail.com
www.rachelhardwick.com

Harreveld, Katie van
e-mail: bookings@angeliquehoorn.com
telephone: +31 0 20 420 99 90
www.angeliquehoorn.com

Herrero, Jeffrey
e-mail: jeffreyherrero@gmail.com
telephone: 34 625690656
www.jeffreyherrero.com

Hess, Kerrie
e-mail: khess@netspace.net.au
www.kerriehess.com
Agent in US: www.illoreps.com
Agent in Japan: artliaison
e-mail: mail@art-liaison.com
telephone: +81 0 3 6413 5502
www.art-liaison.com

Hisa, Kentaro
Agent: artliaison
e-mail: mail@art-liaison.com
telephone: +81 0 3 6413 5502
www.art-liaison.com

Hisiro, Sheena
e-mail: sheena.hisiro@gmail.com
telephone: 717.649.5940
www.oodlesofdoodles.tumblr.com

Hjelte, Eva
e-mail: eva@evahjelte.com
telephone: +46 709 14 86 47
www.evahjelte.com

Ichikawa, Soto
e-mail: sichi725@ybb.ne.jp
telephone: +81 0 3 5716 4378
www.geocities.jp/sichi725

Imai, Yumi
Agent: artliaison
e-mail: mail@art-liaison.com
telephone: +81 0 3 6413 5502
www.art-liaison.com

IZM
e-mail: izumisan@hotmail.com
telephone: (5511) 8284-3239
www.gge.me

Jabenko, Daria
e-mail: dariadesignca@yahoo.ca
telephone: +1 416 305 2357
www.dariadesignca.com
Represented by Illustration Web
www.illustrationweb.com/dariajabenko
Agent in Japan: artliaison
e-mail: mail@artliaison.com
telephone: +81 0 3 6413 5502
http://www.art-liaison.com

James, Richard
e-mail: ridjames@hotmail.com
telephone: 07967 321866
www.dickiesdrawings.blogspot.com
www.dickiesdrawings.artworkfolio.com

Jensen, Barbara
e-mail: Arteest111@aol.com
telephone: 386 255 1836
www.eroticartistgallery.com

Johnson, Julie
e-mail: julie@juliejohnsonart.com
telephone: (415) 317 3159
www.juliejohnsonart.com

Jones, Samuel Andrew
e-mail: samueljones1234@hotmail.com
telephone: 07504221866
www.finalcrit.com/art/samueljones

Karlsson, Anne-Li
e-mail: anne-li@woo.se
Agent: Woo Agency, Stockholm, Sweden
e-mail: office@woo.se
telephone: +46 0 8 6402305
www.woo.se

Kasaj, Ivan
e-mail: ivan@kasaj.sk
telephone: +421 911 535 250
www.kasaj.sk

Kazim, Sherine
e-mail: sherine@betweenhopeandgrand.com
telephone: 646 867 3801
www.betweenhopeandgrand.com

Kessel, Bob
e-mail: b.kessel@snet.net
telephone: 860-334-9438
www.bobkessel.com

Kettunen, Jarno
e-mail: info@jarnok.com
telephone: +32(0)475 96 66 75
www.jarnok.com

Kim, Victoria
e-mail: victoriaillust@gmail.com
telephone: +82-10-4430-4076
www.victoriaillust.com

Kim, Esther
www.estherlovesyou.com

King, Christopher 'Wing'
e-mail: chris@wingsart.net
telephone: 01934 750 827
mobile: 07841 716 911
www.wingsart.net

Kittozutto
e-mail: info@kittozutto.com
telephone: +65 98511145
www.kittozutto.com

Komachi, Hanako
www.hana-koma.com
Agent: artliaison
e-mail: mail@art-liaison.com
telephone: +81-(0)3-6413-5502
www.art-liason.com

Ladiga, Baiba
e-mail: baiba@ladiga.com
telephone: +86 15900539455
www.ladiga.com

Lavdovskaya, Alena
e-mail: lavdov@mail.ru
telephone: +7-903-7488055
www.lavdovskaya.com

Leibenguth, Finna
e-mail: finna@wg-atelier.de
telephone: 0049-(0)163-903 350 4
www.wg-atelier.de

Lim, Connie
e-mail: c0n2i3@hotmail.com
telephone: 626)376-5233
www.connielim.com

Lim, Daniel Hyun
e-mail: fawnfruits@gmail.com
telephone: 3234249519
www.fawnfruits.com

Lopez, Chris
e-mail: clopezstudio@aol.com
telephone: 954 295 3269
www.lopezgallery.com

Lind, Monica
e-mail: aria@art-liaison.com
telephone: +81 03 6413-5502
www.workbook.com
Agent in Japan: artliaison
e-mail: mail@art-liaison.com
telephone: +81-(0)3-6413-5502
www.art-liaison.com

Lück, Anne
e-mail: welcome@annelueck.com
telephone: +49.30.40987577
www.annelueck.com

Lunenburg, Petra
e-mail: Bookings@angeliquehoorn.com or
p.lunenburg@tiscali.nl
telephone: +31 (0)20-420 9990 or +31 6 288 33 617
www.angeliquehoorn.com
www.drawthing.com

McCollam, Phil
e-mail: phil@philrules.com
telephone: 1-218-340-7988
www.philrules.com

McWilliams, Courtney
e-mail: courtney@courtneymc.com
telephone: +44(0)7971236115
www.courtneymc.com

Maclean, Fiona
e-mail: Fiona@fionamaclean.com
telephone: +61 2 80907370
www.fionamaclean.com
www.fionamaclean.blogspot.com

Mahoney, John
e-mail: johnmahoney@sbcglobal.net
telephone: 661-252-3979
www.johnjmahoney.daportfolio.com
www.mahoneydrawings.blogspot.com

Makarova, Svetlana
e-mail: lanitta@lanitta.com
www.lanitta.com

Matsubara, Shiho
e-mail: matsubara@shiho.co.uk
telephone: +81-(0)42-360-8411
www.shiho.co.uk
Agent: artliaison
e-mail: mail@art-liaison.com
telephone: +81-(0)3-6413-5502
www.art-liaison.com

Meder, Danielle
e-mail: contact@daniellemeder.com
telephone: 416 603 6671
www.daniellemeder.com

Mi-suk, Han
e-mail: hms87@naver.com
telephone: 82-31-949-3548
mobile: 82-10-3719-5766
www.flickr.com/artistms

Mitsuda, Megumi
e-mail: sette_miele801@fj8.so-net.ne.jp
http://www003.upp.so-net.ne.jp/miele_7sette/
Agent: artliaison
e-mail: mail@art-liaison.com
telephone: +81-(0)3-6413-5502
www.art-liaison.com

Moden, Kari
e-mail: kari@moden.se
telephone: +46704 833450
www.karimoden.se

Mount, Arthur
e-mail: arthur@arthurmount.com
telephone: 971-645-2481
www.arthurmount.com

Munoz, Adriana
e-mail: adriana@colourpiano.com
telephone: +44 (0)7906243377 / +34 686721233
www.colourpiano.com

Nadreau, Ëlodie
e-mail: contact@elodie-illustrations.net
telephone: +3306 81 04 75 54
www.elodie-illustrations.net

Narielwalla, Hormazd Geve
e-mail: hormazd@narielwalla.com
telephone: 07786011530
www.narielwalla.com

Neild, Robyn Nicole
e-mail: Robyn@RobynNeild.com
telephone: +44 (0)7855 344 239
www.RobynNeild.com

Newman, Gary
e-mail: gary@garynewman.co.uk
telephone: 07903 584 937
www.garynewman.co.uk

Newton, Rowan
e-mail: rowan_newton@yahoo.co.uk
www.rowannewton.co.uk

Nicholas, Clare
e-mail: clare.nic@btinternet.com
telephone: + 44 (0) 1788 522356
www.contact-me.net/clarenicholas

Nicolle, Florian
e-mail: neo.innov@gmail.com
telephone: +33(0)6 88 61 37 72
www.neo-innov.fr

Noda, Makiko
e-mail: nodamakiko@nodamakiko.net
telephone: +81(90)-9110-6209
www.nodamakiko.net
Agent: artliaison
e-mail: mail@art-liaison.com
telephone: +81-(0)3-6413-5502
www.art-liaison.com

Nowicka, Agata
e-mail: endo@agatanowicka.com
telephone: +48 790 011 932
www.agatanowicka.com
Agent: Marlena Agency
e-mail: marlena@marlenaagency.com
telephone: +1 609 252 9405
www.marlenaagency.com

Nuñez, Kenji
e-mail: kristoffernunez@gmail.com
telephone: + 63917 5983138
www.kenjiarts.deviantart.com

O'Neill, Jacquie
e-mail: Jacquie@jacquieoneill.com
telephone: 01840 212109
www.jacquieoneill.com

Obasi, Henry
e-mail: Henry@ppaint.net
www.ppaint.net
www.henryobasi.com

Okada, Mika
e-mail: micccca@hotmail.com
telephone: +81-3-3481-3295
www12.ocn.ne.jp/~micca

Painter, Andrew
e-mail: candy@thepainters.me.uk
telephone: 020 8529 7469
www.andrewpainterillustration.me.uk

Papow, Dustin
e-mail: dustinpapow@gmail.com
telephone: 248 982 0004
www.dustinpapow.com

Paprocki, Greg
e-mail: gpaprocki@cox.net
telephone: 1-402-932-0722
www.gregpaprocki.com

Paris, Piet
e-mail: studio@pietparis.com
telephone: +31 20 63 888 52
www.pietparis.com
Agent in Asia: Art Liaison
telephone: 81-(0)3-6413-5502
e-mail: mail@art-liaison.com
www.art-liason.com
Agent in Europe/USA: Unit Creative Management Amsterdam
telephone: 31 20 530 6000
www.unit.nl

Pariseau, Pierre-Paul
e-mail: pierrepaulpariseau@videotron.ca
telephone: 514-528-7715
www.pierrepaulpariseau.com

Paskovsky, Mariya
e-mail: info@mpaskovsky.com
telephone: 1 514 969 1493
www.mpaskovsky.com

Pearce, Karl
e-mail: jimoakley666@hotmail.com
telephone: 07715635273
www.carlpearce.daportfolio.com

Pegler, Charlotte
e-mail: charlottepegler@hotmail.com

Perryman-Burow, Alcine
e-mail: fashionart@alcinep.com
telephone: 702 808 7775
www.alcinep.com

Pfendler, David
e-mail: dpfendler@nyc.rr.com
telephone: 917-363-9523
www.davidpfendler.com

Pfleghaar, Michael
e-mail: michael@pfleghaar.com
telephone: 616-307-5377
www.pfleghaar.com

Plaskett, Lisa
e-mail: lisa@lisaplaskett.com
telephone: 01 415 455 8683
www.lisaplaskett.com
Agent in Japan: artliaison
e-mail: info@art-liaison.com
telephone: +81-(0)3 6413 5502
www.art-liaison.com

Plovmand, Wendy
e-mail: mail@wendyplovmand.com
telephone: + 44 (0) 7551 599596
www.wendyplovmand.com
Agent in US: Traffic creative management
e-mail: info@trafficnyc.com
telephone: + 212 734 0041
www.trafficnyc.com
Agent in UK: CIA - The Central Illustration Agency
e-mail: info@centralillustration.com
telephone: + (44) (0) 20 7734 7187
www.centralillustration.com

Pols, Ivan
e-mail: ivan.pols@gmail.com
telephone: +44 701 786 4207
www.boundlessoptimism.org

puntoos
e-mail: info@puntoos.com
telephone: +34 636375572
www.puntoos.com
Agent in US & Canada: Traffic Creative Management
e-mail: info@trafficnyc.com
telephone: 212 734 0041
www.trafficnyc.com

Puspasari, Nani
e-mail: nanisakurai@yahoo.com
telephone: +62423391361
www.designani.net

Riti, Marsha
e-mail: marshariti@marshariti.com
telephone: 512 669-0700
www.marshariti.com

Rodgers, Katie
e-mail: paperfashionart@gmail.com
telephone: 678 982 6291
www.paperfashion.wordpress.com

Røise, Esra Caroline
e-mail: esra@esraroise.com
telephone: +4745055276
www.esraroise.com

Rosini, Barbara
e-mail: brosini@hotmail.com
telephone: 514-758-3630
www.rosinib.com

Roy, Pascal
e-mail: pascaleroy@gmail.com
telephone: 52 777 316 8716
www.pascalroy.com

Rumaisha, Selina
e-mail: selinaru@gmail.com
telephone: 65-96558629

Sauvage, Marguerite
e-mail: margueritesauvage@gmail.com
telephone: +33 (0) 6 17 82 40 29
www.margueritesauvage.com
Agent in US: Magnet Reps
telephone: (866) 390-5656
art@magnetreps.com

Savva, Maxim
e-mail: max@maximsavva.com
www.maximsavva.com
Agent: artliaison
e-mail: mail@art-liaison.com
telephone: +81-(0)3-6413-5502
www.art-liaison.com

Scandella, Alessandra
e-mail: alefast@fastwebnet.it
telephone: +39 0236552324
mobile: +39 3385332913
www.alessandrascandella.com

Sergeev, Dmitry
e-mail: dmitrysart@gmail.com
telephone: 61 8 0405263678
www.dmitrys.deviantart.com

Shimizu, Shingo
e-mail: shingo@shingo.ca
telephone: +1 416.825.8603
www.shingo.ca

Siew, Jason
e-mail: jason.smc75@gmail.com
telephone: +65 98794648
www.jasonsiew.blogspot.com

Sofronova, Aneta
e-mail: sofronova.aneta@gmail.com
telephone: 647-201-3186
www.anetasofronova.com

Sneddon, Jamie
e-mail: jamie@jamiesneddon.co.uk
telephone: +44 [0]1273 67 22 11
mobile: +44 [0]7779 71 53 53
www.jamiesneddon.co.uk

Spaeth, Paloma
e-mail: paloma@palomaspaeth.com
www.palomaspaeth.com

Stap, Odile van der
e-mail: Jumei.san@gmail.com
www.oneiric-elegance.artworkfolio.com

Strang, Alec
mondrianwasaliar@yahoo.co.uk
telephone: 07970804964
www.alstrang.com

Streeter, Loreto Binvignat
e-mail: loreto@loretobinvignat.com
www.loretobinvignat.com

Suy, Sandra
e-mail: hola@sandrasuy.com
www.sandrasuy.com

Szczecinska, Beata 'Cityabyss'
e-mail: info@cityabyss.com
telephone: +48 797052884
www.cityabyss.com

Takagi, Nobuko
e-mail: heaven@heaven-illust.com
telephone: +81-(0)4-2959-0854
www.heaven-illust.com
Agent: artliaison
e-mail: mail@art-liaison.com
telephone: +81-(0)3-6413-5502
www.art-liaison.com

Tang, Meikei
e-mail: me@meekhee.nl
www.meekhee.nl

Tinoco, Luis
e-mail: info@lemonadeillustration.com
telephone: +34 620 209 735
www.luistinoco.com

Tirado, Robert
e-mail: Robert@roberttiradoart.com
telephone: +34 634- 927 469
www.roberttiradoart.com

Todd, Mark
e-mail: marktoddart@gmail.com
telephone: (626) 836-2210
www.marktoddillustration.com

Tovey, Jill
e-mail: hello@jilltovey.com
telephone: 07740 342188
www.jilltovey.com

twisstii
e-mail: twisstii@yahoo.com
telephone: +65 94894255
www.twisstii.blogspot.com

Tye, Sokkuan
e-mail: tye_sk@yahoo.com.sg
telephone: +65 91836484
www.sokkuan.com

UFHO
e-mail: info@ufho.com
telephone: +65 98511145
www.ufho.com

Velasquez, Monica
e-mail: Monicavelasquez@comcast.net
www.monicavelasquez.com

Wacker, Kerstin
e-mail: henrik@wacker1.com
telephone: ++49-177.70.30.260
www.wacker1.com

Walgraeve, Marie 'marmushka'
e-mail: marmushka@telenet.be
telephone: +32498814550
www.flickr.com/photos/mrrrie

Webster, Kyle T
e-mail: kyle@kyletwebster.com
telephone: 336.253.4612
www.kyletwebster.com

Wetzler, Rebecca
e-mail: info@rebeccawetzler.com
www.rebeccawetzler.com

Whitehurst, Autumn
e-mail: autumn@awhitehurst.com
Agent's email: illustration@art-dept.com
telephone: 21.243.2103
www.art-dept.com/illustration/

Whiteley, Laurence
e-mail: info@laurencewhiteley.com
www.laurencewhiteley.com

Woodhouse, Jessica
e-mail: jess@jessicawoodhouse.com
telephone: (+44) 7870 363 922
www.jessicawoodhouse.com

Wu, Annie
e-mail: anniewuart@gmail.com
www.anniewuart.com

Zelnick, Renee Reeser
e-mail: reneereeserzelnick@me.com
www.reneereeserzelnick.com
Agent: Famous Frames
e-mail: info@famousframes.com
telephone: US (800)-530-3375 or (310) 642-2721
www.famousframes.com